# Believing and Seeing

# Believing and Seeing

## THE ART OF GOTHIC CATHEDRALS

## Roland Recht

*Translated by Mary Whittall*

The University of Chicago Press  CHICAGO & LONDON

ROLAND RECHT is professor of art history at the University of Strasbourg.
He is the author of several books, including *Les Bâtisseurs des cathédrales
gothiques* (Musées de la Ville de Strasbourg, 1989), *Le Dessin d'architecture:
Origine et fonctions* (Éditions Adam Biro, 1995), and *Penser le patrimoine:
Mise en scène et mise en ordre de l'art* (Éditions Hazan, 1999).

MARY WHITTALL (1937–2005) worked for many publishers, producing
numerous English translations from French and German. She rendered several
important translations for the University of Chicago Press, including translations
from the German for Lorenzo Bianconi and Giorgio Pestelli's *Opera in Theory and
Practice, Image and Myth* (2003), and, from the French, Anselm Gerhard's *The
Urbanization of Opera: Music Theater in Paris in the Nineteenth Century* (1998).

The University of Chicago Press, Chicago 60637
The University of Chicago Press, Ltd., London
© 2008 by The University of Chicago
All rights reserved. Published 2008
Printed in the United States of America

Originally published as *Le Croire et le voir: L'art des cathédrals (XII$^e$–XV$^e$ siècle)*,
© Éditions Gallimard, 1999.

Published with the support of the National Center for the Book—French Ministry
of Culture.

Ouvrage publié avec le soutien du Centre national du livre—ministère français
chargé de la culture.

17  16  15  14  13  12  11  10  09  08        1  2  3  4  5

ISBN-13: 978-0-226-70606-1 (cloth)
ISBN-10: 0-226-70606-0 (cloth)

Library of Congress Cataloging-in-Publication Data

Recht, Roland.
[Croire et le voir. English]
Believing and seeing : the art of Gothic cathedrals /
Roland Recht ; translated by Mary Whittall.
    p.   cm.
Includes bibliographical references and index.
ISBN-13: 978-0-226-70606-1 (cloth : alk. paper)
ISBN-10: 0-226-70606-0 (cloth : alk. paper)
    1. Art, Gothic.    2. Christian art and symbolism—Medieval,
500–1500.    3. Cathedrals.    I. Title.
N6310.R4313 2008
709.02′2—dc22                                      2007050123

⊗ The paper used in this publication meets the minimum requirements of the
American National Standard for Information Sciences—Permanence of
Paper for Printed Library Materials, ANSI z39.48-1992.

# CONTENTS

# ILLUSTRATIONS

# NOTE ON THE TRANSLATION

Sadly, Mary Whittall passed away as this book went to press. Although we never had the chance to meet in person, I had the pleasure of assisting her as she worked on this translation. Mary was a wonderful colleague and correspondent to me over the years. Her care and dedication to the beauty of the written word is felt on every page of her lovely translation.

In Mary's absence, many have helped to bring this project to its completion, including Susan Bielstein, Mary Gehl, and Anthony Burton at the University of Chicago Press. I would also like to thank David J. Johnson for his tireless efforts in seeing Mary's project through to the end.

*Christine Hahn*
*March 2008*

# INTRODUCTION

This book begins with a question fundamental to any consideration of the "Gothic." The concept being neither wholly formal nor historical, it enjoys a certain haziness, allowing the actual word to mean what users want it to mean in different contexts. The question remains unresolved, but reflection on it has led me to a conviction—a thesis, it might be said—that works of the twelfth and thirteenth centuries were progressively affected by a discernible change, namely an enhancement of their visual value. I should like to illustrate this change by the example of a number of churches, spaces built for worship but also entered and traversed by the people of the time in which they were built. This new space may enable us to find the key to an essentially psychophysical dimension of the history of time past.

Deliberately choosing a course opposed to the fragmentation general in academic research nowadays, I discuss architecture, sculpture, and the arts of stained glass and goldsmithing. A long view of the period as a whole predominates but does not exclude taking account of the differences of time scale affecting developments of thought and artistic creation, and the nature of the works themselves.

Without losing sight of the fact that no single explanation for a work of art could possibly be found in an extraneous system of thought, I have nonetheless resorted to all manners of means of modifying the way we look at works, if only in the form of some slight displacement: architectural allegorization, literary expression in general, theological or philosophical thought. I have taken the greatest of care, however, in examining the properties—formal and material on the one hand, historical on the other—of individual works. Before all else,

a work of art possesses the material dimension of an object: it could even be said that in the last resort that material dimension is all it has. Yet that does not mean it has no connection to the world of ideas or speculative excitement. And, last of all, its style asserts itself as the authoritative agreement between the idea and the material form.

From the twelfth century to the fifteenth, works of art were produced in conditions very different not only from those of today but from those of the entire modern era. The artist of the late Middle Ages was under a dual constraint: that of the program, which was at first exclusively, and later, predominately religious; and that of the institution—lodge or corporation—to which he and his workshop were attached. The program necessarily imposed a limit on the number of work types, dependent on their functions, and also determined their content. To the fixed nature of the program can be added that of the procedures enabling the artist-craftsman to produce these works, whether controlled by the corporation or guild or by the internal hierarchical organization of the workshop. The transmission of iconographic and formal models also took place in accordance with modalities that correspond only remotely to those we know of in more recent periods. When art is dependent to that extent on the person or institution commissioning the work and on the function assigned to it, it becomes, at least partly, an expression of power. It is as necessary to examine this complex game played out between art and power as it is to define precisely the function of the artist. Because when art is linked in such a way to the interests and aspirations of one group of people it becomes indispensable to them—in other words, the artist advances towards emancipation because he possesses a power that power needs.

In the Middle Ages that advance was very slow and became manifest only at the end of the period. Yet already in the twelfth century, eloquent signs were visible proof that a transformation was taking place and that an elite was forming around the artist and his works, a circle of artists, intellectuals, and clerics reflecting the range of discussion and artistic judgments on the respective and comparative values of works of art. The relatively early rise of a market in art outside the circle of commissioned work confirms the activities of this elite.

If we are to approach mechanisms separated from us by a distance of seven or eight centuries, we must exercise the utmost caution: there can be no resort to such modern concepts as "art for art's sake" as a means of designating aesthetic attitudes to which they are completely alien. It is my belief that the simple examination of the works of art themselves—the structure of a pillar, the polychromy of a crucifix, or the composition of a stained-glass window—will

teach us much about areas on which the archives are silent and speak volumes about the conception that people in the thirteenth century might have had— not of architectural space, for the concept is barely a hundred years old—but of relations of proximity and hierarchy with the physical world and with their fellow men; or about the degree of reality they attached to the image of the high altar.

The revolutionary changes that profoundly modified medieval man's conception of pictorial art and the buildings in the heart of which the sacrament of the Eucharist was celebrated and the Host elevated in public view are reduced by the use of the word "Gothic" to a category of forms or certain structural principles: the flying buttress, the pointed arch. Yet the structural principles and the formal solutions were only responses to much more pressing problems.

The process of making the Incarnation visible rests on a physics, and metaphysics, of seeing, of "perspective" or optics, elaborated during the thirteenth century on the basis of Greek and Arabic sources. The popular demand to see the Host raised at the moment of consecration and the exemplary nature of the life of St. Francis of Assisi were just two aspects of the need to see in order to believe that took hold of congregations in the late twelfth and the thirteenth centuries. And the demand had other effects, on reliquaries in particular, in which sacred material fragments were displayed with theatrical flair.

Focusing principally on ecclesiastical architecture holds out the greatest promise of revealing its essentially visual qualities and its system of references to tradition. I shall explore the role of architecture in elaborating a new kind of space and give special attention to architectural polychromy, an aspect of medieval architecture that is too often neglected. But the formal properties were always placed at the service of a program, for architecture necessarily fulfilled a symbolic function that reveals itself only after careful reading and interpretation of types. If Chartres Cathedral is called "classical," it is perhaps because it perpetuates models of ancient architecture in its own way, whereas Bourges Cathedral laid the foundations for modern architecture—yes, even contemporary architecture. The system of meaning that each of them retained ensured their acceptance by a bishop or a king who would transform it in his turn.

The place of worship becomes the support for carved and painted images. But a reliquary bust and a figure in the embrasure of a doorway do not have the same function or the same meaning. It is important to distinguish between works according to their functions. Devotional images imply a certain proximity to worshippers, and we shall see the use made of them by mystics. As for the sculptural adornment of facades and screens, theologians of the

twelfth century already considered it as a kind of "Bible for the unlettered." We shall examine the extent to which the programs allow us to support such a definition.

Outside the field of private devotion, linked to Christ's Passion, there exists a "functional" class of sculpture closely associated with paraliturgical ceremonies and with a carefully controlled dramaturgy that allows us to discern the intense need to visualize the events of Eastertide, which led the clergy to commemorate those events in the form of virtual reenactments. In the field of the representative arts, accentuated visual effects aroused a new expressivity, benefited from a particularly rich chromatic palette, and allowed artists to experiment with the plastic quality of drapery.

But despite the steadily increasing freedom of plastic forms, the art of the twelfth and thirteenth centuries never renounced exclusive two-dimensionalism. The processes governing the representation of form in space demonstrate the extent to which two dimensions continued to constitute the vehicle par excellence of forms and types, whatever the degree of spatial illusion that it was desired to suggest. This did not prevent the accentuation of visual values—far from it. An entire aspect of reality that had been subject until then to a purely symbolic mode of representation suddenly opened up to sculptural representation: this was the field of the royal "portrait." Corresponding to those significant modifications came a change in the status of the work of art, which now, in certain circumstances, escaped from direct circulation—from the artist to the client—and found its way into the open market in art that was born in the fourteenth century. Already in the thirteenth, moreover, the construction of the great cathedrals shows us the earliest signs of rationalization in labor: the distribution of tasks and serial production. In the workshops of sculptors, master glaziers, and painters, the collaboration of several artists on one work became a frequent practice—a fact which undermines the credibility of the search for an individual "hand," that is, a particular creative personality behind a particular work.

We certainly need to divest ourselves of more than one a priori assumption about the Middle Ages and to resist imposing modern concepts on territories that are still largely unknown to us. We must also abandon the illusion that we are capable of putting ourselves in the place of a person of the twelfth or thirteenth century. For that reason, the first section of this book addresses problems of historiography, devoting attention in particular to nineteenth- and twentieth-century views of Gothic art and to the influence of different currents of thought on definitions of one and the same historical concept.

The word "Gothic" designated different assemblages of things for Viollet-le-Duc, Panofsky, Focillon and Sedlmayr. Both of the world wars of the twentieth century were followed by a process of reassessment of the concept, especially among German-speaking scholars: it seems to me to be useful to seek to understand the currents at work by placing them in a larger intellectual and symbolic context, even if only in outline. The purpose is to establish the assemblage of ideas and considerations that form the basis of today's concept of the "Gothic" Middle Ages. Like buildings that reused the stones and the foundations of earlier structures, so every concept, even if it claims to reflect solely its author's thinking, was nonetheless founded on an earlier construction. The first part of this book does not aspire to define these intellectual structures as representing either accepted authority or established tradition, but rather to establish the sedimented layers of meanings that have accumulated between ourselves and the subject of our interest.

# * 1 *

## *From Romanticized Mechanics to the Cathedral of Light*

# Gothic Architecture: Technology and Symbolism

Gothic art had a cool reception from Italian historians and theorists of the Renaissance, who had a better appreciation of Romanesque art and its analogies to the art of classical antiquity. The nineteenth-century historicist school, on the other hand, discovered an all-but-infinite repertory of forms in Gothic architecture, offering inspiration for the new projects linked with developments in the later stages of the industrial revolution.

In exile in the United States, Paul Frankl completed an immense work, started nearly twenty years earlier, on the literary sources of Gothic art and its interpretation over eight centuries. Behind this monument of historiography lay the formalist vision that had been Frankl's chief preoccupation ever since his formative years as a pupil of Wölfflin. In the seventh and final chapter he defines the essence of Gothic architecture as the "cultural and intellectual background insofar as it entered into the building and was absorbed by it; it is the interpenetration, the saturation, of the form of the building by the significance of the culture. . . . The essence of the Gothic is the intellectual and spiritual factor inherent in it, its eternal content."[1]

Frankl's was, in fact, the last in a series of five books that appeared in the space of ten years, each of which left its own distinctive mark on the historiography of Gothic art. The others were *Die Entstehung der Kathedrale* by Hans Sedlmayr (1950), *Gothic Architecture and Scholasticism* by Erwin Panofsky (1953), *The Gothic Cathedral* by Otto von Simson (1956), and *Kunst der Gotik* by Hans Jantzen (1957; the English translation, *High Gothic*, was published in 1962). That they were all published within fifteen years of the end of the Second World War is not at all surprising if we examine what they have in

common. The passage by Frankl quoted above gives us a definition of their common objective: they all held that the essence of Gothic art was spiritual, and this spiritual character, anchored in the thinking of Max Dvorak, was an intense preoccupation of the postwar world.

It was a point of view shared by numerous German scholars; some, like Panofsky and Frankl, had emigrated to the United States, while one of those named above, Sedlmayr, had Nazi sympathies. Their interpretations amount to separate proposals of an iconology of Gothic architecture, formalist in cases like Jantzen's, while others (Sedlmayr and Simson, for instance) are more concerned with seeking out, behind the stone building, a spiritual edifice cemented with medieval exegesis or some other intellectual construct such as scholasticism (Panofsky). One further book, with a programmatic title, accompanied this surge of interest: *Mittelalterliche Architektur als Bedeutungsträger (Medieval Architecture as a Vehicle of Meaning)* by Günter Bandmann, published in 1951.

To understand these works it is necessary to consider at least some of the things they challenged. Without necessarily naming or directly quoting him, they questioned the rationalism of Viollet-le-Duc and a not-insignificant sector of modern thinking deriving from his influence in favor of an interpretation of Gothic architecture that shifted the focus of interest away from techniques towards symbolic significance. For that reason this chapter is in two parts, each pursuing one of these two themes: the first will trace the main outlines of the debate springing from Viollet-le-Duc's rationalism, and in the other I shall examine some of the interpretative models focusing on symbolic interpretations.

## THE GOTHIC SYSTEM: "ROMANTICIZED MECHANICS"?

The fortunes of Gothic architecture passed through two periods definable by two mutually contradictory assessments of it. With the Italians of the Quattrocento and Vasari a little later, a long diatribe began against the formal excesses of all kinds that went on being attributed to Gothic architecture until the very end of the eighteenth century. Not until the middle of that century was a case for the defense first mounted, originally in France and England, taking into consideration Gothic architecture's system of construction rather than superficial aspects alone, as previously. Jacques François Blondel, author of *Discours sur la manière d'étudier l'architecture* (1747), recommended the study of the church of Notre-Dame de Dijon, and this same building is cited as a paradigm of the "rational" Gothic system in the article "Construction" in Viollet-le-Duc's *Dictionnaire*. Le Jolivet was to play a leading role in the decisive

movement towards reevaluation and rediscovery of the technology of the architecture of the thirteenth and fourteenth centuries. In 1762, for example, at the behest of the Académie Royale, he set himself to drawing plans and particularly transverse sections of Notre-Dame de Dijon, in order to illustrate the subtleties of its structural system. The Abbé Laugier declared in 1765: "The masters of Gothic Architecture . . . knew what we do not, the maximum that a column can support, relative to the density of its materials."[2] And when Gauthey wanted to demonstrate his esteem for the architecture of Sainte-Geneviève in Paris, he averred that Soufflot was one of those architects of the day who "have taken us back to the purity and elegance of Greek architecture, while reconciling it with the learned examples of the art of construction left us by the Goth architects."[3]

Undoubtedly Soufflot himself admired the practical knowledge of the "Goths." On April 12, 1741, at the age of twenty-eight, he read a "memoir" on Gothic architecture to the Académie des Beaux-Arts in Lyon. After describing general characteristics of Gothic buildings relative to their plans and elevations and deploring the decoration of capitals for "bad taste" and that of doorways as a "true galimatias," Soufflot went on: "As for the construction . . . we shall see that it is more ingenious, stronger, and even more exacting than our own: these tribunes worked in the thickness of the wall, piercing the principal pillars, sometimes in two places, reducing them to nothing, in effect. . . . They always knew how to make the principal thrust fall on the point of resistance. . . . The workmanship of our own vaults is neither as delicate nor as exacting."[4]

Soufflot read this paper again in 1762 to the Académie Royale, accompanied on this occasion by the drawings of Le Jolivet that the Académie had commissioned. Engraved by Rançonnette, they then served as illustrations in Blondel's *Cours d'architecture*, a work that was continued by Pierre Patte. The plate with the section drawings is particularly instructive: two sections are illustrated, one along the longitudinal axis of the transept, facing east, and the other in the middle of a bay of the side aisle of the nave. A third drawing, without shading, relates to the "development of the galleries and a flying buttress," that is, it shows a section drawn through the vault of the side aisle and the upper wall of the nave, with the triforium (fig. 1). The extreme simplicity of the system only makes it all the more eloquent: the doubling of the wall on which the buttress abuts provides maximal refinement without being any the less efficient.

It is the exemplary quality of Notre-Dame de Dijon that explains why Viollet-le-Duc in his turn gave it such prominence. A comparison of his drawings with those of Le Jolivet demonstrates the advantage of the archeological eye

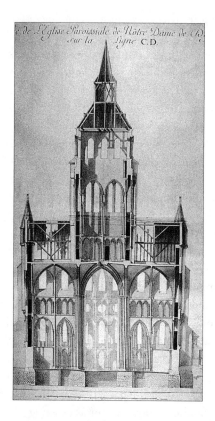

FIGURE 1. Section of Notre-Dame de Dijon (after Jacques François Blondel, *Cours d'architecture*, vol.6 [by Pierre Patte] Paris, 1777).

FIGURE 2. The structure of the choir of Notre-Dame de Dijon. (Drawing by E. Viollet-le-Duc)

when it is turned on a structural system of the past (fig. 2). In effect, Viollet-le-Duc "deconstructs" the system in such a way as to make its function intelligible, as Georges Cuvier, the father of paleontology, might have said. With this type of drawing, the architect comes close to the paleontologist: the "bones" of the Gothic structure are taken apart and suspended in space, like the skeleton of a dinosaur, as if the laws of statics had been abolished. The common purpose of paleontology and archeology is reconstruction—of an animal's body on the basis of one or two parts in the first case, and of a relic's form with the help of a few fragments in the second. In the plates of his *Dictionnaire*, having deconstructed a building, Viollet-le-Duc reconstitutes it in a perfectly logical manner before the reader's eyes. The drawing and the

"restoration" share a common purpose, that of calling into evidence the logical thinking that Viollet-le-Duc insisted presided over Gothic architecture.

Notre-Dame de Dijon, the architect tells us, "is a masterpiece of reasoning, in which the science of the builder is hidden under an apparent simplicity."[5] A lengthy analysis follows, intended to show that the church's master mason perfected a system of "hollow" buttresses, if one may so term the role played by the galleries set one above the other and the double walls, the inner "rigid" and the outer "compressible." The system made it possible to do without "enormous abutments." Viollet-le-Duc asks his readers to concede "that it is ingenious, very skillful and scientific, and that the authors of this system have made no confusion of Grecian art with the art of the North; . . . that they have not put caprice in the place of reason and that there is in these constructions more than the appearance of a logical system. . . . [T]here is more to be gained here [in Notre-Dame de Dijon], by us architects of the nineteenth century, called upon to raise very complicated edifices, to strive with matter" than from ancient Greek or Roman models.[6]

Viollet-le-Duc went so far in his study of Notre-Dame de Dijon as to seek to give his argument even greater force by proposing experiments. He contended that, executed in cast iron, stone, and wood, and reduced to its structural elements, the Dijon system would provide all the clarity necessary for proof. He thought he had shown the Gothic structure to be prodigiously ingenious, and the only system capable of meeting the needs of modern architecture. "We cannot reasonably build a railroad-station, a market, a hall for our assemblies, a bazaar, or an exchange, in accordance with the workings of the Grecian or even of the Roman system, while the supple principles already applied by the architects of the Middle Ages, after careful study, place us upon the modern path, of incessant progress." The principles of rational architecture, he went on, "consist essentially in submitting everything, materials, form, general arrangements and details to the reason; in reaching the utmost limits of possibility; in substituting the resources of industry for inert force and the search after the unknown for tradition." The "Gothic builders" would have done better than Viollet-le-Duc's contemporaries: "they would have taken [cast iron] frankly for what it is, profiting by all the advantages that it presents and without trying to give it other forms than those appropriate to it." It was "*classic teaching*" that prevented attempts to marry stone and cast iron from coming to anything. He would extol the marriage in the twelfth of his *Entretiens sur l'architecture.*[7]

It was a bold throw. Viollet-le-Duc was in effect accusing modern architects of being unable to provide the appropriate formal and technical solutions for

the needs born from the advances of the industrial era. He advocated turning to the Gothic Middle Ages, when, between the twelfth and the fifteenth centuries, architect-engineers had created a "rational" architecture. In closely examining the "rational," "logical," Gothic system of construction, Viollet-le-Duc sought to establish his own vision of modernity.

We should recall the dispute that had arisen in 1846 when the Académie, through its spokesman Raoul Rochette, took a stand against the champions of the Gothic, among them Viollet-le-Duc and Jean-Baptiste Lassus. It was during these same years that the use of iron and cast iron was promoted. In fact, paradoxically, the taste for the Gothic did not mean a return to the past but the renunciation of classical canons. Gothic architecture was better fitted to the needs of the modern era, just as modern materials were.

Viollet-le-Duc was still writing his *Dictionnaire* when iron and cast iron were used in churches for the first time by Baltard and Louis Auguste Boileau; and, before the middle of the eighteenth century, the materials were envisaged for use by both Dainville and Hector Horeau. Boileau wanted to employ these modern materials in the service of a new kind of architecture, that of the "synthetic cathedral," expected to surpass the thirteenth-century model. Inspired by Philippe Buchez's ideas about the three great "syntheses" of human history—barbarian society, tribal society, and Christian society—Boileau claimed to be able to "determine the different architectural types marking the different limits of the progress of monumental art, establish their order, confirm the highest point reached by this art in order to raise it yet higher." According to Boileau, there was a system of construction corresponding to each synthesis; it was a matter of improving "the ogival skeleton," apparently the most advanced system, which the men of the thirteenth century had not understood how to extend as far as it could go. It was in the process of perfectibility that Boileau saw the future of architecture, capable of "assembling the spiritual and fraternal community of the faithful within one space and under one symbolic roof, endowed with the properties of unity and great size, though they seem to be mutually exclusive."[8]

Were these ideas so very remote from those of someone like Viollet-le-Duc, who dreamed, in David Watkin's words, of a "secular, egalitarian, rationalist, and progressive" society? Or who saw universal qualities in the Gothic system of construction? Not really, even if Viollet-le-Duc threw himself into a sometimes heated dispute with Boileau. They did not disagree on the question of the architect-engineer but about what relationship could exist between the truth of the procedures of Gothic construction and the lies of a feudal and monastic society. The latter did not apply to Romanesque

architecture alone, nor could it be secularized at a stroke, as Viollet-le-Duc believed, in order to give birth to a Gothic architecture which would be "lay, bourgeois, secular, almost Protestant."[9]

If I have dwelt on these aspects of Viollet-le-Duc's thought, it is because ultimately they contain the seeds of the two main directions that interpretation of Gothic architecture was to take: that of the modern movement, which would regard the cathedral as the symbol of society, and that which would place greater emphasis on its role as a technological model.

This second orientation was to dominate the development of architecture in the twentieth century in one of its most important aspects: the erection of lightweight structures, built of iron and, later, steel, permitting larger spaces and the introduction of curtain walls. According to historians of modern architecture, the prototypes for these were Chartres Cathedral and, more particularly, La Sainte-Chapelle in Paris. The Bauhaus studios in Dessau by Gropius (1926) and the Seagram Building in New York by Mies van der Rohe (1958) can be regarded as the classic examples of these procedures in practice.

Such developments obviously called for close collaboration between architects and engineers, as was foreseen in the nineteenth century: "If the engineer was called by inclination and education to replace the modern architect—to become the modern architect—art would lose nothing by it," declared Anatole de Baudot at the International Congress of Architects held in Paris in 1889. Hans Poelzig wrote that architect and engineer ought to coexist in the same individual: in the nineteenth century it would have led to imitation of Gothic formalism rather than what he called "its tectonic core." Yet Poelzig himself indulged in a paraphrase of Gothic form in his fine designs for the concert hall in Dresden where, according to one commentator, he created a synthesis of the Gothic and the Baroque.

Frank Lloyd Wright, whose generous use of light was already in evidence in his earliest work, considered that the use of stone in the Gothic era illustrated the limits of the age as he saw them. But in the hands of Gothic stone carvers, "it was as though stone blossomed into a thing of the human-spirit. As though a wave of creative-impulse had seized stone and, mutable as the sea, it had heaved and swelled and broken into lines of surge, peaks of foam—human-symbols, images of organic life."[10] All these architects agreed with Peter Behrens that the most impressive creations of their time were products of modern technology. But the most precise expression of the technological contribution of the Gothic cathedral was probably that voiced by Bruno Taut. He devoted an entire chapter of his *Architekturlehre* (1936–1937) to "construction" as the essential element in every work of architecture. Gothic

architecture is a supreme example of architecture as construction or "constructive" architecture: "In it, it is the forms of the construction that make us forget the material."[11] The effect of its very finest realizations brings Gothic architecture close to the art of modern engineers. All the decorative elements are intrinsically a "sort of construction, a continuation of the interior forces which took shape in the static construction of the building. . . . The Gothic cathedral is not 'constructivist' in the modern sense of the term. . . . In the Gothic, the static forces themselves came alive. . . . Even when only one part of a cathedral was completed these forces were already expressed in full. . . . This is much more than merely construction. But construction, even in the rational sense, was emphatically not subordinated to form." The successful realization of the Gothic church was due to the "élan of the engineer" who knew better than to neglect "beauty, that is, proportion or architecture."[12]

It was important to Taut not to overlook the primacy of the artistic conception over the rational element. And the "alliance between proportion and construction," sealed by Gothic architecture, should show the way to the architecture of the future. Up to this point, the debate had hardly altered since the days of Boileau and Viollet-le-Duc. It was 1933 before the rationalism vaunted by Viollet-le-Duc was seriously challenged. The attack came from the architect Pol Abraham, defending a dissertation at the École du Louvre, in which he contested Viollet-le Duc's attribution of a static function to the ogive, or cross rib. This function was at the heart of Viollet-le Duc's definition of Gothic architecture as a rational and logical system, and while it was true that others had already questioned the load-bearing function of the cross rib (the art historian Kingsley Porter in 1912, by reference to vaults in Lombardy, and the engineer Victor Sabouret in 1928, citing examples of vaults damaged during the Great War), Abraham was to carry his critique of Viollet-le Duc's theory much further. The author of the *Dictionnaire*, he wrote:

> was almost completely ignorant of the elementary laws of statics as applied to buildings, he grasped only certain notions which he did not elaborate, adopting certain ill-defined terms to which he lent an arbitrary significance. By way of a vague analogy to the fertile inventions of the engineers of his own time, he proposed, in his twelfth *Entretien*, systems of construction impossible to realize but derived, he claimed, from polyvalent principles of medieval architecture. He made his points by demonstrations with the allure of theorems, but the postulates are gratuitous, the developments contradictory, and the conclusions a priori. It is truly remarkable that this work, which exalts constructive logic,

contains no correct notions of applied mechanics worthy of the name. Rather, from first to last, it is romanticized mechanics.[13]

It is enough for us to follow the direction of the controversy without plunging into its heart. Despite the extreme rigor with which he examines each point in Viollet-le-Duc's case, without always succeeding in convincing the reader of its faults, Abraham breathes new life into an aspect of Gothic architecture that can sometimes be lost in the maze of Viollet-le-Duc's thought. "No other [architecture] has taken further . . . the illusion of an idealized structure, based on adventitious linear elements deprived of any material utility. Gothic architecture is therefore essentially a form of sculpture, and consequently Viollet-le-Duc did no more than sustain a brilliant paradox."[14] And, returning for one last time to Notre-Dame de Dijon, Abraham concludes: "In this building, though without extremes and possessed of a certain classicism, an adventitious architecture was drawn in space by means of materialized lines—an architecture able to disappear without damaging the functional building."[15]

According to this argument, every completed Gothic building was composed of two interlinked structures: one "functional" on the level of statics, the other rendering a solely aesthetic service. So Viollet-le-Duc would have been a bad architect, one "whose artistic imagination, outside pastiche, was grievously impoverished";[16] the only outlet for it was the intellectual construction he put on the history of medieval architecture, which rested on misconceptions or his fallacious interpretations of Gothic structural processes. We might add, although Abraham does not appear to have appreciated it, that Viollet-le-Duc sought above all to show that a good architect will necessarily master engineering problems, and thereby bypass the architect-engineer debate, resolving the question in the figure of one person. He purported to find the model for this figure in the architecture of the Gothic era, although paradoxically, according to his own observation, individuals were absent from that scene.

Alongside the futility of Viollet-le-Duc's definition of a secular art, the second pillar of his intellectual construction was severely shaken. Unlike the first, however, it was never reduced entirely to nothing. Abraham's thesis stirred up controversy in its turn and as a result, Viollet-le-Duc's was revived. In 1935 an engineer addressed the question from the standpoint of modern understanding of the resistance and elasticity of materials. Every vault undergoes an "elastic deformation [that] takes the form above all of a lowering of the keystone."[17] "The *nervures* as a whole [therefore] constitute a kind of elastic chassis

limiting the characteristic deformations of the vault. . . . The more slender the vault, the greater is the proportion of its weight borne by the ribs."[18] Masson reaffirmed the rationalism of the Gothic system.

It fell to Henri Focillon to return the debate to where it belonged. "The problem of the ogive," he wrote in 1939, "is twofold. . . . It is simultaneously historical and structural." He reminded readers that the cross rib was not miraculous in origin but the outcome of trial and error, followed by adaptations carried out in both the Eastern and Western worlds. Its genealogy needed to be traced, not from one fixed and unique model, but through a network of complex ramifications. Long before the example of Durham (ca. 1100), "the ogive is known to have been used in diverse forms on buildings in very different regions and the attribute that interested the Christian builder was not a plastic resource, the agreeable quality of a decorative contrivance, but the strengthening of masonry." That answered one of Abraham's points. Similarly, Focillon was far from content to assign to the flying buttress an "adventitious and contingent" role: it shoulders the vault through a series of pressures passed on through the system of cross ribs. At the same time, however, Focillon disputed Viollet-le-Duc's mechanistic interpretation, emphasizing that the sculptural quality is of considerable importance in Gothic architecture, and does much to enhance "the processes of illusion."[19]

The question of the statics of Gothic buildings was approached finally from two points of view that neither Viollet-le-Duc nor Abraham had really envisaged. One of the huge lacunae of which both made good use was the absence of any document of medieval origin testifying to any concern with the matter. In 1944, however, George Kubler published a text on structures and methods of construction, written by a Spanish architect of the sixteenth century, Rodrigo Gil de Hontañon, who was, among other things, *maestro mayor* of Salamanca Cathedral from 1538 onwards.[20] Notably, Rodrigo thought that cross ribs (*arcos cruceros*) exerted a thrust less than that of transverse ribs (*arcos pripiaños*). These arches are comparable to the several fingers of a hand, which function jointly although unequal in strength (fig. 3). In other words he considered that, in respect of the stability of a Gothic building, the diagonal or cross rib played a certain role but in alliance with other elements in the structure. This is exactly what was confirmed by the structural analysis of Beauvais Cathedral conducted by the English engineer Jacques Heyman: "The typical Gothic structure is, in fact, an example of an assemblage of structural elements acting one on another to assure the complete equilibrium of the whole."[21] Computer analyses of the stability of Chartres have led to similar observations.

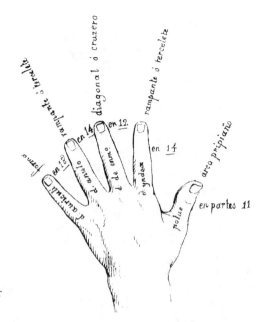

FIGURE 3. The fingers of the
hand and the system of vaulting,
according to Rodrigo Gil, master
mason of Salamanca Cathedral.

## SYMBOLICAL INTERPRETATIONS AND THE
## TWO WORLD WARS

The Bauhaus manifesto, issued in 1919, had a woodcut by Lyonel Feininger
on the cover, depicting a "cubist" Gothic building somewhat reminiscent of
the designs of Robert Wiene's film *The Cabinet of Dr. Caligari*, made the
same year (fig. 4). The text of the manifesto, written by Walter Gropius,
makes it clear that Feininger's intention was to represent the form exalted by
Gropius: "Let us create a new guild of craftsmen. . . . Together let us conceive
and create the new building of the future, which will embrace architecture
*and* sculpture *and* painting in one unity and which will rise one day toward
heaven from the hands of a million workers like the crystal symbol of a new
faith."[22] The "cathedral" of the future, as Gropius calls it, became the Weimar
Republic's expression of the symbolic dynamic of a communal faith. The "cry-
stal symbol" so well represented in Feininger's woodcut obviously alludes to
*Glasarchitektur*, the collection of aphorisms published by Paul Scheerbart in
1914. The worldwide use of glass, Scheerbart averred, would transform the
earth's surface, bringing paradise on earth and eliminating any further reason
to yearn for the celestial paradise.

 This is a lay formulation of the idea of the heavenly Jerusalem which Bruno
Taut later called "religious architecture" or "the people's architecture." Taut's

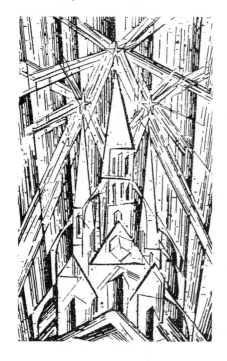

FIGURE 4. Lyonel Feininger, *The Cathedral of Socialism*, woodcut. This was the cover for the manifesto of the Weimar Bauhaus, text by Walter Gropius, 1919. (Credit: Artists Rights Society [ARS], New York/VG Vil-Kunst, Bonn, 2007)

"glass chain" of like-minded correspondents would bring together, from late 1919 onwards, a critic like Adolf Behne and the artists W. A. Hablik, Max Taut, Wassily and Hans Luckhardt, and Hans Scharoun, at the instigation of Bruno Taut. Scharoun, Taut, and Finsterlin all made drawings that were so many attempts to embody these "glass houses" (Taut) or the "cathedral of light" (Finsterlin).

Mies van der Rohe's design for the German pavilion at the 1929 Barcelona International Exposition was one of the supreme architectural masterpieces of the first half of the twentieth century. This ephemeral structure was "one of the rare buildings with which the twentieth century aspired to measure up to the great periods of the past."[23] Mies made remarkable use of the glass walls and the play of reflections from them, which, together with encircling pools, constituted the sole "decoration." The German architect's treatment of light seems to have owed something to the symbolic function of glass as it was proclaimed in the years immediately before and after the First World War, but he stripped it of all expressive, "empathetic" values. Gothic architecture patently played a role in the formation of Mies's sensibilities: a native of Aachen, it was not just the city's architecture that made an early impression on him, as he himself emphasized, but the choir of its cathedral in particular,

which was added to the Carolingian octagon in the fourteenth century with a structure inspired by La Sainte-Chapelle in Paris, including "curtain walls." Mies adopted the Barcelona curtain walls in other buildings; one of the most indisputably eloquent examples of this is the Crown Hall of the Illinois Institute of Technology, built in Chicago between 1950 and 1956 (fig. 5).

Gothic architecture scored an unexpected popular success in the cinema. It was in effect the model followed by the designers of the famous *Cabinet of Dr. Caligari*, Hermann Warm, Walter Röhrig, and Walter Reimann, all three of whom belonged to the Berlin avant-garde movement Der Sturm. They chose to distort the sets with slanting lines and false perspectives projected onto a backcloth, with the aim of arousing "unease and terror" in the spectators. The intention conformed to theories on empathy developed by Robert Vischer and Theodor Lipps, and adopted by Wilhelm Worringer. It gave architectural elements a life and emotions of their own, and therefore expression. As in one of E. T. A. Hoffmann's fantastic stories, the gaze of each individual viewer lends the objects a life that is an extension of his own. The Gothic forms treated in this way dominate the film, and must have made the town of Holstentall where the action takes place simultaneously very old and wholly familiar to German audiences: the effect of the distortions was all the more powerful.

A Gothic town was thought to be the most likely place for such formal metamorphoses, because Gothic style was considered to have translated into

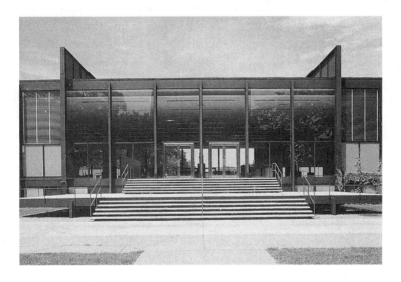

FIGURE 5. Ludwig Mies van der Rohe, Crown Hall, Illinois Institute of Technology, Chicago, 1950–1956. (Photo by Jean-Louis Cohen)

the language of architecture the play of strength at work in all matter, and this play itself was linked to psychic states. Art historians such as August Schmarsow and Wilhelm Worringer were lavish with observations of this nature. In Le Corbusier's view, meanwhile, it is precisely in the resort to the subjective, essential to the apprehension of the Gothic, that the weakness of this architecture lies.

Gothic forms were called into service in another film, the second version of Paul Wegener's *The Golem*, made in 1920. For this, the architect Hans Poelzig built fifty-four houses partly inspired by the Old Town neighborhood in Prague in order to create a solid urban setting, and not just a backdrop, as in *Caligari*. The interiors struck a contemporary critic, Paul Westheim, as particularly atmospheric: "The house of the Chief Rabbi Loeb, with . . . its dark, mysterious alchemist's workshop, the synagogue, the baroque imperial hall, in which Poelzig has shaped a fantastic Gothic—somewhat in the style of the gothicizing Egyptianism, or egyptianizing Gothic of Gustave Doré's Bible—a Gothic seen through the temperament of an architect of the present day, an outpouring of forces like flying buttresses in scouring, serpentine shapes like flames."[24]

In architectural utopias where the cathedral is a vision of a form of universal harmony, as in the writings of Gropius and Taut, the Gothic is invested with a social function. This function recurs, though inverted, in films such as *The Cabinet of Dr. Caligari* and *The Golem* where the Gothic embodies a world of hallucination and disharmony,[25] a world seeking an improbable reconciliation akin to the dream (or the nightmare) of the German nation. The period immediately following the First World War was clearly not a time for dreams: and to escape nightmares, the Germans withdrew partly "into the intangible realm of the soul" but their intention was "to reconsider their traditional faith in authority."[26]

If I have dwelt on the Expressionist cinema and the use it made of Gothic architecture, it is because it seems to me there is a parallel in the way the Germans turned to the Gothic again after the Second World War. The tug of introspection must have exerted even greater force then. And in a very symptomatic manner, Gothic architecture was going to serve once more as the embodiment of some very unusual values.

The field of application was not exactly the same the second time: in 1919–1920, it was the cinema, a medium of popular expression; in 1950, it was in books destined for a cultivated reading public. The cathedral of socialism gave way to the cathedral of light, and Scheerbart's utopia reverted to its original biblical form: the heavenly Jerusalem. That, at least, is how the Viennese

Hans Sedlmayr formulated his theory of imitation in his celebrated book *Die Entstehung der Kathedrale*, where he proposed that the Gothic cathedral was an *Abbild*—a copy or depiction—of the heavenly Jerusalem. That is the book's central idea: the purpose of describing an architectural monument like Notre Dame in Paris, from top to bottom, as if the building were hovering above the ground, was to disengage the architectural form from physical laws in order to make it conform all the better to its celestial "model." There can be little doubt that his desire to justify this nonsense at any price plunged Sedlmayr into the most regrettable excesses.

The "depiction" postulate is central to the book, along with others equally impossible to sustain. Critics recognized the book's Expressionist affiliation from the first and gave it a rough ride, stirred as much by its dogmatism as by its superficiality. Sedlmayr saw in the cathedral (a *gesamtkunstwerk* if ever there was one) a remedy for the general loss of values that he believed he had diagnosed in his times. Placing the book in its author's personal evolution reveals it as the culmination of a succession of positions Sedlmayr had adopted over time: in 1938 he had openly manifested his faith in National Socialism, and in 1948 he published a polemical book in which he sought to identify the morbid sources of modern art and disparage its nihilist ideology. The French Revolution was not the only origin of the "loss of the center" that he found in 1938 when Ledoux's projects still represented a symbol of paradise in his eyes: Romanesque art, as an expression of the irrational and the demonic, was another. From Romanesque representational art to surrealism, Sedlmayr beheld the same tendency to make artistic forms the uncontrolled, irrational, antispiritual expression of the human soul. Against that development, he underlined the triumph of spirituality in the thirteenth-century cathedral. For Sedlmayr in 1950, contemplating the devastation left by Hitler, the significance of that triumph was that salvation was not to be found either in the spirit of the Enlightenment or in National Socialist ideology, but in faith in a Catholic Europe, and he thought he could contribute to the restoration of such belief by publishing *Die Entstehung der Kathedrale*. Once again, we see the cathedral being called upon to play a utopian role. It would be tedious to reiterate, point by point, the polemics the book aroused, particularly in the pages of *Kunstchronik*: during 1951 the periodical (which had resumed publication in 1948) published critiques by Ernst Gall, Otto von Simson, and Walter Überwasser, and a reply by Sedlmayr.[27]

Gall and Überwasser found that Sedlmayr ignored technical aspects of Gothic construction or, when he mentioned them, frequently misinterpreted them. In particular, Gall, who had published his book on the early Gothic

architecture of the Lower Rhineland and Normandy in 1915, disputed Sedl-mayr's thesis of the "baldachin"—the term he used for the ensemble formed by a vault and its four supports—as a defining element of Gothic architectural space: the terminology Sedlmayr sought everywhere to renovate proved inapplicable in most cases. Grodecki, for his part, proposed replacing the notion of "baldachin structure," which Sedlmayr had already introduced to designate the structural system current in the reign of Justinian, with that of the "bay," a much clearer way to convey the idea of the spatial unit which, with repetition, creates an aisle. The penchant for inappropriate neologisms was proof, in Gall's view, that Sedlmayr proceeded only by successive deductions from concepts and "sees nothing."

Otto von Simson's review was different in tenor. He found the idea of architecture as a depiction of an ideal fruitful, but thought the medieval texts to which Sedlmayr appealed to underpin his thesis were descriptions or evocations rather than true sources. In general, Simson regretted that Sedlmayr had restricted his choice to works of poetic literature when theology might have served his turn better. He referred, in particular, to the aesthetics of light represented in the exegetical texts published by Edgar de Bruyne. Such witnesses to medieval thought, Simson argued, made it possible to envisage a conception of art—architecture in particular—as a reflection that would be radically different from Sedlmayr's.

In fact, Simson was preparing the ground for his own book, *The Gothic Cathedral: Origins of Gothic Architecture and the Medieval Concept of Order*, which appeared in 1956. To Panofsky's thesis that the aesthetics of Gothic architecture were imbued with the mysticism of light that went back to Pseudo-Dionysius, he added the Neoplatonic concepts of order and proportion, supposed to lie at the heart of the preoccupations of the school of Chartres. It meant setting aside the distinction, effective at the time of Gothic art's inception, between speculative geometry—the only thing that interested Simson—and practical geometry, the theoretical and practical tool of the builders. To some extent, *The Gothic Cathedral* claimed to be an equivalent, for the high Middle Ages, to Rudolf Wittkower's *Architectural Principles in the Age of Humanism* (1949), a substantial part of which was devoted to the laws of harmonic proportion applied in musical composition and architecture.

Simson's allegorical interpretation undoubtedly had a strong Neoplatonic slant. Quite as much as Sedlmayr, he believed in the preeminence of the pure idea in every great work of architecture. Each held that every formal creation must be the consequence of some idea: theological for Simson, poetic for Sedlmayr. The symbolic intention is the true and unique point of departure

for every aesthetic enterprise. Panofsky, too, asserted a causal relationship between scholasticism and Gothic architecture in *Gothic Architecture and Scholasticism*, which had begun as a lecture he gave in 1948 at the invitation of the Benedictines of Latrobe and appeared as a book in 1951 complete with annotation. For Panofsky, the connections between scholastic thought and architecture were formal in character, and the "mental habit"[28] he proposed as the common basis on which the relationships were founded is not far removed from Riegl's *Kunstwollen*.[29] Panofsky saw in the medieval masonic lodge the "meeting ground where the priest and the layman, the poet and the lawyer, the scholar and the artisan could get together on terms of near equality." The architect clearly had his rightful place in this harmonious community, which shares something of Gropius's vision, yet he enjoyed "a social prestige unequalled before and unsurpassed since." And Panofsky described him as being looked upon "as a kind of Scholastic."

Panofsky shared Viollet-le-Duc's vision of the Gothic as an urbane and rational architecture. He spoke of Pierre de Montreuil as "the most logical architect who has ever lived," and situated his proposed analogy between scholasticism and Gothic architecture on the formal level of the modus operandi demanded by human reason. As a product of organization and clarification of thought, scholasticism provided the model for the Gothic, according to Panofsky. But even if, like the present author, one is struck by the temporal coincidence (between 1140 and 1270) and the geographical concurrence (a circle around Paris with a radius of 100 miles) of the two phenomena, the fact remains that Panofsky exaggerated the parallels. Every style of architecture is rational, by definition, and the plan and structure alike of a great Romanesque building—Saint-Étienne in Nevers, for example—are equally the response to a need for clarification. Furthermore, this "structuralist" interpretation of Gothic architecture does not take into account other developments which must have a part to play for anyone who wishes to follow the historical genesis and evolution of Gothic architecture particularly in relation to the monarchy.

Panofsky set this question aside for a reason he explains in the introduction to his 1946 edition of Abbot Suger's account of his administration at Saint-Denis.[30] The abbey was inseparable from the personality of the abbot: political mediator, ecclesiastical administrator, aesthete and ascetic, and even artist, inasmuch as he was an innovator—he thus emerges as the only begetter of the abbey's renovation. But Suger is also presented by Panofsky as "the father of the French monarchy," concerned to "strengthen the power of the crown of France." Hence, the birth of Gothic art falls on the same date as that of the French monarchy, and Suger unites in his one person the peacemaker, the

thinker, and the artist. Panofsky refers to Suger's political role only in order to bring out all the more vividly his fitness to serve as a "proto-humanist" model for the years 1944–1948.

The man Panofsky describes in such admiring terms is the one venerated in the epitaph for Suger composed by Simon Chèvre d'Or, a Victorine canon of Paris, but with the telling difference that the allusion to the light of life as opposed to the true light of death appears only in the funerary inscription, in the last two lines. This Suger never existed, of course, inasmuch as the abbot himself had a part in falsifying the historical record. In reality, if his activity as architectural patron is described in such minute detail, it is because Suger wanted to emphasize his qualities as administrator; the abbey's chapter general had in fact asked him, in the winter of 1144–1145, to render an account of his activity since his election as abbot in 1122, when in secular terms it was close to ruin. It seems that his stewardship had been exemplary, a compound of foresight and reason.[31] In *De consecratione* and *De administratione*, Suger gave a meticulous account of his expenditure, as every conscientious manager must. With frequent references to miracles, or events that only divine intervention could explain, Suger sought to prove that when he incurred sumptuary expenses it was the wish of the Almighty: "Our sufficiency is of God" (2 Corinthians 3:5).

There can be little doubt that he had an eye for the beauty of precious stones and the splendor of gold. But it is by no means certain that his taste in architecture was as good. In any event, the man Panofsky described as a peacemaker was far more familiar with the vocabulary of warfare than with that of architecture. If, as I believe, Villard de Honnecourt was a cleric, it is significant that he was infinitely more familiar with the technical terms of building than Suger, for all that Panofsky presented him as the inventor of Gothic architecture. That he could distinguish the *opus novum* from the *opus antiquum* was not at all remarkable for a man who knew Rome, as any number of prelates did. It is not the same as being "fully aware of the new style's distinctive aesthetic qualities" (the Gothic, that is) as Panofsky claims.

If there is a justification for talking of a protohumanist lesson to be learned from Suger it is undoubtedly, in Panofsky's eyes, the "neo-Platonic light metaphysics" in which he was steeped. Panofsky wrote admirably about the blaze of light that fills Suger's Saint-Denis. And the reader quickly understands that Panofsky shares the "blissful enthusiasm with which [Suger] must have absorbed these neo-Platonic doctrines" as well as the conviction that "what seems mutually to conflict by inferiority of origin and contrariety of nature

is conjoined by the single, delightful concordance of one superior, well-tempered harmony." Like Sedlmayr, like Simson, Panofsky regarded the theology of light as the true substance of Gothic architecture: today we know that there is no foundation for that interpretation. Suger's Neoplatonism was not exceptional in the first half of the twelfth century and, without making him a "proto-Jesuit," who would seduce souls through beauty, we must agree that he had both a real sense of what a work of art is and an exceptional ability to formulate it. Moreover, Suger's testimony is unique in the history of medieval art, which explains the status he has acquired in recent art history.

The concordance between all these works written in the period immediately following the end of the Second World War is obviously not fortuitous. We can see it as the resurgence of the utopias of light, from Scheerbart to Taut and Gropius, evoked above.[32] The writers were all Germans who found some kind of spiritual model of harmony and universal peace in French architecture of the thirteenth century. The theoretical model that made an impression on all of them was that of the iconology of architecture, that is, the interpretation of architecture in accordance with the symbolic intentions of those who commissioned it.

Father Joseph Sauer, in a book on medieval conceptions of the symbolism of church architecture and furnishings (*Symbolik des Kirchengebäudes und seiner Ausstattung in der Auffassung des Mittelalters*, 1902), brought together texts from the time of St. Augustine and from medieval theologians that authorize the attribution of particular symbolic significances to particular architectural elements. But it is with the studies by Richard Krautheimer and Günter Bandmann that we move on from primary symbolism to more finely nuanced interpretations.

Krautheimer's "Introduction to an 'Iconography of Mediaeval Architecture,'" published in London in 1942, took a little time to become widely known, but it exercised a considerable influence on architectural scholarship from the 1950s onwards. It underlines the existence of copies—that is, monuments reproducing more or less freely prototypes chosen for their political or their religious values (the Church of the Holy Sepulchre in Jerusalem and the Church of the Nativity in Bethlehem are examples of the latter).

Krautheimer's paper was published in the *Journal of the Warburg and Courtauld Institutes*, but the iconologists of the Warburgian confession, Panofsky at their head, had shown scarcely any interest in architecture up to that point. The first steps taken into the domain—by André Grabar with *Martyrium* (1946) and E. Baldwin Smith with *The Dome* (1950)—did not venture beyond architecture of the paleo-Christian era and the high Middle Ages.

The same applies to Bandmann's book on medieval architecture as a "vehicle of meaning": despite the word "medieval" in the title, it does not cover the Gothic period. In fact, Bandmann believed that the role of the patron and client in the conception of a work of architecture diminished from the thirteenth to the fifteenth century, as the profession of architect and the existence of the autonomous lodge strengthened, as buildings became works of art, and the primacy of content yielded to formal expression. For this stance alone, Bandmann's volume needs to be handled with infinite caution. The importance he invests in the client—which recalls Panofsky's attitude to Suger—allows him to identify the *symbolique* intention as preceding any architectural undertaking. For Bandmann, all pre-Romanesque and Romanesque architecture was governed by the symbolic intentions of their originators, the clients. He consequently thought any formal analysis of this purely conceptual architecture would simply be inappropriate, whereas the Gothic allowed free rein to imaginative invention—that is, art.

In reality, Bandmann's book and those of Panofsky and Sedlmayr (Simson's, too, but to a lesser extent) are remarkable for their suspicion of the artist and, one might say, distrust of anything that might bear any resemblance, great or small, to the notion of art for art's sake.

The return to formalism came about in the work of Hans Jantzen, a pupil of Adolph Goldschmidt and, as a professor at the university of Freiburg im Breisgau, an associate of Heidegger. Not that Jantzen dispensed of the preoccupation with content: on the contrary, every work of art, for him, would reveal a spiritual significance through its unique formal language. The fact remains that, after his 1908 dissertation on Dutch architectural painting (*Das niederländische Architekturbild*), his relatively few publications were mainly on the subject of medieval art. Appointed to Wilhelm Vöge's chair at Freiburg from 1915 to 1931, he published in 1925 a book on German sculptors of the thirteenth century (*Deutsche Bildhauer des dreizehnten Jahrhunderts*) and in 1928 a paper he had read in Freiburg in November 1927, on space in the Gothic church (*Über den gotischen Kirchenraum*). His pioneering work on Ottonian art (*Ottonische Kunst*) appeared in 1947, and two books on Gothic art in 1957 (*Kunst der Gotik*) and 1962 (*Die Gotik des Abendlandes*). The main preoccupation of all of these was the question of space (*raum*) in its relationship to man, which had been the topic of his dissertation. The concept of architectural space is relatively new: it was first formulated in the late nineteenth century, notably in the work of Schmarsow who must be credited with inventing the concept; already in his writing it suffered an inflation which did much to render it suspect.

True, the Romantics had more than once stressed the limitlessness of Gothic interiors. The novelty of Schmarsow's new term lay in his definition of architecture as *raumgestaltung*: spatial composition or articulation. Such a hypothesis unquestionably opened new paths for thinking about architecture—paths which both the practitioners and the critics and historians continued to explore throughout the twentieth century.

While it is relatively easy for us to understand what the word space means in an illusionist painting, it becomes much more difficult to reach consensus on the meaning of the expression "architectural space." Does it designate the entire space enclosed by a building, consequently excluding the shell and the exterior? Or does it embrace material elements, such as cornices and vaults? If the space is not simply the empty space, what parts of the material reality define it? Just the architectural fabric, or the furnishings as well? The very newness of the concept of architectural space bears witness that it scarcely seemed necessary to an architecture that defined itself essentially in relation to a formal grammar. It is obviously a concept born from the meeting of experimental psychology and neo-Kantian aesthetics: it does not belong exclusively to the domain of architecture but is coupled with the question of apprehending the psychosensorial relationships between objects or between individuals and objects.

For Jantzen, it was essentially a question of analyzing the spatial boundary (*raumgrenze*), "since the impression of the space as a whole is determined primarily by its boundary," and he defined the spatial boundary in a church as "the limits of the nave . . . for its full length, including the chancel" but excluding the side aisles.[33] Referring to Schmarsow's "laws of composition," Jantzen explored the question of what was specifically Gothic about the structure of the spatial boundary, for paradoxically Gothic architecture always contrives to give the spatial boundary of the nave solid existence, "despite the growing dissolution of the wall."[34] His answer was the phenomenon he called "diaphanous structure," illustrated in its purest form by the triforium. "Diaphanous structure" designates "an arcaded wall articulated plastically, with the effect of relief, and underlaid to varying levels of depth by a background of darkness [the side aisles] or of coloured light."[35] In Jantzen's view, the principle of diaphaneity conveyed what was special about the character of space in French Gothic more effectively than the use of pointed arches or cross rib vaults. "With this space for religious observances," he wrote, "the Christian Middle Ages creates for itself an completely new formal symbolism."[36]

In his definition of Gothic space, Jantzen failed to take account of the important question of architectural polychromy. As we shall see later, it would

have modified the relationship he posited between figure and background, in his definition of the "diaphanous structure." However, he addressed it very fully in his book on Ottonian art, where he drew attention to the distinction between *mauer* and *wand* (essentially the distinction between a wall that supports, encloses, or surrounds, and a partition wall): only our knowledge of polychromy, he wrote, allows us to reconstruct the form of interior walls as a whole and, consequently, the original space of Ottonian buildings.[37]

In his book *High Gothic* (*Kunst der Gotik*, 1957), concentrating on Gothic art as represented by Chartres, Reims, and Amiens, Jantzen developed his thesis of diaphaneity yet further. This time he placed it within a general tendency of Gothic architects to "dematerialize" the building: "weightlessness," "verticality," "invisible support," "diaphanous structure" are among the terms he deploys to denote the characteristics of this art.[38] In placing the emphasis on matters of structure and visual values, Jantzen distances himself hardly at all from Panofsky, Sedlmayr, or Simson. For him as for them, the cathedral is a kind of absolute model of a better world: whether irradiated with light or freed from weight, it is above all a spiritual structure.

During the following decade, art history moved towards a systematic revision of such idealist interpretations, in particular by taking economic and material aspects of building into account. L. F. Salzman's 1952 "documentary history" *Building in England down to 1540* had already shown the way the wind would blow, and a historiographic tradition established itself in the English-speaking world that placed more emphasis on documentation and technological aspects of medieval, and especially Gothic, construction. Next, a number of monographs appeared during the 1970s and 1980s, dedicated to individual buildings, preeminently French and German ones, but written in many cases by foreign scholars. Nowadays, however, the systematic examination of a building calls for so many skills that it requires the collaboration of architect and architectural historian to bring it to a successful conclusion. We have entered a new phase, that of ever more elaborate "rematerialization" of Gothic architecture.

# Ornament, Style, and Space

The previous chapter demonstrated that within a cultural phenomenon as important and as complex as Gothic art, presuppositions that weigh very heavily on any analysis rest not on the interpretation of facts but on the definition of the phenomenon, and even the choice of terminology with which to describe it. In the case of the Gothic cathedral, opinion is divided on whether it owes its unity to one of the technical innovations (the cross rib, the flying buttress) or to a doctrine, a preexisting intellectual category (the metaphysics of light, scholasticism) that it came to embody in architectural form.

Since the end of the nineteenth century the history of medieval art has been written using certain ideas repeated often enough to prove that they correspond to fundamental preoccupations of modern art history. Two such ideas are ornament and space, which are all the more complex because they did not mean the same things to a man of the twelfth or thirteenth century as they do to us: the notion of space would have had no meaning whatever for him. As a concept relevant to art, space has existed for only a hundred years, but today art history invokes the concepts of ornament and space very frequently. Although they enable us to refine the idea of style, we must not lose sight of the fact that stylistic analysis, as practiced for eras more recent than the Middle Ages, is usually extended backwards, freighted with the same presuppositions, to cover the medieval era too. But the mechanisms of the transmission of forms and the individual artistic consciousness of the modern age do not apply to the Middle Ages.

Unlike the previous chapter, this one takes the form of a survey of different opinions, that is, the views of individuals belonging to one or another school of

thought, whose doctrines I shall outline. The method has the inconvenience of rehearsing the same questions several times—that of space, in particular—but its advantage is that it preserves a certain homogeneity in individual ideas.

## THE FIRST AND SECOND VIENNESE SCHOOLS

Regarded as the true "father" of the Viennese school, Franz Wickhoff is also its least doctrinaire representative. Unlike Riegl or Dvorak, but also unlike Schmarsow or Wölfflin, he did not seek to impose a system or to establish any "fundamental concepts."[1] Reading him, one often gets the impression that his underlying interests drew him towards modern art (the art of the last twenty years of the nineteenth century, from Manet to Klimt) and that although he worked in the fields of the Italian Renaissance and paleo-Christian art it was primarily in order to shed light on the premises of modernity. Like other evolutionists, he believed in the existence of cycles, which explained the reappearance of a certain form after an interval of centuries. Problems of attribution would be solved according to the method of Giovanni Morelli (whose pseudonym was Lemorlief), of whom Wickhoff was an ardent supporter.

The edition of the *Vienna Genesis* published in 1895 contained an essay by Wickhoff that conveys the essence of his conception of art. In his view, this fourth-century illuminated manuscript presented a mixture of representational styles of the preceding three centuries, and also of two distinct artistic techniques: mural painting and miniature. Above all, the manuscript held a position at the very wellsprings of medieval art.

The problem confronting the first Christian artists, Wickhoff believed, was how to fill "a poetic framework from which the imagery that once informed it had faded away, with a fresh imaginative content drawn from another cycle of forms."[2] He characterized what was new about the images devised in these circumstances as their narrative mode: "No decisive moment is chosen uniting the most important personages in the text in one common action of consequence, in order to show them to us in a second picture in another equally striking situation." Rather than "pictures of striking, epoch-making moments . . . as the text flows on, the heroes of the narrative accompany it in a continuous series of related circumstances passing, smoothly and unbroken, one into another."[3]

Wickhoff distinguishes three narrative modes or styles, each pertaining to a civilization: the "complementary" (*komplettierend*), the "isolating" (*distinguierend*), and the "continuous" (*kontinuierend*). *Komplettierend* is Asiatic

in origin and corresponding to epic; *distinguierend* is Hellenic and corresponding to drama; and *kontinuierend* is Roman, corresponding to prose and originating in the second century of the Christian era.[4] Wickhoff speculates that the continuous mode may be the outcome, in part, of the adoption of an illusionist style during the second and third centuries. He methodically differentiates illusionism from naturalism, saying of the latter:

> [Naturalism] limits the painter's art to the rendering of bodily form. We can observe this best in the art of the fifteenth century. Italian, Flemish, and German painters all prepared themselves for the production of a picture in one and the same way. They made preparatory studies in Nature of all the details and gave to these plastic projection. They observed the laws of linear perspective, they carefully observed the changes in the more distant objects caused by the intervening air, but while they drew the figures in the foreground from the model, working out separately the faces, hands, feet, folds of drapery, jewels, etc., they treated the figures of the middle distance in just the same way, and they even made up the background out of studies from Nature accommodating the eye each time to the relative distance. Hence the completed picture, in spite of the strict observance of *one* perspective point of sight, is not the result of *one* definitive act of vision, but is rather an amalgamation of the impressions received in several acts of vision, for each of which the eye must be separately focused.[5]

Illusionism would follow a very different path, rejecting "bodily form," as such, in favor of "true appearance" by using appropriate gradations of colors: the image of a body "is the result rather of contiguous and entirely dissimilar values of light and of their physiological effect upon the eye."[6]

Thus Wickhoff appealed directly to the lessons of impressionism in order to explain the passage from naturalism to illusionism effected by Pompeian painting in late antiquity. But modern art was more than Manet. What characterized it for Wickhoff was equivalence: the conviction that there was no longer anything too insignificant to be depicted in a painting or unworthy to inspire a picture with atmosphere (*Stimmungsbild*). The slope of a roof was as beautiful as an expanse of countryside. In one polemical article, Wickhoff sprang to the defense of Klimt's allegory, entitled *Philosophy*, painted for the University of Vienna, which had been received with hostility by the academic body. The idea that there was nothing unworthy of the status of art, and

that there was also no art unworthy of aesthetic and historical analysis was a fundamentally new one. It led Wickhoff to the rehabilitation of Roman art, the portrait in particular, which he made the decisive instance in the genesis of medieval art.

For Wickhoff, style was the expression of content. Let us now examine how this concept was defined at the end of the nineteenth century, and what the consequences were for art history as an academic discipline.

Stylistic analysis focuses on the formal characteristics conjoined in a construct composing a work or a group of works, which, when related to each other, support an interpretation: place, date, attribution. It regards a style as being equivalent to a language or, more precisely, handwriting. To that extent at least, style is outside the control of consciousness. Such is, in any event, the implicit premise of Morelli's method and of Freud's interest in Morelli. This physiognomic dimension of style had already been aired by Weisse in the middle of the nineteenth century.[7]

With Gottfried Semper, and then with Riegl, the concept of style lost the absolute status conferred on it by Goethe, ceasing to be the highest human aspiration and becoming a historical phenomenon instead. Thanks to the concept of style, in the late nineteenth century art history established itself as an autonomous discipline with its own tools and techniques, on a par with the other studies grouped under the rubric of "humanities" (*Geisteswissenschaften*).

For Semper, style was a general manifestation of mankind's creative activity; there was no call, in his view, to create a hierarchy between court art and popular art, or between the artist and the artisan. They have a common origin, which Semper took as authorization to draw up a sort of comparative morphology of all artistic productivity, in which a determining role falls to the relationship between the form, the technique which produces it, and the material in which it is worked. For Semper, evoking the strong impression made on him by Cuvier's collections of skeletons and fossils at the Jardin des Plantes in Paris, the creations of human hands, "like the works of nature[,] are linked together by a few fundamental ideas which have their simplest expression in certain originating types or forms."[8] The concept of style lends the physical presence the characteristics of an infrastructure, an original thought discernible behind the external formal manifestations.

Although Riegl challenged what he loftily called Semper's "materialism," he nevertheless owed some of his own ideas to him. As Sedlmayr recalled, Riegl regarded function, material, and technology as so many "negative" factors, but on the other hand it was from Semper, to a very great extent, that he

derived his interest in periods thought decadent in the nineteenth century. Subsequently, Riegl developed an interest in ornament, at least for a time, and the repertory of ornament was the basis on which Semper was able to construct his comparative morphology.

In *Problems of Style: Foundations for a History of Ornament* (*Stilfragen, Grundlegungen zu einer Geschichte der Ornamentik*, 1893), Riegl sought to show that the transition from a geometrical to a naturalistic representation of a palmette paradoxically resembles a process of abstraction where the form itself is the source of its own transformation. For Riegl, progressing from the tactile to the visual meant moving from realism to abstraction, from the objective to the subjective. The vital force at work in this capacity for transformation, in both the artist and the viewer, is what Riegl called *das Kunstwollen*—"the artistic will." It is a collective force, but also manifests itself in a single creator, and it is a regulatory flow allowing all artifacts to be set out in perfectly legible sequences, from the meanest evidence of material culture to masterpieces of world heritage. For the classifying mania of the nineteenth century, Riegl substituted a system of interpretation that saw the artist's action as a sort of oscillating scan in response to a movement, itself subject to evolution, between the accentuation and effacement of traits that separate objects or link them together. Accordingly, style means two distinct things: a variable external character and an internal structural principle on which the former depends. In other words, style is both what is fixed and what changes; it is as much ideal type as transient characteristic. Semper had no interest at all in external stylistic character.

Riegl conferred on ornament the legitimacy hitherto denied it. True, the whole of Arcisse de Caumont's classification of Romanesque buildings was founded on their external ornamentation, in accordance with a principle that Quicherat had good reason to criticize. But Riegl, the author of *Problems of Style* and *The Late Roman Art Industry*, isolated the ornamental motif like a specimen under scientific examination, giving it a inexpressive character that allowed it to be treated objectively. Riegl claimed, moreover, that the structural laws revealed by this means were valid for the entire world of artistic forms: painting as well as architecture and sculpture. His "structuralism" resides in the claim to derive a universal system of interpretation from the study of ornament. It is the reason why his influence was so strong—especially on Viennese scholars such as Otto Pächt and Hans Sedlmayr—in the years immediately following the First World War when it complemented gestalt theory.

The principles defined by Heinrich Wölfflin are essentially remote from Riegl's way of seeing. Even if Wölfflin believed that "formal sensibility finds an

immediate and unchecked outlet" in the "less monumental decorative arts,"[9] it did not prevent him from taking architecture, painting, and sculpture as the basis of his system. Whereas for Riegl, *das Kunstwollen* alone was subject to evolution, in Wölfflin's view works of art themselves were subject to a sort of biological cycle, passing from growth to maturity and then to degeneration: Early Renaissance, High Renaissance, and baroque, or rather, Renaissance, classicism, and baroque, might correspond quite well to these three stages, but the classicism/baroque antithesis was what really interested Wölfflin and underpinned his thesis of suprahistorical categories.

From the first, even in his dissertation, Wölfflin concerned himself with the psychological foundations of the work of art, which he expected to provide actual laws governing the apprehension of forms. He wrote in 1886:

> A history content with establishing the order of events cannot survive: it would be deluded to think that this would make it 'exact'. One's work can only be exact in situations where it is possible to grasp the flow of phenomena in stable forms—such as mechanics, for example, provides for physics. The humanities still lack this basis; it is to be sought only in psychology. Psychology would enable art history, too, to relate the particular to the general, to laws."[10]

But the process should allow for the particular conditions required by history:

> Every artist finds certain visual possibilities before him, to which he is bound. Not everything is possible at all times. Vision itself has its history, and the revelation of these visual strata must be regarded as the primary task of art history.[11]

Wölfflin enunciated these laws by degrees: classical art or the classical phase of art is when it is at its zenith. True, as he showed in *Renaissance and Baroque*, a period of decadence, characterized by its relaxation of formal rules and capriciousness, can furnish laws making it possible to examine the inner life of art. But Wölfflin built his entire binary system of description on the foundations of normative classicism. Even his book on Dürer is yet another way of defining classicism as the aspiration—and the lure—for a northern artist on whose vision the fading Gothic world was still strongly imprinted.

Just like Riegl, Wölfflin in fact wanted to discuss works of art unconstrained by nineteenth-century taxonomies. The same impulse led both to separate the work of art from the manifold ties that confined it inside systems of

interpretation heavily indebted to models alien to art history. To proclaim that a form engenders another form without the milieu or even the moment in history exerting any influence liable to hinder the transformation is to grant art history the right to remain in control of its subject as well as its methods.

Evolutionists both, Riegl and Wölfflin sought to encompass the formal characteristics capable of providing the art historian with a system of interpretation that would ultimately embrace every single work of art. It is Max Dvorak, a Viennese art historian, trained as a historian, a disciple of Wickhoff and Riegl, who deserves the credit for devising other ways.

Aware of the twofold necessity implanted by Wickhoff for both a "general historical method" and an "ability to discern historical styles," Max Dvorak attempted to circumvent the problem by integrating art history into the humanities. To that end, he aspired to cover the entire field of art history from the paleo-Christian era up to his own time—he was the author of a remarkable essay on Kokoschka. He regarded it as essential to recognize the "contemporaneity" (*Gegenwartswert*) of every work of art: this is what gives it the power to affect the viewer, now and always, regardless of the profound modifications that may have occurred in its relation to its original context. Contemporaneity, however, did not justify interpreting a work by anachronistic standards. Each work of art is necessarily the fruit of a given stage in artistic, spiritual, and intellectual evolution. Dvorak was opposed to the practice of examining works of art in order, primarily, "to determine whether or not they are still 'classical' or already 'true to nature'. . . . In other words, medieval painting and sculpture are judged by standards of a far distant past or a much later development, standards which forget that between these two extremes lay centuries forming a world unto themselves."[12]

Systematic adoption of "fundamental principles" is equally misguided when it rests on "the assumption that, no matter how often the goals and technical skills of art might change, the concept of a work of art can nevertheless be considered something which on principle is constant and immutable. Nothing, however, is more false and more antihistorical than such an assumption, for the concept of the work of art and of the artistic has in the course of its historical development undergone the most diverse transformations even with respect to its most fundamental presuppositions and is at all times a temporally and culturally defined and variable result of the general evolution of mankind."[13]

If the very concept of art itself is subject to profound transformations, the present situation (Dvorak contended) issued an invitation to seek the spiritual dimension which, beyond its formal values, was the foundation of every work of art. The cause of modern man's difficulty in understanding medieval art

was precisely his unfamiliarity with its spiritual foundations. There is much that distinguished German painting of the first half of the fifteenth century from Flemish naturalism and Italian empiricism:

> In paintings by men such as Master Franke, Lukas Moser or Multscher we encounter a world similar to that of the medieval mystery play, a world in which ideal figures are sharply contrasted with others representing dark, satanic powers, and we see man crippled by crime and passion. This juxtaposition of symbols of ideal value with others representing blind apathy is, in fact, the first step towards a renewed awareness of the universal implications of human tragedy. There had been no room for such an awareness in the anti-rationalistic framework of medieval philosophy.[14]

This passage, from a study of Schongauer dating from 1920–1921, calls for a second reading. Clearly, Dvorak was not writing only about German primitives: he wanted to characterize all Germanic art, Expressionism included, by its spiritual roots. Similarly, when he stresses the true significance of Dürer's *Apocalypse* he is led to evoke "the urge to see the world as essentially a problem of man's inner life and art as a way of creating dialogue, of bringing together God and the Devil, this world and the next, and uniting the individual to that which moves mankind as a whole."[15]

Dvorak's psychological interpretation is undeniably akin to Warburg's. But while the latter saw the work of art as the supreme attempt to resolve psychological tensions, Dvorak regarded it only as a symptom. For Warburg, form is still the repository of those tensions, and is (despite itself, one might add) partly contaminated by evil. For Dvorak, form had forever to be mastered. That is why he traced a development he called "autonomy," the origin of which he dated in the fourteenth century. With it, art attained a status analogous to that of science, and became, like science, equal to the task of explaining the world. "Thus, the transcendental idealism of the Middle Ages in its union with secular values leads directly to extreme naturalism; later in the Renaissance and post-Renaissance periods, the very reverse was true, for out of this naturalism developed a new anthropological and cosmic idealism in conjunction with a partial return to classical antiquity."[16] The importance of the Middle Ages as they drew to a close lay in this transition from idealism to naturalism. The two terms are not equivalent to what haptic and optic or objectivity and subjectivity were for Riegl: Dvorak regarded them as possible guidelines. Riegl's dogmatism had to be challenged, even if, in the final

analysis, Dvorak wanted to extract a worldview from the reading of individual works of art. Unlike Warburg, he seems to have thought of medieval art as the only recourse against the chaos of his own time; it was in the two years immediately before the outbreak of the First World War—1912 to 1914—that he made the Middle Ages the subject of several of his courses, and it was in 1918 that he published a programmatic text, *Idealismus und Naturalismus in der gotischen Skulptur und Malerei.* At the heart of his philosophy of history was a metaphysical vision governing all his thought. It organized the world, as it did art, in a succession of single and unique objects, to which no system could do justice.

More than any other innovative thinkers of the time, it was the philosopher Wilhelm Dilthey who had the most profound influence on Dvorak's philosophy of history. "The manifest meaning of history," Dilthey wrote, "must first be sought in what is ever-present, ever-recurrent in structural relations, in interactive dynamic systems [*Wirkungszusammenhängen*], the way values and purposes develop within them, the order they maintain among themselves—from the structure of the individual life to the ultimate, all-embracing whole. This is the meaning of history, always and everywhere: it rests on the structure of the individual existence and, in the structure of conjoined dynamic systems, manifests itself in the objectivation of life." The primary task of any analysis of the structures of the world of the mind, Dilthey continued, would be to identify these ever-present features in the structure of the historical world. The intimate character of the relationship that the historian (of art) can have with the "homogeneous remains of the past" rests on the fact that "these are always connections that the historian has lived in his own life. The primal cell of the historical world is lived experience, where the subject's environment is the interactive dynamic system of life itself."[17] Starting from Dilthey's "construction of the historical world in the humanities," Dvorak sought the roots of the transformations observable in the history of art in the general history of ideas. In doing so, he quite naturally explored in two directions: on the one hand, he became increasingly responsive to the content of works of art, to the neglect of their form, and on the other hand, it was in the great creative personalities—Brueghel, Rembrandt, El Greco, and the like—that he thought he found the most accomplished mediation between the world of ideas and artistic form.

With Julius von Schlosser, the other eminent representative of the school of Vienna and also a pupil of Wickhoff, general formal and aesthetic problems yielded to philology and consideration of the individual artist: a position taking us a long way from Riegl. In 1901, Schlosser published "Zur Genesis der

mittelalterlichen Kunstanschauung" ("On the Genesis of the Medieval Perception of Art"), and, in 1902, "Zur Kenntnis der künstlerischen Überlieferung
im späten Mittelalter" ("On Artistic Transmission in the Late Middle Ages").
The first of these marked him down as Wickhoff's disciple, seeking to show
the extent to which the medieval era had been successful in assimilating the
heritage of classical antiquity, which it transformed thanks to "elementary
effects of color and line."

In the long 1902 study, he published manuscripts that were simultaneously
collections of figurative *exempla*. These provided the foundation for his concept of the *Gedankenbild*, which would be taken up, with some variation, by
his pupil Hahnloser, the exegete of Villard de Honnecourt. This "mnemonic
image" bears the slightly different name of "*symbolistisches Erinnerungsbild*"
("symbolist visual memory") in the 1901 article, where it is said to be a defining
characteristic of medieval art. The "mnemonic image" is in reality the true
stimulus of artistic creation in the Middle Ages: it keeps the artist aloof from
observation and supplies him with an autonomous system of known givens.
Towards the end of his life, however, under the influence of Benedetto Croce
and Karl Vossler, Schlosser tried to establish a system of interpreting art on
the basis of language. While the "language of art" embraces all the manifestations which make the work of art no more than an everyday instrument of
communication, "style" raises it to the rank of pure creation. Art history clearly
concerns itself only with the history of style.

A common thread links the article of 1902 to those Schlosser published
in the mid-1930s. When he was studying the collections of *exempla*, he was
accumulating the very broadest range of vocabulary: this kind of linguistic
knowledge is necessary to anyone aspiring to draw even a little closer to the
elaborate and refined language of the accomplished artist. Already in 1902,
Schlosser was implicitly asking himself about the transition from the category
of language—a collective possession—to the category of style.

In "Randglossen zu einer Stelle Montaignes" ("Marginal Glosses on a Passage of Montaigne"), he returned to the question of ornament, its psychological origin and the ahistorical nature of its existence. Here, he had all the greater
reason to invoke the analogy with language, because a theory of imitation existed in the domains of both language and ornament that was contrary to the so-
called spiritualist theory of Wilhelm Wundt. According to Wundt, it was not an
urge to imitate that made a child produce pictures or words but the far more imperious pressure of particular psychological dispositions, in which mnemonic
images—*Gedankensbilder* or *Erinnerungsbilder*—played a determining role.

When Dagobert Frey published *Gotik und Renaissance als Grundlagen der modernen Weltanschauung* ("The Gothic and the Renaissance as Foundations of the Modern World View) in 1929, he had already spent several years engaged in Austria's exemplary program of action to conserve the country's architectural heritage. He was Dvorak's successor as head of the Institute of Art History, attached to the government department in charge of historical monuments. The ability he demonstrated in *Gotik und Renaissance* to deal with questions of historiography, philosophy of art, and aesthetics, while not neglecting phenomenological knowledge of individual works of art, was characteristic, of course, of the Viennese school.

Art, as one of the "humanities," is explained in part by its origins in the human psyche: origins it shares with other arts and intellectual pursuits. The manifestations of the humanities may assume some very different forms. For Frey, a reference to a general cultural or stylistic concept—the Gothic, say, or scholasticism—does not serve to designate the essence of an idea if the reference does not go beyond analogy. The historical context and the history of the human subject, contributing to the production of the idea, are fundamental givens: "The foundation of a history of ideas [*Geistesgeschichte*] is therefore a history of the evolution of the human faculty of imagination."[18] And it is the different forms prompted by the imagination that differentiate medieval art from modern art, especially with respect to the representation of space.

In antiquity and the Middle Ages, the Euclidean optics that would make linear perspective possible in due course was not "read" as it would be later. If it was "discovered" during the Renaissance, it was in the sense that the Renaissance regarded perspective as "an exact science and epistemological method," for which reason the fifteenth century had no solution to "the problem of the discrepancy between mathematical construction and the psycho-physical process of perception."[19] Hence the distortions at the edges that strike a viewer standing at a normal distance from a perspective painting are not corrected empirically in a way that would match psychophysical perception. With the Renaissance, laws of mathematical construction took precedence over sensory experience. Frey reminds his readers that an optical procedure enables these distortions to be corrected, or rather, integrated into a "plastic" way of looking at a picture: it only takes a lens to facilitate the adjustment to a distance from which adult vision will be slightly out of focus. *Costruzione legittima* assigns a fixed position to the eye, and, on this basis, linear perspective produces the illusion of space. This position also allows forms to assume plastic values, thus absorbing the distortions attributable to the system of construction.

The change in conceptions of space is, according to Frey, the nodal point in the history of ideas. The Renaissance substituted simultaneity for the characteristically Gothic juxtaposition of successive elements. Moreover, as medieval man conceived a picture, the illusion it presents "is not confined to the purely visual pictoriality; it is much more comprehensive and more general and is much closer, in the nature of its synthesis, to the imaginative content [*Vorstellungsinhalte*] suggested by poetry than to our purely optical and predominantly formalist conception of a picture."[20] But with the introduction of Renaissance conceptions, this kind of congruence was abandoned, to be replaced by "the fundamental separation of the formal principles of painting and poetry."[21]

In the Middle Ages, therefore, the scale of objects and figures was not governed by the reality of the physical world; rather, it reflected their symbolic status as signifiers of concepts. To medieval man, "space is only imaginable to the extent that it is defined by its content, as qualifiable space," and (Frey continues), the Renaissance would confront this with "geometrically defined—that is, quantitative—space."[22] Thirty-five years later, Kurt Badt would demonstrate that such was indeed the Renaissance's ambition, but that in the end it too remained under the sway of a concept of space qualified by what it contained. For Frey, medieval man had no concept of space and time as distinct categories but, when it came to combining space and matter, as in a Gothic building, "matter might be said to be only the principle of how space presents itself,"[23] and this unformulated intuition already gave him an inkling of a conception of space that would be decisive for the Renaissance: "that of the continuity and infinity of space."[24]

### AUGUST SCHMARSOW: ART AS A SYSTEM

August Schmarsow may be regarded as one of the most impressive figures in art history; yet, unlike his contemporary Riegl, he has been completely neglected since 1936, the year of his death at the age of eighty-three. While he lived he was never out of the limelight, from his dissertation on Melozzo da Forlí to his regular, disputatious contributions to the *Zeitschrift für Aesthetik und allgemeine Kunstwissenschaft*. Although he manifested a pronounced taste for Italian art (for example, Orvieto Cathedral, Giotto, and Ghiberti) Schmarsow's reach extended into countless areas, from architecture to the applied arts, and to all the nonvisual arts as well. In this, he could be said to have sought to found a universalist aesthetics with a Hegelian pedigree. He wrote in two modes simultaneously, or, to be more precise, alternately: as an

art historian, meticulous in observing precise chronologies and scrupulous attributions, and as a theorist, attempting to establish a system where precise examples are rare. His more successful essays are those where the liking for systemization is tempered by the exigency of the art historian.

Schmarsow was a positivist for the same reasons as most of his contemporaries. He believed the art historian should think and look at the same time, and in his use of the faculty of sight he made common cause with the physicist, the mathematician, the geographer, and the physician, and parted company with the lawyer, the theologian, the philologist, and the historian, whose disciplines relied too exclusively on books, in his opinion.

The point of departure for any inquiry should be the work of art itself, which did not prohibit turning to other disciplines to facilitate the inquiry. The idea that was to dominate everything he wrote, from the most strictly historical essays to the most resolutely aesthetic, was already set out in the inaugural lecture he gave in 1893 on taking up his chair at Leipzig (as successor to Janitschek). The lecture was about the essence of architectural creation, and in it Schmarsow examined the role of the human body in the perception of architectural space. It appeared seven years after Wölfflin's *Prolegomena zu einer Psychologie der Architektur*. Wölfflin averred that our experience of architecture is based on our physical constitution, and that every architectural system is dependent on larger systems embracing it; hence, a style is defined as the distinguishing mark of those general principles. For Schmarsow, architecture was the "structuring" (*Raumgestaltung*) or "forming" (*Raumbildung*) of space. The difference between Wölfflin's and Schmarsow's conceptions can be illustrated by the different ways they distinguish between the notions of "regularity" (*Regelmässigkeit*) and "conformity to laws" (*Gesetzmässigkeit*). For Wölfflin, the laws establishing this architectural form or that have nothing to do with the human physique, unlike regularity. On the contrary, Schmarsow believed that looking involves the participation of other senses and that conformity to laws is not the outcome of a purely intellectual experience.

Schmarsow's primary intention in *Grundbegriffe der Kunstwissenschaft* (1905) was to respond to Riegl's theses. His principal charge was that his Viennese opposite number did not take the human subject sufficiently into account. Art could be defined as man's "creative confrontation with his environment." The conflict involved two protagonists: man, who must, however, "be understood not only as body but also as spirit," and the external world, which "comprises not only external objects but also the manifold relationships with man's sensory life."[25] The body is the center around which a topology is organized, to which every plastic system of representation pays tribute. The body imposes

the three fundamental laws of all human creativity: symmetry, proportionality, and rhythm.[26] In the final analysis, even if the work of art originates in conflict, it is also the form through which the "living individual" is manifested as "the given centre of all relationships and repeatedly the ultimate goal of all excursions, however wide-ranging, into the external world."[27]

From here, Schmarsow went on to contrast the conceptions of the world and of art exemplified in the work of Giotto. Whereas in the Arena Chapel in Padua and the chapels of Santa Croce in Florence, Giotto painted narrative cycles within the conventions of a longstanding artistic tradition, in the Upper Church in Assisi he favored a prosaic naturalism and took advantage of the church's Gothic structure to bring very recent history to life. According to Schmarsow, Giotto made no attempt to create three-dimensional space: the deformations he imposed on buildings in the paintings are comparable to the effect of an unfixed, movable viewpoint, that of a spectator in motion. What was taken by some art historians (Rintelen, for example) as an inability to master illusionist space was to Giotto's credit, Schmarsow declared, because he invented his own spatial dispositions as he went along.[28] Schmarsow's undying determination to disengage artistic phenomena from a teleological way of looking at them constitutes one of his essential contributions to art history, and in that respect his thought was close to that of Wickhoff and Riegl.

Schmarsow's proposals for revising the teaching of renaissance history in Germany, laid out in an important paper of 1899, provide another illustration of this attitude. Late medieval German art ought not be judged by the criteria worked out for the study of Italian art of the Renaissance. The concept of space (*Raum*) was capable of accounting not only for German art's singularity but also for its novelty: viewed from this standpoint, German art of the time was as progressive as Italian art.

At an early stage, Schmarsow dropped the term *Grundbegriffe* ("fundamental principles") in favor of *Kompositionsgesetze* ("laws of composition"). The publication and instant success of Wölfflin's *Grundbegriffe* probably had something to do with this. But the realities behind the "laws of composition" are quite fluid. When they concern features such as "Romanesque" windows in early Gothic churches they are something different from when they are applied to the cycle of the legend of St. Francis or, again, the works of Robert Campin or Rogier van der Weyden. Sometimes they are determined by iconographic content, at other times by more strictly formal questions. But at all times Schmarsow's "laws of composition" imply an interaction between architecture and stained glass, mural painting, or painted altarpieces. The

organization of the space is what dictates the law of the composition of the image.

During the 1920s and 1930s, Schmarsow dedicated himself to the study of "pure form in the ornamentation of all the arts."[29] He wrote, "Every ornament is an index of value to the benefit of its support"; ornamentation is "a prior stage common to all the liberal arts. It is not in itself an art in the highest sense of the term because it does not represent values, it only accompanies them." In sculpture, for instance, ornament only makes an appearance in the treatment of hair and (especially) draperies, where the dominant characteristics of ornament are manifested: "Repetition of characteristic motifs, pure in form and for the sake of form itself, reducing or eliminating every intrinsic value except the inescapable expressive value of each line, each complex of stimuli, even each individual point."

As for pure form, it exists where there is no sign of any whimsical desire for "mimetic reproduction of natural creatures or of technical procedures." In stressing rhythm's role as the active principle within ornamentation in every art, Schmarsow formulates all that form owes to the human body, for rhythm is the very manifestation of organic life. Schmarsow's system of "laws of composition," in which ornamentation constitutes the elementary stage, has a psychophysiological foundation and the style of a single artist or of a school is the result of adopting one law or another. These laws are simultaneously both historical (altering from one period to the next) and ahistorical, since the characteristics of visual perception are constant and rest, notably, on elementary geometrical shapes or the intrinsic values of specific colors. Schmarsow's thinking depends equally on experimental psychology and experimental physiology. His aesthetic vision, tending to establish a hierarchy of the arts, is in the line of descent from Hegel and exhibits numerous traits derived from the German Romantics and ultimately Goethe. The system he tried to establish, with a stubbornness that seems only to have increased with age, sometimes displays a dispiriting aridity. Like all systems, it has its reductive aspects. The abstraction in which Schmarsow often delighted contributed to making him a dogmatic spirit more often cited than read. This is a shame, because among the lengthy and frequently repetitive arguments there is an impressive number of bold intuitions, much ahead of their time. The one thing, probably, that discredits the historian Schmarsow believed himself to be is that far too often, as Wickhoff pointed out, the individual work of art is relegated to second place. If Wölfflin invoked art history without names, all too often Schmarsow practiced art history without works of art.

THE QUESTION OF STYLE, OR, THE SEARCH FOR UNITY

The question of style became central during the 1920s and 1930s. Classifications that had served during the nineteenth century, essentially imitating models forged for the natural sciences, were replaced by more exhaustive categories: Paul Frankl, for one, worked out an extremely sophisticated system of stylistic interpretation, which, although it led to a dead end, fulfilled an epistemological function.

It is probably unnecessary to reiterate Frankl's categories, which he created to some extent only for his own use. No other art historian really adopted his ideas, one major reason for this being that his book *Das System der Kunstwissenschaft* (1938), which represented the essence of his thought, had only very limited distribution. It was in architecture that he applied himself to distinguishing some "fundamental principles," perhaps influenced by the Wölfflin of the *Prolegomena* and certainly because of his own training as an architect.

At the time of Frankl's death, in Princeton in 1962, he was working on a manuscript (*Zu Fragen des Stils*, published posthumously in 1988) in which he was revisiting the issues of style to which he had already given definitive shape twenty-four years earlier. In this last work, he considered "membrological styles." Membrology is "the study of the *membra* present in every style, their forms, and the general meaning and general form of the *membra* as a whole."[30] Where styles are distinguished by polar oppositions, or "limitologies" (Wölfflin's term), Frankl specified that "Romanesque and Renaissance are styles of being (*Seinstile*) and Gothic and Baroque are styles of becoming (*Werdestile*). But Romanesque differs membrologically from Renaissance, and so does Gothic from Baroque. Styles cannot be understood exhaustively, either by description, denomination, or classification of the *membra* alone, or by recognition of their stylistic polar oppositions alone: each must be grasped jointly in their reciprocal relationships. Each *membrum*, even, is saturated with one of the two polarities."[31]

Frankl's propositions are obsolete for all practical purposes. Paradoxically, they have aged less well than Schmarsow's. As attempts to clarify the intellectual operations that every art historian undertakes empirically, they turn out to be useless. Frankl wrote some fine books in his quest for the essence of styles but he bequeathed neither a method nor satisfactory concepts.

Yet the critique of the concept of style led art historians such as Hans Sedlmayr to search for an alternative to an excessive emphasis on linearity.

Sedlmayr thought that by formulating the concept of "structure" he would be able to restore to style its relative position within the complete organism of the work of art. The "structuralism" that emerged from this exercise, possessing little in common with the product of Saussurean linguistics, did not in the end lead to anything more satisfactory with which to replace stylistic analysis, but perhaps did something to reveal its inadequacies. It has to be said that at no point during the debate about the concept of style did any definitive challenge ever emerge to the general accepted existence of a referential norm taken as the basis for all the systems, classificatory or structural: let us call it a form of "classicism," understood as designating an acme, rather than a historical style. In fact, from Wölfflin to Gadamer, classicism represents the supreme model, the rule from which all other formal phenomena are only departures. For someone like Sedlmayr, classical art, even in manifestations that tempt artists to surpass them, was nonetheless a fundamental given of Western civilization before what he called the "loss of the centre."

The initiatives of Frankl and Sedlmayr caused little stir, unlike Aby Warburg's concept of the *Pathosformel* ("pathetic formula"). Warburg sought to identify a certain number of *bewegte Beiwerke*—"mobile" or "animated" accessories, such as gesture, expression, hair, drapery—adopted from classical antiquity by Florentine artists in the Quattrocento in order to resolve interior conflicts.

*Pathosformeln* are, nevertheless, constituent formal elements of a style. Once spotlighted, they set Warburg on the path toward an interpretation of images, considered by him to be so many different expressions of the psychological tensions inescapable by social man. In order to convey the emotional content of images, an artist like Ghirlandaio would take a repertory of forms from classical antiquity and breathe new life into them in the desire to resolve problems of his own time. In Warburg's view, style is not the outcome of conventions but a question of social psychology. In this sense, stylistic analysis is an integral part of iconographic investigation.

Henri Focillon's position was diametrically opposite to that of Warburg. His books *La Vie des formes* (*The Life of Forms in Art*) and *L'Art des sculpteurs romans* (based on lectures given at the Sorbonne during 1928–1929), as well as a short article published in 1933, are devoted to the question of style. Focillon defined forms as "the place where extent and idea meet."[32] Hence, Romanesque sculpture is a measure of space. But space was "disordered" for modern artists, who saw the "spiritual values of art" lost in it; that was the reason, he thought, for the preponderance of interest in "intentions and fables."[33]

If art history wanted to account scientifically for medieval sculpture, it needed to be "simultaneously iconography, philosophy, and formal analysis."[34]

In such terms, Focillon expressed his reservations about iconographic studies, such as those by Emile Mâle in particular. Iconography does not explain "the poetics of forms"; "Perhaps the essential principle that enables us to grasp the originality of Romanesque sculpture is that the form as such is not enough in itself. It obeys a rigorous stylistics."[35]

Sometimes that last word appears to be modeled on "poetics" and to bear the same relationship to "style" that poetics does to "poetry." At other times it appears equivalent to "stylization," so closely does it seem to define the current of abstraction by means of which the artist proceeds. But we should not overlook another, more central meaning, where stylistics seems to denote an intrinsic logic governing the treatment of every ornament and every figurative form: "It is not excessive," according to Focillon, "to relate style and stylistics, that is, re-establish a logical process which lives within styles, demonstrating a superabundance of strength and rigour."[36]

We do not know how well Focillon was acquainted with Viennese and German *Kunstwissenschaft*. Clearly he could subscribe only to the second affirmation of Riegl's declaration that "the whole history of art assumes the form of a constant struggle with the material. In this struggle, it is not the tools or the technique that come first, but, on the contrary, the creative idea desiring to extend its field of operations, increase its formative capacity."[37] In Focillon's view, in fact, tools, materials, and technique were constantly in the forefront. "Technique is at the centre of analysis. . . . [I]t is spirit as much as speculation about space."[38] On the other hand, he was at one with Riegl in the belief that style, as a principle contributing to the "stabilization" of forms, is a term which "has two very different, indeed opposite meanings. *Style* is an absolute. *A* style is a variable."[39] Even when Focillon emphasizes that "the history of forms cannot be indicated by a single, ascending line" and that it is, consequently, "only natural that mankind should revaluate . . . styles over and over again, and it is in the application to this task that I apprehend the constancy and identity of the human spirit,"[40] it is hard to deny that there is an analogy between Focillon's thinking and Riegl's *Kunstwollen*. Like Riegl, Focillon was steeped in vitalism, even if for different reasons. Whatever may have been said about it, Riegl's vitalism, as translated into the concept of *das Kunstwollen*, relates approximately to Hegel's *Zeitgeist*. In more than one aspect, however, Focillon's thought probably traced its descent from the philosophy of Bergson, while Bergson describes a process which serves rather well as a definition of Riegl's *Kunstwollen*: "This [original] impetus,

sustained right along the lines of evolution among which it gets divided, is the fundamental cause of variations, at least of those that are regularly passed on, that accumulate and create new species."[41]

Bergson wrote in 1907 in *Creative Evolution*: "In reality, life is a movement, materiality is the inverse movement, and each of these two movements is simple. . . . Of these two currents, the second runs counter to the first, but the first obtains, all the same, something from the second. There results between them a *modus vivendi*, which is organization."[42] It is easy to see a connection between this and Focillon's way of describing artistic creation as governed by the primacy of materials and techniques, on which the artist impresses his organizing principle. The very idea of the constant metamorphosis of things at the behest of a principle of order, which is at the heart of *The Life of Forms*, could have derived partly from a reading of Bergson, who wrote: "There is no doubt that life as a whole is an evolution, that is, an unceasing transformation";[43] "every human work . . . every voluntary act . . . every movement of an organism" effects the creation of new forms.[44] A theory of knowledge could be based on the notion of disorder: what makes people regard this disposition or that as disorderly? The question and Bergson's answer to it are bound to have interested Focillon as he sought to define the laws of the internal organization of Romanesque art. Bergson postulated two kinds of "order": "I shall . . . place at the summit of the hierarchy the vital order; then, as a diminution or lower complication of it, the geometrical order; and finally, at the bottom of all, an absence of order, incoherence itself."[45] The first is "willed," the second "inert" and "automatic." The third arises whenever, expecting one of them, we encounter the other.[46]

The two types of order shed light indirectly on the process of artistic creation as defined by Focillon, who ranked technique so highly. Technique, in his view, is what transforms the "inert" into the "willed." The transformation is possible if we accept Bergson's insistence (in a critique of Kant) on "regarding the intellect as a special function of the mind, essentially turned towards inert matter." Bergson continues: "Intellect and matter have progressively adapted themselves one to the other in order to attain at last a common form."[47] And that, more or less, is how Focillon defined form: "the place where the expanse and the idea meet."

Ornament for Focillon, as for Semper and for Riegl, was the thing best fitted to reveal "internal logic." But the Frenchman was closer to Schmarsow in his conclusion that the logic was the result of "geometrical reasoning," which, for Riegl, would have represented a significant reduction of its exemplary value.

The constituents of a style, in Focillon's view, were "its formal elements, which have a certain index value and which make up its repertory, its vocabulary, and, occasionally, the very instrument with which it yields its power; second, although less obviously, its system of relationships, its syntax. The affirmation of a style is found in its measures." Yet style is not evolutionary in any biological sense. "Any interpretation of the movements of styles must take into account two essential facts. First, several styles may exist simultaneously within neighboring districts and even within the same district; second, styles develop differently in accordance with whatever technical domain they may occupy."[48]

And so Focillon was led to emphasize a dimension of time which constitutes one of the essential aspects of his doctrine: "The districts of a time do not all exist in the same epoch."[49] He put his finger on what he called "simultaneity in duration."

This open, nonlinear conception of time influenced one of Focillon's disciples, George Kubler, in a fine book called *The Shape of Time*, to put forward an idea of different types of duration which is not far removed from the ideas of Fernand Braudel. For Kubler, style and the flux of events are antinomic, because style belongs to a nontemporal sphere. Stylistic analysis, therefore, is only suited to the description of synchronic situations.

Focillon hoped that, with *The Life of Forms*, he would force disciplines to interact even if his book is patently nonsystematic. He made no secret of his wish to settle certain scores, with Wölfflin in particular. Significantly, the book was given a twenty-five page review in the leading periodical *Kritische Berichte*, whereas *L'Art des sculpteurs romans* had received scarcely a line two years earlier.[50] The reviewer, Nicolaj Worobiow, accused Focillon in particular of having introduced numerous ideas without first defining them. Although Focillon did not mention any author writing in the German language, Worobiow stressed the similarities between Focillon's comments on duration and Pinder's book on the question of generations, and between Focillon's "genealogical research" and the "ontogenetic" research of Sedlmayr, which indeed covered comparable material.

Worobiow predicted that Focillon's ideas would in the future lead him to intensive structural analysis of individual works of art, which alone would correct the regrettable methodological shortcomings of *La Vie des formes*. It is interesting to observe, in fact, that the "structuralism" of the 1930s, seemingly inaugurated by Sedlmayr in 1925 and illustrated by the work of Andreades on Hagia Sophia in Istanbul and Alpatoff on Poussin, came to constitute, in the eyes of certain commentators such as Walter Benjamin from 1931 onwards,[51] and Roberto Salvini from 1936, the outstanding methodology of the kind

of art history that would no longer be confined exclusively to style history. The structuralism developed in the two volumes of *Kunstwissenschaftliche Forschungen* aimed to replace the knowledge of series of works with knowledge of individual works as the foundation for art history.

In relation to this conception of the science, it becomes clear that Focillon's reflections rest on nineteenth-century evolutionist premises. He was concerned to classify and connect phenomena, even if his classifications were often remote from the schemes outlined by his predecessors. The essential difference lies, perhaps, in the fact that he considered experiment necessary, and that it should conform to practices in the natural sciences.

It should be remembered, with regard to Focillon, that stylistic analysis is a matter of language, operating with the verbal formulation of a complex phenomenological reality. The language charged with this formulation must be suggestive: simple description cannot adequately suggest the style of a work of art. Focillon was incontestably a master of language. There is something of Jules Michelet about him, as Chastel observed. It could be said that, with Élie Faure and André Malraux, he belonged to a certain literary tradition. Focillon has the ability to draw the reader into the landscape of a particularly suggestive style, a style mastering a dramatic gift, and the opposite in every respect to Warburg's unwieldy, nervous writing. Focillon's books—*L'Art d'Occident* above all—present a certain vision of the Middle Ages, as Michelet had done in his day.

In the same year, 1931, that Focillon published *L'Art des sculpteurs romans*, the product of a course he had taught at the Sorbonne since 1928, his disciple Baltrusaïtis published *La Stylistique ornementale dans la sculpture romane*, which was a direct echo of that course. It was a first—and lengthy—series of experiments by means of which the author hoped to illustrate the generative principles of forms, a "logical procedure" (Focillon's term) underpinning them.

The "dialectical" movement that Baltrusaïtis discovered between the order and apparent disorder of figurative sculptures gave rise, according to him, to "a morphological and intellectual system, complete in every element, which is like the proof of a theorem." He claimed to sweep away the division generally adopted by specialists in Romanesque art, between the ornamental and the figurative, the neutral and the significant. The rules governing figurative scenes also applied to bands of ornament, in his view. The same intention was the starting point for both types of sculpture, and that was the case in Romanesque art as a whole. Baltrusaïtis elaborated a normative system of interpretation which was all the more persuasive for the considerable number of drawings, in his own hand, reconstructing hundreds of examples in support

of his thesis. The drawings accentuate the geometrical character of figures, overriding the part that rules of order and composition may have played in their positioning. Consequently, the relief carving on a capital is reduced to a regulatory design which the reader inevitably identifies with the need for order that was the primary preoccupation of all Romanesque sculptors, according to Baltrusaïtis.

In other respects, a degree of uncertainty can be detected in the way concepts are handled. For instance, when Baltrusaïtis speaks of "deformation," as the antithesis of "formation," he is simply alluding to the monstrous beasts that make up a not insignificant proportion of Romanesque iconography. But he appeals to the principles of "dislocation" or "deformation" as if more was at stake than just monstrous deformities or aberrations within a mimetic system of representation—which is what they are, strictly speaking—and as if they affected the very composition of a scene, by "deforming" it. This ambivalence is all the more puzzling because Baltrusaïtis insists that his book is intended to be a "strictly formal study."

From the time the first edition of Baltrusaïtis's book appeared, it aroused differing reactions in France itself. While Jean Valléry-Radot commented approvingly, as he did on Focillon's *L'Art des sculpteurs romains*, George Wildenstein wrote that Baltrusaïtis presented his case as if it was a treatise by a forerunner of Villard de Honnecourt, that is, as if it had been written two hundred years previously, as if it had had "all the force of law in every workshop in Christendom." In his efforts to discover the order triumphing even over apparent disorder, Baltrusaïtis had imposed on the subject of his study an abstract schematism that overlooked simultaneously the content of images (iconography), their historical specificity, and even, more surprisingly still, the "life" forms possess outside any organizational purpose.

The most radical criticism came from Meyer Schapiro. I quote the final paragraph of his review in full here, because I want to kill two birds with one stone, and demonstrate the preoccupations of the American scholar who had published his own thesis on the Romanesque sculpture of Moissac in the same year. "Baltrusaïtis's method," Schapiro wrote:

recalls the instruction in certain American art schools, based on the Hambidge system of "dynamic symmetry." Students are taught to divide the surface of a picture by diagonals and perpendiculars, and to fit the subject—figures, still-life, or landscape—into the resulting areas, or along these lines. With this system, the history of art has been reinterpreted to show the Hambidgian, mathematical basis of masterpieces,

as if Classic, Renaissance and Modern art were alike in compositional principle. It is fortunate that we have no Romanesque texts to lend credibility to such a method as [Baltrusaïtis's]. For if a theologian had told us that all forms were triangles, rectangles, and palmettes, one would be tempted to identify the structure of Romanesque art with this formula. But how little such formulations penetrate into the nature of an art we can judge from the schematic application of Cézanne's statement on spheres, cones, and cylinders to his pictures. It is from the aesthetic milieu surrounding the practice of Cubism[,] which certain critics rationalized in terms of Cézanne's misquoted dictum and endowed with the prestige of a mathematical method and content, that is derived the approach of [Baltrusaïtis]. It is a work emerging from the ultimately Platonic studio aesthetic of recent times and the passionate feeling for primitive art. [Baltrusaïtis's] method is an example of the verbally formulated, rather than real, "Kunstwollen," of French post-Impressionism and Cubism. To make Romanesque a modern art, or an art in modern terms, he has reduced content to a passive role, and has identified form with geometrical schematisms and with architecture—an abstract art. But this passivity of content has today become problematic. The condition and interests which promoted an analytic geometrical style no longer exist. We detect all the more readily the inadequacy of an interpretation like [Baltrusaïtis's], which gives no formative role to the functions and meanings of a public religious art and which explains the choice of expressive effects solely by a geometrical coincidence.[52]

There is no doubt whatever that in writing these lines Schapiro had his sights set equally on Focillon: the gulf between Focillon and Schapiro is equally evident from reading *L'Art des sculpteurs romans* in conjunction with Schapiro's own essay *The Romanesque Sculpture of Moissac*.

Just as Wölfflin had done with regard to the concepts of "classical" and "baroque," Schapiro claimed to use the term "archaic" in an ahistorical sense. He described the figures at Moissac:

not to show the immaturity of the sculptors in the process of representation, but to demonstrate that their departures from natural shapes have a common character which is intimately bound up with the harmonious formal structure of the works . . . The particular problem in description was to show a connection between the treatments of various elements employed by the sculptors—to show that the use of line corresponds

to the handling of relief, or that the seemingly confused or arbitrary space is a correlate of the design, and that both of these are equally characteristic features of the inherent style. I find the essence of the style in the archaic representation of forms, designed in restless but well-coordinated opposition, with a pronounced tendency towards realism. Archaic representation implies an unplastic relief of parallel planes, concentric surfaces and movements parallel to the background, the limitation of horizontal planes, the vertical projection of spatial themes, the schematic reduction of natural shapes, their generalized aspect, and the ornamental abstraction or regular succession of repeated elements. In the dominant restlessness are implied unstable postures, energetic movements, diagonal and zigzag lines, and the complication of surfaces by overlapping and contrasted forms, which sometimes compromise the order and clarity inherent in the archaic method."[53]

There is no mistaking all that divided Schapiro and Baltrusaïtis. Schapiro completely rejected any idea of principles of organization underlying all Romanesque representational art from its beginnings. He espoused the doctrines of Emmanuel Löwy on the subject of archaic Greek sculpture and, in his doctoral dissertation, remained wholly faithful to traditional methods of attribution, classifying works according to criteria of quality in time—their chronology—and in what he assumed about the personal development of each artist.

Schapiro was *au fait* with the Viennese school, both the first and that of the "structuralists" of *Kunstwissenschaftliche Forschungen*. In any case, he never discussed the questions of composition that concerned him without taking into account both the space and also the form adopted by the Romanesque artist, that is, the way the figure and its background were articulated. This is an issue touching both the theory of perception and, even more closely, gestalt theory—which originated in Vienna, after all. Schapiro was familiar with gestalt theory, as is demonstrated by the passage quoted above and also by his 1969 essay on "image-signs," which was enthusiastically received in France in translation in 1973, when interest in semiology was at its height.[54] Furthermore, the theory of perception in the form of genial psychologism is a prominent feature of the work of a critic who influenced Schapiro, namely Roger Fry. Let us pause at those "image-signs." It is a deceptive text, it must be confessed: nothing on ornament, nothing on gold backgrounds, nothing on cubism, nothing on collage. Some such content would undeniably have given a different

complexion to an essay that seduced, above all, those who were ignorant of the work of the "second" Viennese school—I am thinking in particular of the 1933 article by Otto Pächt, "Principles of Organization of Western Painting in the Fifteenth Century," which Schapiro reviewed with particularly close attention to detail, delivering a negative verdict.[55]

When Schapiro proceeded to rehabilitate "background as field," it was of course one part in the whole current of modernism in American painting after the Second World War, much discussed in France in the 1970s, precisely at the time when his essay was translated. There is an earlier parallel in the "principle of ambivalence," which Riegl took as authorization to locate in "the late Roman art industry" the optical inversion of the figure/background relationship as found in the painting of Gustav Klimt. Of course this question runs through all modern art since neo-impressionism. It is not the subject of this book, however, but the wider issue affects comprehension of the theoretical positions adopted by art historians, and the debates that inevitably arose from them.

For Riegl and those who shared his views, the figure/background relationship raises the twofold question of style and space. In conquering space, or rather, in mastering an enlarged field of perception, the modern subject simultaneously expands the possibilities of style. For Focillon, the forms taken by the figurative idea are always governed by a "grammar," that is, a logical structure controlling the place they occupy.[56] It was not to the psychology of perception, on which German-speaking and transatlantic art historians alike were nurtured, that Focillon turned. He looked on the single, unique work of art as an idea expressed in a ductile material, which, like every idea, called for a "vocabulary," a "syntax," and a "grammar," sometimes "dialectical" or "syllogistical." When he invented the concepts of *espace-milieu* or *espace-limite*, the words "*milieu*" and "*limite*" described the attitude that space adopts vis-à-vis form. There is no ambivalence in that; it is impossible to conceive of any inversion of the figure/background relationship. Focillon talks about a form as a direct given of consciousness, and takes space—the background—into account only to the extent that it actively affects the form. Space realizes the form's assets. This is why the analogy with writing is constantly needed: a piece of writing can be read, whatever its form, dimensions, or color of its background, for these do nothing to modify the meaning of what is written.

From Riegl's *Kunstwollen* to Sedlmayr's need for structure or Focillon's insistence on organization, the same unifying principle is invoked, that which presides over the origin of style.

SPACE AND THE PICTURE AS PLANE

There are two further important texts bearing on the question of space in Western painting that we must examine: Erwin Panofsky's *Perspective as Symbolic Form*, first published in German in 1927 in the series of Warburg Library lectures, and Otto Pächt's "Gestaltungsprinzipien der westlichen Malerei," published in 1933 in a collection of texts by Viennese "structuralists," Sedlmayr at their head. Between those two dates, Dagobert Frey had published his *Gothik und Renaissance als Grundlagen der modernen Weltanschauung* in 1929, which pays a great deal of attention to questions of space.

The reference to Ernst Cassirer's *Philosophy of Symbolic Forms* is manifest in Panofsky's title;[57] the conquest of perspective, Panofsky wrote, "is nothing other than a concrete expression of a contemporary advance in epistemology or natural philosophy."[58] Conceptions of the representation of space in the late Romano-Hellenistic world and in the Renaissance corresponded to two different visions of the world, Panofsky stated, affirming that the problem of space is indeed the central problem of painting (and of sculpture too, as we shall see).

For Panofsky, the centralizing vision on which the Italians had conferred a scientific status and function represented the culmination of a long series of experiments, marked alternately by advance and regression. Even if northern Europe had "arrived at 'correct' construction by an empirical route,"[59] the roundabout journey had been a necessary one. Panofsky wrote: "It is clear how much the artistic conquest [in the Renaissance] of this not only infinite and 'homogeneous,' but also 'isotropic' systematic space (all the apparent modernity of Greco-Roman painting notwithstanding) presupposes the medieval development."[60] Neither Byzantine nor Gothic art would have been able to find this path on its own: only at the moment when they came together did it become possible. "Modern" perspective began at the point where "the northern Gothic feeling for space, strengthened in architecture and especially sculpture, seizes upon the architectural and landscape forms preserved in fragments in Byzantine painting, and welds them into a new unity."[61]

Identifying Italian geometrical perspective as the culmination of an intellectual process, Panofsky tried to justify the idea by reference to analogies with a worldview of a later historical date. Citing the vision of the universe held by a Giordano Bruno or even a Nicholas of Cusa, for example, is no way to prove that the foundation of the perspective system, so far as concerns the world of ideas, lies in the realm of the phenomenology of knowledge.[62]

Otto Pächt adopted a very different view of Western art in his paper on principles of design in Western painting in the fifteenth century, treating the question of perspective as, strictly speaking, neither aesthetic nor symbolic. Contrary to Panofsky's assertion, the question of space was not the central issue in modern painting: "The specific sphere of aesthetic legitimacy is . . . the plane [*Fläche*], that is, the imaginary plane of the visual surface."[63]

With regard to the illusion of three-dimensional representation, there can be no disputing the legitimacy of the plane. This legitimacy is twofold, according to "two heteronomous principles of order. While the realm where one of the two principles holds sway reaches beyond the limits of the image . . . the linkage of planes arising from the values of the outlines [*Silhouettenwerte*] creates a self-contained unity." The plane bounded by an outline is the projection of every object or every figure on the general picture plane; each such plane obviously contains a "value of spatial illusion" (*Raumillusionswert*), but the object's outline simultaneously encloses a "purely planar value" (*Flächenwert*).[64] These projected planes often belong to objects that are fully differentiated within the pictorial space but, as Pächt observes it in the painting of the Low Countries, this "organization" (*Gestaltung*) even of the planes is what constitutes the picture. "In the painting of the Low Countries, one should not suppose that the pictorial imagination rests on a judicious distribution of objects and figures across the real space, but on the organization of the plane as a plane of projection. One must read the picture from top to bottom, or rather from background to foreground."[65]

Pächt borrowed Theodor Hetzer's term *Bildmuster* ("picture pattern") to denote this continuous linkage of planes formed by the outlines of objects, an essential constituent of every painting from the Low Countries. The *Bildmuster* is a kind of flexible or adjustable equilibrium covering the format of the picture itself. Given that every projected plane can in its turn become the plane of projection for another form—Pächt cites the table in the Annunciation of the Mérode altarpiece, by the Master of Flémalle, which is a plane onto which the plane of a pitcher is projected—"no single place in the picture field possesses absolutely the value of 'background' or 'figure,' as was the case in painting of the high Middle Ages (with a gold background or absolutely empty colored plane as foil!), each projected form is also, in this respect, ambivalent in principle"[66] (fig. 6).

So we are back at the potential equivalence of "figure" and "background," for which we encountered a precedent in Riegl's attempt to characterize the modernity of the art of classical antiquity. It is on this equivalence that Pächt

FIGURE 6. The Mérode altarpiece, by the Master of Flémalle. (The Cloisters Collection, Metropolitan Museum of Art/Art Resource, New York)

rests the essence of the contribution made by the art of northern Europe—specifically the Low Countries—to modern art: "When what is inorganic, inanimate (domestic objects, furniture) appears as equal in value to the human figure in the system of relations between the planes in the *Bildmuster*, and when, on the other hand, this support may be only secondary, then homogeneity of everything visible has been achieved."[67] For Panofsky that homogeneity was the necessary condition allowing space to take the decisive step by which it obtained objective status. For Pächt, it found some kind of place within the tightly constructed network of the "picture pattern." But if

the "medieval development" was a necessary prelude to the Renaissance in Panofsky's new vision of it, how did he envisage it? "It was the medieval 'massive style' [*Massenstil*] that first created that homogeneity of the representational substratum without which not only the infiniteness but also the directional indifference of space, would have been inconceivable."[68]

"Massive style": an unexpected and rather unsatisfactory notion. In the attempt to define it, we must turn to other writings by Panofsky, in particular to his 1924 study of German sculpture from the eleventh to thirteenth centuries. There we read that in order to advance beyond the art of antiquity medieval art had to move towards a "style of mass" (*Stil der Masse*), mass being a "material configuration" (*materielles Gebilde*) intrinsic to Romanesque art, of which Gothic art was the fulfillment. Panofsky described such configurations as being "massively concentrated, unmovable and rigid, dissolved from any relationship with a surrounding space," and these, "in their elemental three-dimensionality, had first of all to establish the phonology and syntax of the new plastic language, before its poetics and rhetoric could be developed."[69]

It is not easy to grasp how the same notion of mass can also designate the representation of space in northern European painting of the fifteenth century. Panofsky indeed writes, "Innate to 'mass,' that specifically Northern formal substance, is a peculiar indifference to direction . . . The North . . . felt even pictorial space as 'mass,' that is, as a homogeneous substance within which open space, the space of light, was felt to be almost as dense and 'material' as the individual bodies distributed in it."[70]

For Panofsky, therefore, Romanesque sculpture is characterized by a massiveness and a plasticity that radically transformed ancient art in every respect. As a result, it developed characteristics of its own which, according to Panofsky, are those of the Germanic race and can be attributed to principles of "disorganization" and "planarity."[71]

In sum, the notion of "mass" refers to a configuration of forms distinguished by perfect homogeneity and lack of a dominant direction. If the term is equally appropriate for a Romanesque relief and a fifteenth-century painted panel in which space is "rotated," it is because it is scarcely applicable to analogous handling of pictorial space, let alone a style. It seeks to define a manner of representing space which is the manifest sign of the specificity of a style—for Panofsky as for Riegl.

Oddly enough, it was in analyzing sculpture that Panofsky was to discover a treatment of space that brings us markedly closer to Pächt's theory. Medieval sculpture transforms a surface into "a stereometrically condensed surface, a surface articulated by linear contours; [it] creates an indissoluble

unity between figures and their spatial environment, that is, the background surface. . . . A relief figure is now no longer a body standing before a wall or in a niche; rather, figure and relief ground are manifestations of one and the same substance."[72] Elsewhere, Panofsky cites "the natural spatiality, deepened by perspective, [which] retracts to a shallow layer [and then] can take up only single objects similarly reduced. These single objects and this spatiality merge in what might be called an insubstantial texture, within which the totality of the reduced objects appears as a 'pattern' [*Muster*] and the similarly reduced space appears as the 'ground' [*Grund*], the pattern's equal in value."[73] Pächt differed from Panofsky in observing this process taking place in fifteenth-century painting, in the works of the Master of Flémalle or Van Eyck, where an illusion of three-dimensional space was already formulated.

Two points require further development. The first concerns the allegedly fragmentary nature of the representation of space, from the moment when the picture offers itself as an opening onto a space which overflows it on every side. One may wonder whether, as Panofsky contends, "the finiteness of the picture makes perceptible the infiniteness and continuity of the space,"[74] or whether, rather, the finite nature of the picture does not first and foremost express the homogeneity and autonomy, on the structural plane, of Pächt's *Bildmuster*. The fact the pictorial space continues in all four directions scarcely prevents the projection plane of the objects and figures constituting it from being self-sufficient overall, organized as to its format and proportions. That is why the view of a building interior satisfies the taste of the artists of the Low Countries particularly well; the space thus depicted presents itself as the extension of a space on the viewers' side of the picture plane, one that includes ourselves.

This brings us to the second point, relating to a somewhat confused aspect of Panofsky's remarks on perspective, when he addresses the question of the "oblique" view of space. He deplores the confusion regarding it, "in that oblique placement of the pictorial architecture in the space [as in Giotto and Duccio] is not always clearly distinguished from a rotation of the space itself."[75] It is in the work of Giotto and Duccio that "closed interior spaces reappear for the first time. . . . These interiors can in the final analysis only be understood as painterly projections of those 'space boxes' [*Raumkasten*] which the northern Gothic had produced as plastic forms."[76]

As for the "rotation of the space," Panofsky assigns it a date of origin of around 1500 and locates it in, for example, Gérard David's *Judgment of Cambyses* (fig. 7). He means by it simply the rotation of the floor in the fore-ground, so that, in this particular example, the lower edge of the picture plane cuts diagonally across the square tiles on the ground; this procedure serves

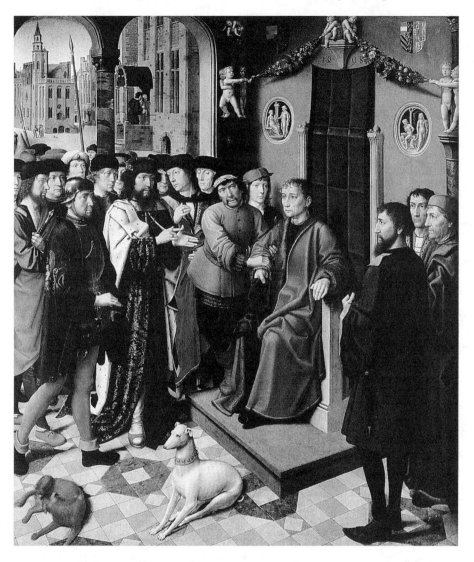

FIGURE 7. Gérard David, *The Judgment of Cambyses*. Musée Communal, Bruges.
(Photo by Gallimard-Hugo Maetens)

to reinforce the fragmentary character of the image. But there are earlier instances of such rotation, in the illuminations of around 1400 that Panofsky himself published in his *Early Netherlandish Painters*, for example, where the remarkable treatment of the space does not excite any comment from him, or in work from the milieu of the Limbourg brothers, to give another example.

Panofsky becomes a little obscure as he presses his argument: he cites the middle panel of the Bladelin altarpiece, with the cradle of the newborn Christ, as an example of "architecture rotated in space," instead of using the term "oblique space."[77] Yet what is there to choose between the "boxes" placed in space by Giotto and this "box" of Rogier van der Weyden? In reality, Panofsky wants to set apart a theoretical Italian model unaffected by northern contact, while acknowledging that the north developed preoccupations about space in motion that were different, although similar in nature.

Panofsky failed to see that the representation of a church interior constituted the empirical model of "perspective" space for northern art. By reason of its form, the succession of bays leading toward the apse presents a certain analogy with the pyramid of perpendiculars "converging" on the vanishing point which, in *costruzione legitima*, is the symmetrical principle of the optical pyramid. The interior of a church provides the painter with a scene enclosed on five sides (like a stage) but suggests the extension in depth that the spatial representation needs in order to achieve a certain degree of verisimilitude. But above all, this space has a direction firmly imprinted on it, and that is where the theory of "mass" proves inadequate. This again raises an essential point to which I shall return: "homogeneity" can describe the dominant quality of the plane of representation, not that of the depicted space. For the nature of the latter is completely different in the miniature of the Mass for the Dead (in the *Turin Book of Hours*) and in the Van Eyck panel *The Virgin in a Church* (figs. 8 and 9).

In the miniature, the section of the spatial pseudo-pyramid formed by the church interior is drawn exactly at the crossing of two arcades (hence at a right angle to the axis of the nave); in other words, the picture plane—where the space depicted coincides with the *Bildmuster*—is constructed by means of a transverse section across the building's three aisles. In the Van Eyck panel, the section the picture plane makes across the nave is not identified with any element of the architectural structure. Van Eyck fixes the section arbitrarily in the span of a bay of which we see nothing but an infinitesimal fragment of the vault. But he compensates for this loss of architectural coherence, this absence of depth, by the format of the plane of representation, which, because the top of the panel is curved, does something to restore an architectural dimension to the image. This also has the effect of diminishing the fragmentary character of the view; a rectangular format would have added to the impression that the section was made arbitrarily.

Unlike the miniature, the panel has a spatially indeterminate zone, between the vertical elements and the upper edge of the picture on the one hand, and

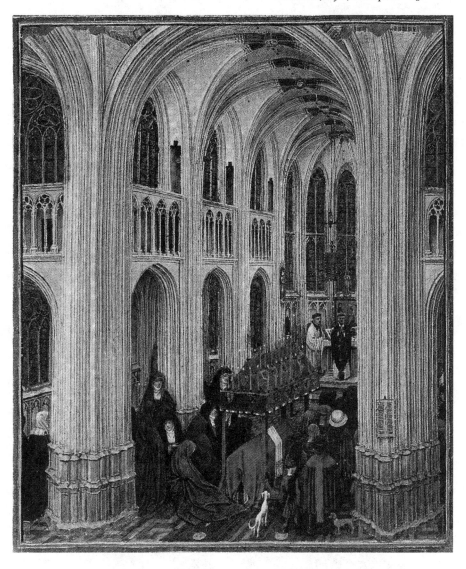

FIGURE 8. Mass for the Dead, in *Les Très Belles Heures de Notre-Dame.*
Museo Civico, Turin.

the start of the space we see on the other. We sense that between the two
elements there is a space that cannot be represented—something that does
not recur at the bottom of the painting, where the lower edge corresponds
visually and spatially to the start of the tiled floor. That the viewpoint from
which the scene is depicted is high makes no difference to this observation.

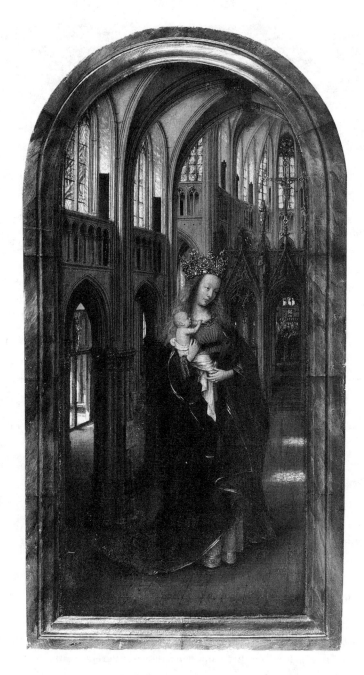

FIGURE 9. Jan van Eyck, *The Virgin in a Church*.
Gemäldegalerie, Berlin. (Photo by Jorg P. Anders. Credit:
Bildarchiv Preussischer Kulturbesitz/Art Resource, New York)

Drawing the tiled floor as a cluster of vanishing lines perpendicular to the picture plane is a technique also adopted in the miniature. But a difference in scale makes a difference between the two images: Van Eyck succeeds in disguising this distortion of the pictorial space, that is, he has brought off a subterfuge designed to convince the viewer that the homogeneity of the *Bildmuster* is matched by that of the space depicted.

If I have lingered on the question posed by these two works, it is in part because of the space Panofsky himself gives them. But the main reason is that his incomplete reading of them allowed him to display less philological rigor than he might have done, in respect of the notions of "mass," "direction," and "homogeneity" that he himself introduced. On these points, Pächt's analysis proves infinitely more convincing, quite simply because it introduces the concept of the *Bildmuster*, which avoids confusion between space of representation and plane of representation (projected plane). The dominant role Pächt gives the latter was criticized by Schapiro, but if Pächt wanted to "neutralize" a painting's individual expressive values and even its content, as Schapiro complains, it could be interpreted as an appropriate strategy in establishing the novelty of a concept. That does not mean at all that Pächt introduced a qualitative hierarchy governing every painted representation, but rather, that the *Bildmuster* should henceforth be regarded as the necessary foundation for any analysis of the painting as a whole.

Schapiro's criticism of Pächt in his review article of 1936 was annulled by the latter's subsequent work and (it gives me some satisfaction to say this) by the delayed benefit Schapiro himself drew from the "new Viennese School" in his article on "image-signs."

Another question about Panofsky's teleological idea of pictorial space was raised by Kurt Badt. Badt asserted that the conception of pictorial space current in art history applied to a relatively short period—the fifteenth to seventeenth centuries—and that it had no relevance to the broader situation. This conception of space, seemingly taken for granted by art historians, rested on three properties, namely that the space was isotropic, continuous, and infinite; and it was thought reasonable to base evaluation of the art of all epochs and all civilizations on these assumptions. At first sight, the focusing of linear perspective appeared to have partly solved the problem of isotropic and continuous space. Space was conceived, then, both as framework and as internal space. But such space could not be called isotropic, because the Renaissance brought an opposition between figures and empty space, thereby threatening the unity of the picture. Western painting continued, nevertheless, to prefer isotropic and continuous pictorial space until around 1910; the reason

for its decline, according to Badt, was the erroneous premise which confused conceived space with perceived space.

It is conceived space, not perceived space, that effectively presents itself as being unique in form. Fifteenth-century painting focused on processes intended to produce the illusion of a continuous space, possessing the same physical properties in every direction; in the south by means of tiled floors, in the north by recourse to colors (brown, green, and blue) in order to differentiate foreground, middle ground, and background. Whatever the technique employed to suggest it, this space induces a sense of movement, drawing the viewer in and towards the background, an unexpected result which mannerism would explore further.

# * 2 *

## *An Introduction to the Art of Cathedrals*

CHAPTER THREE

# The Seen and the Unseen

## SEEING THE HOST

"The renown of good cities depends . . . even more on the relics they hold than on the strength of their walls or the reputation of their tribunals," according to a recent history of French towns and cities in the late Middle Ages.[1] From his baptism to guild membership, from his parish and the vestry board on which he sat to the processions in which he took part, the town dweller found himself bound up in a network of relationships linking him to innumerable saints, from all of whom he expected blessings and protection. Mingling with the community of men, these saints formed a spiritual community with a physical presence in the form of relics.

It is not easy for us today to find our way through this "city reliquary" (*ville reliquaire*, to use Bernard Chevalier's term): not just because the institutions—above all, those of the Church—have been supplanted by others, but also because the urban fabric has changed materially and physically. We retain very little indeed of the secular architecture, and only isolated examples of the religious architecture. But the Gothic church or cathedral surviving in the modern European town displays an assemblage of architectural and representational forms, each of which once had its individual meaning and function—not that the meaning and the function were clear to the eyes of the congregation of the faithful, or even to the eyes of the priesthood. At the end of the thirteenth century, Guillaume Durand compiled the *Rationale divinorum officiorum* (*Manual of the Divine Offices*) with the object of reminding the clergy of the symbolic significance of the liturgy and sacraments, the architecture, and the church furnishings, which had gradually been forgotten. Yet the beauty and abundance of the visible forms were such that no one could remain

unaffected by the multitude of signs. The monumental building, far larger than its neighbors, is the permanent witness to a need for enhanced visibility that was characteristic of late medieval society. The indications of this need can be found in several discrete areas, from the twelfth century onwards, and an eloquent example is that of the increasingly overt demand by the congregation to see the Host at the moment of consecration.

The elevation of the Host was almost unknown before the end of the twelfth century, yet by the middle of the thirteenth it was common throughout Europe. It has not been dated more precisely within that period; a reference in a synodal precept of 1208 establishes the practice as extant by then, and the Lateran Council of 1215 adopted the expression "transubstantiation of the bread to the Body and of the wine to the Blood," thus affirming the Real Presence of Christ in the church.

It was in the councils of theologians and of the regular religious orders that questions about the Eucharist were first posed. The earliest signs of veneration specifically of the holy sacrament are to be seen at Cluny during the mid-eleventh century. The proclamation of the transubstantiation of the elements was part of a battle waged by the Church that led to the proliferation of miracles of the Host.

Thus the popular demand was anticipated, to some extent, by the theologians themselves. Anselm of Laon (d. 1117) and William of Champeaux (d. 1121) both affirmed that Christ was present entirely in the sacrament of the Eucharist, not His Blood alone. What St. Thomas Aquinas said in his *Summa* about this question of the presence of the Body of Christ was of the utmost importance in the deliberations of the Council of Trent. For Hugh of Saint-Victor, Christ entered into the Eucharist so that His physical presence should spur the believer to seek His spiritual presence. In fact, the very existence of the concept of symbolism can be imputed to the distinction between the visible and the invisible found everywhere in medieval exegesis. The visible needs to be interpreted if we are to gain access to the invisible. Sacramental symbolism was instituted precisely to make us know divine truth by means of a certain number of signs. Exegetical definitions of the word *sacramentum* are illuminating. In *The City of God*, St. Augustine defined it as *sacrum signum*. For Hugh of Saint-Victor, again, it is a material element which represents by resemblance, signifies by institution, and contains by sanctification. St. Augustine had already formulated the distinction between *sacramentum*—for example, the bread and the wine in their species, in the case of the Eucharist—and *res*, designating the oneness of the Body and Blood of

Christ. Peter Lombard distinguished *sacramentum tantum* (the visible, external sign), *sacramentum et res* (the spiritual reality contained in the sacrament), and *res et non sacramentum* (the ultimate reality signified but not contained in the sacrament). Concretely, in the case of the Eucharist, the visible species of the bread and wine were of the order of *sacramentum tantum*, symbolizing both the true Body and the true Blood of Christ—*sacramentum et res*—and simultaneously the mystical body or the union of the faithful in the Church—*res et non sacramentum*.

In St. Thomas's eyes, the sacraments also possessed a threefold symbolism:

a symbolism commemorating the passion of Christ,
a symbolism demonstrating the grace of God,
a symbolism anticipating the glory to come.

The institution of the Eucharist enacts the representation of the Body of Christ in the bread. The Body has a real existence but also a symbolic significance: it symbolizes both the union of Christendom in the Church and the commemoration of Christ's Passion. In the bread broken and shared in the communion rite, Christ is a premonitory symbol of the fullness of joy in God which will be revealed in Heaven.

The demand for something to see became more and more urgent around 1200. The elevation of the Host is attested for the first time, in fact, in a synodal statute of Eudes of Sully, Bishop of Paris (1196–1201). During the *Qui pridie*, he ordered, "when they hold the Host, [celebrants] should not at first raise it high enough to be seen by the whole congregation, but should keep it close to the breast until they have said 'This is My Body,' and raise it then for all to see."

Apparently in order to further encourage the faithful to gaze on the Host, William of Auvergne averred that God was pleased to grant prayers made at the moment of contemplating the Body of Christ. Around 1230–1240, certain theologians, taking up his ideas, expressed a fear that congregations were satisfied with seeing the Host rather than receiving it. But the Franciscan Alexander of Hales responded that as the nourishment dispensed by the Eucharist is spiritual, the least material of our senses, namely sight, sufficed to receive it. At that period there were devout people who would hurry from one church to another, in order to see the Body of Christ several times on the same day.

Concerning the moment of elevation, several councils of the thirteenth century prescribed that it should be done immediately after the consecration

"so that it may be seen" (*ita quod possit videri*), conforming with the practice initiated in the diocese of Paris. In the previous century, Peter the Cantor (d. 1197) had thought that the Body could not be present until after the words "*Hic est calix*" (this is the cup). But Eudes of Sully thought the celebrant ought not to lift the Host too high at the moment of saying "*Qui pridie*," but rather, hold it close to his chest and raise it only after the words "*Hoc est corpus meum.*" In fact, from the first half of the twelfth century, priests used to raise the Host at the moment of consecration, which carried the risk that some of the congregation would adore the Host before it became the Body, thus committing the sin of idolatry. For Peter the Cantor, transubstantiation did not take place until after the consecration of the wine. Aquinas, Albertus Magnus, and Alexander of Hales asked for the Host to be elevated before being shown. Later, liturgists would prescribe various practices in order to allow the faithful to see the Host raised: lighting candles at the moment of elevation, to make it easier to see, or, in collegiate churches, opening the chancel gates at the moment of elevation. The Carmelites recommended avoiding too dense a cloud of incense lest it veil the Host. The use of colored curtains was also known, allowing the white Host to be more easily seen against them.

The example of the Host shows how necessary it was for theologians to warn of the dangers of substitution. According to Eudes of Sully, the Host is only a *signum* for as long as it is not consecrated. When it becomes the Body, the sign does not change its physical appearance, and yet its meaning changes. What the congregation should be able to witness is the conversion of substances into *species*. By elevating the Host, the celebrant demonstrates that the Incarnation has actually taken place and incites adoration. Berthold of Regensburg (d. 1272) would say that the elevation signified three things: "This is the Son of God who, for you, shows His wounds to the Father; this is the Son of God who, for you, was raised on the Cross; this is the Son of God who shall come again to judge the living and the dead."

But except in the act of consecration, carried out in the new conditions outlined above, the holy sacrament could not be seen by the congregation. To begin with, this was because it was not exposed uncovered except during the mass: such exposure is recorded first in Germany, Sweden, and Livonia. The existence of a tabernacle with a rock crystal door, at Lugo in Galicia, is mentioned in the fifteenth century.

During the fourteenth century it became usual to expose the Host, whether or not consecrated, in a monstrance. The cathedral in Zurich is known to have owned a *cristallus Christi* in 1333, and there is a description dated 1340, from Trier, of the "glorious Body of the Lord placed in a pyx [box] made of

crystal and silver gilt sumptuously worked, and adorned with the likenesses of three winged angels all around the box, and that of a priest set above the crystal." A canon of Strasbourg mentions in his will, as early as 1304, "one crystal monstrance made of copper gilt." In 1324 the Archbishop of Reims, Robert of Courtrai, gave his cathedral a gold cross, decorated with precious stones, and with a piece of rock crystal at its centre which enabled the Host to be seen.

Artifacts of this type, and of equally early date, survive to the present day. A monstrance from an Austrian convent, mounted on a pedestal, decorated with Sienese enamel, and dating from the decade 1310–1320, bears the text of the *Agnus Dei*, leaving no doubt as to its original function. Its appearance has changed due to the removal of part of its metal base. A monstrance in the treasury of Basel Cathedral can be dated to about 1330. Sixteen translucent enamel medallions of an exceptionally high quality frame a case of rock crystal in which there is a crescent-shaped hollow intended to display the Host vertically. At Fritzlar, there is a monstrance from the second quarter of the fourteenth century, in silver gilt, with the words "*Agnus Dei qui tollis peccata mundi miserere nobis*" inscribed on the foot, the invocation following the "*Hoc est corpus meum*" of the consecration.

The Real Presence of the Body of Christ is a relatively late dogma, therefore, and one that certainly modified the practices, if not the religious mentality, of congregations and even of the clergy. Reflecting this, Robert Grosseteste, Bishop of Lincoln, addressed the Benedictine monks of Peterborough Abbey as follows: "In your convents . . . the King of Heaven lives, not through divinity alone, but in the sacrament of the Eucharist through the true substance of the flesh given by the Virgin Mary."[2] In nunneries in particular, veneration of the Eucharist proceeded apace, but it spread relatively slowly among the lay community. Part of the explanation for this may lie in the fact that many churches, at least until the middle of the fifteenth century, were not open to the public except during celebrations of the mass. In 1204 the Bishop of Paris forbade the closure of Notre Dame during the day. Closed doors meant that the Eucharist was rarely on view and explains the insistence of some prelates on its being shown, at least at times when the faithful were admitted to the church.

The Real Presence of Christ at the heart of the church profoundly modified the perception that a believer could have of a space given over to religion: the definition of a church as the heavenly Jerusalem was to be supplanted by something that could be experienced at all times within the space, the chance to verify the Real Presence through the evidence of one's own eyes.

The new situation was reflected in the statement of a Franciscan chronicler of the fourteenth century, John of Winterthur: "The Eucharist is the sacrament on which the faith of modern men depends."

## ST. FRANCIS AND THE TESTIMONY OF ONE'S OWN EYES

The teachings of St. Francis of Assisi are known to have played a significant role in the process of enhanced visibility. He wanted to open men's eyes to the immediate reality of two things: the Eucharist and the Gospels. With respect to the Eucharist, it is enough to cite a passage from his *Counsels* to confirm the central role he assigned to visual testimony:

> Our Lord Jesus Christ said to His disciples, "I am the Way; I am Truth and Life; nobody can come to the Father except through Me. If you had learned to recognize Me, you would have learned to recognize My Father too. From now onwards you are to recognize Him; you have seen Him." Philip said to Him, "Lord, let us see the Father; that is all we ask." Jesus said to Him, "What, Philip, here am I, Who have been all this while in your company; hast thou not learned to recognize Me yet? Whoever has *seen* Me, has *seen* the Father." The Father dwells in unapproachable light, and God is a spirit, and no man has ever *seen* God. Because God is a spirit, He cannot be *seen* except in the spirit; for only the spirit gives life; the flesh is of no avail. Nor is the Son, Who is equal to the Father, *seen* by any but the Father and the Holy Spirit. Therefore, all who have *seen* the Lord Jesus Christ in His Humanity without *seeing* or believing in His spirit and divinity, and without believing that He is the Son of God, are condemned. In the same way, those who *see* the Sacrament of Christ's Body, which is hallowed by the words of our Lord at the altar in the hands of His priest under the forms of bread and wine, and who do not recognize His spirit and divinity, believing It to be truly the most holy Body and Blood of our Lord Jesus Christ, are condemned out of the mouth of Almighty God Himself, Who testifies: "This is My Body and Blood of the New Testament"; and "Whoso eateth My Flesh and drinketh My Blood hath eternal Life."

St. Francis continues:

> As He [the Son of God] once *appeared* to the holy Apostles in true flesh, so does He *reveal* Himself to us in the hallowed bread. And as

they gazed on Him with their bodily eyes and *saw* only His human nature, although when they *contemplated* Him with the eyes of the spirit they knew Him to be God, so we, as we *look* on the bread and wine with our bodily eyes, firmly believe and know that here are His most holy Body and Blood, living and true.[3]

Secondly, St. Francis bore witness to the necessity of rendering the gospel message visible: he lived a public life, thus manifesting a parallel with the life of Christ. He placed an emphasis on actions rather than words. The *imitatio* of Christ provided a structure for such conduct just as the conduct provided a model for the *imitatio*. Eyewitnesses of his pastoral actions—Thomas of Celano and St. Bonaventure—wrote his biography; others were still alive when work began on decorating the church at Assisi.

The immediate consequence was the work of correction and adjustment undertaken by pontifical ideologues when faced with the image of Francis as *il poverello*. Without favoring either of the extreme positions in the controversy about the question of the objectivity, or otherwise, of Thomas of Celano's *Vita Prima*, we should remember that it was commissioned by Pope Gregory IX immediately after Francis's canonization, in July 1228, and that therefore it accords with the line issuing from Rome. Equally, St. Bonaventure's biography is first and foremost a polemic, intended to refute the arguments of Parisian theologians and of spiritualists. In 1226, the Chapter General of the Franciscan order decided that Thomas's account was outdated and Bonaventure's was the only acceptable one. The Church gave its blessing to this choice, declaring the author a "seraphic master," spiritual son of the "seraphic saint," because, in the words of an exegete of Franciscanism, "St. Francis brought about the return to the way of living according to the Gospels, St. Bonaventure the return to the way of knowing according to the Gospels."[4]

The public image of St. Francis was carefully controlled by the Roman authorities: of that there can be no doubt. The execution of the cycle of paintings in Assisi is one of the proofs. While the lower church is a sanctuary containing important relics of the saint, the upper storey is a church of the Franciscan order and of the pope. Founded by Gregory IX, it was consecrated by Innocent IV, and the program of the frescoes was devised by Matteo Rosso Orsini, archpriest of St. Peter's in Rome. The paintings of the Franciscan cycle in the Bardi Chapel in Santa Croce in Florence establish a more concise iconography than that of the Franciscan mother church, even more submissive to Roman orthodoxy, with the papal recognition and the missionary campaign in the Holy Land taking a central place, while the ideal of poverty is somewhat marginalized.

On a purely formal level, it is clear that in Florence, Giotto completely re-worked the composition of scenes corresponding to ones at Assisi, subjecting them to an authoritarian and, if I may so term it, centralist structure. The authority of the dogma is transcribed, to some extent, in the organization of these scenes.

The different "portraits" of the saint that survive from the thirteenth century illustrate the two orientations. While Berlinghieri's altarpiece and the Assisi cycle depict him bearded, in Santa Croce he is clean shaven, in conformity with the contemporary convention reserving beards to men of humble condition. It is another sign of the gradual process of marginalizing the ideal of poverty, under pressure from the monastic orders and reinforced by the pontifical doctrine set out in the bull *Cum inter nonnullos* (1323).

The demand, echoed by St. Dominic, for renunciation of all forms of pro-perty had consequences beyond any economic ones: Franciscans did not live in self-governing communities like monks and were therefore not confined in convents, so their daily behavior was on public view in the streets and squares of the towns where they held out their begging bowls. Exposed to the sight of all, their conduct was transparent. That, at least, was the ideal of the early years, before Gregory IX's bull *Quo elongati* (1230) distorted the sense of St. Francis's testament, notably by denying the need for literal and rigorous interpretation of his Rule. The transparency had already had a considerable influence, however. The exemplary character of the friars' conduct ensured that it had a profound effect on consciences at a time when the economic development of cities and towns led to an upsurge of a desire on the part of ever-growing numbers of people to live lives of poverty. This desire attracted them at first towards heresies, but it was channeled by the Dominican and Franciscan ideal. After 1230, when the friars' conduct was no longer on view, the papal authorities hastened to provide the faithful with pictorial evidence of the saint's pastoral activities. The images were intended to uphold the public nature of his ministry.

The decade following 1230 saw, in fact, the foundation of Franciscan ico-nography, as fixed by the date of the St. Francis altarpiece at Pescia, painted by Bonaventura Berlinghieri in 1235 (fig. 10), but the programs of the later, large-scale cycles of frescoes at Assisi and in Santa Croce have a completely different function and are incontestably the fruit of papal ideology.[5] The struc-ture of the Pescia altarpiece is based on the central iconic representation of the saint (in the position normally reserved for Christ), set between small scenes depicting his life: the purpose is to help the faithful to remember and meditate on his example. The narrative scenes are very literal, giving very little space

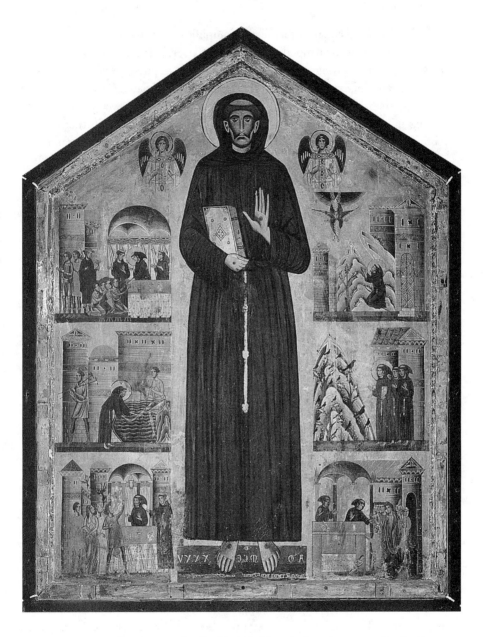

FIGURE 10. Bonaventura Berlinghieri, St. Francis altarpiece, 1235. Pescia, San Francesco. (Photo credit: SCALA/Art Resource, New York)

to incidental details or any other form of amplification of the story. The sense that the art has been stripped down to some degree, suiting the spirit of *il poverello*, is even stronger in the icons of the Arezzo painter Margaritone (a literal instance of *arte povera*). The effect in Assisi and Santa Croce is totally different, the story is told in such a way as to appeal to the viewer's emotions, calling on every kind of formal resource and the heritage of a learned and noble art. The painters of the Assisi cycle of the life of St. Francis had far more ambitious descriptive ends in view than Berlinghieri, and this is obviously due to more than the difference of format. They lingered on the depiction of flora and fauna, rocks, water, and buildings, taking remarkable care over details. In this, they are kindred to Thomas of Celano, who rarely missed an opportunity in his account of the life of the saint to embroider the recital of facts with evocations of ambience, or descriptions of gestural language. Writers and painters alike tend to make their narrative all the more vivid because the saint himself integrated numerous elements into his ministry that were close to comical or burlesque—so effectively that in many respects the realism in popular art of the late Middle Ages is associated with the Franciscans. The stories of St. Francis as recorded by his faithful disciples easily tip over into the burlesque, as high and mighty things are brought down to earth, and he is shown taking some gleeful pleasure in it; for example, when he pronounced the name of Bethlehem he imitated the sound of a bleating lamb. As Bakhtin has demonstrated, in the Middle Ages the spiritual or temporal authorities either channeled or eradicated comedy. Here, we have an exemplary instance of channeling.[6]

Things that look in some contexts like dangerous subversiveness or harmless eccentricity can become a literary genre in others. Introduction of the burlesque is only one technique employed in a more general descriptive technique borrowed from Greco-Roman and Byzantine rhetoric, namely, ekphrasis. Descriptions constantly break into the pure enunciation of facts (if there is such a thing). The procedure entered Christian literature at a very early date; by the fourth century the Church Fathers were using it alongside panegyric and emotional heightening. In sermons, it boosts the power of evocation by anchoring factual statements in the fabric of listeners' daily experiences. The hagiographic literature about St. Francis uses ekphrasis a lot, and so does Giotto. It is not my purpose here to measure precisely the proportion of Giotto's hypothetical input to the pictorial equivalent of ekphrasis. It is enough to record the kind of modifications that occurred in Franciscan iconography between the Pescia altarpiece and the frescoes in Santa Croce. Where Berlinghieri's narrative voluntarily limits itself to an account of events

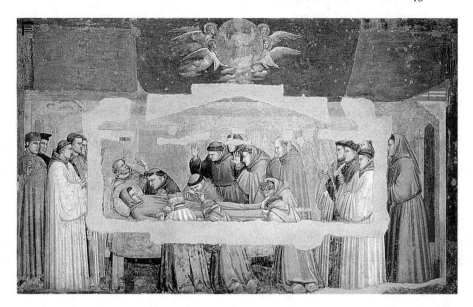

FIGURE 11. Giotto, *The Death of St. Francis*. Bardi Chapel, Santa Croce, Florence.
(Photo credit: SCALA/Art Resource, New York)

in the framework of a sort of dialogue with the faithful, Giotto's allies itself with a rhetorical style, and as such has recourse to ekphrasis. Giotto's paintings are addressed to a large public and the painter himself constantly reminds us of the fact by including spectators, in groups of twos and threes, engaged in conversations. They are distinguished by gestures and features, they comment or explain, or they simply observe the main action. The public character of the saint's action is redoubled by the movement it sets off in the members of the public incorporated into the scene. All the men and women painted by Giotto are there to witness something for the first time, attesting the truth of what is painted because they are already there as part of the scene and as witnesses, guaranteeing to those who look at the paintings that all this really happened. And the picture speaks all the more directly to the faithful because it attracts their attention and holds on to it. In the way it deploys artifacts, accessories, "backdrops," gestures, and mimicry, it keeps pace with the rise of the lay spirit (fig. 11).

The concept of the eyewitness is also at the heart of devotional literature, as in the case of the celebrated *Meditationes vitae Christi,* long thought to be the work of a Franciscan of San Gimignano, Jean de Caulibus, but often attributed nowadays to St. Bonaventure. Addressed to a nun, the book is written in

lively, colorful language—in a "familiar, though plain and unpolished style," as the author readily admits—and the reader is incessantly addressed directly, called to attention: "you must earnestly endeavour, by a serious attention, to be present to every thing that is here written . . ."[7]

The chapter about the Sermon on the Mount is especially interesting: the reader is exhorted to become a hearer and witness of Christ himself.

> Consider then our Lord Jesus humbly sitting on the ground, with his disciples round him. How affably does he converse with them, as if one of themselves; teaching, and in a benign, and pathetic manner, inculcating to them the practice of the above-mentioned virtues. And ever study, as I have before advised you, to contemplate his divine countenance. Cast an attentive eye likewise on his disciples, and imagine you see with what reverence, humility, and fixed attention they observe his blessed aspect, hear his wonderful discourse, and imprint it in their minds; reaping sovereign delight from his words and heavenly looks. In this meditation, endeavour to share their delight with them; attentive, as if you beheld him speaking; and ready to approach with them, in case you should be called. . . .
>
> After the sermon is over, behold our Lord Jesus descending from the mount with his disciples, and familiarly conversing with them on the road; and observe how that little simple congregation followed him, not in any formal order, but as the hen is followed by her chickens; each crowding about him, and struggling to get near him. . . .[8]

The narrative is admirably written. The author paints the scene of Christ preaching to his disciples, then he closes in on the faces of Christ and his hearers; in a third movement, he draws back to show Christ walking down the road with his followers, and we see the group enlarged as other hearers join it. The simile of a hen and her chicks is close to burlesque but also has the effect of further increasing the distance between the eye of the beholder and the scene. The way the author moves us up to and away from the scene, according to what he wants us to understand, augments the effectiveness of the idea he wants to imprint in us: all this play with the act of seeing—we ourselves looking at Christ and at the disciples alternately, the disciples' eyes fixed on Jesus, the stares of the people following them—are meant to confuse the reader so that, in the end, he no longer knows if he has seen with his own eyes or through an intermediary. By seeing it in his mind's eye, the reader will add himself to the circle of witnesses crowding into this short scene. In

the end, we notice that the author has devoted more time to describing the sermon's effects on the listeners and spectators than to reporting the sermon itself. The intention of the *Meditationes* is to make every reader an eyewitness of the life of Christ.

### SEEING MYSTERIES

Relics are literally the "remains" of a saint's body: the word *reliquiae* was used for the first time in its modern sense by St. Augustine. It seems that the practice of dividing a dead body up, prohibited in Western Christendom, was eventually adopted there, as it was in the East, with the object of preserving the bodies of saints from barbarian profanation. If the tomb was thus the first kind of reliquary, the proliferation of relics swiftly made it necessary to use containers that would simultaneously protect them, preserve them, and make them easy to transport. Such receptacles were called *capsae*.[9]

The cult of relics is one of the most eloquent manifestations of medieval mankind's conception of the sacred, and consequently it poses a severe test of modern man's propensity to see a rationale where there is none: the cult of relics depends on belief in the magical virtues of these human remains.

It has been possible to distinguish between two types of belief, the "orendist"[10] and the "animist." According to the former, widespread in the East, a relic emits an inexhaustible fluid—this power is attributed to amulets, for example. Orendism implies that a saint's body will be divided, leading to the proliferation and trafficking of relics. Animists believe that the saint from whom the relic comes will perform some action after death. Practiced by the Greeks, the animist cult of relics did not allow for proliferation, trafficking, or display. The cult of saints in the Christian religion is based on the principle that the saint is the bearer of a particular kind of energy which survives with undiminished intensity in his or her bodily remains or in something that has touched them. The cult of the tombs of saints, analogous to the belief held in Greece, gradually developed into a cult of the orendist type, favoring the proliferation and eager circulation of relics and the desire of the devout to see them. Two concepts frequently arise in discussion of the power of relics in Western Christianity: *virtus* and *praesentia*. The first refers to the miraculous power retained by the relic, the second to its active presence here and now. On the occasion of the consecration of Cambrai Cathedral in 1030, the remains of all the saints in the diocese were brought together and the reliquaries arranged round the high altar in a hierarchy that gave pride of place to the relics of St. Géry, who had been Bishop of Cambrai in 586: these were placed on

the episcopal throne. In Basel Cathedral on June 25, 1439, in the presence of Cardinal d'Arles, president of the Council of Basel, all the reliquaries in the cathedral treasury were exposed in the chancel, some of which were placed on stalls left empty by the absence of some bishops, so making the saints participants in the ceremony. In other words, the relics were treated as equivalent to the saints themselves. An animist attitude is even more obvious in the case of the arm reliquary of St. Firminus, which the Bishop of Amiens wielded in benediction. Garments once worn by saints were also objects of veneration. Familiarity with relics was bound to encourage the faithful to try to establish even closer contact with them. For that reason, in the early thirteenth century, the same era that saw the growing demand for the elevation of the Host, congregations also tried to see relics hitherto buried from sight in closed containers within shrines. Before then, relics were only exposed on feast days, and were uncovered only very exceptionally.

A sort of hierarchical order was observed among the relics kept in Basel Cathedral, mentioned above; wooden plinths were carved for the most important of them, which were swathed in colored cloths—white, blue, red, black with gold stars, according to the occasion. The famous gold frontal (now in the Musée de Cluny in Paris) of Henry II, saint and Holy Roman Emperor, was kept in the sacristy and exposed only on seven major liturgical festivals: Christmas, Easter, Whitsunday, Corpus Christi, Assumption, All Saints', and the feast day of St. Henry II. A document of around 1500 tells us that two levels were prescribed for the exposition of relics, depending on the importance of the feast day: the frontal and the cathedral's three principal crosses were not exposed on feasts meriting only the lower level of display. The arrangement of liturgical objects and reliquaries corresponded to a principle of absolute symmetry, which was adopted later in cabinets of curiosities. All the evidence indicates that the principle had a mnemonic function.

On one occasion when the reliquary at Saint-Martial in Limoges, a saint's head, had been taken out of the reliquary, large numbers of pilgrims demanded to see it uncovered. The fact that the Lateran Council was driven to order in canon 62 that relics should not be exposed out of their reliquaries proves that abuses had become frequent. Thereafter the practice of removing them ceased, but the growing demand for visibility led to a proliferation of reliquaries that were either transparent or provided with some means of opening.

Innumerable shapes and forms for the receptacles for precious relics were invented in the Middle Ages. In his study of the evolution of reliquaries, Joseph Braun proposed a typology, but it did not take their function adequately into account. A great deal more work has been done since then, and today it can

be said that a veritable reevaluation is underway, attempting to go further than separating the forms and functions of these articles into distinct subgroups.

The exposition of relics calls for a simple container mounted in a precious object which can take many different forms. Sometimes the container is assimilated to the relic it contains, as was the case with some of the relics brought to the West from Constantinople after 1204. In response to the public's growing pressure to be allowed to see, of which the new form of the Eucharistic rite was a striking illustration, a series of changes took place during the thirteenth century, producing reliquaries in more and more elaborate forms. The use of rock crystal, both because it allowed optical magnification of the relics and also for its symbolic value, was part of this development; so too was the devising of dramatic settings, underlining the *praesentia* of the relic by deictic gestures.

The use of rock crystal to form a showcase, even a magnifying lens, for the relic gave birth to a type of object which expresses with remarkable concision exactly what the function of a reliquary is. The twelfth-century treatise *De poliendis gemmis* by Theophilus Presbyter, included in the famous *Schedula diversarum*, refers to various techniques for cutting rock crystal, according to whether it was intended for the pommel of an episcopal crozier or a lamp, but not for a reliquary. Reliquaries with translucent panels permitting some view of their contents began to appear in the third quarter of the thirteenth century. The best material for this was rock crystal. To begin with, as Theophilus described, the crystal was hollowed out in order to fit over an object or allow a relic to be placed inside it, but gradually, drilling techniques were refined to the point of producing the ideal shape for a receptacle. These cylindrical "showcases" were then sealed inside mounts of different styles and shapes: caryatid, phylactery, carriage, aedicule, urn, ampulla, and so on. There seem to have been a considerable number of workshops where crystal was carved in Paris, in the region of the basins of the middle Rhine, the Meuse, and the Moselle, and in Venice. It is virtually certain that there were crystal carvers in Cairo before the twelfth century who were responsible for a large quantity of Fatimid artifacts that reached the West during the eleventh century. It is certain that the use of rock crystal goes back to Carolingian times, although the upsurge dates from only the twelfth and thirteenth centuries.

Some of the very earliest transparent reliquaries, revealing the relic wrapped in silk to the gaze of the devout, are that of St. Peter of Gesecke in Westphalia and the one in the Schnütgen Museum in Cologne, both datable to around 1200, and the slightly later reliquary of the hand of St. Attale in Strasbourg.

Precious stones such as rock crystal are often thought to possess magic powers and allegorical functions. According to St. Augustine, crystal stood for the transformation of evil into good; for St. Gregory the Great, it represented Christ. Hrabanus Maurus said the same: "That rock crystal signifies the solidity of the angels, or the incarnation of the Lord, is proved in the testimony of the prophet Ezekiel." A medieval penchant for erroneous etymology led Meister Eckhart to link "Christ" with "crystal."

The development of crystal's allegorical significance also owes something to the visions of God recounted in the Old and New Testaments, especially those in the book of Ezekiel, and to St. John's visions of the heavenly Jerusalem in Revelation. One example will serve, namely, the cruciform reliquary (staurotheca) of the church of Sainte-Croix (Holy Cross) in Liège (1160–1170; fig. 12). The whole object is constructed as a triptych, with the relic, a fragment of the True Cross, at the center. Two allegorical figures, personifications of Truth (*veritas*) and Justice (*iudicium*), each extend an arm to support the reliquary. Above is a bust of Mercy (*misericordia*) in champlevé enamel, and immediately below the relic of the True Cross are relics of St. Vincent and St. John the Baptist in a crystal capsule. The central panel also includes a group of five busts of saints framed in a semicircle with the inscription *RESURRECTIO SANCTORUM*, and the whole is surmounted by a semicircular tympanum, showing the figure of Christ holding out his arms to show his wounds, conforming to the iconographic type of a *misericordia domini*, a theme repeated in the allegorical representation of Mercy already mentioned. In fact, only the little gold cross containing the remnants of the Cross, decorated with filigree, pearls, and a jewel, goes back to the tenth century; the box under a crystal window, in which it is set, and the accompanying inscription *LIGNU[m] VIT[a]E* (wood of life) are part of the mount.

In this artifact, the relic becomes an image, since the material fragments are reconstituted in the form of a cross. A large number of twelfth-century staurothecae demonstrate this same elision. But here the theologian who devised the object intends something further: he wants to combine a Crucifixion with a Last Judgment (represented in abridged form by the bust of Christ), the two events being linked by the allegorical presence of Mercy. The idea which dominates this iconographic program is that of redemption according to the prayer for mercy in psalm 85, verse 11.[11] The Liège reliquary seems to be the first known version. Before our eyes, the relic's value is increased by being given this dramatic setting: from being a simple sign, as it originally was, it acquires a secondary function as the central image of the Passion. The need

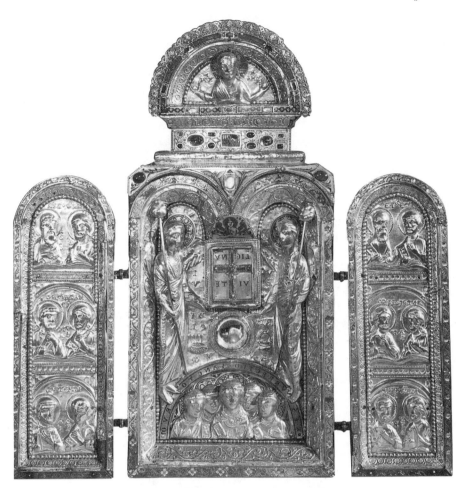

FIGURE 12. The Liège Staurotheca, from the church of Sainte-Croix, ca. 1160–
1170. Musée d'Art religieux et d'Art mosan.

to see was accompanied by a liking for a narrative integrating the symbolic
object into the fabric of a story.

The Liège reliquary may be compared with another, dating from around
1255 and now preserved in Pamplona (fig. 13). The reliquary itself takes the
form of an open-sided aedicule on an oblong plan, flanked at its four corners by
buttresses topped by pinnacles. Each of the wider sides presents a cusped arch
framed between abutments. A rose fills the tympanum, its "windows" are filled

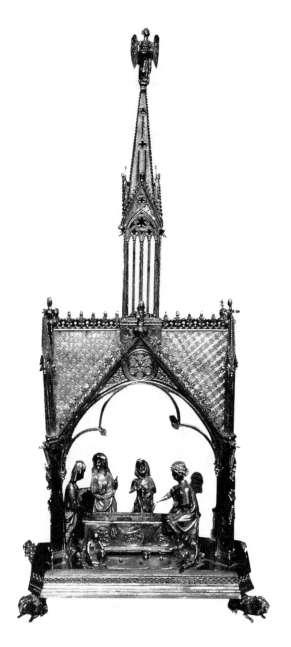

FIGURE 13. Reliquary of the Holy Sepulchre, northern France, ca. 1255. Pamplona Cathedral Treasury. (Photo by Clara Fernandez-Ladreda)

with pieces of champlevé enamel, which is also found on the sarcophagus. A slender turret rises above the roof ridge, supporting a spire surmounted by an angel bearing a crown in its hands. The whole structure suggests a chapel, inside which we see the dramatic scene of the holy women with jars of ointment in their hands arriving at Christ's tomb only to find it empty. Two sleeping soldiers occupy the foreground, and an angel is seated on the end of the sarcophagus gesturing to the interior with its right hand. The lid of the sarcophagus is made of rock crystal, and we are able to see that the angel's finger points not to the tomb—empty, in conformity with the iconography of the Holy Sepulchre—but to relics of the holy shroud, enclosed in a gold capsule bearing the words *DE SUDARIO DOMINI*. The presence of the shroud is further indicated by its representation in metal, a fold of which appears over the side of the tomb.

The quality of the working of the figurines in repoussé silver, in a style resembling that of sculpture from Reims, but also Rouen, plays a large part in the deliberately theatrical effect. The gestures of the women's hands, and the slight turn of their heads, and above all the expression of the angel, are imbued with a quite extraordinary presence and give the group an expressive force, a theatricality which comes close to contradicting the primary function of the reliquary. The relics of the shroud are only shown by the angel's gesture, which is itself a response to those of the women. Thus the viewing of the relic is given a place in a temporal sequence; it is not just seen in an imagistic form as with the Liège reliquary but is assigned to a precise moment in the brief narrative, drawn from the story of Christ's Passion and located at the Holy Sepulchre, conflating the arrival of the holy women with the resurrection itself.

The eminently visual, even spectacular, character of the object is reinforced by one very important element, that is, the architecture. The rosettes and chasings beaten in the silver, and, above all, an attention to detail perfectly conforming to real architecture make this reliquary an object worthy of contemplation. Yet this artistry is surpassed in other architectural artifacts, such as the two reliquaries in the treasury of Aachen Cathedral: that of Charlemagne (1350–1360) and the other, slightly later, known as the reliquary of the Three Towers. The taste for small forms spread at breathtaking speed, to the point that, in the second of these pieces, it is only with considerable difficulty that one can find the whereabouts of the relics themselves.

Between the Liège staurotheca and the Pamplona reliquary lies a whole repertory of reliquaries that are obviously the expression of a need to emphasize the visual values of the cult object. The Floreffe reliquary of the True Cross (after 1254), for example, resembles an altarpiece in its form of a pentaptych

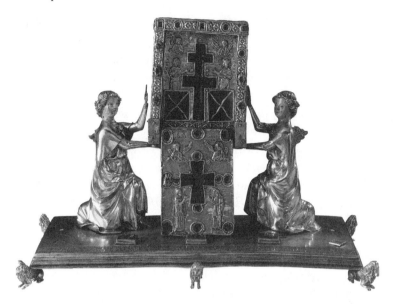

FIGURE 14. Jaucourt altarpiece of the True Cross. Louvre, Paris.
(Photo by Daniel Arnaudet. Credit: Réunion des Musées Nationaux/
Art Resource, New York)

with folding leaves; the pieces of the Cross themselves are also arranged in the form of a cross. More than its actual sacred value, the relic is also a historical sign—a summary of the Crucifixion—and a more general symbol of Christ's sacrifice.

The use of figurines, usually angels holding up the relic, became more general during and after the twelfth century. Here too the statuary of the great cathedrals of the thirteenth century, an age of greatly enhanced expressivity, provided a whole repertory of new models for the goldsmiths. The Louvre has a reliquary of the True Cross (fig. 14) in which the protoreliquary is a piece of Byzantine workmanship of the eleventh or twelfth century. The mount, of about 1320–1340, sets it at the center of a little scene: two kneeling angels in silver gilt hold up the reliquary to make it more easily visible. Armorial bearings on the clasps of the angels' cloaks are those of the person who commissioned the mount: Marguerite Dace (d. 1380), wife of Érard II de Jaucourt, according to the inscription on the plinth. The relics can be hidden inside this article, thanks to a sliding shutter decorated with a Crucifixion scene.

The treasury of the former abbey of Charroux has a reliquary that makes exposition of the relic rather playful. The reliquary itself (fig. 15), made during

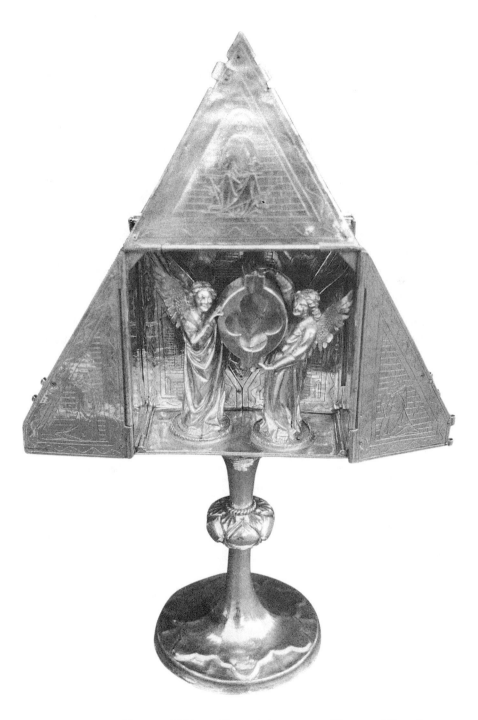

FIGURE 15. Charroux Tableau reliquary, shown open. Charroux (Vienne), former abbey. (Photo by Jean-Louis Mestivier)

the third quarter of the thirteenth century, is constructed as a cube mounted on a pedestal, and closed by three triangular panels which form a large isosceles triangle when opened. When open, they reveal Christ in Majesty in the top panel and two monks kneeling before the relics in the lower ones. When closed, the panels are decorated with a field of gold filigree, with two bezels in the middle framing the fleur-de-lis of France and the castle of Castile. Inside the cavity are two angels holding a container with a quatrefoil opening, inside of which is a little silver gilt box with a picture of Christ on each of its faces. The box, in turn, contains a gold capsule which was formerly able to be worn as a pendant, its two halves opening to show images of the Virgin and Saints Pantaleon and Demetrius.

The treasury of Basel Cathedral formerly housed a cross reliquary dating from the 1320s. It was constructed according to a quite remarkable architectural conception, with an aedicule suggesting the Holy Sepulchre rested on a base ornamented with translucent enamels on its side panels; Christ on the Cross was in the center, and the Virgin and St. John the Evangelist were on either side, on brackets branching out from the shaft of the Cross. Angels stood on either side of the aedicule, holding at arm's length crystal phylacteries containing relics that can be assumed to have an association with Christ's death. Descriptions of this piece, which was destroyed in 1945, dwell on its beauty, due especially to the colors of the enamels and the flesh tints of the figures, which left the silver from which they were made exposed, while their garments were gilded. The embossed mounds in a vivid green enamel, sprinkled with flowers, were especially striking. As with the Pamplona reliquary, the care the goldsmith took in the execution of details encouraged the devout to pay the object even greater attention.

Other reliquaries that present their content with a similar theatrical flair have direct associations with the Franciscans. One example is a monstrance (figs. 16 and 17) in quatrefoil form. On one side, five oval crystals magnify the relics visible behind them; on the other, there is a representation in champlevé enamel of St. Francis standing among flowering trees, and holding up his hands to show his stigmata. The saint turns his face up towards a seraph, a symbol of Christ on the Cross, depicted on a background engraved with stars, the sun, and the moon. The originality of this type of reliquary resides in its bringing together of two realities generally kept separate: the sacred physical remains of the saint and the miracle of the life of the Christ-like *poverello*. The relic is thus in some way visually associated—articulated, indeed, because the device swivels on its base—with the sanctity of the body, at the very time of Francis's canonization; the reliquary is dated to 1228. Turning one

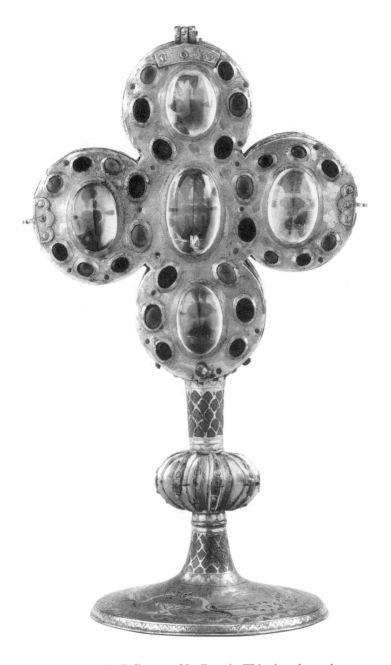

FIGURE 16. Reliquary of St. Francis. This view shows the
magnifying crystals behind which the relics were placed. Lourve, Paris.
(Photo by Daniel Arnaudet. Credit: Réunion des Musées
Nationaux/Art Resource, New York)

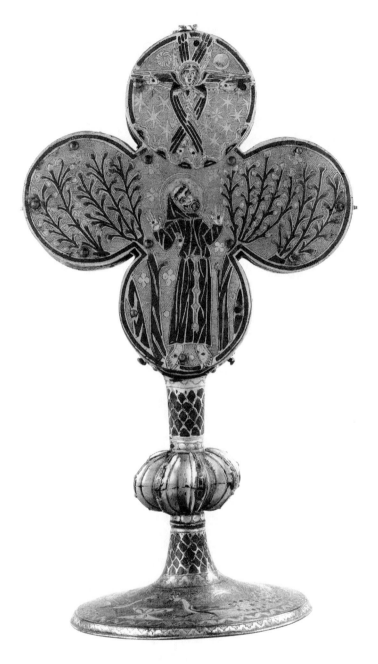

FIGURE 17. Reliquary of St. Francis. This view shows the saint
receiving the stigmata. Louvre, Paris. (Photo by Daniel Arnaudet.
Credit: Réunion des Musées Nationaux/Art Resource, New York)

face or other toward the congregation as he thought fit, the officiating priest encouraged "active" devotion, as the stigmatization served as a reminder of Christ's sacrifice.

Another reliquary (fig. 18), now in the treasury of the Basilica of St. Francis in Assisi, is very similar to the Pamplona one. Made in Paris in the 1270s, it was given to Jeanne of Navarre (d. 1305), the wife of Philip IV of France. Originally, it held fragments of the True Cross, the pillar of the Flagellation, and the cord with which Christ was bound; the seamless robe from which the reliquary took the name it now has was added only in 1597. The object presents a transverse section of the body of a church with three aisles, surmounted by gables and bristling with pinnacles; inside, it is less than ten centimeters deep. The principal face presents three niches: the two small lateral ones are occupied by St. Francis and St. Claire, holding up the palms of their hands and tilting their heads back so that they look at the central niche. For two-thirds of its height, this contains a grille of quatrefoil rosettes, behind which the relics can be seen; the trefoil arch contains a bust of Christ showing his wounds, making the gesture of consecrating the Eucharist. The whole aedicule stands on a larger base, on which are the kneeling figures of three Franciscan nuns, smaller than the saints they venerate. These little statuettes serve as a devotional staging post between the devout viewer and the two saints of their order, and these in their turn direct our gaze to the presence of the relics and the body of Christ. The system of successive referrals is obtained here by a fully thought out mise-en-scène in which the gestures play a decisive role.

The arm reliquary in the treasury of Essen Cathedral (fig. 19) provides a rather atypical illustration of this type of suggestive visualization. Unlike nearly all other reliquaries of this type, the hand on this one is not making the sign of benediction but holds a five-sided aedicule between its fingers, which previously contained a relic and might be a representation of the Holy Sepulchre. The interest in this case is that the artifact was reworked. The arm is from a reliquary made at the start of the thirteenth century, and at the end of that century the original hand, probably raised in blessing, was replaced by this hand supporting the centrally planned aedicule, which forms a second receptacle for relics in addition to the arm itself. A little niello-work plaque was fixed to the arm, showing the donor, Abbess Beatrix of Holte, depicted as a *gisante* on a tomb, with folded hands.

The idea that the link between the relic inside the reliquary and the scene represented by its exterior should be made clearly visible to the faithful took hold all the more easily because many reliquaries were covered with a cloth during Lent, as the Ordinaries of Chartres and Amiens attest. Unveiling them

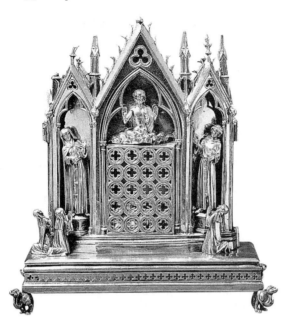
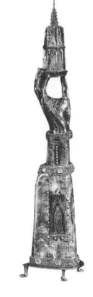

FIGURE 18. Reliquary of Jeanne of Navarre,
1270–1280. Treasury of the Basilica of St. Francis
(Assisi). (Photo credit: SCALA/Art Resource,
New York)

FIGURE 19. Arm
reliquary, Essen
Cathedral Treasury.
(Photo by Peter Happel)

after Lent led eyes to seek to experience the mystery of Easter by another route, one prompted by the theatrical scene on the reliquary itself. The demand to see the Host and the desire to gaze on relics were approximately contemporary phenomena. It is even arguable that the need to see the Host was only the symptom of a more general demand, and the ritual exposition of relics outside the reliquary was for a long time the preamble to that.

We have already noted that monstrances intended to show the Host did not become widespread until the fourteenth century. In many cases these contained both the Host and relics. In Arras in 1328, a goldsmith adapted a reliquary of the Holy Thorn to make it a eucharistic monstrance. The inventory of the treasury of the church of Saint-Sépulchre in Paris, compiled in 1379, mentions a monstrance in the form of a statue of St. John the Baptist holding "a little vessel where there is a Lamb of God and another vessel with two crystals to hold the Body of the Lord on the feast of the Holy Sacrament [Corpus Christi]." It was possible, therefore, to remove the Host from the saint's keeping and replace it with relics. There are frequent references to this

dual function of certain reliquaries and the keeping of Host and relics in the same receptacle.

Although the sack of Constantinople and the importing of relics and icons on a massive scale that followed cannot be regarded as the sole causes of the changes that affected, notably, the form of reliquaries, they can nevertheless be said to have served to encourage them. The relics and their protoreliquaries, which themselves became objects of veneration as much as the relics in the eyes of Western believers, underwent a kind of revitalization and aestheticization. At the same time, the relic assumed an even more powerful historical value. Detached from the body or the holy object from which it originated and therefore liberated from the physical association originally linking it to something of a given volume, a relic is characteristically small. An amorphous, minuscule fragment of a scarcely identifiable material, it owes its meaning entirely to textual records—reliably authenticated ones, above all—and to the *capsa* containing it. In practice, this casing gave birth to a whole network of new associations, after having served to define the identity of the relic, one way or another. In a certain sense, the reliquary is often authenticated by the dogmatic program of its iconography; the reliquary contributes to the effect of "inverted magnitudes," to use Peter Brown's term.[12] The costliness of the ornamentation or figures with which the holy relics were adorned amazed the faithful: the tomb reliquary of St. Éloi at Noyon was veiled during Lent because the gold and precious stones were inappropriate for that season of the church year.

Thanks to the reliquary, the relic became one of the innumerable works made by mankind for the greater glory of God. Paradoxically, from its position inside the aedicule radiating color and light, and through its mediation, this tiny little fragment came to be "joined by a thread to the whole expanse of eternity," in the words of Victrice of Rouen. The idea did not always find approval; some reliquaries were excessively sumptuous for the taste of Guibert of Nogent, already a stern critic and historian of the cult of relics in the early twelfth century, and he denounced them in his *De pignoribus sanctorum*. In his view, exposing relics in such shrines and bearing them in procession brought the event uncomfortably close to commerce, not to say charlatanism. The great perspicacity of his analysis, from his investigation of the mechanisms that might give rise to a new cult to his equally rigorous efforts to understand the causes of excesses, make his study valid for the whole Middle Ages. After him, we witness the gradual movement of relics into the interior of reliquaries. In the instance of statuette reliquaries, initially a relic was placed inside the figure itself; in the thirteenth century it was generally visible behind a crystal

lens, and by the end of the fourteenth century it went into the base, leaving
the figure free. The relic was then no longer part of the image, for which it
could be said to be only the pretext.

Two examples will illustrate the change. The first is provided by an excep-
tional artifact now in the Walters Art Gallery in Baltimore: a reliquary made for
a thorn from Christ's crown of thorns, dated with near certainty to 1347–1349
(fig. 20). The thorn was enclosed in a little gabled picture frame, about five
centimeters high, held up by the figure of a kneeling angel. Also distributed
about the rectangular base supporting the statuette are three dice, two angels
holding hammer, nails, and scourge, the pillar of the Flagellation surmounted
by a cockerel (an allusion to Peter's betrayal), the Cross—the pillar and the
cross also housed relics—and, dominating these *arma Christi*, the standing
figure of Christ, clad in perizonium, crowned with thorns, His hands folded
across His body in the attitude known as *imago pietatis*, above all from the
icon of the church of Santa Croce in Gerusaleme, in Rome.

However, the Man of Sorrows is represented in this reliquary with the eyes
open, contrary to the iconographic tradition of the time. The composition as a
whole is conceived as a devotional image, veneration of which could instigate
a dialogue between the believer and Christ. Prayers could be addressed to the
*arma Christi* alone, although the *arma* backed up by relics—Thorn, Cross,
and Pillar—would be the object of exceptional veneration. A ruby is mounted
at the front of the crown of thorns; it is perhaps a reference to a fourteenth-
century hymn—"Precious stones sparkle [on His crown] like stars, they are
drops of blood"—but the ruby is also, on the body of Christ, a way of localizing
the precious relic. Some such intention, born of a theological impulse, might be
confirmed by the existence (attested independently) of various prayers relating
to the Passion, the wounds, the sacred blood. The heraldic arrangement of
the *arma Christi*, especially as they are on this object, assists memorization
of prayers but also, probably, the order in which they should be said. Let us
be quite clear about one thing: the arrangement did not play an aesthetic role
in the Middle Ages but a mnemonic one. Unlike reliquaries of the thirteenth
and fourteenth centuries, where the relic is the object of an elaborate theatrical
"staging" with all the eloquence of the characters' gestures subordinated to the
relic, here it gives supplementary force but is scarcely involved in determining
the positions of the figures.

The second example is one of the masterpieces of Parisian craftsmanship
of around 1400, preserved in the treasury of Esztergom Cathedral in Hungary,
and known as the Calvary of Matthias Corvinus (fig. 21). Executed in enamel
on gold in high relief, it shows Christ on the Cross between the Virgin and

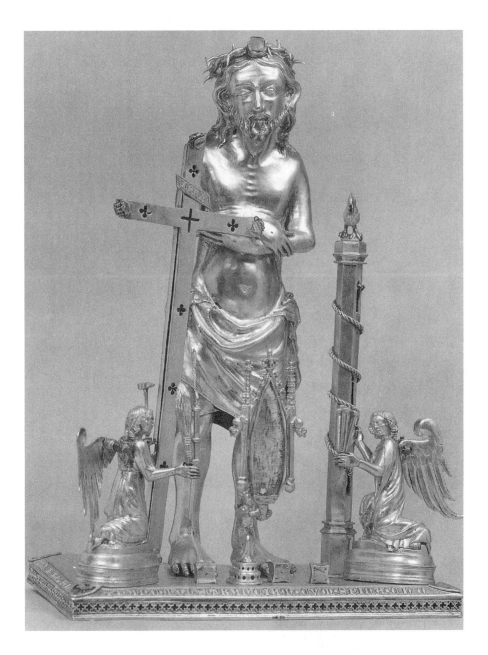

FIGURE 20. Reliquary of the Holy Thorn. The Walters Art Museum, Baltimore.

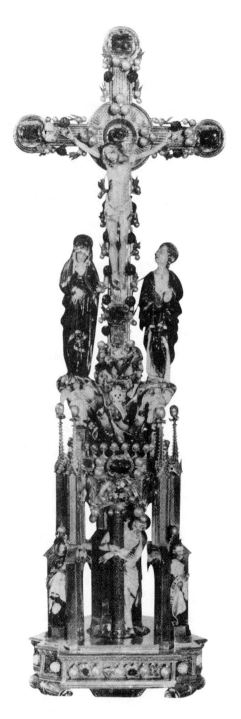

FIGURE 21. Calvary of Matthias
Corvinus, Parisian workshop, 1403.
Esztergom, Diocesan Museum.

St. John, on top of an aedicule framed by buttresses with niches sheltering fig-
urines of three prophets (Elijah, Isaiah, and Jeremiah); another Christ, bound
to the pillar of sorrows, as a prisoner in the house of the High Priest, stands
on the axis of the Cross. The inventory compiled on the death of Philip the
Bold, Duke of Burgundy, mentions the existence of this calvary and adds that
it was given to the duke by Marguerite of Flanders in 1403. At the center of
the Cross, on its rear face, is a receptacle containing a relic of the True Cross.
Even if the iconography is wholly individual, the composition nevertheless
recalls the calvary known as the Well of Moses, designed by Claus Sluter for
the charterhouse at Champmol, founded by the duke. The costliness of the ar-
tifact—the "Cross adorned with five balas-rubies, two medium camaïeux, and
forty-one large pearls, and many more small pearls round about"—is at odds
with the sorrowful aspect of the three principal figures. But its radiant physical
beauty and the dramatic intensity of the scene depicted attract attention more
forcefully than the presence of relics.

### THE PHYSICS AND METAPHYSICS OF SEEING

Let us leave artifacts for the moment and turn to some texts that reveal the
extent to which medieval thinkers concerned themselves with the question of
vision, from the most basic form—optics—to the most extreme: the mystical
vision. Indeed, both should be regarded as activities of the mind seeking by
one path or another to reach the unseen from a starting point in the visible
world.

For Robert Grosseteste, consideration of the iris involved both optics and
natural philosophy ("*et perspectivi et physici est speculatio de iride*"[13]). Already
for Plotinus, a work of art was "the representational image of a thing" whose
influence it reflected "like a mirror."[14] Optical perception is very important,
because the organ of sight itself plays a role that is at once metaphysical and
psychological in this way of thinking. The distance between eye and object can
falsify perception by reason of the effect of diminution, common to both color,
which grows dim at a distance, and size, which grows less.[15] In a picture, the
foreground should be reserved for objects or given over to contemplation;
depth is matter below the surface and is dark. Light illuminates and is form;
reason distinguishes form. Seeing form in an entity, reason judges that the
depth of that being is darkness below the light; similarly, the light-giving
eye, brought to bear on light, where colors are modes of light, discerns the
existence of the dark, material foundation hidden below the colored surface.[16]
In order to see an object as it should be, the eye must make itself like and

similar to the object seen, or the viewer must even have recourse to the inner eye.[17] Thanks to his "mind's eye," man can disregard the spatial expanse surrounding his physical eye. The removal of every obstacle, physical or optical, is the condition necessary for reaching a loss of consciousness that allows us literally to dissolve into the all.

We can see how this question of vision forms the point of departure for a description of the mystical practices of which many testimonies have come down to us from the Middle Ages, from Bernard of Clairvaux onward. Mystical vision is modeled on speculation about light.

In medieval thought, everything refers back to the supernatural, and consequently the gaze is drawn to pass through the apparent opacity of material objects. But matter itself is necessary. We read already in *The Celestial Hierarchy* of Pseudo-Dionysus: "It is quite impossible that we humans should, in any immaterial way, rise up to imitate and to contemplate the heavenly hierarchies without the aid of those material means capable of guiding us as our nature requires."[18] Dante says that art exists on three levels: in the artist's spirit, in the implement, and in the material. For John Duns Scotus, all matter is beautiful. We should recall the lines that Abbot Suger ordered to be inscribed on the doors of the abbey church of Saint-Denis, rebuilt at his instigation.

We shall have occasion to return to this aspect of medieval thought. For the moment, it is important to remember that St. Bernard's *Apologia ad Guillelmum* does not deny the need for works of art at the heart of religious practices. He disapproves of them when they echo a pagan outlook, notably within the monastery, but when they help to draw in the people, their action is beneficent. For St. Bernard, recourse to the senses, especially sight, is not a fitting means for bringing the believer closer to God, but he is obliged to concede the principle. At a later date, the Dominican Vincent of Beauvais would teach that visible beauty can constitute a "springboard to God."

I have said that the thirteenth century saw the birth of a completely new attitude toward works of art, from the very fact that the question of optics was central to their contemplation. Even if optics (or perspective—the two terms were synonymous at the time) constitutes an essential chapter in the philosophical, theological, and scientific thinking of the thirteenth century, that does not mean that it gave rise to a new conception of art. The interest in optics shown at that period by, above all, theologians of the Franciscan order goes hand in hand with plentiful and fruitful developments in the study of sight. The role played by visual witness in the evangelical program of St. Francis, or by sight in the cult of relics, clearly indicates that the eye has a

metaphorical function: as Roger Bacon pointed out, the propagation of light can be likened to that of divine grace. Sensory experience, in general, when studied and understood with the aid of scientific experimentation, assists the progress of the intellect in its search for God.

Another Franciscan, Bartholomaeus of Bologna, wrote a treatise on light (*De Luce*) in which he demonstrated that, as *Lux*, God is the paramount source of light. As a study of the physics of light, therefore, optics played an important part in theological thought as a whole.

We find applications of optics in the work of Roger Bacon, or more precisely, applications of the three types of vision he distinguished: direct, reflected, and refracted. Like rays of material light, the light of truth falls on perfect souls in a straight line, is refracted on imperfect souls, and is reflected from evil souls. Or again, in the domain of spiritual truth, God's vision is direct, the vision of angels is refracted, and the vision of corporeal beings is reflected.

For the Franciscan friar Bonaventure, the divine being is light, and all light reflects (*relucet*) the light of its transcendent origin. In mystical ecstasy, reflection is replaced by *cognitio experimentalis*—tentative touching and tasting. Love, not thought, extends much further than the eye can see: "*Amor . . . multo plus se extendit quam visio.*"[19]

Many medieval theologians recognized sight as the most perfect of our senses. "It is through sight that sublime and luminous bodies effect entry" (*Per visum intrant corpora sublima et luminosa*), wrote Bonaventure,[20] and Thomas Aquinas argued that (unlike beasts) "man has his face erect, in order that by the senses, and chiefly by sight, which is more subtle and penetrates further into the differences of things, he may freely survey the sensible objects around him, both heavenly and earthly, so as to gather intelligible truth from all things."[21] For Roger Bacon, the eye, if perfect, corresponded to the perfect form of the sphere.

Interest in optics, as in the anatomy and physiology of the eye, did not begin with thirteenth-century philosophers. It originated with the classical Greek philosophers whose thinking was adopted and enriched by Arab scholars. In turn, Latin translations of Arab treatises gave the thirteenth century its knowledge of the optics of Euclid and Ptolemy and of Galen's physiological treatises, notably those on the anatomy of the eye. The works of two Arab scholars, Alhazen and Al-Kindi, augmented the Greek sources on which they had in turn drawn for their own experiments.

For our purposes, four men of the thirteenth century stand out for the impact they had on the science of optics: Robert Grosseteste, Roger Bacon, and John Peckham (all Franciscans and all English), and Witelo, a native of

Silesia. Bacon gave a very extensive description of the anatomy and physiology of the eye in his *Perspectiva*. Sight is not a function of the eye, he wrote, but of the brain. "This is the common nerve in the surface of the brain, where the two nerves, coming from the two parts of the anterior brain meet, and after meeting are divided and extend to the eyes." Bacon continues: "But since Alhazen says this ultimate perception is in the anterior part of the brain, someone might think that it is the common sense and the imagination or phantasy which are in the anterior brain."[22]

Witelo agrees with Alhazen in describing the eye as an aqueous substance issuing from three *humores*, surrounded by four *tunicae* (coats, that is, membranes). The seat of vision is at the center of the eye in the "crystalline or glacial humor" (*humor crystallinus vel glacialis*) which forms the front part of a "glacial sphere" (*sphaera glacialis*), while the rear part is the "vitreus humor" (*humor vitreus*). The crystalline humor is behind the albuminous or albugineous humor (*humor albugineus*), resembling the white of an egg; the vitreus and crystalline humors are wrapped in the arachnean or reticulated coat (*tunica aranea* or *tunica retina*), while the crystalline liquid and the albuminous humor together are wrapped in the uveal ("grapy") coat (*tunica uvea*), so called because of its resemblance to a bunch of grapes. On its forward surface, this membrane is pierced by an opening, the pupil, through which objects are seen. The liquid is prevented from escaping by the presence, in front of the pupil, of a membrane called the cornean coat (*tunica cornea*), which extends sideways as an opaque membrane termed *coniunctiva* or *consolidativa*. The optic nerve (*nervus opticus*) is composed of two hollow sheaths enclosing a substance, the "visible spirit" (*spiritus visibilis*), which conditions the sight; these sheaths originate in the front part of the brain, collect in a common nerve (the *nervus communis*), then separate again. *Spiritus visibilis* also flows inside the *nervus communis:* this is the seat of visual perception (*virtus distinctiva*).[23]

For Witelo, again adopting Alhazen's opinion, the eye does not emit rays that envelop forms in some way, as the Platonists thought. Rather, rays of light, along with colors, traverse the eye, which receives them and allows them to penetrate the collective nerve, where the capacity for judgment resides. Thus the eye collects forms or images, or "intentions of forms" (*species*, to Bacon).

Alhazen enumerates twenty-two *visibilia* (visible objects), in which Witelo and Bacon also concur. The list is headed by light and color: "No visible object is perceived by the sense of sight alone except light and colors" (*Nullum visiblium comprehenditur solo senso visus, nisi solum luces et colores*). Light, whether a primary light source or a reflection, supports color: "[of] light which is the hypostasis of color" (*lucis quae est hypostasis coloris*)—a definition

taken from Aristotle. Light and color are "visible in themselves" (*visibilia per se*), because they are perceptible by sight alone, whereas the other twenty objects, according to the degree to which other senses may be called upon for the perception of them, are "visible by accident" (*visibilia per accidens*). They include distance, size, position (*situs*), corporeality, shape, dependency, separateness, number, movement or stillness, roughness or smoothness, transparency, density, shadow, darkness, beauty, ugliness, and deformity.[24] For Roger Bacon, sight is the most reliable verifying sense for the experimental scientist; it requires seven to ten conditions if the best use is to be made of it: light, suitable distance, frontality, sufficient size, a density greater than that of the ambient air, rarity of the medium, and persistence of light for a sufficient time.[25]

Bacon considers that there are three modes of perception through sight. The first is "by the sense alone, without any faculty of the soul, and it is thus that light and color in general are perceived"; if lookers have forgotten the impression of the light of particular stars seen some time previously, "they can recognize the light of these stars by means of a second perception which is by similitude, according to Alhazen"; and the third type of perception is not achieved either by the sense of sight alone or by comparison with anything previously seen, but requires consideration of the object itself, "for its perception several things are required, and the process is like a kind of reasoning."[26]

Bacon, as was said earlier, distinguished three types of vision: direct, reflected, and refracted. The eye can use instruments to facilitate or augment visual capacity: sphere, quadrant, astrolabe, and so forth. Heavenly bodies, for instance, are not knowable except with the help of these instruments and "verifying" experiments. Just as verification by the external senses can be facilitated by such means, so too illumination, which Bacon defines as the means to know spiritual realities, is our inner science. Thus Bacon finds the equivalent of optical instruments in the sacraments: they constitute our inner science, and of them all it is the Eucharist that provides the "verifying" truth—the truth that makes man like God, makes him like Christ.

When all the ideal conditions specified by Witelo and Bacon are found together, perception is possible—not only of simple forms but also of compound forms, in which proportion governs the internal organization. According to Witelo, certain forms should be seen from afar, others from close by. Some material aspects may deceive the eye more than others—outline and corporeal mass, continuity and discontinuity, transparency and opacity, likeness and difference may all acquire their own intrinsic beauties. A conjunction within a compound form is harmonious if it is based entirely on fitting proportion. "Everything beautiful issuing from the conjunction of

sensible emissions . . . consists in the due proportionality of the image." Aesthetic perception can be falsified in certain conditions: poor light, of course, but also distance, an ill chosen angle of vision, size (too small or too large), environmental factors, substance of the materials themselves, weakness of the visual organ, brevity of stimulus.

The originality of Witelo's thinking within the frame of scholasticism—an originality he owed to Alhazen—lies in the interest he takes in man's perceptive activity. By linking judgment to sensory activity from the base of perception upwards, Witelo defines a psychology of perception ahead of his time. In apprehending an object visually, he writes, we assign to it a position within the totality of objects known to us, so causing the intervention of the "universal forms" (*formae universales*) that exist in the spirit. Every object possesses some traits peculiar to itself, and other traits that it shares with other objects—form, appearance, color, the last not being constant.

We should also consider another idea, however, owing nothing to Alhazen, which would be developed by Grosseteste and especially Bacon: the concept of *species*. The author of a treatise *De intelligentii* (formerly identified as Witelo) wrote that "species is a reproductive force" (*species est virtus exemplar*). For Grosseteste, seeing a thing is possible because the object, or "patient" (*patiens*), and the viewer, or "agent" (*agens*), emit *species*. Bacon used the term constantly, and devoted an entire treatise to it. *Species* are rays, or emanations of forces. They are produced by various objects: attributes that act on the senses, substances, matter associated with forms, sensory organs—matter does not produce them, nor quantity, nor *sensibilia communia*. Bacon ends by asking whether *species* are emitted by universals.[27]

In geometrical terms, the existence of *species* supposes that each of these objects emits a pyramid of lines, multiplying to infinity, and crossing the *species* of another object, for example, the viewer's sight. The diffusion of *species* brings to the fore the active role played by the viewer and by the object seen. There exists between the *species* emitted by these two a common trajectory which is the axis of vision, the visual pyramid being formed by the *agens* at its base and by the *patiens* at its tip. In one respect, the theory of *species* resolved the conflict that pitted Epicureans against Pythagoreans in ancient Greece. The former held that objects transmitted their *eidola*—images, a sort of faithful imprint of the object—to the eye; the latter that there were forces emanating from the eye, not from the object. The Stoics even gave this theory a geometrical foundation since, in their opinion, the forces emitted by the eye would take the form of a cone.

When the Bishop of Paris, Étienne Templier, proclaimed in 1277 that there might be more worlds than the one, he replaced the Greek cosmos with an extendable universe, supported not by scientific certainties based on experience but by faith in divine omnipotence. This opened the way for reason to extend its field of experimentation, and for science to demonstrate, as it did in the mind of a Roger Bacon, the greatness of divine acts.

With the mystic Meister Eckhart, the question of sight and visibility is linked to that of inner experience:

> A master says, "If there were no means, we could see nothing." If I am to see the colour on the wall, it must be made small in the light and in the air and its image must be conveyed to my eye. St. Bernard says the eye is like heaven, it receives heaven in itself. The ear does not do that: it does not hear it, nor does the tongue taste it. Secondly, the eye is shaped round like heaven. Thirdly, it stands high like heaven. Therefore the eye receives the impression of light, because it has the property of heaven.[28]

According to Meister Eckhart, the eye's likeness to heaven makes sight preeminent among our senses. The operation of sight helps understanding of what happens in an ecstatic vision:

> I hit on an analogy. If you can understand it, you will be able to grasp my meaning and get to the bottom of all that I have ever preached about. The analogy is with my eye and wood. When my eye is open it is an eye: when it is shut it is still the same eye; and the wood is neither more nor less by reason of my seeing it. Now mark me well: Suppose my eye, being one and single in itself, falls on the wood with vision, then though each thing stays as it is, yet in the very act of seeing they are so much at one that we can really say "eye-wood," and the wood *is* my eye. Now if the wood were free from matter and wholly immaterial as my eyesight is, then we could truly say that in the act of seeing the wood and my eye were of one essence.[29]

Nicholas of Cusa formulated a kind of allegory on the theme of intellectual vision as defined by Aquinas. According to Nicholas, light spreads in the form of a pyramid which touches the base of the pyramid of darkness, and the summit of the latter in turn touches the middle of the base of the pyramid of

light. Between these two bases, the realms of the intellect, the soul, and the body are spaced out evenly, like a web of unity and diversity.

While Meister Eckhart might say "an eye is more noble in itself than an eye painted on a wall," Nicholas of Cusa made the painted eye a symbol of God's gaze and omnipotence. In *The Vision of God*, he drew an analogy with "an image which is omnivoyant—its face, by the painter's cunning art, being made to appear as though looking on all around it."[30] Nicholas spoke of this to the monks of the Tegernsee congregation; the gaze directed simultaneously in all directions, putting us constantly face-to-face, is a metaphor of *visio intellectualis*. It is a mystical experience because there is a fusion at work and also an experience of union in diversity.

A great reader of Meister Eckhart, Nicholas frequently encountered in his writing metaphors involving the human eye or sight. For example, in his Sermon 64, he states: "Scripture says 'Moses saw God face to face.' The masters contradict this as follows: where there are two faces a person does not see God, because God is one and not two, for he who sees God sees only one." Or in Sermon 48, he defines the nature of the spiritual gaze. The gaze of all-seeing God could, in Nicholas's terms, be only a metaphor for the coincidence of opposites (*coincidentia oppositorum*), manifested to the human soul when "the more it goes out from itself in order to enter and know other things, the more it returns into itself to know itself" (*et quanto plus egreditur ad alia ut ipsa cognoscat, tanto plus in se ingreditur, ut se cognoscat*). The more it turns to exterior objects, the more it turns back to itself. This "optical" reversal sets a limit of a sort to the history of seeing as written by the metaphysicians of light.

Despite what others may have written, I do not think that there is a direct connection between the questions of optics addressed by the Franciscan friars of Oxford and the new conception of space to which the art of Giotto in Assisi bears witness. The origins of the latter lie, rather, in the attempts— ongoing since the mid-thirteenth century—to place events in the public life of St. Francis in the real world; the techniques adopted by Giotto to depict the third dimension were intended to have a more powerful effect on the believer's senses. One thing certain is that interests converged in paying greater attention to sight. How could thinkers have failed to see a parallel between speculations about optics and the new importance given to visual testimony by the burgeoning of Franciscanism? How could the expectation of blessings from saints' relics not have put them in mind of the *species* emanating from them and encountering the equally active *species* coming from the eyes of the believer? And does not the elaborate dramaturgy of the reliquaries I described earlier make the action of these *species* even more apparent? Does

it not enable the faithful to "target" the scrap of precious matter, the point in space where the *axis visualis* should touch down?

We must remember, however, that the above are only parallel phenomena and belong to discrete levels of reality; no chain of causality links them. For all their sumptuous elaboration, the works of art never serve to illustrate a philosophy, much less metaphysics. But when forms are so refined and gestures and expressions so ostentatiously recherché that it is perfectly obvious that they solicit our visual attention; when a reliquary is no longer fashioned as the prop for a program of dogmatic learning but as the stage for a visual game which leads the eye through a succession of movements into the heart of the sacred mystery; then, surely, we are entitled to think that the theologians and artists who made these objects emphasized their visual qualities intentionally. Even if they spent the greater part of the year hidden away in inaccessible sacristies, or on altars invisible behind a rood screen, or in churches that were closed except during services, the reliquaries were only waiting for a great religious festival to display their elaborate scenographies to the faithful. The limits on their accessibility undoubtedly increased the congregation's longing to see them and satisfaction when they did appear. In the "city reliquary" of the late Middle Ages, the citizen's space was clearly distinguished from the space occupied by the saint's remains, despite their close proximity and interdependence; consciousness of the saint's permanent proximity and accessibility inevitably exercised a considerable influence on the way citizens lived their lives.

# Architecture and the "Connoisseurs"

## ARCHITECTURAL RELICS AND INNOVATIONS

Although I begin this chapter with Abbot Suger's Saint-Denis (fig. 22), it is not because I believe that this church marks the beginning of Gothic architecture as a whole. However, that belief is still widely held, because, in a way that Suger himself would have pronounced miraculous, it satisfies historians' needs on three levels: it provides a precise date for the start of a new era in art history, the era in question is manifested in a single monument, and moreover the man who instigated the work left his own written account of it, which survives to this day. But this neat mesh of certainties conceals a multitude of other unanswered questions. Very little is known about the earlier state of the church, considerable difficulties arise if we try to relate Suger's testimony to what we know about architecture in the early 1140s, and the loss of the great majority of the sculpture makes it all but impossible to visualize the monument as a whole at the moment of completion. So it is not easy to restore Suger's Saint-Denis to its place in the context of other buildings under royal patronage between 1130 and 1150. It would be a considerable gain if we could find out more about the building immediately preceding Suger's, or if we knew, at least, the state of the structure in 1125, around the time when the abbot began to assemble funds for its reconstruction. Obsessed by the innovative elements in Suger's church to the exclusion of all else, art historians have overlooked the physiognomy of what Suger desired only, by his own account, "to enlarge."[1]

It is a striking discovery to perceive a reminiscence of the "west work" of a great Carolingian cathedral in the monumental complex forming the west front of Saint-Denis. The double span of the entrance and the two adjacent towers

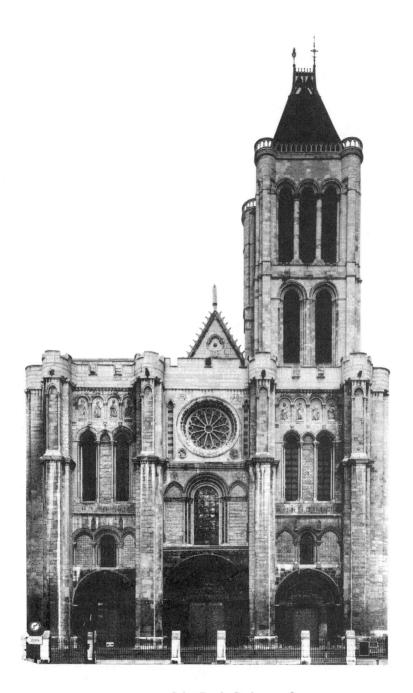

FIGURE 22. Saint-Denis, Paris, west front

do in fact house upper chapels, the middle one being dedicated to the Virgin and St. Michael. There are numerous Romanesque and pre-Romanesque churches in which the chapels above the west doors are likewise dedicated to the archangel; for example, Saint-Père in Chartres, Saint-Germain-des-Près in Paris, Saint-Benoît-sur-Loire, and Saint-Philibert in Tournus. Suger says expressly that this central oratory is "most beautiful and worthy to be the dwelling place of angels, in honor of the Holy Mother of God, the eternal Virgin Mary, of St. Michael the Archangel, of All the Angels, [and] of St. Romanus."[2]

Alcuin celebrated the Archangel Michael as intercessor for mankind with God and as guardian of the celestial city. In a Coptic text about the enthronement of St. Michael, the archangel is said to be charged with carrying souls at the Last Judgment from the regions of death (in the west) towards the light. In Carolingian churches, the west end was thought of as prefiguring the Heavenly Jerusalem, the place for celebrating the Resurrection and Ascension, and these are the scenes depicted on the panels of the doors of Saint-Denis. In effect, the places where angels alight on Earth, situated at the west end, "form a screen between the house [of God] and mankind." Suger's insistence on the beauty of the chapel is not so much an aesthetic opinion as a precise iconological indication. In this respect, it takes its proper place in the spirit of the Neoplatonic metaphysics of light. In fact, *The Celestial Hierarchy* of Pseudo-Dionysus, which begins with an invocation of the "Light of the Father," "the light which is the source of all Light," and the "anagogic" nature of the "intelligent hierarchies of heaven" that point our way,[3] shows us both the significance and the contemporary relevance of these upper chapels, which were probably imitated from the previous church. The existence of these chapels, in particular the one dedicated to St. Michael, should be regarded as an explicit allusion to an architectural theme going back to Carolingian precedents, even if they might have nothing in common with them in form or general appearance.

In appearance, the west front of Saint-Denis has a severe grandeur markedly different from the refinement exhibited in the chancel inside, which, too, was rebuilt by Suger. It brings to mind the west front of Saint-Étienne in Caen, but there are notable differences: the emphasis given to the central bay, the cycles of carvings in the three doorways, the crenellations along the wall immediately beneath the base of the towers. Suger made a point of telling his readers the purpose of these crenellations, which is both aesthetic and military.[4]

The iconographic program of the doorways is not known in full. The tympanum of the central arch represented the Last Judgment, with the Wise and

Foolish Virgins on the pillars flanking the opening; this scheme served as a model for, notably, Notre Dame of Paris and Amiens Cathedral. The right-hand tympanum was devoted to the church's patron saint, with the Works of the Months on the flanking pillars. The latter continued on the left-hand side, where the tympanum was filled with a mosaic. Its iconographic meaning is obscure, but Suger tells us that he ordered it to be put there although it was "contrary to modern custom."[5] A mosaic in that position recalls churches in Rome; it is even possible that its iconographic program was of papal inspiration, to form a pendant to the life of St. Denis in the right-hand doorway, which "had nothing to do with the Roman church," as *Gallia Christiana* reminds us (*nullo ad Romanam ecclesiam medio pertinens*). The choice of an obviously "ancient"—that is, early Christian—technique suggests that the image it represented had all the characteristics of a reliquary, in contrast to the carved stonework in which it was inserted.

The three doorways were completed by twenty pillar statues—eight in the middle, the other twelve to the left and right, representing characters from the Old Testament and forming what was probably the earliest array of this type.

Suger clearly thought out this program down to its smallest details and followed its execution closely. Even though he was quite capable of envisaging several significances simultaneously, it seems to me that the primary meaning is that of the *porta coeli*, the Gate of Heaven: such is the impression received at the first sight of it. And the lines he had inscribed on the doors themselves only reinforce this hypothesis:

Whoever thou art, if thou seekest to extol the glory of these doors,
Marvel not at the gold and the expense but at the craftsmanship of the work.
Bright is the noble work; but, being nobly bright, the work
Should brighten the minds, so that they may travel, through the true lights,
To the True Light where Christ is the true door.[6]

Since Panofsky, these lines have been rightly interpreted in a Neoplatonic light, but I believe the reading does not go far enough. For even if the west front of Saint-Denis as a whole represents the Gate of Heaven, as indicated both by the iconography of the central doorway, in particular, with the Last Judgment and the Wise and Foolish Virgins, and by the dedication of the chapel above, the fourth and fifth lines do not just evoke the spiritual ascension of the believer, traveling "through the true lights to the True Light," but the literal progression of the believer from the door to the sanctuary, "where Christ is the true door." The burning lamps of the Wise Virgins are another manifestation of the light illuminating the path of Truth.

Suger's second undertaking was the enlargement of the upper choir, "from the crypt below to the summit of the vaults above, elaborated with the variety of so many arches and columns, including even the consummation of the roof"; "we . . . strove to raise and to enlarge the transept wings of the church [so as to correspond] to the form of the earlier work that had to be joined [by them]."[7] This work was started before the west towers had been finished, but that was frequently the case in the Middle Ages, because the towers were used for hoisting the construction materials up to the higher parts of the building. For this reason, towers were often never finished or remained unfinished for many years, even centuries, after the rest of a building. Suger already had a third project in mind: he wanted to put a vault over the nave in order to "harmonize and equalize it with the two parts [already] remodeled. We would retain, however, as much as we could of the old walls on which, by the testimony of ancient writers, the Highest Priest, our Lord Jesus Christ, had laid His hand." These ancient, "consecrated" stones were, therefore, in Suger's words, true "relics."[8]

The enlargement of the choir consisted in remodeling the two crypts, upper and lower, which contained holy relics, in order to cover them with a vault of the same height; this would have the outcome of raising the floor of the new choir, so making the reliquaries on the altars visible. Suger writes of the ambulatory as "that elegant and praiseworthy extension, in [the form of] a circular string of chapels, by virtue of which the whole [church] would shine with the wonderful and uninterrupted light of most luminous windows, pervading the interior beauty."[9] He placed in the choir "twelve columns representing the number of the Twelve Apostles and . . . as many columns in the side-aisles [the ambulatory] signifying the number of the [minor] Prophets," and referred to St. Paul's words in his letter to the Ephesians (2:19–21): "'Ye . . . are built upon the foundation of the apostles and prophets, Jesus Christ Himself being the chief cornerstone' which joins one wall to the other; 'in Whom all the building'—whether spiritual or material—'groweth unto one holy temple in the Lord.'"[10]

Let us set aside the question of the Christ symbolism, which would deserve lengthy discussion in its own right; the cornerstone in Suger's text is the keystone of the vaulted roof. Medieval allegory commonly associated Christ with the foundation stone[11] or with the cornerstone.

The identification of the apostles as pillars is an interpretation elaborated by St. Augustine and taken up in the Middle Ages by the Venerable Bede, Hrabanus Maurus, Honorius of Autun, and others. The parallelism established by Suger between the pillars representing the apostles and those representing the

prophets, rather than the hierarchy one might expect, is more original. The two sets are charged equally with supporting the Church. The importance Suger attached to this interpretation will not be grasped unless we notice the beauty of these pillars, so slender that they suggest a vast space.

We can see the attention Suger paid to these architectural elements in his treatment of the pillars of his new chevet and the older crypt. In the crypt, he moved them and aligned them against the enclosing wall so that they lost their original function; they survived with a purely illustrative value, as architectural relics of the crypt built under Abbot Fulrad. In the chancel of Magdeburg Cathedral, begun in 1209, the pillars of the Ottonian building were preserved and set on Gothic piers, like exhibits in a museum, giving the impression of having lost their function and being kept only on account of their age. These are treated as "relics," in Suger's word. In *De Consecratione*, the abbot recounts how he would have liked to go to Rome, to take marble columns from the palace of Diocletian or other ancient buildings. Charlemagne did something of that sort in building his chapel at Aachen. Discouraged by the difficulties of transporting them, however, Suger found blocks of marble in the nearby quarry at Pontoise, thanks to "the generous munificence of the Almighty." A very early text about Saint-Denis, dating from 799, indicates that the church's pillars were an object of pride, used as a measure of the importance and beauty of the building as a whole: a brief description of the basilica enumerates—in addition to its 101 windows—50 large pillars, 35 others, and 5 made of a particular stone; the cloister had 59 large pillars, 37 small ones, and 7 of a particular stone. That is a total of 193 pillars, to which we may add a further 102, if we take the other churches within the abbey's precincts into account.

The old description gives us the means of measuring the pains Suger took to respect the remains of the old basilica at the same time as he introduced the innovations of which he was so proud. The mosaic over the door at the west end and the pillars in the crypt are both relics, in their way, which he spotlighted by exercising the skill of a markedly innovative stage designer. The vaulted ceiling of the choir's double ambulatory, with cross ribs supported by slender pillars, bears witness to an architecture which must have appeared challenging at the time. This is how art evolves: not in a straight line, a steady progression from the inchoate to the masterpiece, but in fits and starts, one step backward for every two forward. A masterpiece is not achieved without interruptions, setbacks, good ideas renounced. For each work that survives, how many have been destroyed, links in a chain we could have read? Suger's Saint-Denis was not the only architectural masterpiece of the 1130s. Our estimation of it is influenced too much by our knowledge of the evolution

of the style overall, while we know too little about what was accomplished elsewhere in the same period. It is for their ability to experiment that we should appreciate Suger and his architect. Integrating the crypt into a new chevet and enlarging the choir to serve new concepts of worship was a program of considerable difficulty, and in confronting it they had, at the same time, to use structural techniques that would achieve the sanctuary bathed in light, intended to inspire reverence in the believer from the moment he crossed the threshold, presenting a vivid contrast to the surviving Carolingian nave and plunging it into yet deeper shadow.

Suger's objective with Saint-Denis was to translate the dialectical relationship between architectural relics and formal innovations. The new chevet was to be like a shrine enclosing the Carolingian crypt; its luminescence was to contrast with the obscurity predominant in a building that was partly below ground level. Similarly, the saints buried there would be moved from the shadow into the light flooding the altars in the choir. Surely it was a highly symbolic undertaking, by means of which Suger let it be known that he was being faithful to the venerable old church at the same time as he proclaimed, with some emphasis, a new consecration that was both mystical and aesthetic.

Less than a century later, Suger's choir was in danger of collapse. That, at least, we may infer from the spectacle of an architect of genius applying himself to its restoration and renovation in 1231. In fact, the flying buttresses that shouldered the upper part of the choir of 1140, and perhaps the roof itself, were in all probability showing signs of aging. Part of the blame must have lain with the inner line of pillars, for the first act of the architect in 1231 was to demolish them and replace them with new shafts, with the help of underpinning. The new piers were probably thicker than the original ones, which must have been not much stronger than those of the outer circle. The next step was the complete reconstruction of the upper windows and the ceiling vaults. There can be little doubt that demolishing the choir and rebuilding it altogether would have entailed less risk; if the architect commissioned in 1231 retained the double ambulatory and the chapels radiating from it, it was because this part of the building seemed to him, and to his patron, worthy of being preserved in its perfection as another architectural relic. This approach obviously bears a twofold interpretation: it constitutes a kind of commentary on Suger's work, and it allows the architect to claim his place in an architectural line of descent that he carried on and that which carried on from him in turn.

At this point, let us turn to two other examples which show how this dialectical relationship to history was largely shared by the better architects.

The first can claim to rival Saint-Denis in more than one respect: Saint-Remi in Reims (fig. 23). The relics in this Benedictine abbey church had a special historical significance for their links to the conversion of France to Christianity, and Abbot Pierre de Celle was an important figure in twelfth-century theology, even if he did not have Suger's charisma. The reconstruction work instigated by Pierre began around 1165; the choir and above all the west front, undertaken with an eye to the example of what was done at Saint-Denis twenty years earlier, are admirable creations, deserving more credit than they frequently get. The need for more light inspired the architect to pierce windows in the galleries above the choir. The light also reached the west end of the church where a sumptuous front, presenting the appearance of a kind of triumphal arch to the outside, but constructed as a double wall inside, illustrates the richness and variety possible when a great creative artist has to work within powerful restraints.

Unlike Saint-Denis, the pre-Romanesque church in Reims already had two staircase towers at the north and south ends of the west front, which the master mason was told to preserve, although it would have been possible, by the middle of the twelfth century, to build towers with an infinitely lighter silhouette. The gesture of preserving the old towers gave the new architect a place in a tradition and also allowed the true age of the church to be seen.

Another sign of its antiquity is the presence of two half-columns and fluted pilasters on the west front and of half-columns at the entrance to the choir. These forms, with their references to classical architecture, were not new—fluted pilasters were found at Cluny and in Saint-Lazare in Autun, for example—but in Reims they seem justified solely by the statement they make, like the marble pillars and capitals at Saint-Denis, dating from the Merovingian era, or the Ottonian pillars in Magdeburg. Architectural relics (false or authentic), they are aesthetic objects making an allusion to antiquity and represent what has been called the "twelfth-century renaissance." We have another example in Langres Cathedral; the capitals in the (reconstructed) nave display a very large repertory of forms taken from classical models.

A display of references to Roman or Greek architecture is not the only feature of what is often called the "first Gothic architecture" (my reasons for challenging the expression will become clear in due course). It also often resorts to borrowings or "quotations" from Romanesque architecture. Saint-Lucien in Beauvais (begun around 1090) and Winchester Cathedral (1079) influenced a certain number of buildings of the 1160s and 1170s. Searching for traces of literal copying from those sources would be a wasted effort, however; it is always a matter of adapting borrowed motifs to the new context. I shall

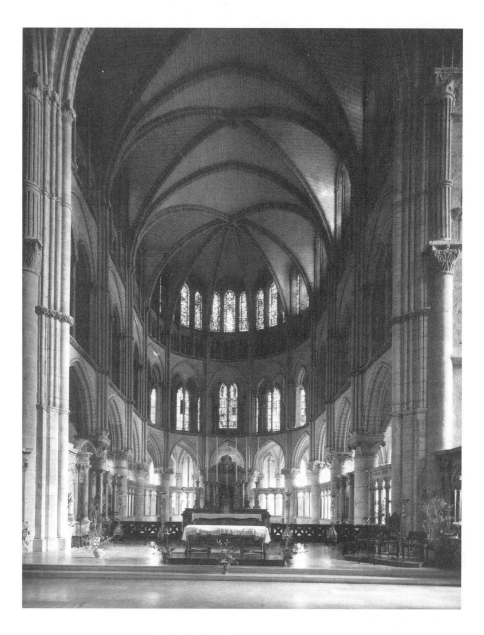

FIGURE 23. The choir of Saint-Rémi, Reims, seen from the nave

have more to say about the modalities of such borrowing, specific to the Middle Ages.

Saint-Denis, as I have said, has been regarded by art historians since the nineteenth century as the building which marks the start of a new style called "Gothic." The assumption overlooks the claims of other buildings, erected in the same period in the same part of Europe. Among those by which even today we may still measure the prodigious possibilities of the architecture of the 1140s, Sens Cathedral is, beyond all doubt, the most original monument, perhaps even more interesting than Saint-Denis (fig. 24). The patron here was again an outstanding personality. Henri Sanglier (who, unlike Suger, was of noble birth), to whom Bernard of Clairvaux dedicated his treatise on episcopal administration, was Archbishop of Sens from 1122 to 1142, and as such primate of France. Reliable documents indicate that the building work started in 1140; thus, the enterprise was painstakingly prepared by a prelate who had decided to replace his tenth-century church completely, chose his architect, decided on his program, and encountered no real financial difficulties. On the other hand, unlike Suger, he did not have the good fortune to see the work completed, as he died two years after it was begun.

Sens is built to a perfectly homogeneous plan: there are decisive arguments to support this assertion. The principle of having no transept and only one chapel, extending on the axis of the choir, is something of an archaism, but it may conform to the layout of the earlier church. The ambulatory is the continuation of the side aisles, enlarged by the simple means of two laterally aligned chapels. Because of this homogeneity, the architectural design of Sens is much easier to analyze than that of Saint-Denis. The master mason at Sens built a nave and a chancel in three tiers, with a blind gallery between the upper windows and the principal arcades. The bays of the central nave are roofed with sexpartite rib vaults above a corresponding infrastructure of alternating piers. The most innovative aesthetic effect is not due to the simple adoption of this principle but to the plasticity of its realization: the profiles of the pillars and arches give rise to contrasts of light and shade which express the austere character of this architecture.

On the structural level, this is the earliest known example of an admirable concordance between supports and the elements supported. The radius of the engaged columns increases according to the weight they bear. The plinths and abacuses are treated as autonomous entities, those of the pillars supporting the pointed arches are set at an angle indicating their direction in the vault. The cross ribs and transverse ridge ribs are composed of three torus moldings resting on a dosseret, which has the effect of underlining the arc optically

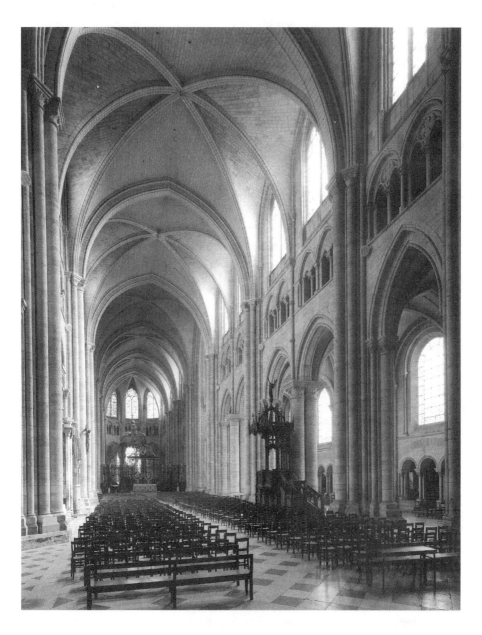

FIGURE 24. The interior of Sens Cathedral, Yonne, looking towards the choir

while it lightens the form. By contrast, the transverse ribs have a certain weightiness. The absence of a projecting boss has a visual consequence of some significance; it reduces perception of a median axis to the bay and so augments the importance of its infrastructure.

The "modernity" of Sens is possibly even more apparent in the refined treatment of the modenature. Looking at the openings on the three levels, we can see a torus molding in front of each of the moulded openings of the arches themselves, casting a line of shadow between itself and the arch. An analogous formal treatment is also found in the elevation of the nave of Amiens Cathedral. These torus moldings belong in what might be called the foreground, seeming to suggest that the wall is a plastic entity, as liable to expressive possibilities as to structural ones. The ambivalence recurs in the choice of the paired columns that alternate with the bigger piers. In order to avoid giving these intermediate supports greater girth, as is seen in some English churches, the architect divided them into two, and the vertical division contributes visually to lightening the infrastructure; moreover, their juxtaposition at right angles to the axis of the nave lets in yet more of the light entering the nave from the side aisles.

The treatment of light is much more subtle here than in Suger's ambulatory, where the communication between the radiating chapels, added to the slenderness of the pillars, gave the determining function to the windows. In Sens the darkness of the blind galleries and the existence of the sexpartite vaults, the cells in which act like a kind of blinkers on either side of the windows, work against a similar glorification of light.

Even if we agree that all architecture has content and that it is perfectly legitimate to study its iconography or iconology, the proposition of a strictly causal relationship between architecture and a theological idea or a symbolic model is scarcely tenable. Concepts contribute nothing to architecture. Nonetheless, just as it seems, judging by the evidence, that a desire to champion light led Suger to ask his master mason for technical and formal ways of transcribing light in space, in Sens a light was produced that is enriched by its shadows.

In this, we are closer to the mysticism of Bernard of Clairvaux than that of Suger: "When, for the space of a fleeting instant, and with the speed of lightning, a ray of divine sunlight is glimpsed by the soul in ecstasy, the soul draws, I know not whence, imaginary representations of terrestrial objects corresponding to the messages received from heaven. These images come, in some sort, to wrap a protective shade about the prodigious brilliance of the truth perceived."[12] Thus truth, according to St. Bernard, comes out of the interactive contrast of shade and light.

The master mason of Sens mixed traditional Romanesque forms—round arches, imposts to support the cross ribs of the side aisles—with new forms. An archaic rhythm, alternating stronger and weaker pillars, is made to correspond to a roof of rigorously constructed rib vaulting, reinforced by flying buttresses. There are precedents in Anglo-Norman architecture, for Sens as for Saint-Denis, but no other example conveys such a sense of monumentality.

Sens offers one of the very earliest signs of a "foliation" of the wall surface. There is nothing similar in Saint-Denis, but the inner side of the west front of Saint-Remi presents another version, more overtly stated, and the principle was to undergo varied fortunes up until the fourteenth century. Though compiled from elements with contradictory stylistic origins, Saint-Étienne in Sens possesses great homogeneity, due to the equilibrium of mass and the imposing monumentality. If we imagine Suger's Saint-Denis completed, and try to compare the two, it is very hard to say which of the two would seem the more innovative. The only criteria by which they can be judged, ultimately, are those laid down by the success of the totality of the architectural solutions responding to the totality of the problems posed by the program. This was determined partly by the wishes of the patron, to be sure, but also by the contingencies of site, materials, workmanship, and financial provisions.

In the light of these two great churches, certain interpretations become unacceptable. Is there any point is discussing the origins of Gothic art in terms of "accident" or "necessity"? A work of architecture does not come about by accident; it is the product of setbacks and experiments, of borrowing and innovation, of calculations, as Henri Focillon would say. The walls start to rise when sufficient preparation has been made, and the means by which they continue to rise are provided by the architect's genius or constrained by the limits of his talent. I hope that, in any case, I have placed sufficient emphasis on the respective qualities of these two buildings and on the very subtle interactions each reveals between fidelity to traditional principles and innovative affirmations. It should be clear by now that the persistent practice of attributing the origin of the new Gothic style to the combination of pointed arches, cross ribs, and flying buttresses does not stand up to analysis. The pointed arch existed before the end of the eleventh century; cross ribs supported the vaults of Durham from 1093 and of Rivolta d'Adda and Moissac from around 1120. As for flying buttresses, the difficulty of fixing their date of origin probably arises from the relatively discreet positions to which the earliest were assigned, and from the fact that large numbers of them were replaced when their stabilizing role was better understood and their visual realization was perfected.

## THE ENHANCEMENT OF THE VISUAL

The religious architecture of Western Europe in the Middle Ages occupies a unique place in the universal history of architecture. In adopting the longitudinal character of the Roman basilica it accentuated and, even more, enriched it in a series of developments that led to highly original creations. Whether or not transepts were added, lit by a cupola above the crossing, whether or not an ambulatory surrounded the choir, whether the nave had a flat or vaulted ceiling above two, three, or even four stories, in every case, once past the threshold of the west door, the eye was drawn in only one direction, toward the altar at the geometrical center of the sanctuary, at the other end of the building. We need to have this general conception in mind if we are to evaluate the contributions of the twelfth and thirteenth centuries.

Let us first consider two earlier buildings: the Dreieinigkeitskirche in Essen, finished in 1058, and Saint-Étienne in Vignory, completed by 1050 (fig. 25). Despite its choir and ambulatory, the sanctuary at Vignory, as seen from the west door, is not truly homogeneous. The regularly aligned square pillars and double arches of the false tribune do not lead the eye towards the choir; rather, they form two massively proportioned walls, while the choir appears to have been conceived on a different scale. In Essen, the church's west choir, a two-story demi-octagon like the one at Aachen, was probably originally the starting point of a much more successful axial perspective, although again involving two scales; however, the existing Gothic nave makes it almost impossible to judge the original effect.

Nearly all the monuments surviving from the eleventh century evince a gap in date between the realizations of the nave and the choir. The growing popularity of pilgrimage and the adaptation of great basilicas to meet the needs of ever-growing numbers of pilgrims (for example, Saint-Martin in Tours, Sainte-Foy in Conques, Saint-Sernin in Toulouse, and Santiago in Compostella) gave rise to a type of choir with chapels radiating around it which was to go from strength to strength. The high altar took pride of place at the center of the choir, while the secondary altars converging on it, dedicated to other saints, exerted a huge attraction. Now, from the moment he entered the nave, the believer was carried in the stream of other pilgrims towards the east end, where a rhythmic progression towards the choir was resultant on the systematic introduction of rib vaulting and, consequently, of regular bays. These did not simply represent a technical advance in size; they would have a decisive effect on how viewers direct their gaze, creating a fusion of supporting walls and roof in a homogenous whole, as well as a spatial

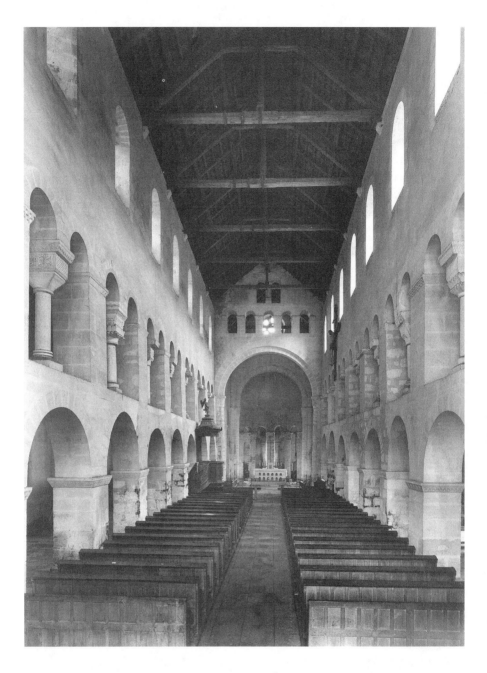

FIGURE 25. The nave and choir of Saint-Étienne, Vignory, Haute-Marne

entity—the bay—which would shape the nave in a manner Frankl termed additive.

The nave had to prepare the eye so that it was drawn to the choir as the focal point. It was equally important to ensure that the eye passed from the nave to the choir without encountering an obstacle or, alternately, being rushed; one of the functions of a transept is to provide a breathing space. But the eye can pass to the choir without a transept; the essential thing is that the openings and the supports of the chevet retain a relationship of scale with the nave, even if it takes artifice to accomplish it. In general, the choir enjoys a different status from the nave, but at the same time the nave is the space which visually proclaims the choir to come, and so it cannot be realized independently of the choir. Notre Dame in Paris is a case in point.

The choir of Notre Dame was built before the nave that exists today. One architect seems to have replaced another as head of the works, but the second of the two conceived a nave which, though faithful overall to the elevation of the choir, displays some remarkable innovations. In the choir, large pillars support three engaged columns facing inwards and bearing the arches of the sexpartite vaults. The middle one of these rests on a rectangular dosseret. In the nave, by contrast, there is no dosseret and the engaged columns, face-bedded, are simply set in place.

The result of the uniformity in the deployment of the columns in the two parts of the church is to make the choir the visual prolongation of the nave. The upper stories differentiate them, but the difference is subtly achieved. In the choir the supports of the vaults are solid extensions of the bearing walls; in the nave they are treated like plastic elements, freed from the wall from which they detach themselves. One might propose the following analogy: the supports of the choir vaults are comparable to relief sculpture, those of the nave to freestanding statues. Not only are the supports separated from the wall, but also the springers of the sexpartite vault are not echoed in the alternation of the supports. Notre Dame seems therefore to be one building where a change of master mason did not lead to radical modifications but sustained a will to affirm a new language, moving away from outmoded elements such as column and tribune.

The contrast between choir and nave was achieved by different means in Cologne Cathedral. Statues of the twelve apostles stand against the pillars in the choir, following an example introduced in La Sainte-Chapelle in Paris (see fig. 66 on p. 237); the sanctuary, its altar bearing the magnificent shrine of the Magi, is thus associated with the Heavenly Jerusalem; the choir, additionally enriched by a ceiling covered with a cycle of paintings and by the carved

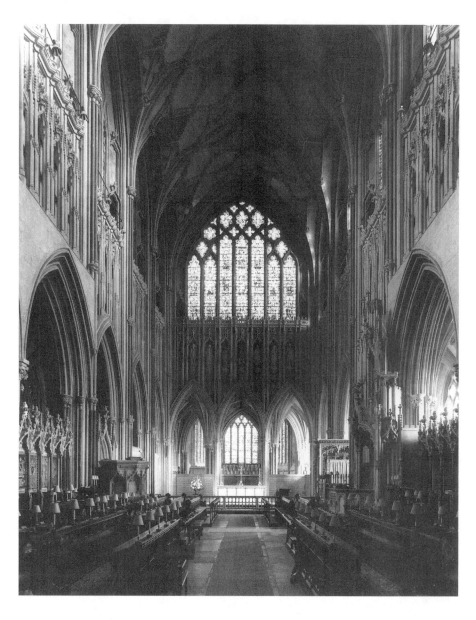

FIGURE 26. The choir of Wells Cathedral, Somerset, with view through to the Lady Chapel. (Conway Library, Courtauld Institute of Art, London)

stalls, is close to being a autonomous monument within the cathedral. The perspective from the west doors towards the altar is accentuated by the height of the roof, which visually emphasizes the narrowness of the main nave.

In German and English churches, some especially original solutions were realized in choirs, exhibiting overall a more general—I have termed it "kinetic"—conception of space, in which the choir has a privileged position. The essential difference between French churches and these lies in their relinquishing of the axial viewpoint in favor of an oblique one.

As it is today, the choir of Wells Cathedral in Somerset (fig. 26) is the product of successive remodeling of the earlier building, extending the chancel eastwards by the construction of the Lady Chapel, finished in 1306. An irregular octagon in shape, this chapel has three sides outlined by piers to the west with direct access from the ambulatory. When one approaches from the aisle beside the chancel and turns from its last bay in the eastern end of the ambulatory, one discovers a dual scheme on a central plan, delineated in the ambulatory by the positions of the pillars and the form of the vaults and, in the chapel, by the position of the walls. Alternatively, if one looks east from the transept crossing, one sees three arches at ground level that repeat those in the long sides of the chancel and allow one to discern the space of the Lady Chapel as a kind of luminous backcloth. These arches are surmounted by a wall with niches occupied by statues, and yet higher, by an immense window with seven lancets. Although one can distinguish several different scales here, they are harmonized by very subtle transitions which the human eye discovers only gradually. The ideal viewpoint from which to appreciate the aesthetic unity of Wells—as well as its religious dimension—is in the center of the Lady Chapel looking west. From there the viewer perceives this space as both intimate, dedicated to contemplation, and limitless. In the realm of the medieval Holy Roman (German) Empire, the architecture of which has been termed *Sondergotik* by some German historians, denoting what they see as a specific or autonomous type of Gothic, there is nothing like this, if only because there are none of the long chancels and Lady Chapels that determine the plan of a large number of England's medieval churches. Medieval German architecture sought to elaborate specific architectural types from a very early date; the Elisabethkirche in Marburg and the Liebfrauenkirche in Trier are examples that, taking their inspiration from forms originating in northern France, integrated them into a wholly unique conception of space.

The relatively precocious church of Our Lady in the Fields (Wiesenkirche) in Soest provides an interesting specimen to set beside Wells (fig. 27). Everything distinguishes them from each other, and everything distinguishes each

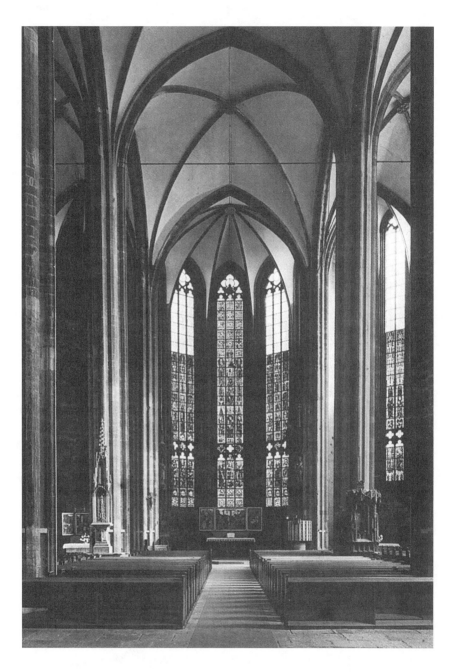

FIGURE 27. Frauenkirche (also called Wiesenkirche), in Soest, Westphalia

of them from French buildings. In Soest the three aisles are united spatially in a hall church, a type already well-known in Westphalia by the thirteenth century. The middle aisle, the widest, finishes at the east end in an apse formed as five sides of an octagon. The compound piers are widely spaced, the profiles of the shafts continuing into the arches of the vaults they support, uninterrupted by capitals. The windows are almost the full height of the walls, their verticality modified only by a quatrefoil horizontal subdivision. The choir, which is not long, does not constitute the horizon for visitors entering the church, because they will look around to take in the space as a whole, following several axes at once. One would surmise that the function of the altarpieces found in choirs like this was to focus the believer's attention on the altar.

The relationship between choir and nave is not the only manifestation of an emphasis on visual effects, however, once certain problems of construction had been solved. In rebuilding the transept of Soissons Cathedral, starting in 1176, the architect resorted to a form already known—the (apsidal) vaulted semicircle—but was able to give it a breadth and spatial quality never previously achieved (fig. 28). It is enough to compare the final outcome with analogous structures such as the transepts at Noyon, which may have served as an immediate model, at Tournai, and, at a rather greater remove, Sankt Maria im Kapitol in Cologne. At Soissons, it is interesting to note that the gain in luminosity is due to the gallery, while the light entering at ground level and through the higher windows is much less abundant. Even so, the dark level formed by the blind triforium is placed above the galleries and thus achieves a suggestion of stronger light coming through the windows above.

The deliberate seeking of visual effects has been recognized as characteristic of the architect of Soissons Cathedral. An example is the elevation of the wall of the rectangular bay preceding the apse where he inserted only two arches instead of three, but made the first, the nearer to the transept crossing, wider. Viewed full on, this detail creates an imbalance, but to the viewer approaching the transept it gives the impression that this first bay has as many arches as the following walls. Contrivances of this nature constitute a response worked out to meet a particular problem: how to avoid consequences for the wall of this rectangular bay from the exceptional dimensions of the first pier, which supports the crossing tower, while the load-bearing pillars in the apse are much more slender. The problem thus formulated did not necessarily require so subtle a formal solution that the viewer has to take a precise position in a perspective scheme. The fact that it received one shows that a new period in the history of architecture was just beginning, when account would be

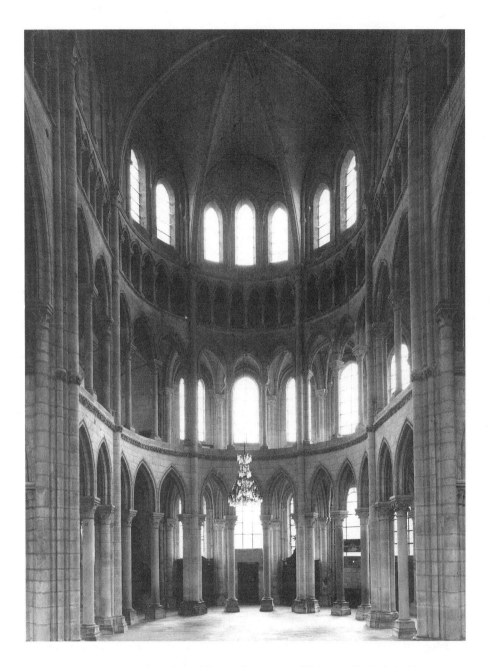

FIGURE 28. Interior view of the south transept of Soissons Cathedral, Aisne.
(Photo: Centre Gothique en Picardie/E. Georges, 1995)

taken of the viewer's position and when, whatever might be said, a cathedral was no longer dedicated to God alone. A work of man's hands, it was now thought of as a spectacle too, with a mise-en-scène offered as a bonus to the discerning eye. I believe it was a matter not so much of wanting to "distract" the believer by aesthetic refinement as of addressing a different gaze, that of a public sensitive in some degree, however restrained, to architecture. The extraordinary developments in this art in northern France are inconceivable unless there had been comment and discussion among a select band on the subject of the buildings now beginning to arise everywhere. How else should we interpret the caption on a page in Villard de Honnecourt's album, saying that he "invented" (*trove*) the plan with a certain Pierre de Corbie? And if the interpretation fits the facts (and how should it not, since every period of intense architectural development is necessarily matched by the existence of communities of knowledgeable people, in classical antiquity, in the Renaissance, or in the age of classicism alike?) its corollary must follow, namely that the architect himself was aware of himself as an artist. I shall return in due course to the conclusions that can be drawn from this historical situation.

For the moment, let us look in greater detail at the new concern with form that is the sign of a way of creative thinking freer and more eager to experiment than ever before. Modenature provides a body of extraordinarily diverse evidence, too often overlooked in the absence of sufficient studies, except what has been done in connection with the most illustrious buildings. Nothing has been written to replace the pioneering article by Viollet-le-Duc, even if his conclusions are no longer acceptable because the profile of a cornice is not a manifestation of the rational thinking he believed characteristic of Gothic architecture. Profiles embody simultaneously the sense of the monumental and the taste for small forms, condensed in a design governed by illusionist effects—and illusion is the enemy of all rational thought. Illusion makes one line twist and coil and draws another out to an impossible length. A profile solicits the gaze directly, and connoisseurs appreciate it as a summary of an architectural style as a whole; they know how to read one as they know how to read the plan or the outline of a building drawn on parchment.

Attempts have been made to project a primary evolutionary scheme on the development of cornice profiles, as with window tracery, based on the conviction that they "progressed" from simple forms to elaborate ones. If it is indisputable that there were indeed early forms that disappeared quite quickly, and that a twelfth-century profile cannot be mistaken for a thirteenth-century one, it is nevertheless true that every architect came up with his own

formal solutions, even though borrowings are easier, more numerous and more ramified in this particular domain than in any other.

Let us take an example in an English church, Chichester Cathedral (fig. 29), the choir of which was rebuilt after a fire in the roof in 1187, and probably reconsecrated as early as 1199. Here we find round arches supported by columns which are themselves encircled by slimmer columns of black Purbeck marble; similar slender columns are also to be seen in the embrasures, notably in the gallery. Yet it is surprising how delicate the profiles of the cornices are, in which thin torus and shallow cavetto moldings alternate; the refinement contrasts with the retention of round arches and the general proportions. The "modernization" of the old part of the building therefore changed little in the structure—except the roof—but it radically modified the general effect by optical means tending to reduce the massiveness of the walls and the supports.

Comparison of the Trinity Chapel in Canterbury Cathedral (1180–1184) with the choir of Pontigny Abbey (1180–1210) (fig. 30), purely from the point of view of the modenature, is very instructive. At Canterbury, the profile of the great arches, for example, where the differentiation is very emphatic, creates a vivid contrast of zones of light and shadow (see fig. 47, below). Despite the thickness of the masonry, the convex moldings are not bulky; ornamental scallops border them, not easily seen, like so many vestiges of the decoration of Romanesque churches. The realization of the triforium arches confirms that the modenature helps to give the wall a plastic quality throughout its thickness.

With the choir at Pontigny, the first thing to remember is that the renunciation of ostentatious decoration, in the spirit of Cistercian architecture, led to a simplification of the modenature overall. So the profile of the lowest tier of arches is reduced to a right-angled intrados with torus moldings in the angles inside the extrados of an upper arch of the same thickness as the wall. To effect the transition between the two intradoses, another torus molding is placed between two cavettos, the two convex moldings having practically the same diameter. The visual effect of this profile is more graphic than plastic, and this is the difference from Canterbury. In general terms (but generalization must be treated with great caution in this area) modenature in northern French buildings is characterized by a kind of undulating rhythm, in which the eye passes from one convex form to another, together maintaining a clear proportional relationship, then to a concave form, and so on, with fillets as a rule to mark the boundary between the two.

Allowing for the ambition evinced by the conception of Notre Dame in Paris—the work probably started around 1163, and the choir was finished in

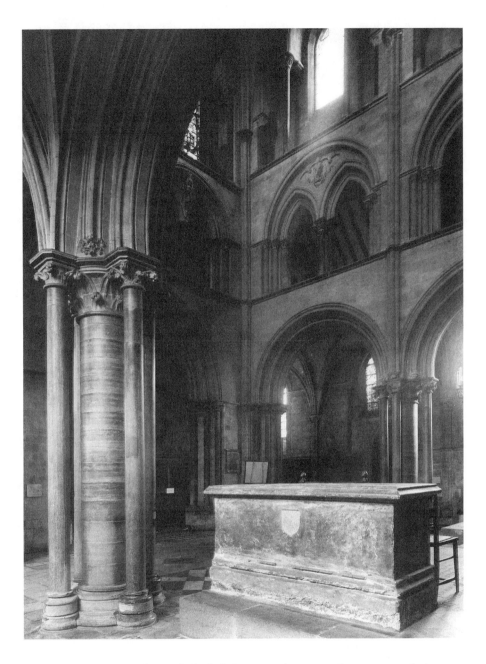

FIGURE 29. Chichester Cathedral, Sussex, a view across the nave towards the southeast corner. (Photo: Crown copyright, NMR)

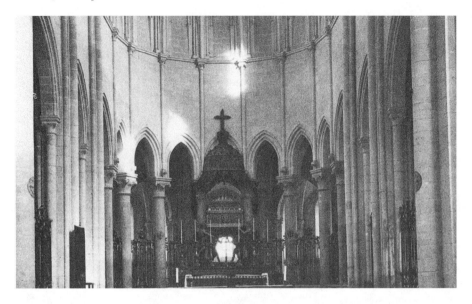

FIGURE 30. The east wall of the choir of Pontigny, in Yonne. (Photo: Zodiaque)

1182, while the nave, probably begun before then, was not completed until 1218—the study of which helps us understand another aspect of this period in the history of architecture when such care was taken over visual effects. The choir, unlike the nave, has large arches, the profile of which is a single arch—a wide flat fillet edged by two convex moldings. The paired arches in the gallery have an outline of three convex moldings, the middle one being thinner. The profile of the cross and transverse ribs in the roof is of two convex moldings, separated at the angles of the dosseret by a lintel which is wider or narrower accordingly. The wall rib has the same profile cut in half. As Viollet-le-Duc noted, these three profiles are identical but for the variation in width, conforming to the tectonic importance of each element. The profile of the large arches is conceived according to the same principle. The differences are virtually undetectable in the load-bearing structure, because the engaged columns intended to bear the transverse ribs and those that take only the transverse ridge ribs have exactly the same dimensions. The difference is visible only in the impost of the wall ribs.

Viollet-le-Duc regarded this harmonization of profiles as evidence of a wish to draw attention to the different scales of the parts of the building. My own view is that it reveals, rather, a doctrinaire attitude denying the concordance of form and function and favoring the treatment of surfaces. That is why it

is hard to agree with the claim that Notre Dame is an attempt to create a synthesis. Undoubtedly, more than some other buildings, it is compiled of a large number of elements and demonstrates in-depth knowledge of the architecture of the time. But rather than synthesis, what we seem to see is the attempt to elaborate a system that would be easy to repeat and imitate. In other words, the bishop of Paris, Maurice de Sully, wanted his cathedral to be simultaneously an unsurpassable monument and a definitive model of the possibilities offered by the new style of architecture.

There were technical as well as aesthetic reasons for producing a range of different profiles based on one nuclear formula. We should remember that the realization of profiles began with a preliminary design, drawn by the master builder's assistant on a one-to-one scale on wood or metal, sometimes as a working drawing on the wall or floor of the building under construction. The thirteenth century saw the development of a new craft, that of the *apparator*, or stone dresser. Next, the outline of the drawing was cut out in the wood or metal, producing the template with which the stone dresser transferred the outline to the block of quarried stone to ready it for cutting. Making templates for the entire building was a relatively lengthy, and therefore costly, operation; reducing their generative design to a single motif was one way of making the task easier and so considerably less expensive. The work on the cathedral church in Paris seems, moreover, to have benefited from other advances, notably the invention and use of machinery and lifting apparatuses, the stones used in the nave being larger than those in the choir.

The history of modenature has yet to be written, for obvious reasons. Here, it is enough to indicate a very general line of evolution, one that is necessarily extremely simplified but relatively valid in methodological terms, given the long period of time under consideration. From the start of the thirteenth century, there was an increasingly systematic resort to the molding with an almond profile culminating in a ridge or a facet; at the same time, the hollowing of gorges and scotias became more and more pronounced.

The almond molding gave Gothic architecture a form uniquely its own. Unlike the semicircular torus or the cylindrical bead, the slimmer profile and median axis of the almond allowed a more fluid distribution of light and shadow. Generating the almond outline involved not just one segment of a circle but the combination and intersection of several circles—four in principle, although the radii may vary. A crest or a fillet meant that this architectural style could be better drawn, and its linearity accentuated.

The increasingly deep carving of gorges, scotias and cavettos went hand in hand with this development, intensifying the dark values against which the

projecting forms stood out all the more cleanly. Such contrast is especially visible in the treatment of the bases of pillars: the lower, larger convex molding projected further as the groove between it and the smaller, upper convex molding deepened. In section, the base no longer presented the alternation of torus-scotia-torus, but a sort of oblong shelf, overrunning the plinth, on which it cast a pronounced shadow, and bordered on its upper side by a deep-cut scotia, which forms a dark line in buildings of the second quarter of the thirteenth century. The oblong profile of this type of convex molding belongs to the same generation of elastic and elongated forms as the almond.

Many other visual effects were elaborated, just as decisive in their contribution to our overall understanding of a building. Counting the number of engaged columns employed in the interior elevation of Reims Cathedral, and taking account of the differences in format, one is tempted to see a process of accumulation at work, intended to lay bare a framework of stones. But looking at it closely, one should be able to recognize that the process has at least one other function, which I would call kinetic.

If one walks along the nave in Reims, looking at the alignment of the piers from the right, having started from a position to the right of the central axis and close to the west door, one can see only a succession of engaged columns facing into the nave (figs. 31 and 32). Their diameter, which is not to scale with a roof vault nearly forty meters high, is nevertheless greater than the diameter of the engaged columns resting on their abacuses to take the transverse arches. In other words, the columns attached to the main piers were conceived in the function of a visual hierarchy of the elements and not for the functional role of those elements. The experiment can be repeated in the side aisle, where the seven engaged columns against the external wall, rising from the floor, repeat the structure of the engaged columns attached to the lateral wall of the central nave. Walking toward the further end, one sees the closely aligned engaged columns gradually break ranks, so to speak, and divide into groups of seven, bringing into sight the wall between them, in particular the string course running along the internal abutments to which the bundles of columns are attached. This architecture was not conceived solely for an attentive viewer but also for a body in motion, and its expressive possibilities are innumerable.

The importance of elements such as cornice, hood-mold, and abacus as markers of the horizontal in a building that, by definition, is a triumph of verticality and height, is often mentioned. The case should be argued more cautiously than it usually is, however, because any such effect could well have been counteracted by the use of polychromy—and we do not know to what

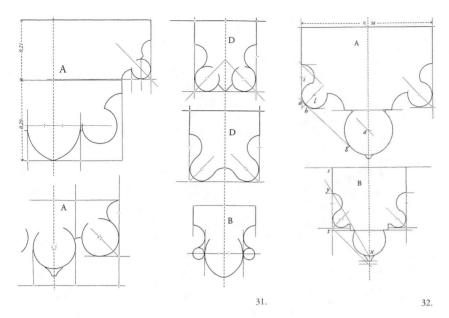

31.                                                    32.

FIGURES 31 and 32. Forms of *nervure* in vaults, with almond-shaped profiles
(*A* and *B*), after Viollet-le-Duc.

extent that was so. I shall come back to this essential point in connection with
Chartres Cathedral.

Let us consider the question in one instance only, that of capitals and aba-
cuses at the top of the principal piers in a building. Comparing those of the
naves of Reims and Amiens is all the more justified, because in both cases
the piers are composed of a central column with four thinner columns, also
circular, clustered round it. In the nave at Amiens the circular nucleus is or-
namented with vegetal crockets, independent of the three engaged columns
that all have ornaments of their own, as well as projecting rectangular abacuses
which individualize them. Only the engaged column facing the nave has neither
capital nor abacus, and only the upper profile of the abacus of the nuclear
column is extended in the form of a shaft ring. The vertical liaison between
the three tiers is formally established by this means. This liaison is all the more
important because this is the first nave in which the major arches are the same
height as the wall above, containing the triforium and the upper windows,
with the vaults launched 139 feet above the floor.

In the nave at Reims, the accent falls on the horizontal line drawn by the cap-
itals (fig. 33), which are at a uniform height and are found on all four engaged

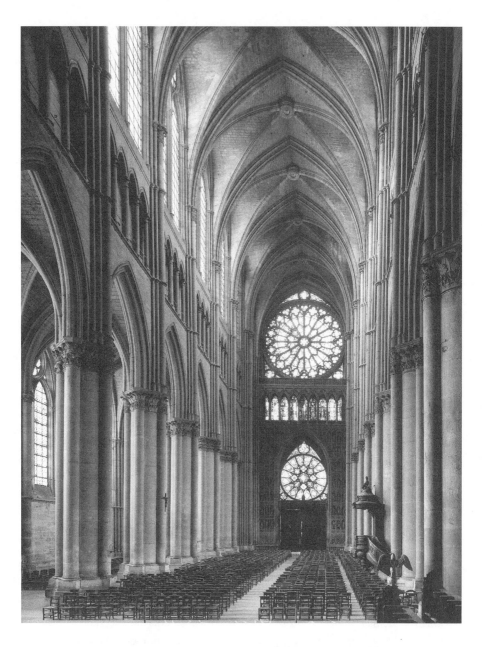

FIGURE 33. The nave of Reims Cathedral, looking west. (Photo: Hirmer Fotoarchiv, Munich)

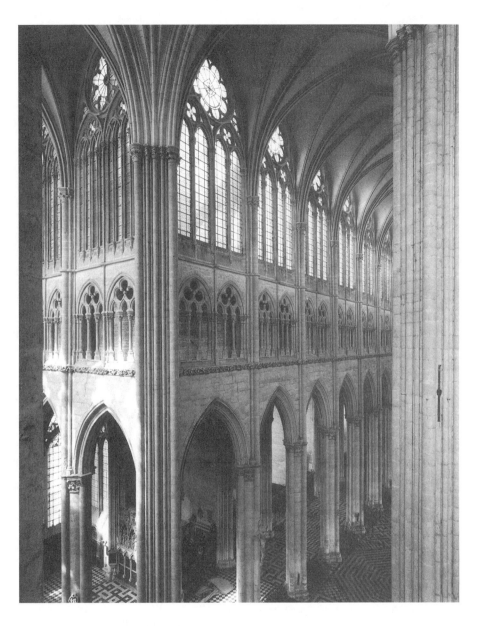

FIGURE 34. Amiens Cathedral, a view of the upper wall of the nave and south transept. (Photo: Hirmer Fotoarchiv, Munich)

columns as well as the nucleus (fig. 34). Unlike at Amiens, the abacuses do not project but suggest only a slight, scarcely visible dislocation; their profile receives little emphasis, all the visual impact being reserved for the several rows of foliage adorning the capitals, disregarding the orderliness of Amiens's crockets, a motif inherited from the classical past. The differences between these two great works of thirteenth-century architecture can be characterized very precisely by saying that the scale at Reims is indicated by the load-bearing elements as they appear at the different levels in the central nave, and as they are reprised in the side aisles, whereas the scale at Amiens is infinitely larger—the entire height of the nave—and simply graded by the horizontal scansion. The additional observation that the modenature is more rounded at Reims and more incisive at Amiens is all that is necessary to confirm that, beyond their superficial kinship, these two great buildings follow quite distinct aesthetic orientations.

We could also have examined the formal developments of the tracery, but however highly elaborated this became, essentially it amounts to design in two dimensions. The interesting thing about modenature is that it constitutes a plastic syntax that, to some extent, is close to that of figurative sculpture. The proximity strikes us, at any event, if we reflect that the treatment of light and shade is one of the essential objectives of all architectural thinking. Unlike the Romanesque sculptor, the Gothic sculptor also pursued that objective.

## ARCHITECTURAL ICONOLOGY AND THE ARCHITECT'S ROLE

For too long it was thought that any similarity between the forms of column bases or window tracery in two buildings was necessarily the result of a stylistic affiliation, generally direct, and enabling one or other of them to be dated. A certain number of other conclusions were also drawn, in particular that of the existence of identifiable "hands," which could, moreover, be traced among the entire repertory of features constituting the style of a building. The reason for this belief was that a building was thought, like any other work of art, to require a "hand" or at least a single creative idea, even if several hands were necessarily involved. But architecture is linked by definition to particular socioeconomic givens; more than any other art form, it is subject to anything but trifling material and technical conditions. Its realization calls for the collaboration of a very large number of people, representing a host of different skills and professions; it is a "symbolic" system with a representative function. And last but not least, it has a function. Every architectural study has to take

account of all these factors if it is to lead to a clear historical vision of something like the Gothic church.

Nowadays, it seems clear that the crucial link in the chain was the architect. In examining the change that took place in the architect's status during the course of the twelfth and thirteenth centuries, and also the precise tasks he was given, we arrive at a critical and historical vision of architecture that is not confined to the simple projection of a figure all the more idealized for being akin to that of the modern creative artist.

The works by Krautheimer and Bandmann to which I referred in the first chapter were suddenly taken up and developed further in the 1970s by German art historians who greatly transformed our approach to medieval architecture. Meticulous examination of certain construction processes helped to establish more exact chronologies and theories about the organization of construction sites and the methods of architectural production. Similar work was done in France, triggered by the international conferences of the Société Française d'Archéologie. Meanwhile, the iconological aspect, to adopt Krautheimer's term, was not neglected. Hans Joachim Kunst published an article in 1976 on what he called "freedom and quotation in thirteenth-century architecture" taking Reims Cathedral as his example.[13] If I single it out, it is not only for its methodological interest but also for its progeny: since its appearance, a huge number of studies have taken up the notion of "quotation" as the basis of architectural analysis. In my view the concept is fraught with ambiguities and therefore a potential source of confusion. Kunst's intention was to distinguish three types of architectural quotation:

when the quotation has a dominant function in relation to all innovation;
when its function is passive and consequently underlines the presence of formal innovations;
when quotation and innovation merge in a harmonious whole.

The term "quotation" is ambiguous in itself, simply because it relates to language, not to visual forms. Textual quotation must necessarily conform to certain modalities if it is to remain faithful to its definition as allusion. The definition of architectural quotation is much woollier: it would be very hard to find a work of architecture, or an important element within one, reproduced in its entirety anywhere else in the Middle Ages. And yet no epoch probably ever saw more acts of textual quotation. The choice of the term seems to have been dictated by the postmodern current in the architecture of the 1970s and then the 1980s, in which the linguistic model—and quotation in

particular—loomed large. It seems to me there are other terms applicable to the operations in which Gothic art engaged knowingly and with such remarkable aptitude. Although they too are borrowed from literary models, I think them better suited than "quotation" to express the dialectical character of Gothic architectural thinking.

I take them from St. Bonaventure's definition of the four ways of making a book: the *scriptor* writes words that are not his own; the *compilator* does the same, while adding something else that is also not his own; the *commentator*, still writing words not his own, adds words of his own in the guise of ex-planation; finally there is the *auctor* who differs from the others, not because he writes exclusively his own words (as a modern reader might expect), but because he also uses the words of another to confirm his own.

The first thing to note is that the author in the modern sense—the person who puts his name to a text he has written—did not exist in the thirteenth century. In the above example, it is matter written by others that makes the texts of the compiler, the commentator, and the author. Similar definitions also define the framework of architectural thinking; the difficulty we have in discovering precise "quotations" in the architectural field disappears if we conceive that the master builder, in including this archaic form or that, this architectural relic or another, at the same time as he was trying to realize his own project, was working in the spirit of a *commentator* or *auctor*.

The Italian art historian Salvatore Settis has examined this question in depth, especially in relation to classical Greek and Roman sculpture and its reuse or reappropriation in Italy during the medieval period. He finds it useful to distinguish, from the start of the late Middle Ages, three attitudes to classical remains: a spirit of "continuity" characterized by "reuse," "historical distance" leading to "collection," and the pursuit of "knowledge" of antiquity resulting in the construction of a corpus.

In the period that concerns us the third of these attitudes was still unknown, but "continuity" and "historical distance" certainly did exist. It is not partic-ularly easy to tell whether an element—a capital, for example—was removed from a classical site and reerected in a new building because it testified to the authority of the classical past or to the strength of its continuing tradition: the answer is quite possibly both. Unfortunately, Settis does not put himself in the position of the receptor, the artist who appropriated the ancient fragment, and thus he does not consider the new work into which it was incorporated. His entire taxonomy rests on the assumption that classical *auctoritas* was al-ways invoked for its own sake and not because it served to raise the standing of a modern work. The type of evaluation which necessarily meant distance, that

is, an awareness that the fragment belonged to *vetustas*, did indeed take place during the Middle Ages. The *commentator* and *auctor* did not receive classical antiquity passively but exploited it to underline what their own modernity owed to it *and* what it did not.

Suger referred to himself as an *auctor* at a date and in a context when the architect's own name had no real importance. He was perfectly justified in doing so, even if he did not admit to St. Bonaventure's subtle distinctions. It is true, however, that the term would not have been used of an architect in the twelfth century. If anything, the profession was belittled by someone like Suger, who did not write a single word in praise of his employee or so much as mention his name in all his writings. This attitude was not going to change before the middle of the thirteenth century. On the other hand, Suger named himself in the building thirteen times. Other prelates, as subtle program makers as he, assumed the title of *architectus* on their own behalf; Suger's contemporary Bishop Rudolf of Halberstadt referred to himself as *devotus architectus*.

Every stage in the evolution of Gothic architecture has something to tell us about the profound changes that affected the profession of architect and the respect in which it was held, as well as its view of itself. The formal innovations, the new structures, the ever-growing ambitions of the patrons— everything indicates that architects took control of architecture from the 1170s onwards, following an era in which projects were still overseen by a Suger or a Pierre de Celle.

One particularly vivid and informative record has come down to us in the chronicles of St. Albans Abbey written by Matthew Paris in the first half of the thirteenth century. Describing what happened when the abbot John de Cella decided to rebuild the west front of the abbey church, Paris launches into furious criticism of the activities of the architect Hugh de Goldclif, whereas normally he has nothing but praise for all the artists who worked on his beloved abbey. Having the necessary funds, the abbot entrusted the enterprise to Hugh and a team of picked masons—who, it should be noted, were not natives of St. Albans, nor were they attached to the abbey. But the work came to a halt not long after it had started because the architect, according to Paris, had added "unnecessary, futile and excessively expensive ornaments" instead of observing the abbot's intentions. These additions soaked up the budget and provoked sarcastic comments from the general public.[14] The unfinished and uncovered wall fell down during the first winter and, according to Paris, the fallen "remains of sculpted images and flowers caused the laughter and derision of those looking on."

All the archeological information in Paris's invaluable history suggests that Hugh was an up-to-the-minute artist, well qualified to introduce the new forms that were spreading across northern France, while Paris, though he cared passionately about art, was a man of conservative taste and added his own strictures to the almost unanimous resentment of this itinerant artist felt by local artists and the monastic community in particular. An additional cause of the chronicler's indignation was that, contrary to what was usual at the time, Hugh had had the ornamentation put in place after it had been carved—reason enough for Paris to call him "a deceitful man and a liar."

One thing in particular to be learnt from this story is the power that even a demanding patron handed over to an architect recruited from secular society on the strength of his reputation. It shows the architect's freedom to divert the project into directions of his own choosing, without the person who had commissioned the work having any real sanction over him, short of dismissal. We have already come a long way from Suger's exercise of absolute authority over the work and the workforce, and his declaration: "The identity of the author and the work ensures the sufficiency of the worker."

This division of functions, with the authority of the person who instigated the project affirmed at the start, followed at a second stage by rapid recognition on the architect's part that he alone is capable of realizing it, is analogous in every respect to what happens nowadays in museums throughout Europe and the United States. Perhaps the museum's status as a kind of latter-day, if secular, temple, where society's representative values are concentrated, is close to that of a cathedral in the Middle Ages. In the early days, authorities wishing to construct "cultural amenities" of this kind sent for architects; the municipal authority and the museum director were practically masters of their project. When building a museum became more effective than other forms of work as an opportunity for an architect to affirm his historical place and role, he increasingly imposed his own vision of the museum on the client. The client would then lose the power to control everything, for the simple enough reason that architects developed a language that has become more and more autonomous, bordering on a self-referential system. Of course, the aptness of such an analogy between the situations in the last quarter of the twelfth century and the last quarter of the twentieth century is only relative, but it draws attention to the process that starts as soon as growing demand gives rise to unbridled rivalry between patrons, triggering extraordinary competitiveness between the builders. The artistic self-confidence of architects increases at the same rate as the demands made by their clients.

The fact that, during the twelfth century and well into the thirteenth, the majority of architects are not mentioned on inscriptions in the monuments they erected does not indicate that they were thought of as inferiors. Quite the contrary, the silence surrounding them is, if anything, a sign of the gradual shift taking place, which brought them to a position of prominence and, above all, recognition. It was not long before the Benedictines of Saint-Germain-des-Près called Pierre de Montreuil a "learned doctor of stones" (*doctor lathomorum*), and Hugues Libergier, the architect of Saint-Nicaise in Reims, was represented on his tombstone with the attributes of a benefactor.

The change is perceptible in buildings constructed during the reign of Philip II of France (1180–1223). The example of modenature has already served to illustrate the extreme differentiation capable of augmenting the visual values of an architect's work. But this did not inevitably mean the emergence of individual style, because the architect, though now an *auctor*, did not give up adopting for his own use profiles already used by a *confrère*, or copying motifs from elsewhere. The duty to follow the program, along with the need to take account of local custom, remained an effective constraint.

The case of Gauthier de Varinfroy is an especially informative one in this respect. A contract of employment for Meaux Cathedral (1253) mentions him as master builder, and states that he was simultaneously engaged in Évreux (fig. 35). Archeological research, in the absence of more precise documentation, leads to the conclusion that he was occupied with repairs at Évreux and more creative work at Meaux. What he did at Évreux concerns us more, because there he had to respect a very interesting program. His task was to rebuild the upper stories of the nave, dating from the first half of the twelfth century, while preserving the main arcades at ground level.

Having marked the lower limit of the triforium with a cornice, which he also took round the Romanesque engaged columns, Gauthier erected the two upper tiers according to a conception in which *rayonnant* Parisian motifs borrowed from various sources interlocked. The compilation paid due attention to the optical transition from the older Romanesque fabric; before sending the supports upward, Gauthier rested them on plinths which already adopt the angular forms he favored in their upper parts but retain the dimensions of the Romanesque engaged columns below. This is an example of perfect juxtaposition, where the master builder enhances his own contribution by making use of that of his predecessors and shows himself *auctor* in respect to the past and *compilator* in respect to the present.

In fact, Gauthier de Varinfroy was certainly no exception in Gothic architecture. His ability to solve a problem like the one of Évreux Cathedral—his

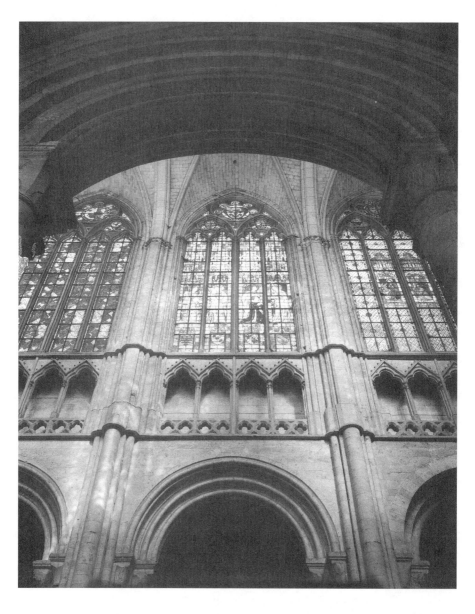

FIGURE 35. Évreux Cathedral, north side of a bay in the nave as remodeled by
Gauthier de Varinfroy.

work was equally adept at Meaux, Saint-Père in Chartres, and Sens Cathedral—does not mean that that kind of intervention was his speciality. Like every other architect of his day he knew how to make the most of the boundless resources of Gothic style, combining elements in arrangements that satisfied the specific requirements of an individual program.

We have come to the great innovation Gothic architecture represents by comparison with its predecessor: it had a whole catalog of forms to offer, making innumerable combinations possible. The reasons for its popularity with nineteenth-century eclectics, who found in it a versatility superior to that of the Romanesque style, a greater capacity to adapt itself to projects as diverse as a parliament building or a post office, are not very remote from those that explain its prodigious development from the twelfth century to the fourteenth.

These combinations of a diversity of forms and elements only gave rise to masterworks, however, because of the law to which they were all subject—the law of geometry. Not the speculative geometry of medieval exegesis, but a practical geometry which determined the dimensions of the elements and made them proportional to one another.

Two innovations accompanied the resources of the architecture called Gothic: the new ways of organizing work on the construction sites and the use of preliminary drawings. Both also had a direct bearing on the role of the architect. In a contract dated December 25, 1272, the Abbot of Cambron, in Bruges, commissioned two stonecutters from the neighborhood of Tournai to supply him with 3 pillars, 100 keystones, 64 feet of cornicing, 38 feet of coving, 10 windows "well made like the *molles* [models] supplied," 3 sills, and 12 cornices; in other words, the *molles* were sufficient for the craftsmen to carry out this order, which proves that methods of manufacture and assembly had been perfected by this date.

This new development was made possible by a strict rationalization of labor and the existence of extremely precise drawings, essential for the subsequent realization of accurate templates. But above all these drawings were reference tools, allowing everyone's work to be perfectly coordinated.

Dieter Kimpel made a series of exciting discoveries during the 1970s, while examining mural ornamentation and the system of constructing supports in a very large number of monuments from the twelfth and thirteenth centuries. In building a structure as "modern" as the ambulatory of Saint-Denis, for example, a wholly traditional construction method had been used: walls, window frames, supports had all been put up in horizontal courses, resulting in a homogeneous elevation overall. The example of the upper windows

in Chartres Cathedral shows exactly how this construction method allowed every element to be assimilated in the wall, because even the windows were built in successive courses. Those same upper windows in Reims Cathedral, on the other hand, were constructed inside a frame, and so they are dissociated from the masonry of the abutting walls. This was a new procedure when it was used at Reims, probably after having been tried out at Soissons; it involved the intensive prefabrication of a large number of elements and a process of serialization which, consequently, considerably reduced the time the work took. Then the stonecutters could go on to prepare the decorated blocks, which could be put in place systematically without requiring any but minor adjustments. The principle, which would be greatly perfected by the time it was used at Amiens, allowed the Reims architects to erect the supports before "filling in" the intervening parts: wall, triforium, upper wall, and windows. This method enabled a kind of "stone skeleton" to be erected, the invention of which constitutes the great originality of Gothic art. A cathedral no longer rose in horizontal planes throughout its entire length but in vertical tranches, one bay after another.

These observations prompt the conclusion that the double ambulatory and radiating chapels of Saint-Denis, with their pointed arches, rib vaulting, slender columns, and large windows, only *look* Gothic, while their construction system remains wholly indebted to traditional stonecutting. What differentiates the corresponding area of Reims Cathedral is not the evolution of more refined, lighter forms but a completely different construction system, which determined the formal mutation. Recognition of this enables us, incidentally, to see that parts of Pol Abraham's critique of Viollet-le-Duc are untenable, as the function of the cross rib in the case of Saint-Denis in 1140 was not the same as it was in Reims and Amiens in the 1220s.

If the conception of the stone skeleton meant that the fabric between the load-bearing elements became no more than infill, the step of doing without it altogether was going to be easy. The architect of La Sainte-Chapelle in Paris, for one, took the step, reducing the architecture to structure. On the other hand, he used a particularly sophisticated construction procedure, sorting the stones systematically, a method which determined the horizontal and vertical joints and the precise place each stone, prepared according to a specific template, would occupy in the wall. Of course this meant that the construction costs rose for what was, after all, being built by royal command, which proves that there was no overall uniformity in the situation governing major construction sites in the first half of the thirteenth century. After the standardization we have observed at Reims and Amiens came procedures

which did absolutely nothing to reduce costs. It is by no means certain, indeed, that financial considerations were a motive for those who invented the cheaper methods. The need for better organization on site, the benefits of more specialized craftsmanship, and, above all, the possibility of getting the work done faster were more powerful incentives for introducing the new methods.

The organization the new methods required reinforced the roles of the coordinator (the architect, that is), his colleague the stone dresser, who took charge at the site, and the drawing which gave everyone engaged in the construction of a great building a clear view of the end towards which they were working.

Producing architectural drawings gradually became the architect's principal activity, and the drawings for the west front of Strasbourg Cathedral demonstrate that by 1275 the two-dimensional rendition of architectural forms had advanced a long way towards perfection. We might say such a drawing had a function like a contract, between the architect and his workforce on the one hand and the architect and the clients on the other. A drawing 9 feet high, like the one of the Strasbourg west front, was clearly meant to win over the bishop, the cathedral chapter, and probably the city, too (fig. 36). A small drawing would have been thought inadequate and unimpressive. The graphic representation of the principal facade, which seems to have been a matter of particular concern to architects from the thirteenth century onwards—witness drawings *A*, *A'*, *B*, and *C* for Strasbourg—illustrates how much public-relations significance was invested in this part of a building.

The modern status of the architect as the person who conceives a work and is then content to supervise, even to let work proceed at several construction sites at the same time, was born during the thirteenth century. The architect's episodic presence on a site increased the importance of the stone dresser's role (he became known as the *parler*, or spokesman), but truth to tell, the standardization of working practices rendered his presence less and less necessary. The existence of a contract like the one from Bruges mentioned a few pages back meant that the architect could in the future concentrate on designing, while his colleagues took on the tasks of drawing templates, ordering materials, and, probably, supervising construction sites.

So what should we understand by the "style" of this architect or that? Increasingly, in the thirteenth century, the term refers to the architect's design or his manner in the sense that looks back to the word's etymological origin: his "handling" of a project. The profile of an arch, certainly prescribed in the initial drawings, would nevertheless be subject to decisive modifications

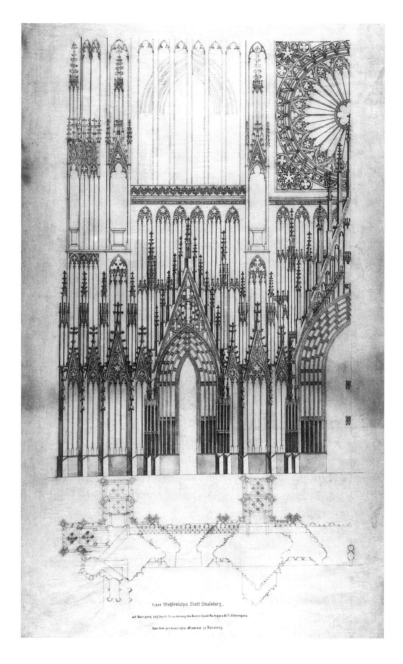

FIGURE 36. Drawing *C* for the west front of Strasbourg Cathedral, 1275 (copy). Musée de l'Oeuvre Notre-Dame, Strasbourg.

initiated by the stone dresser, not to mention adaptations made necessary by the specific local material or the skill of individual workers. The stone dresser's role as head of the *chantier* deserves closer study. No architectural design from the Middle Ages where the resulting building survives was realized entirely as first drawn. In every case, the plan was adapted to a greater or less degree, in matters of proportion or in details. This implies that the *parler* had a lot of freedom, with the consent of the client, in how he interpreted the original design. The drawings accompanying estimates or contracts resemble musical scores, the interpretation of which is always subject to the personality of the interpreter.

In such circumstances, the very significance of the architect changed. Fortified by ever-growing respect, the architect was someone possessed of a specific knowledge, which was above all technical, but also artistic; in the eyes of the client he had the power to resolve the problems raised by the project, whether they were technical or aesthetic, as the case of Gauthier de Varinfroy illustrates. But the title of "doctor" accorded to Pierre de Montreuil by the monks of Saint-Germain-des-Près shows that the knowledge, so keenly sought by the clients, made him the equal of the most learned scholars and gave him a very high social standing.

The significance of architecture also changed, because the architect's intentions had to be taken into account alongside those of the client. Architecture became a visual art during the reign of Philip II; it was now in order for an architect to "quote" the profile of a plinth or an arch invented by a *confrère* because he looked on the form in question as perfect, an absolute model. The more he was aware of his artistic freedom, the freer he felt to use this form or that as he pleased: his artistic horizons were widening. By erecting a stone skeleton, he gave himself even more liberty, because each part of the structure was completely independent of the next.

## CHARTRES AND BOURGES: CLASSICAL OR GOTHIC?

Histories of Gothic art have awarded Chartres Cathedral the status of paradigm. It can legitimately claim the title, indeed, because it is the only church to preserve an architecture regarded as innovative, complemented by an extremely rich sculptural program representative of Gothic sculpture both at an early stage, in the Royal Portal, and in its full flowering, and further enhanced by an ensemble of stained glass windows that is approximately faithful to its original state. The dedication to the Virgin Mary, and the presence in the church, since the ninth century, of the priceless *sancta camisia* must also be set

beside these artistic factors, for they made the cathedral one of the premier sites of medieval Christianity.

The cathedral in Bourges, dedicated to St. Stephen, could not compete on any of these levels; the program of its windows was not carried out in full, nor was its sculptural cycle—itself less well developed than the one in Chartres. Above all, the custom arose of treating the architecture of Bourges as an isolated case with only limited influence and an artistic conception opposed in any case to the so-called classical monuments such as Chartres, Reims, or Amiens.

There was also a powerful contrast between the political situations of the two cities; regarded as a "royal city," Chartres had a cathedral chapter that set great store by the power royal protection gave it to resist the pretensions of the lords of Dreux and Blois. Philip II himself gave a very generous grant of two hundred livres to finance part of the construction work and undertook to supply financial help on an annual basis. Philip I bought Bourges around 1100 as a result of which the archbishop was subordinate to the crown. Bourges was the seat not only of an archdiocese comprising the secular province of Berry but also of the ecclesiastical province of the Aquitaines.

Three archbishops in particular devoted themselves to the cathedral's embellishment: Pierre de la Châtre (d. 1171); Henri de Sully (1183–1199), a member of an illustrious family (his uncle was Abbot Raoul of Cluny and his brother Eudes bishop of Paris); and St. Guillaume(1199–1210), who was canonized in 1218 after the citizens of Bourges ascribed miraculous healings to him after his death. Even if the dynasties of these three prelates supplied several more archbishops of Bourges during the course of the thirteenth century, we must keep in mind that it was the chapter, not the archbishop, who owned the land on which the new cathedral was built, and that it is the chapter who should be regarded as the true patron.

In this last respect, the situation was similar to that at Chartres, where Renaud de Mouçon, nephew of the Queen of France and bishop from 1182 to 1217, could count on the active support of the canons for the reconstruction of the church whose altars, it is true, represented an important source of income for them—the chapter of Chartres was one of the most notable in Europe.

Work began on both churches at almost the same time. The fire of 1194 left nothing of the old Chartres Cathedral standing except the west front, with the royal portals and the crypt. The basilica had to meet the needs of a great pilgrimage church, like those spread across the south of France by the builders of the eleventh and twelfth centuries. Bourges Cathedral owed its rebuilding, like that of Chartres, to its chapter's ambitions, namely to rival

other great churches such as Sens, Paris, or even Cluny: a chancel big enough for the college of canons and open to the congregation by means of a spacious ambulatory.

Whereas the church at Chartres, the financial means of which were assured, was erected in horizontal stages along the whole of its intended length, work at Bourges began with the choir, enveloping the old crypt and also taking in land from outside the Gallo-Roman curtain wall. When the choir was finished, the nave went up bay by bay from east to west. At Chartres and at Bourges alike, a definitive plan was agreed upon and respected once and for all, despite the interruption of the work and its resumption in successive stages. I do not believe that there is any point, in either case, in trying to detect the master builders, who followed very distinctive styles. The *auteur* of Chartres was the person who designed the plan and the overall nature of the work. The same goes for the *auteur* of Bourges, and the modifications introduced into the plan later, in the choir clerestory and at the west end of the nave, are slight in relation to the original design, although that does not detract from their artistic interest, as we shall see.

It is to the design provided by the master at Chartres that the cathedral owes a major share of its singularity and its novelty, despite the fact that it used much of the foundations of the earlier nave and despite the existence of a choir with ambulatory and chapels resting on a crypt. These potentially restrictive givens were profoundly modified by the conception of a transept which extends beyond the width of the rest of the building, with a triple elevation echoing that of the nave. The transept was the means of effecting the transition between three aisles to the west, only seven bays long, and a choir five aisles wide and four bays long, leading to a double ambulatory which opens onto seven radiating chapels of identical dimensions. The transept is positioned midway between the eastern and western extremities of the building, with the entire emphasis falling on it and on the choir. A west front with three doors, decorated with sculptured tympana and columnar statuary, undertaken by 1145 at the latest and intended for a slightly wider site, was left in its place at the end of the new nave.

The originality of the design of Chartres rests on the monumental proportions of the extra-wide transept. Each of its two ends is approached from outside through a deep porch decorated with carvings. The function of these porches is not clearly defined; one might guess that it was connected with the Marian pilgrimages, but other functions have been suggested for such porches: liturgical, juridical, or symbolic—and there seems no good reason why they should not have been multifunctional (fig. 37).

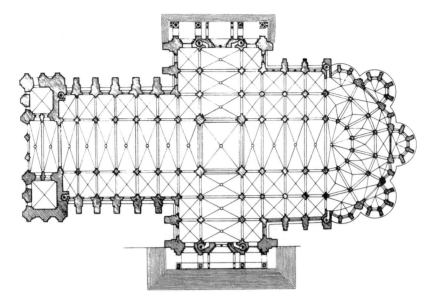

FIGURE 37. Plan of Chartres Cathedral, from Louis Grodecki,
*Gothic Architecture* (1977).

The plan of Saint-Étienne in Bourges adopts a more uniform design: the
body of the church consists of five aisles, which extend into a choir and a
double ambulatory without an intervening transept. Each of the five segments
of the semicircular chevet was lit initially by three windows at ground-floor
level, but during construction the middle window in each segment was pushed
out to form a five-sided apsidiole. The entire length of the church is formed
from five double bays, plus two oblong bays at the west end supporting
sexpartite vaults. The third bay from the west opens onto covered porches on
the north and south sides, both sheltering a door framed by columnar statues;
though less spectacular than those at Chartres, here too these sculptures are
relics of the earlier building (figs. 38 and 39).

For the modern visitor, the differences in the plans of the two cathedrals
are secondary, compared with the general impression made by their interior
and exterior elevations. To approach these in more detail, we need to examine
each building separately.

By eliminating the tribune, the architect of Chartres made possible a better
balance between the level of the arches and that of the clerestory. Thus the
height of the clerestory windows is equal to that of the arcade. Although the
vaults are quadripartite, the nave piers alternate in section. In one attached

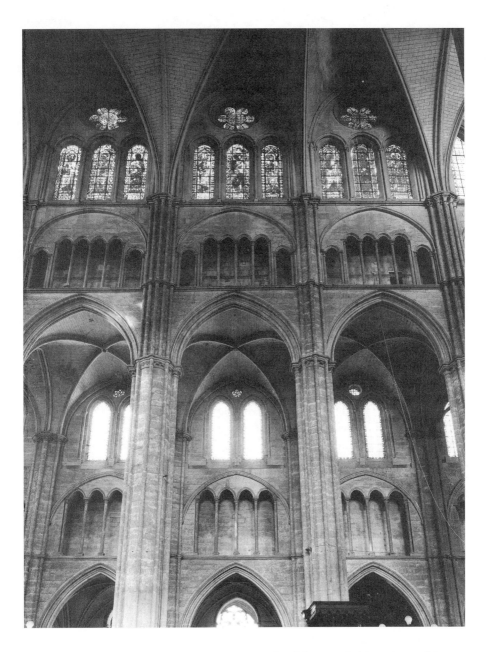

FIGURE 38. Bourges Cathedral, the upper walls of the central aisle and one of the inner aisles. (Photo: Hirmer Fotoarchiv, Munich)

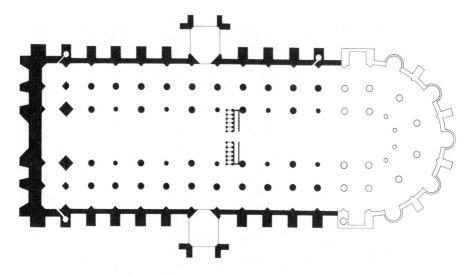

FIGURE 39. A plan for Bourges Cathedral showing the different phases of
construction and the position of the screen.

octagonal shafts surround a cylindrical central trunk, in the other cylindrical
shafts surround an octagonal core; the conception is admirable. Alternation
ceases from the level of the abacus upwards, however, each of which supports
five attached columns corresponding to the two wall ribs, the two diagonal
ribs and the transverse rib in the superstructure. At the level of the bases of
the triforium and the clerestory windows, a cornice runs along round all the
attached shafts. We should also note that the capital of the central shaft of
each pier is decorated with a stylized motif of leafy crockets and that three
of the attached shafts have a similar decoration halfway up, while the fourth,
the one facing the nave, has only an abacus and no capital. The clerestory
windows are composed of two lancets surmounted by a large multifoil oculus.
The window arch is shaped by a chamfer cut in the thickness of the wall
(fig. 40).

It is not altogether correct, in fact, to think that visual considerations had
no part to play in Chartres. Purely formal reasons dictated the choice of
alternating piers, for instance, and what an admirable solution it was to the
monotony that might have resulted from having the same support all the way
along the nave!

The effect of verticality, counterbalanced to some extent by the frequency
of the horizontal elements I have mentioned, is then reinforced by the piers at
the crossing, from which the horizontal elements are banished, whereas the

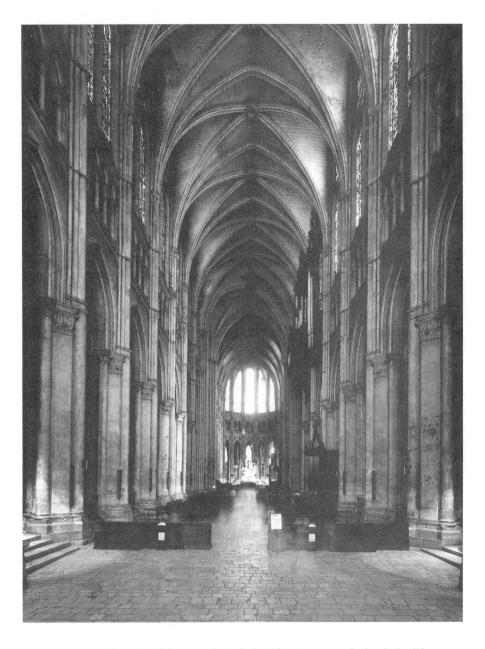

FIGURE 40. Interior of Chartres Cathedral, with a view towards the choir. (Photo: Hirmer Fotoarchiv, Munich)

attached columns multiply, disguising the cruciform nucleus. For a viewer standing at the west end of the nave, these piers, thrusting inwards into the space by reason of their volume, come to act as a frame for the distant view of the chevet and to mark the boundary between choir and nave.

The interior elevation of Chartres demonstrates the role of the supports: they display their supportive function inasmuch as they echo the rhythm of the bays, and at the same time they obey another formal logic, one which unites them as a story in its own right.

While seeking to harmonize the different elements of the elevation, the *auteur* of Chartres treated each story as an autonomous unit with a decisive position falling to the triforium. It is the triforium's role to mark distinctly a horizontal line of punctuation, which was also to be a characteristic of the two other cathedrals termed "classical"—Reims and Amiens—for the most spectacular result of eliminating the gallery is undoubtedly this concentration and the visual reinforcement of an intermediate story.

By good fortune, enough traces of the original polychromy are preserved at Chartres for us to be able to reconstitute it, at least on paper (figs. 41–44). It was a monochrome decoration of yellow ocher and white. Remarkably, it simulated the appearance of freestone cladding, with vertical and horizontal joints represented by narrow white lines. The piers' supportive function was visually reinforced by the fact that the painted stones were made out to be larger than the real ones. The shafts of the engaged columns were colored white, as were the convex moldings of the main arches and vaults, without any joints being outlined. The thin, regular layer of ocher covering walls, piers, and vaults—except for the elements already referred to—underwent a further metamorphosis: the module of the network of joints diminished consistently from ground level to roof. That is, the treatment was intended to augment the visual impression of the height of the upper levels, and thus reinforce the effect of verticality.

It is easy to envisage, in the case of Chartres, all the optical resources the architect was able to exploit in applying an architectural polychrome decoration, and we should also remember that the yellow ocher on the walls would enhance the effect of the colors of the stained-glass windows, in which blue and red predominate.

We can see more clearly now what differentiates the exterior elevation of Chartres from that of Bourges. At Chartres, the system of buttressing is relatively complicated, but it was probably the first time in the history of medieval architecture that the flying buttress was used in so ambitious a project.

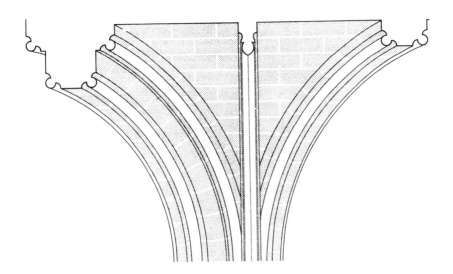

FIGURE 41. Original polychromy of the main arches of Chartres (after J. Michler).

FIGURE 42. Examples of medieval architectural
polychromy (after Viollet-le-Duc).

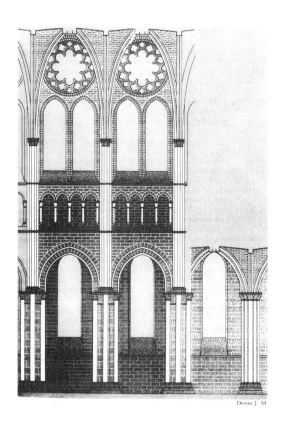

FIGURE 43. Interior polychromy of Chartres
Cathedral (after J. Michler).

FIGURE 44. Original polychromy of pillars in the choir
(E) and the nave (F) of Chartres (after J. Michler).

The massiveness of the abutments shows how far the architect went in deny-ing the building's true structure on the exterior, so benefiting the effects of transparency and lightness in the interior.

The exterior elevation of Bourges reveals a much lighter and more homo-geneous structure. It would appear even more so if later chapels had not been inserted between the abutments. There is scarcely any stone carving, except on the west front. The great narrative cycles are depicted in the windows; that is, the architecture seems to play an even more determinant role than at Chartres, where the sculptural cycles were envisaged as part of a coherent whole with the architectural concept. Bourges took shape, from the first, as a monument of pure architecture, which is already a fundamental, distinctive trait if we take the trouble to define what we mean by those words.

Saint-Étienne can be entered by its central door or by side doors. From every direction, we discover an interior space that has renounced the emphat-ically axial character of virtually every other monument of Gothic architecture in France. The perspective view that tends to elevate the choir and, conse-quently, the high altar, has not been abandoned altogether, of course, as we shall see, but it is not the first thing to strike us. The absence of a transept does not on its own explain this departure from the norm so much as the adoption of an elevation that rises from the side aisles towards the middle aisle. The height of the two outermost aisles is 30 feet, that of the two inner ones is 70 feet, and finally, the central nave rises to 123 feet. The pillars supporting the clerestory, consisting of a triforium and windows, are very tall; the upper walls of the contiguous aisles also have a triforium and windows, which, together, rise to a height equal to that of the central arcade; the outer side aisles, finally, have only a line of windows. So, if we look at the elevation as a whole, we see the succession of window, triforium, window, triforium, window, from lowest level to highest, with the openings discernibly growing in size as they mount. Bourges differs from Chartres in seeking to reinforce the effects not only of height but also of amplitude (fig. 45).

Up to the last rectangular bay before the apse the piers are of two sizes, corresponding alternately to the transverse ribs and transverse ridge ribs rising from them. Those in the side aisles and in the apse have the same section, that of the thinner nave piers. But whatever their girth, they all have the same number of attached columns, which helps partly to efface their differences of function. The three small ones on the side of the central nave support the transverse rib and wall rib arches. Only above the abacuses are the thicker piers provided with supplementary attached shafts destined to support the diagonal ribs of the sexpartite vault. In the side aisles, the two-times-three

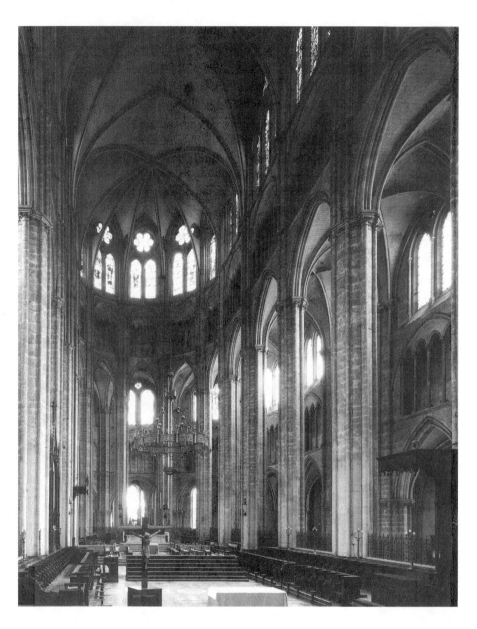

FIGURE 45. The choir of Bourges Cathedral. (Photo: Hirmer Fotoarchiv, Munich)

small attached shafts turned towards the aisles support arches, transverse ribs and diagonal ribs.

The cylindrical piers of Bourges do not stop at the height of the nave arcade, or beneath the triforium, or even the clerestory windows; even in the apse, where the impost of the wall ribs is the highest, one can detect the continuing presence of the pier in the form of a segment of a cylinder placed "behind" the diagonal ribs where the abacuses are at the same height as these imposts. In other words, the pier is deemed to rise above the visible height of the wall and above the vaults that cover it. This is radically different from Chartres: the upper wall, as it fills the space between the continuous piers of Bourges, would be better suited to Chartres, where the vaulting is not sexpartite. But, as we shall see, there were other motives for the choice of sexpartite vaulting here.

What strikes the attentive visitor is that all the elements serving as punctuation were given the same dimension, whatever their position in the church, and without regard to their proximity to any other such element. The moldings are all approximately 8 inches high, the capitals about 16 inches high or low, the diameter of the small engaged shafts is 6½ inches, and that of the large ones 10½ inches. Constituents are composed from a relatively small number of elements, which must have made them easier to realize. Overall, most often, forms result from combining secondary elements: in the central nave, the engaged shafts are not on the same scale as the ones at the heart of the pillars; in the side aisles they gain in effect because the central shafts are visibly smaller.

The chevet, the first part to be constructed, provided modules for the rest of the building. Let us take the case of the upper triforium: in the apse, its arches are of course narrower than on the straight walls. Four equal arches fill the space between two supports. Where the wall is straight, as well as being much wider, the triforium arches have two smaller, supplementary arches on either side of the larger ones. The triforium of the ambulatory has a pattern of six equal arches beneath a relieving arch, but where the choir is straight it has only four arches with plain wall in the last segment of each opening. Standing at the entrance to the choir, on its axis, and looking up at the lower triforium, one sees that the two end piers of the apse "frame" only its four arcades (in other words, they obscure the two extremities), so that what one sees appears to duplicate the upper triforium from this axial position. One gains a very precise sense that these four arcades set between the piers of the curved end of the choir served as the structural basis for all the forms that both triforia would be asked to take: in the end, their elevation constitutes only an enrichment of this module, which is never abandoned.

There is another observation to support the hypothesis that the design of the chevet constitutes the matrix from which the entire building sprang. The diagonal ribs of the apse culminate in a boss placed at a considerable distance from the first transverse rib—exactly the same distance separates the latter from the boss of the most easterly sexpartite vault of the choir.

The four piers marking the last rectangular bay of the chevet are all thicker in section; the four to their east, in the apse, and the first two immediately to their west are all thinner. Here again, everything happens as if the last rectangular bay of the chevet provided the auteur of the architectural program with the module that, multiplied by two, would give the sexpartite module used thereafter.

The second stage of construction, probably begun around 1225, did not introduce any fundamental changes. The openings of the lancets and the oculi in the windows of the three inner aisles were enlarged, however. The pattern of the arches in the openings of the lower triforium was also changed, so that the four are grouped in twos under a relieving arch, with the subdivision between the pairs marked by a thicker column placed on a socle, then on a pedestal. A small oculus for each pair of lancets, and a central oculus below the relieving arch together form a pleasing, hierarchic composition. The outcome is that the concern for uniformity characteristic further east in the triforium yields to a decorative design which is structured in a more modern style but remains, crucially, within the bounds of a single overall form.

It is important to emphasize the subtlety with which all the visual factors are treated. I have already referred to the rejection of any too pronounced axiality, but the choir is nevertheless an essential element in the architectural composition. Standing (once again) centrally at the entrance to the choir and looking up, we can move our gaze backwards from the Lady Chapel (which opens on to the axis of the chevet) toward the summit of the choir ceiling, by way of a succession of small cells—the *S*-shaped ribs of the outer ambulatory, then the arches of the inner one surmounted by its triforium and windows above, the slender, narrow arches of the upper wall, the upper triforium and uppermost windows. The light-filled apsidiole is almost a miniature version of the whole church.

The distance between the first two pillars to left and right of the nave is less than that between the last two in the choir. This stems from a wish to compensate for the effect of narrowing necessarily produced by an architectural perspective of this kind. It is also likely that there was a desire above all to magnify the width rather than the length.

In other respects, the five aisles are not all treated alike. The two inner side aisles are particularly narrow, and their length is increased visually by the narrowing caused, at their east ends, by the broadening of the central part of the choir (fig. 46). The outer aisles, on the other hand, are wider, somewhat archaic in their proportions. The reason for the difference is that the primary function of the intermediate aisles is to fill the middle aisle with an abundance of light. Thus at Bourges, light is not simply associated with the idea of height, as it is at Chartres, where the clerestory windows create a kind of paroxysm of light, but also with spatial depth and its expansion. Knowledgeable organization of volumes and the treatment of light create coulisse-like effects here, as if three pairs of "wings" were being used to suggest a space made up of successive planes. The illusion produced is that of boundless space unceasingly hollowed out by light. The dimension of a space not made by human hands is equally discernible in the realization of the pillars, which pass through the vaulting as if they would support the vault of heaven itself.

All this is diametrically different from Chartres, like the treatment of the walls. Everywhere, relieving arches lighten the mass of the walls. The windows at Bourges have a particularly remarkable quality; it is true that they are still "cut out" in the thickness of the wall, as at Chartres, but small, face-bedded columns support arch moldings forming a kind of frame, both inside and out, of great refinement. It represents the application of a principle that not only lightens the mass of the niche but also confers on it a status analogous to that of the triforia: the wall surfaces give the impression of filmy layers. Between such tall piers they look as if they have been drawn, underlined with light shading.

The true revelation of this architecture does not emerge from its overall "finished" state, which cannot compete with Chartres but from the experience of space it offers. Wherever one stands in the ambulatory or the choir, whether looking up, or along the side aisles, or round the spacious apse itself, perspectives come into view that palpably alter our habitual mode of apprehending a medieval building.

What strikes me is that there is a completely new idea at work in this architecture, one that is perhaps not fully realized. If Bourges borrowed from Cluny III the idea of an immense body with five aisles—which seems undeniable—it was for the sole purpose of executing it in a new language and with the technical means that would give it an exceptional artistic standing. Chartres is magnificent, but it remains indebted to its sources of inspiration,

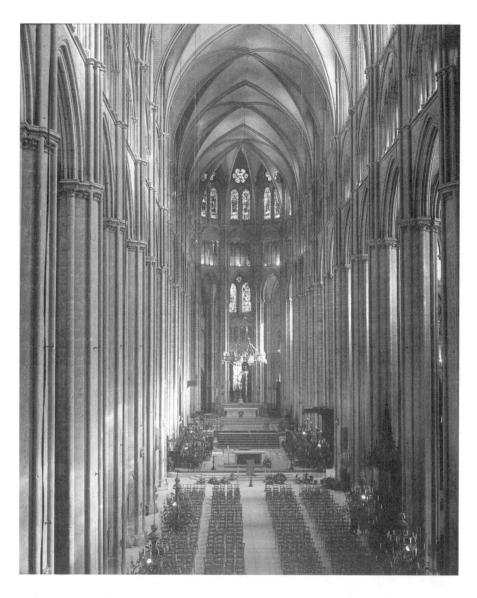

FIGURE 46. The choir of Bourges Cathedral, an axial view. (Photo: Zoom Studio)

both remote and recent—in late classical antiquity and in Romanesque architecture. Nothing could be further from the case with Bourges: the five aisles of Cluny, or even of Notre Dame in Paris, are reinterpreted here, thanks to completely unprecedented conceptions of the pier, first of all, then of the walls, and, above all, of the interior space, treated as a homogeneous whole. The difference can be formulated even more precisely. It is not surprising that the three great cathedrals of Chartres, Reims, and Amiens have been regarded as "classical"; their verticality is accentuated even as it is softened by contrary visual effects, the principal supports in the body of the church, in particular preserving their form, which determines the storied elevation. That, in my view, is what makes them part of a "classical" architectural tradition. The scheme of Bourges Cathedral, on the other hand, is truly Gothic, in that it owes nothing to the classical tradition. If the choice of five aisles can be taken to constitute a reference, via Cluny, to the old basilica of St. Peter in Rome, it was with the ambition of surpassing that model that the master architect at Bourges applied radical innovations made possible by the new conception of architecture manifested in Saint-Denis and Sens Cathedral. The pillars structure the elevation of the whole more than they support it, joining all the stories without breaks and permitting thin screens to act as walls from this time forward, or better still, allowing the upper walls to be eliminated altogether in order to unify the interior space even more completely. When architecture developed a similar conception of space in the fourteenth and fifteenth centuries, especially in eastern Europe, it was simply, according to only slightly different modalities, the accomplishment of the program of the first Master of Bourges.

## THE FRENCH MODEL: CANTERBURY, COLOGNE, AND PRAGUE

I now propose to look at three examples of the way French models were followed outside France, but first, in the light of what I have written above, I must attempt to clarify the notion of "model."

When Abbot Suger wrote in a Latin couplet "May the monument of Denis serve as a model" (*Ut sit in exemplum Dionysi monumentum*), we cannot tell if he was referring to the overall type, certain principles, or perhaps more general characteristics, such as the foundation of the very concept of a "model" or example (*exemplum*). Conformity to a model, in fact, implied an ensemble of features sufficiently visible to evoke the model more or less immediately in the observer's mind.

The question of the model obviously raises that of the beholder: at that date, who were the potential patrons capable of recognizing that Saint-Denis could be taken as a model? The intention to imitate envisages a particular type of public to see the result. Only an advanced architectural culture could make the reference to a model explicit. But if a patron laid claim to so ambitious an association, it ought to have sufficed to establish a relationship with the archetype that would confer a definitive dignity on his enterprise.

The *Chronica Ecclesiae Wympinensis* of Burkard von Hall(ca. 1290), often cited in this context, gives the most precise allusion to the novelty of French architecture. It records the reconstruction of the church at Wimpfen-im-Tal, in Baden-Württemberg, which was directly influenced by the contemporary work on Strasbourg Cathedral, itself influenced by French architecture. Burkard writes that Abbot Richard of Deidesheim, having engaged "a very expert stonecutter [*latomus*], newly come from Paris in France," ordered the construction of "a basilica of stone cut in the French manner." The term *opus francigenum* has often been interpreted as meaning an architectural style; however, in view of the modifications observable in the fabric as one moves from the north to the south of the building, I believe that it is more likely to designate a technique of stonecutting.

For all its intrinsic interest, a document like Burkard's is a drop in the ocean, compared with the number of buildings throughout Europe that took French buildings as their models, with varying degrees of obviousness, or for which workforces of French origin were recruited. Faced with this body of evidence, the art historian is constrained to examine closely the conception and material and technical aspects of these buildings, as well as the historical conditions of the architectural program itself. My chosen examples represent three phases of architectural development (the late twelfth century, the mid-thirteenth, and the mid-fourteenth) and two countries (England and the German empire) in which every aspect of the reception of French architecture differed.

The fire that devastated Canterbury Cathedral in 1174 made substantial rebuilding necessary. For that reason, the monk Gervase of Canterbury tells us, "architects, both French and English were assembled; but they disagreed in their opinions" as to the right course of action. Some believed the damaged pillars could be repaired, others were in favor of completely demolishing the old church and rebuilding from scratch. From among the participants in this discussion, a certain William of Sens was chosen as architect, "a man of great abilities, and a most curious workman in wood and stone." He came from the town where the former Archbishop of Canterbury, Thomas Becket, had been in exile, and he was also probably the most persuasive spokesman of the

faction that favored rebuilding only the choir. The plan was rapidly conceived and put into execution. By the time William of Sens suffered a serious fall from scaffolding in 1178, which forced him to give up directing the work, the right-hand side of the choir was finished and the transept crossing rose to the height of the triforium. His successor, William the Englishman, seems essentially to have followed the first William's intentions for the building of the Trinity Chapel and the Corona, the axial chapel enclosing the chevet where the remains of Thomas Becket, canonized in 1173, had been laid to rest.[15]

The specific influence of Sens is manifested in the twin columns in Trinity Chapel and the magnificent capitals with foliate volutes they support. The shafts of these columns are in red Purbeck marble, a material used throughout the building for small, face-bedded columns. The use of this southern English stone may now look like a stamp of the vernacular on an architectural style partly imported from France, but we should not give this specific feature an importance it may not have had in the Middle Ages, for the shafts in Sens Cathedral itself were certainly painted. I shall return to this point.

I have already drawn attention to what differentiates the modenature of Canterbury from continental forms. Another particular feature, with greater influence on the overall elevation, derives from the Anglo-Norman heritage. This is the structure of the long wall of the nave, where a blind gallery serves as the base for a thick clerestory wall, giving a ledge in front of the windows. At the level of the gallery, a horizontal flying buttress supports the nave wall while being itself supported on a massive abutment protruding below the windows. We should note that the ceiling vaults are distributed in four bays on either side of the transept crossing (fig. 47).

It was William of Sens who decided on the type of structure to be adopted in Canterbury; evidently, he did not import it from France. What he accomplished, in fact, is a compilation of archaizing formulas—borrowings from Anglo-Norman architecture—and "literal" quotations from Saint-Étienne in Sens, but in doing so he produced a perfectly integrated whole, as we might say nowadays. Gervase of Canterbury took pains to write about the work with a competence rare in the Middle Ages and certainly far exceeding the meager architectural knowledge of Abbot Suger.

Demolition of the old choir, Gervase wrote, "changed [it] into a new and more magnificent form"; the new pillars were more slender and the capitals more finely carved than the old ones, which were plain and had been cut with the axe, whereas the new ones were carved with the chisel (no detail could better illustrate just how knowledgeable Gervase was). Terms equivalent to axe and hatchet designate more exactly the tools that produced relatively

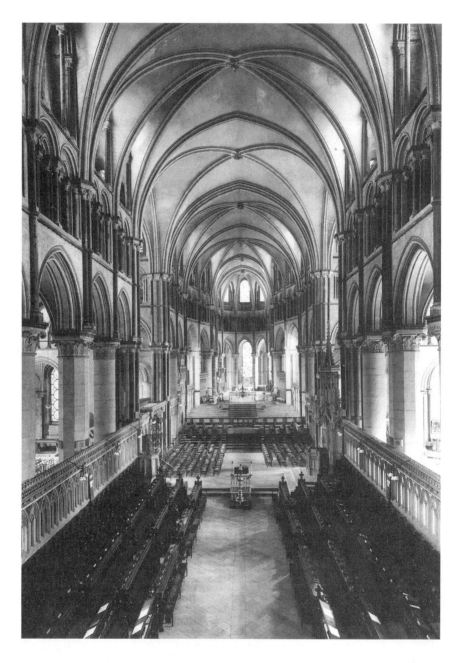

FIGURE 47. The interior of Canterbury Cathedral, with a view towards the choir.
(Photo: Crown copyright, NMR)

coarse finishes, by comparison with the fine carving that could be produced with various types of chisel.

The choice of an architect from Sens, and thus the use of Sens Cathedral as an architectural model, was certainly not simply due to any wishes of the client. Modeling Becket's shrine in Canterbury on the church where the saint had spent so many years in exile was first and foremost a political gesture of major significance. We should remember that Louis VII of France did not merely give the archbishop a refuge but also produced a reconciliation between him and Henry II. In any case, the quarrel between Thomas and Henry certainly had some bearing on the choice of a French church as model.

An aesthetic consideration could have been another reason for it. The need for novelty clearly reflected in Gervase's admirable text inspired the client. Reading Gervase, one even gets the feeling that the party who wanted to raze the old church was influenced less by reasons of safety than by a deliberate will to innovate. But, as always in the Middle Ages, novelty did not mean a definitive break with tradition, just as following a model did not entail servile imitation.

The case of Cologne Cathedral presents related issues. In 1248, when the chapter and the archbishop, Conrad von Hochstaden, decided on the reconstruction of a building that went back to the Carolingian and Ottonian eras, they entrusted the task to a certain Master Gerhard. He conceived a plan analogous to those of Amiens and Beauvais: a relatively short nave—only five rectangular bays, a very wide transept, and a choir with ambulatory giving on to five radiating chapels. The clients' haste was such that the first stone was laid less than four months after the fire. The affinities between the elevations of the choirs at Cologne and at Amiens (where construction was interrupted below the triforium around 1248) have often been pointed out. Where Amiens has a triforium with two-times-two lancets and a high window with four lancets, Cologne reduces the design to two lancets in each position. The simplification accentuates the elevation and increases the entrance of light; the tendency in Cologne to pierce the wall wherever possible is also visible in the decision to dispense with the very long batter supporting the vertical divisions of the upper windows (fig. 48).

In Cologne, as in the new choir at Saint-Denis, there are no horizontal interruptions of the engaged supports in the rectangular bays. The capitals are the only sign of where the vaulting begins. The master mason at Amiens, Robert de Luzarches, put round piers in the choir, surrounded by four shafts. In Cologne each is surrounded by eight shafts, the four facing the choir bearing two diagonal ribs and two exterior faces of an arch in the main arcade, the

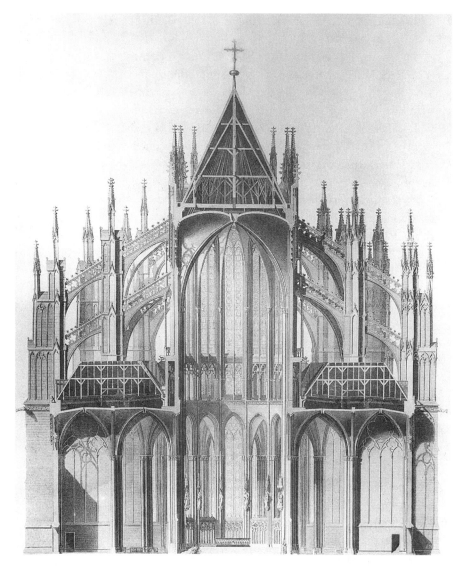

FIGURE 48. Transverse section of the choir of Cologne Cathedral, from the print by Duttenhoffer. (Photo: Rhienisches Bildarchiv, Cologne)

four facing the other way supporting the two diagonal ribs and the exterior faces of an arch in the main arcade. The visual effect is both to accentuate the impression of verticality and to fragment the structural elements. The most obvious pointer to the dominant aesthetic principle of Cologne Cathedral is probably the engaged shafts of the piers of the semicircular apse, so thin that it seems impossible that they should have any supportive function and yet they rise from the floor to take the weight of the diagonal ribs of the roof vault.

If a certain austerity is characteristic of Amiens, the forms in Cologne have a metallic quality. Perhaps it is as much to say that Cologne represents the apogee of the type of the "classical cathedral" whose normative examples are Chartres, Reims, Amiens, and Beauvais. Do Chartres and Beauvais have so much in common, after all? This conception of a norm—a "classical" norm, at that—has a very French resonance, yet paradoxically it is a commonplace of German historiography. It scarcely takes the reality into account: the French monuments are distinguished by their very individual characters. What they have in common is the ambition manifested in each new building to break the records set by the previous one. In the main nave in Cologne, the keystone is 139 feet above the ground, about three feet higher than at Amiens!

Cologne Cathedral was to remain unique within the Holy Roman Empire, the most spectacular manifestation both of Conrad von Hochstaden's savage hostility towards the Hohenstaufens and of his Francophilia, or so we may at least surmise. Amiens, Beauvais, and Saint-Denis for the choir, La Sainte-Chapelle in Paris for the idea of apostles ranged against the pillars in the choir: these provided some of the archbishop's aesthetic models. But Master Gerhard used forms more advanced than those of the French models, which means that Cologne, in spite of everything, is an architectural creation of the first magnitude. The architect thus played the role of a *commentator*, to use St. Bonaventure's term. Nowhere is the modernism propped up by empty gestures inspired by Reims or Amiens; in this respect, Cologne looks somewhat behind the times, perhaps because the architect would have found it impossible to recruit a workforce that had gained its experience on the building sites of northern France and so had to hire masons and stonecutters from Rhineland.

It is hardly surprising to find a large number of architectural drawings at Cologne, providing quite a precise picture of the project. In this particular case, drawings must have played a decisive part in the execution of the constituent elements and ensuring their agreement in even the smallest details, for this architecture manifested an ambition still far beyond anything that a team of stonecutters and masons from within Germany would have learned from their

own experience. Only Strasbourg had been in the position to recruit a qualified workforce trained in the new methods of construction, during the erection of the south transept and above all the nave, not long before work began on Cologne.

The Emperor himself was the client in the case of Prague Cathedral, where, unlike Canterbury or Cologne, a change of master builder was matched by a change in aesthetic orientation.

Charles, King of Bohemia, had obtained Prague's elevation to the seat of an archbishopric from Pope Clement VI in 1344. Charles had gone to Avignon in March, at the moment when the pope, whom he had known as Pierre de Fécamp at the court of his uncle, King Charles IV of France, was putting the papal palace in the hands of Jean de Louvres. Charles lost no time in recruiting an architect called Matthew of Arras for the cathedral church he wanted to build in Prague. It is worth noting that Clement VI had been bishop of Angers in 1328, and all the evidence suggests that Matthew was chosen by Charles on the pope's recommendation.

The first stone of Prague Cathedral was laid on November 21, 1344. Financing of the work was assured by the royal revenues from Bohemia's silver mines. Matthew's plan was for a choir with ambulatory and projecting radiating chapels, a type unknown elsewhere in the Empire except at Cologne. The architect chose models from southern France—Narbonne and Rodez, for instance—but none were copied literally. Furthermore, the buttresses and the abutments around them are furnished with pinnacles, which is completely contrary to what was usual in France at the same period. The piers are formed from bundles of very slender shafts which support the arches as well as the elements of the vaulting.

When Matthew died in 1352, some of the polygonal chapels already stood quite high and the completed piers of the apse supported pointed arches. The project was then interrupted for several years, as it was only in 1356—a year after Charles was crowned as Emperor Charles IV—that a young architect called Peter Parler was appointed to finish the task. The resulting aesthetic change of direction was considerable. The new piers were much more plastic in form because Peter Parler put a tighter ring of columns around them; the more lightly constructed triforium took on an appearance that, although unknown in France, bears some relationship to the great churches of Brabant (figs. 49 and 50).

The roof vault, finally, is the young architect's most masterly creation. Dispensing with transverse arches, he made all the diagonal arches the same size, and they crisscross the vault like a net. Outside, the system of buttressing

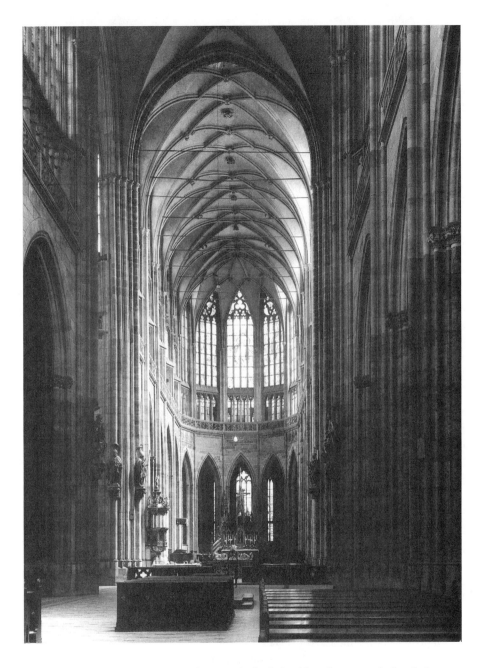

FIGURE 49. The Interior of Prague Cathedral, with a view towards the choir.
(Photo: Werner Neumeister)

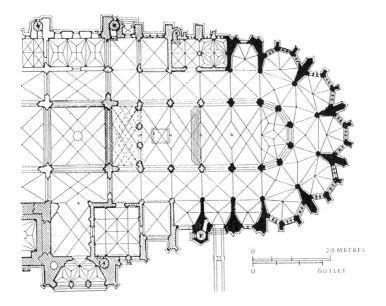

FIGURE 50. Plan of Prague Cathedral

is infected by a taste for dividing every surface by means of lancets and blind arcading. Towards the west end, in accordance with a plan already drafted by Matthew, Parler built the sacristy on the north side and the St. Wenceslas Chapel on the south; these have vaults covered in stars and the sacristy has pendant bosses; this time, we must look to Strasbourg for the model for this extraordinary creation. The influence of Parler's work on the subsequent development of architecture in the late fourteenth and fifteenth centuries was considerable.

We are in a position to distinguish two periods in Charles IV's architectural activity: the first, corresponding by and large to the time when he was margrave, King of Bohemia and King of Germany, is characterized by a certain pluralism in aesthetic outlook. The buildings undertaken directly under Charles in Prague, such as St. Mary of the Snows, the Emmaus Convent, and the Karlov, are strongly marked by the architectural style of the mendicant orders in the first two cases, while the third is modeled on the Palatine Chapel at Aachen. With the appointment of Matthew of Arras, Charles hoped to give the capital of Bohemia, the future capital of the Empire, a cathedral in the French style. French architects had worked in Bohemia before this. William of Avignon had designed the Elbe bridge at Roudniče in 1333, and King John is known to have

erected buildings *gallio modo* in the Old Town in Prague. The idea of a kingdom of Bohemia consolidated by the mythical figure of St. Wenceslas was certainly inspired by the cult of St. Louis in France.

A change in Charles's attitude becomes discernible towards the end of the 1340s. After the death of his mother, Blanche de Valois, in 1348, his political interests distanced him from France, weakened by the defeat of Crécy. Rejecting the advice of Pope Clement VI to take a wife "from the very Christian house of France" (*ex christianissima domo Francie*), he eventually married a Wittelsbach, Anna of Schweidnitz, from the Palatine branch, which gained him strategic advantages in the Middle Rhine.

With the death of Matthew of Arras, the change was reflected in Charles's building activity in the appointment of a member of the Parler dynasty to replace him (another member also worked for Charles as architect of the Frauenkirche in Nuremberg). Things followed an approximately analogous course in the field of painting; the Siena-Avignon influence, dominant at the court until around 1360, waned with the appointment of Master Theoderic as court painter.

Just as it is possible to interpret La Sainte-Chapelle in Paris as a symbol of the ideology of the divine right of kings, so Prague Cathedral conforms to Charles IV's idea of the kingdom of Bohemia and of Prague as the imperial capital. That, however, does not explain the actual history of the building: for a man as knowledgeable as Charles, the choice of Peter Parler was the response to a wish for innovation that Matthew of Arras had not satisfied. What is certainly the most interesting aspect of this French import to Prague is not the work of Matthew but that of Parler and his prodigious ability to develop his own conception of the building on the plans of another while remaining faithful to the monumental ideal of a great cathedral. The result is an astonishing paradox: Prague Cathedral, the typology of which was conceived with the intention of being French, ended up as the most advanced expression of an entirely new phase in the architecture of central Europe. Parler's talent made him a full-fledged *auctor*, with the knowledge to use the visual testament of his predecessor to strengthen his own discourse, and also a *compilator* of genius, capable of assimilating elements drawn from a very large repertory. A similar procedure might have resulted in eclecticism, but not here. His manner of renewing the place and function of the semicircular arch is proof enough.

We can observe a massive return of older forms just about everywhere in Europe from the end of the fourteenth century onward; thirteenth-century ones were particularly prevalent. So we see that there is no such thing as a complete break and above all that no one building can be regarded as decisive

in the emergence of a form. So-called Late Gothic makes use of a large number of earlier forms—profiles, tracery, pillars—without there having necessarily been any programmatic intention. Even in the case of Prague Cathedral, we have seen that only the overall aesthetic option can be attributed to Charles IV; the system of references put in place by Peter Parler inside the church, which is what allows us, after all, to speak of his style, arose only from his exercise of his profession. Just as modes exist that determine the very nature of the architectural solution produced for a particular project—and Parler provides some telling examples of this in both architecture and sculpture—equally there are semantic structures whose modalities of internal organization and distribution are accessible only to professionals.

At Canterbury and Cologne, we see that the adoption of models from Burgundy and northern France came about in the framework of very different projects, obviously, but also in the context of purely architectural considerations. Architects in the late twelfth century clearly regarded their projects as works of art and increasingly gave priority to formal realization and the development of structural solutions in response to the most diverse of demands. In dedicating himself to these two areas of enquiry, the architect began to emerge as an individual and to grow in importance.

The process whereby architecture developed into an autonomous art expanded as the ambitions of the clients grew—sometimes beyond all measure. The direct consequence was the individualization of the architect: he became, in fact, a pure ideas man, someone who, around the middle of the thirteenth century, would perfect the skill indispensable to his own emancipation and to his authoritarian role as head of the masons' lodge, namely, architectural drawing.

## ARCHITECTURE, COLOR, AND GLASS

One of the essential visual qualities of architecture came from polychromy. It was true of the architecture of antiquity and of the Middle Ages, and it was also true during the Renaissance, in the mannerist and baroque eras, and of course in the nineteenth century. Only two periods have refused to allow color to intervene in architecture: the age of classicism and the twentieth century, which sought above all to emphasize the purely linear quality of forms and structures, to which the twentieth century added the beauty of the material itself.

During the nineteenth century, architects and archeologists discovered polychromy's importance for architecture in the course of methodical explorations of ancient monuments. It was the subject of a lively debate, especially

after the discoveries made in Sicily by Hittorff in 1823–1824. The question of medieval polychromy did not cause a comparable controversy; surviving traces were numerous enough to prevent any doubt as to the authenticity of the phenomenon. What is more remarkable is that, until very recently, historians of architecture paid very little attention to it. Yet a host of theories—that of diaphaneity in particular—and a host of formalist interpretations claiming to define the specific qualities of Gothic space are blown sky-high when the eye starts to read the interior of a Gothic building, not as the play of articulated, three-dimensional forms, but as an illusionist construction produced by color effects with their power to contradict the architecture.

The contradiction does not appear to have occurred to Viollet-le-Duc, who saw in Gothic painted decoration "the need to make the painted ornament conform to the structure, and even to support it by the type of painting"; for him there were only two kinds of painting in architecture: one "subject to the lines, the forms, the design of the structure," and one that paid no attention to the structure but "spreads itself independently over walls, vaults, pillars, and profiles."[16]

Mural decoration was the target of severe criticism from the twelfth century onward. St. Bernard fulminated in the *Apologia ad Guillelmum*: "Oh, vanity of vanities, but not more vain than mad! The church is gorgeous on her walls but niggardly toward the poor. She coats her stones with gold and leaves her sons naked." He deplored the huge size of churches and the "sumptuous adornments, questionable paintings." A little later, in *De naturis rerum*, Alexander Neckham condemned the same things: "The even surface of a wall is due to the smoothing and polishing of the mason's trowel."

These two passages draw attention to the twelfth-century notion of decoration, which began with the provision of a surface intended to be painted. It is hard for us today to imagine that the beautiful walls of cut stone we find so admirable were entirely covered with colored ornamentation and painted representations of masonry, already in Norman and Cluniac architecture of the twelfth century, and yet more prominently in Gothic architecture—even Cistercian buildings. The practice arose from a wholly remarkable conception of color and space.

Color had an important place in the philosophy of nature prevalent in the thirteenth century. Regarded by Witelo as the only object of visual experience, along with light, that could be perceived solely by the sight, color gave light its determination. Light is the *hupostasis* of color, as Aristotle had said. Robert Grosseteste wrote a short treatise entitled *De colore*, in which he defined color as "light incorporated in transparency" (*lux incorporata perspicuo*)

and distinguished two opposing colors: black and white. Following Aristotle and Averroes, he regarded the first as absence or deprivation (*privatio*), the second as form or appearance (*habitus, forma*); between them lay seven degrees and innumerable differences of intensity distinguished according to their luminosity and purity.

A number of factors make the study of architectural polychromy a delicate undertaking. Unappreciated during the classical era, medieval polychromy was often whitewashed or repainted without any regard for the original palette. Consequently, nowadays we have to have recourse to stratigraphic analysis in order to reveal the constitution of each layer in succession. The layer that appears to be the original—that is, contemporary with the construction itself, hence the one wanted by the architect—cannot be evaluated historically until it has been compared with the evidence of other examples taken from contemporary monuments. Furthermore, it is almost impossible to examine a building in its entirety, even one of modest dimensions. We have to do what we can with what is accessible, usually without scaffolding. With regard to architectural color, we have to adopt the same circumspect attitude as with ornamental or representational reliefs: we must always bear in mind that each and every instance is subject to change over time and, at any given moment, from one building to another. A decorative scheme may indeed be rich and splendid, as in La Sainte-Chapelle in Paris; it may be spare and simple, conforming to a spare and simple style of architecture, as in the Église des Jacobins in Toulouse or the Cistercian church at Longpont-sur-Orge; or again it may take the form of an array of windows, as at Chartres.

Let us begin with a simple architectural element such as the shaft of a column, taking three specimens from the twelfth century as examples. The simplest case is that of a slender shaft, covered with an undercoat, then with a layer of color. In Saint-Denis, in the chapels where it seems to be the case that the interior of the Carolingian building was covered in color, that is, in the radiating chapels of Suger's *carole*, there are shafts of that description which were covered with spiraling parallel bands "light green on a yellow-white base, bordered with a red-brown strip, with white spots on top of the red and green." Another example is the attached columns flanking the basilica's main doors, decorated with geometrical patterns in low relief. Everything suggests that this carved work was covered with a layer of color which would have emphasized certain motives. The third example could be found in Saint-Denis again or in an English church, such as Canterbury Cathedral, because the example is more telling, or in any other building with columns in a colored marble. Here, the polishing of the marble accentuates the brilliance of the column,

an effect not obtained in either of the other cases. The choice from these three procedures depends on the scale of the architectural project, on local conditions (governing the materials), and on the available financial means. But once the column was in place, the overall effect will have been what was sought for. At the same time, we must be careful not to read into the past the impression produced today by Purbeck marble columns in a church stripped of every other trace of polychromy. It appears that medieval man's conception of the intrinsic beauty of a material applied unreservedly only to goldsmith's work. There is no evidence of any aesthetic appreciation of materials for their own sake in the case of architecture or sculpture; on the contrary, study of work of the time casts serious doubt on any such idea.

It is weakened further by the practice of covering a fabric of cut stone with a colored undercoat or directly with a coat of paint. The original polychromy is remarkably well preserved in the choir of Saint-Quiriace in Provins. The upper wall and the piers surrounded by attached shafts separating the bays are uniformly painted ocher, and vertical and horizontal joints are emphasized by white lines between two thin red lines. This feature does not correspond exactly to the joints between the stones, but it hides them completely. It is also used on the *nervure* of the vault. Only the cornices and the attached face-bedded columns in the triforium are picked out in red, blue, or white. At the level of the triforium, the rectangular or projecting nucleuses of the piers are ocher, a means of underlining that they are part of the wall while the attached columns are treated as purely decorative elements. The capitals were also brightly colored. The choir of Saint-Quiriace provides the proof that it was not the material that counted but rather the general appearance; the illusion had to be created of a perfect unity in the supportive structure, as if the openings were cut in a homogeneous mural mass, which the colored elements were simply there to adorn (fig. 51).

The decorative scheme of Saint-Quiriace can be regarded as characteristic of architectural polychromy as it was used around the year 1200. It was to undergo profound changes during the thirteenth century, although it is important not to generalize from any one instance, as it is known that the upper walls of Amiens Cathedral were painted gray with white joints, the vaults were red with white joints also, while the interior of Chartres was painted ocher all over (see figs. 41–44, above).

The development of the art of stained glass and the enlargement of windows have been related to each other without any consideration being given to the existence of architectural polychromy as a given, though it was essential to the very nature of the relationship. Viollet-le-Duc nevertheless paid a lot of

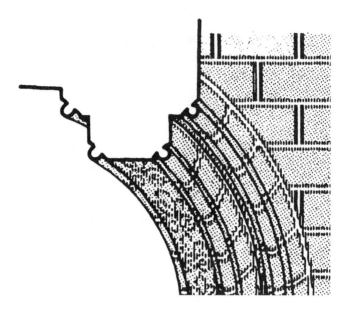

FIGURE 51. Polychromy in Saint-Quiriace, Provins
(after J. Michler).

attention to the matter. He observes that in the early thirteenth century window embrasures were decorated with motifs in black and white and then, in the middle of the century, with "tones very close to black, such as saturated red-brown, very intense blue-green, dark slate-blue, deep brown-purple," which made "a frame for the stained glass," itself bordered with white glass in order to "circumscribe the radiance of the colored panels."

La Sainte-Chapelle in Paris cannot be regarded as representative of Gothic architecture in the Île-de-France in the middle of the thirteenth century. Erected by royal command and using the most expensive building techniques, it was constructed within only a short period, from 1240–1243 to 1248. Its windows constitute a uniquely unified ensemble, and its interior polychromy is also quite unlike any other. No doubt the decoration shocks some present-day visitors, but despite a few of the nuances, it is faithful to the original decor, except on the inside wall of the west front (fig. 52).

During cleaning work in 1842, significant remnants of the original polychromy were discovered in the upper chapel, in the fourth bay from the east, in such good condition that in several places the primer beneath the paint or gilding was still preserved. The architect Félix Duban, charged with the restoration of La Sainte-Chapelle, under the Inspector of Works Jean-Baptiste

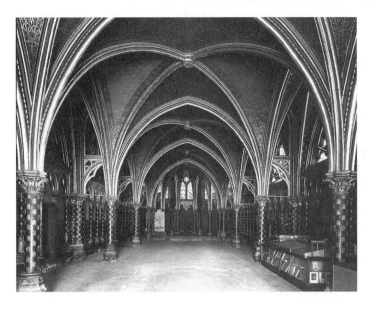

FIGURE 52. The lower chapel of La Sainte-Chapelle, Paris. (Photo: Hirmer Fotoarchiv, Munich)

Lassus, reported: "The shade of blue used [by the restorers] to match the areas of painting beneath the ornaments of the frieze in the arcading and on the capitals is composed of ultramarine and cobalt. The shade of red in the same areas is matched by a pure oak vermilion with madder lacquer. The areas of old paint that existed have been preserved and set off with great care." Viollet-le-Duc, who was associated with the work, refers to it several times in his *Dictionnaire*. In particular, in connection with the "harmonic value of colors" (both absolute and relative), he writes: "La Sainte-Chapelle presents the oddest example of this chromatic scale. Despite numerous and large remnants of the original colors, there were many difficulties at the time of the restoration; some tones had to be redone numerous times, in the absence of perfect experience. In repainting a shade of which a reliable trace remained, it was often necessary to change the value of the tones above or below."

The two dominant colors in the interior decoration of La Sainte-Chapelle are also those used more than any other in the windows, that is, red and blue; but we should not forget the gold which plays a determining role for reasons that Viollet-le-Duc expounded very precisely. Because blue has a strong "radiance," especially when applied to large areas, "its presence alters . . . all

other tones; with blue, red iridesces, yellow turns green, secondary colors turn dull or gaudy. Only gold, by reason of its metallic reflections, is able to restore harmony between the tones." Gold "hinders the blue's radiation . . . , lightens the red . . . , gives the greens a brilliance they would not have next to blue areas." Using gold is dictated less by "a vulgar desire to give richness to a painted decoration" than by "a need for harmony imposed by the adoption of blue over large areas, and the adoption of blue over large areas is dictated by the stained-glass windows."

In fact, the insertion of intensely colored glass, as was done in the thirteenth century, made the light tones used in the decoration of the church's interior seem heavier. The use of a vivid blue was the solution to this problem, but, Viollet-le-Duc continued, this led to a revision of the decorative scheme as a whole. To moderate the azure of the blue surfaces lit by light refracted by the stained glass, gilt stars were sprinkled over them: "Immediately the blue took its true value and instead of appearing to crush the body of the church, it raised itself and became transparent." As a comparison with the decorative scheme used in La Sainte-Chapelle, Viollet-le-Duc cites the later scheme of the choir of Saint-Nazaire in Carcassonne: gold being too expensive, blue was not used either. Blue is the color the master glazier strove to "control" above all others.

However, we should not overlook the heraldic aspect of the decoration of this royal chapel. The principal columns supporting the ribs of the roof are alternately painted red and blue; the castle of Blanche of Castille is painted on the former, the lily of the Capets on the latter. It appears that La Sainte-Chapelle is the earliest religious building to benefit from such a heraldic scheme.

A significant modification in the treatment of architectural polychromy can be observed during the course of the thirteenth century. By degrees, the clusters of supports standing out from the wall were no longer painted like elements in relief against a mural base where the emphasis still lay but like significant punctuation marks beside which what remained of the wall was only a "disembodied" screen. The vertical and horizontal joints form a sort of regular net or mesh, serving as background to the articulated elements of the architecture. In the abbey church of Saint-Ferréol in Essômes, for example, the almond-profile ribs (at the west end of the church) are deceptively dressed in such a way that the joints are out of step with those of the arch on which the ribs give the impression of being supported; the same system is found on the main arches at the same end of the church but, here, on the secondary torus

moldings. Everywhere, the wall surface is ocher with white joints, while the joints on the arches and transverse ribs are white, bordered with red lines, as on the wall surface as a whole at the east end of the building. In the parish church of Cambronne-lès-Clermont (in the diocese of Cambrai), the torus moldings of the transverse ribs are white, emphasized by the red covering the contiguous cells.

All these examples illustrate how far architectural polychromy was from a simple matter of "coloring" a stone support. It served to strengthen the visual impression produced by certain elements, and to accentuate one form over another within a profile. For this reason I cannot support the thesis advanced by the most recent German scholarship, which sees architectural polychromy in the late thirteenth century as a practice perfectly in accord with the way architectural style was developing. The example of the church at Cambronne, dating from around 1239, shows that the profile is in some sort dislocated and lightened by the painting; this is particularly striking when the result is compared with the same form in monochrome. This purely optical double principle anticipates the late Gothic conception of the profile of an arch. I would suggest as a hypothesis that such refinements, being applied to thirteenth-century architectural polychromy, would gradually have encouraged a taste for dislocated and lightened forms among architects and masons. It is obvious, after all, that the colored decoration of Gothic architecture must have had an effect on the architect's overall vision of his work.

Broadly speaking, the dawn of the fourteenth century witnessed the abandonment, just about everywhere, of ocher, gray, and red as colors for wall surfaces such as had been common in the previous century; white, in general use in the interiors of Italian churches, now spread northward as well. A certain number of buildings of the mendicant orders, such as the Dominican church in Constance, perhaps contributed to the introduction of this type of decoration around 1300 (fig. 53). Gray with white joints was adopted from the first half of the thirteenth century onward to simulate the appearance of regular stonework in Lausanne Cathedral. It may strike us today that such coloring is a response to aesthetic notions favoring bareness and simplicity, as among the Cistercians and the mendicants, but it was not adopted universally: Chartres Cathedral and the church of the Cistercian abbey at Longpont-sur-Onge were decorated in yellow ocher paint at just this same period. In the Jacobin church in Toulouse, the painted decoration was tiered: dark colors at ground level, white with red joints at the upper level, and an even more striking color scheme in the roof vault.

FIGURE 53. Polychromy and figural painting in the nave of Dominican Church
in Constance (after J. Michler).

Let us turn to the fraught and even less well documented question of the
exterior polychromy of cathedrals. According to Viollet-le-Duc, no facade
was ever covered entirely with a colored decoration, but selected areas were.

> Thus at Notre-Dame in Paris the three doors with their coving and
> tympana were painted and gilded all over; the four niches linking these
> doors, containing four colossal statues, were also painted. Above, the
> gallery of kings formed a broad band all colored and gilded. Painting
> above this band was found only on the two big arches with windows
> below the towers and on the central rose which sparkled with patches
> of gold. The upper part, lost in the air, was left stone-colored. . . . Black
> had an important part to play in this coloration, outlining mouldings,
> filling in backgrounds, encircling ornaments, redrawing figures in broad
> lines, placed with a true feeling for the form.

That is to say that certain architectural elements in addition to the carvings
were colored. A medieval architectural drawing of Strasbourg Cathedral,
which we know from a copy made in the seventeenth century, was the subject
of a controversy that can now surely be resolved. The copy shows huge areas
highlighted in blue and red, accentuating only architectural elements. The
most common assumption was that these areas of color were the product of

the copyist's imagination, but it is perfectly possible that they represent such of the polychromy as was still visible in the seventeenth century. There are eighteenth-century sources confirming the presence of areas of color on the west front of Amiens Cathedral at that time.

One question still remains: who was responsible for architectural polychromy? One would like to reply "the architect," but that is not certain; professional painters carried out this work, which had to be done at the same time as the building itself or else new scaffolding would have had to be erected, causing extra expense. So these painters must have enjoyed a relative autonomy.

We shall see that in the case of carvings the work of the painter was conceived as a contribution with its own aesthetic finality, which sometimes even succeeded in masking the sculptor's skill. The painter also had the task of glossing—one might say "falsifying"—the nature of the material, as when he painted veins of marbling on the shaft of a column or disguised the wooden structure atop the octagon of Ely Cathedral so that it looked as if it was made of stone.

The quantity of literature on the subject of colors and their symbolic functions is enough to deter anyone from an attempt of sorting through it. But if one focuses on a limited field of research, such as architectural polychromy or the colors of stained-glass windows, the field turns out to be virgin soil. Yet how could we form even an approximate idea of what the interior of a medieval cathedral was like if we do not take these two essential factors into account?

Architectural polychromy had, in fact, a decisive effect on the perception of the stained-glass windows: the yellow ocher covering the interior of Chartres must have taken on a gilded tonality in the colored light, and that would certainly have emphasized and accentuated the dominant colors of the glass: blue, red, green, and yellow.

Since the appearance of the first writing about light, there has been a general tendency to look on stained glass as an art of light, elevated by the architecture called "Gothic." Louis Grodecki was the first (in 1949) to expound the dialectical relationship that existed between architecture and stained glass, from the date of the windows of the choir of Saint-Denis to around 1300. For him, the master glaziers unfailingly kept up with the "advances" made by architecture in the progressive enlargement of windows.

The very conception of the Gothic window had a powerful influence on the palette and arrangement of the colored surfaces. Broadly speaking, during the twelfth and thirteenth centuries, glaziers tended to make glass darker as

windows grew larger. To begin with, in the second half of the twelfth century, windows were light, but colors grew more intense around 1200, particularly as a result of chemical modifications in the manufacture of blues. Toward the middle of the thirteenth century, when a building, such as La Sainte-Chapelle, was being transformed into a veritable glasshouse, the "covering" or "isolating" effect of the glazed surfaces was even more accentuated. A violet shade dominated because of the conjoined effects of a new blue and the proximity of yellow-tinted reds. But this darkening did not become a rule everywhere; inside Bourges Cathedral, for example, one finds lighter colors in the upper windows, at a distance from the viewer, whereas the lower, closer windows present a "covering" range of color. Toward 1300, the more frequent use of grisaille and the invention of a rich yellow using silver nitrate extended the properly pictorial possibilities of glass that led back to lighter windows.

One aspect of the history of the stained-glass window has tended to be neglected: before it is a vehicle of light, the window is a picture and as such, needs to be read as a narrative, or as part of one, even if it may not necessarily be accessible to view. Making up a window in medallions does not correspond to a purely formal consideration but allows the narrative to be structured. The structural function is clear at Chartres and Bourges, even though notable modifications intervened between 1205 and 1215. At Chartres, the window of the Prodigal Son subordinates the narrative structure to the geometrical shape of the medallions; at Bourges, in the window on the same subject, the shape of the medallions has no role to play and the narrative is conducted through the figures. This kind of distribution in geometrically shaped compartments seems to have originated at Canterbury during the last two decades of the twelfth century.

Independently of the iconographic content of these compartments, we should note that they subdivide the surface of the window in plane forms, symmetrically organized around a median axis. The artist is constrained to adapt each scene to the geometrical frame fixed by the overall design, an exercise which allows him to give free rein to his inventive genius. But compartmentalization of the window in this way robs each scene of part of its intrinsic spatial character: the very shape of the medallion and the accommodation of the scene within it do no more than give a precise place to each of the protagonists, and any space for accessories and setting is much reduced.

Such economy in the representation of the narrative corresponds perfectly to the specific nature of the window, as analysis of the range of colors demonstrates.

On an opaque support every color makes a spatial effect: a dark color appears closer than a pale one. When the color is translucent the effect persists but at the same time it varies according to the intensity of the light.

The colors of stained glass in the mass are modified according to the quantity of light they filter. They are in general contaminated by the neighboring colors, especially when the light passing through them is bright. Finally, they do not perform the same action when they are dull or at a great distance from the eye.

A strongly "translucent" color, such as blue, will "radiate" more, says Viollet-le-Duc, than a "covering" color, such as red. Violets are even more radiant than blues, and in a strong light they veer in the direction of white. On the other hand, in order to make up for the excessive opacity of red, it was often backed by white glass. Under the effect of light, colored glass "radiates" onto neighboring material and mixes with neighboring colors—red placed alongside blue in small quantities takes on a violet tinge. To contain this radiation, glaziers used to put a strip of yellow or white between red and blue.

The effect of depth plays an important part here. Warm colors (red and yellow) appear closer than cold colors (blue and green). Because of its strong radiance, blue is well suited to be the "background" for a scene or a figure. More luminous colors (white or violet) always appear to be behind the less luminous.

In the twelfth and thirteenth centuries, blue occupied pride of place in every domain. Suger uses the phrase *saphirorum materia* to designate colored glass. And Theophilus Presbyter states in his treatise that the French are particularly well versed in the art of making "panels of sapphire suitable for windows." These panels were made with opaque blue glass, obtained by mixing translucent glass with fragments of mosaic. Thus the "sapphire" of the twelfth century was not what we understand by that word, a translucent stone, pale blue in color, but rather, it was like lapis lazuli, an opaque, dark blue stone.[17]

When we watch the effects of light on the St. Lubin window at Chartres, or the Good Samaritan window at Bourges, especially at different moments of a day in late summer or autumn, we observe that at times of greatest brightness the noncovering pieces of glass radiate more strongly and, as a consequence, the contrasts between the light-colored glasses and the covering glasses are more marked. As the day closes, the contrast fades and the colors lose a large part of their luminosity. All the subtleties of grisaille painting come back into sight, and the finer nuances resulting from the juxtaposition of this shade of

green and that shade of violet are discernible again. It seems that the ideal conditions for seeing a stained-glass window are when the light is not at its brightest.

But Chartres and Bourges do not present identical scenes. If a blue background with a strong radiance makes a figure stand out more in silhouette, creating an effect not so much of depth as of the figure's isolation, slow diminution of the light makes a closer-woven texture appear where figure and background come together. Or again, it can make the effect one color has on its neighbor disappear gradually and erase by stages the violet tint obtained when red is contaminated by blue. Unlike a mural painting or an illumination in a manuscript, a picture in a stained-glass window modulates with the effect of light, and the equilibrium of the color scale is overthrown. It is easy to understand how such metamorphoses, happening in windows from one moment to the next, make the aesthetics of the stained-glass window incompatible with the illusion of a third dimension. By definition, stained glass is an art of two dimensions, because light, when combined with glass and color (two forms of matter), fundamentally modifies their appearance in an aleatory manner. Surely no other medieval artistic technique agreed so completely with a two-dimensional conception of space. Each figure, each scene is simply positioned on a color background, but the figure-background relationship may sometimes be inverted, in any case rebalanced randomly, according to the brightness of the sun. Changes in the weather, the cycle of the seasons, and the time of day all contributed to the fashioning of the images.

To gain a better idea of what is unique to this art, let us examine one of the windows of Chartres Cathedral, the gift of the town's furriers and drapers, and wholly dedicated to the story of St. Eustace. Dated about 1210, it is the work of a master whose work can also be found in the Laon and Soissons regions. His art has parallels to the Psalter of Ingeburge, executed in a scriptorium of northern France, and can be termed "classical" by reason of characteristics which acknowledge the art of antiquity. The patent contradiction between the archaic character of the ornamentation and the sovereign skill with which every least difficulty of a compositional nature is resolved is nevertheless surprising. This artist, one of the greatest of the early thirteenth century, was a master of the language of stained glass. Blue provides the background to each medallion and is also found in the marvellous foliage ornamentation, where it is combined with yellow, green, white, and above all, red. The arrangement of the medallions takes very little account of the panels and their mounting within the window bars: five lozenges form the central axis of the window, alternating with four pairs of round medallions (see figs. 54 and 55).

FIGURE 54. The hunt of Placidus, a detail of the
St. Eustace window (ca. 1210–1215) in the north aisle of
Chartres Cathedral. (Photo: Giraudon)

FIGURE 55. Key to the medallions in the St. Eustace window.

*1–4.* Donors: drapers and furriers. *5.* Placidus (Eustace) hunting. *6–7.* Hunts-
men. *8.* A man blowing a horn and a pack of hounds. *9.* A man driving the
hounds. *10.* The stag with Christ on the Cross between his antlers; Placidus
kneeling. *11.* Placidus is baptized and changes his name. *12.* Eustace leaves
a town with his wife and children. *13.* Eustace arranges passage on a boat.
*14.* Eustace and his wife embark, each carrying a child. *15.* Eustace is thrown
overboard, while his wife is held hostage. *16.* Eustace halfway across a ford; a
lion on the bank carries off one of his children. *17.* On the other bank a wolf,
chased by peasants and dogs, carries off the other child. *18.* The emperor
sends two soldiers to look for Eustace. *19.* The two soldiers talk with Eustace,
now a peasant. *20.* The two men talk together; one shows a cup. *21.* Eustace's
two sons find each other and touch hands in sign of recognition. *22.* Eustace
finds his wife. *23.* Eustace as commander of the army. *24.* Eustace's wife
leaves the house. *25.* Reunited, Eustace's family celebrate. *26.* Two men.
*27.* The emperor worships an idol. *28.* He tells Eustace to do the same.
*29.* Eustace and his family being thrown into a cauldron. *30.* The emperor
ordering the martyrdom of Eustace and his family. *31.* A man bringing a
bundle of wood. *32–33.* Two armed men helping.

Each lozenge is additionally accompanied by two-times-two smaller round medallions. The direction of reading is very complicated, making the stricter narrative thread illegible; the only logical sequence is the one linking medallions ten through seventeen, that is, the part of the legend from the vision of Christ on the Cross appearing between the stag's antlers to the scene where the second child is carried off by a wolf, before scene eighteen, which shows the emperor Trajan sending soldiers to look for Eustace. These scenes are not all equal in importance, but the pairs of larger round medallions contain scenes that complement one another:

(10) the vision of the Cross, and (11) the baptism of Eustace;
(13) the negotiation of the passage by boat, and (14) Eustace and his family embarking on the boat;
(16) a lion carrying off one of the children, and (17) a wolf carrying off the other;
(27) Trajan worshipping idols, and (28) Trajan ordering Eustace to worship idols.

The symmetry of these scenes is justified by their content, even if the content is not always of a central importance. The significance of the scenes in the smaller round medallions is enhanced by their relationship to the lozenge-shaped medallions, the content of which they enrich, as in the case of the hunt (5) or the martyrdom (29).

The Master of St. Eustace is an admirable storyteller. The hunting scene in the first medallion at the bottom of the window (5) gives a clear idea of his genius (fig. 54). Two horsemen seen in profile occupy the top and left-hand corners of the lozenge, and certain elements, such as the hunting horn and the deer overlap onto the red border. The pack of hounds in the bottom corner seem to be rushing towards the right-hand corner, the upward slope of the edge serving as a springboard for the quarry. The white and violet horses and the horsemen in green and violet tunics stand out sharply against the blue background. Yellow is reserved for details of the clothing. There is no desire to suggest any sense of depth in this scene; the horsemen are as if suspended in space and the restrictive lozenge form encloses them in a wholly artificial frame.

Several of the scenes in the lozenges gave the artist a problem in accommodation: the bottom corner was a trap, into which he had to avoid letting the principal characters fall. He resorted to a system of "bridges," a device already tried and tested in Romanesque painting, providing a kind of platform on which to place the figures. But blue is visible again beneath the "bridge," contributing to the sense that the whole scene floats.

The round medallion containing the vision of the Cross is even more un-expected, with Placidus (Eustace's pagan name) occupying middle ground. His green tunic with its soft drape stands out against the blue background, and his head, lifted towards the vision, is in the very middle of the circle. Luxuriant vegetation spreads all over the surface of the medallion, espousing or contradicting the curvature of its rim: the wreaths of yellow, green, and even red plants compose a kind of harmonious palette. Here again, although the scene depicted is quite different from the hunt scene, the only suggestion of depth comes from a blue background against which the forms stand out, with no spatial cohesion to join them to each other.

If the succession of the narrative scenes by elisions and reverses evades all possibility of straightforward reading, it may not necessarily be due to a deliberate intention on the part of the theologian who devised the program. It is true that few stained-glass windows, at Chartres, at Bourges, or at Sens, present quite so illogical a sequence of scenes—at least as viewed from our modern perception. The most common way of reading windows is from bottom to top and from left to right and right to left alternately; this so-called boustrophedon course appears in the Passion window at Chartres, dated 1145–1150. It should probably be regarded as a solution to the geometrical composition of narrative cycles, given that symmetry is a natural obstacle to continuous narration. If the principle of symmetrical medallions was ideal for the typological windows of Saint-Denis, it was not so for the narrative windows of Chartres. But in the St. Eustace window, the order actually seems to have been muddled deliberately, obeying the boustrophedon principle only very partially. The narrative follows two different scales in terms of size: that of the lozenges and larger round medallions and that of the smaller round medallions. The labyrinthine course taken by the reading reflects something of what Hugo of Saint-Victor had to say about the order of narrative in Holy Scripture where that which is later is often placed before that which is earlier.[18] Deconstructed thus, the legend of St. Eustace became such as to assist realization that the apparent disorder of the narrative responds to a higher order requiring to be understood. Does not the muddled order of the scenes urge a reading more attentive to each scene individually? Identifying the characters (sometimes helped by the insertion of names), then the scenes, and then the order of succession demands close scrutiny. The St. Eustace window can be said to permit at least two (if not more) readings: one focusing exclusively on the larger medallions—lozenges and circles—and one content to concentrate on the secondary scenes. Alternatively one can restrict oneself to the five lozenges alone, which reduce the hagiographic tale to a summary,

using all the resources of a "light," romance-like, narrative thread: (5) the hunt; (12) Eustace leaves the town with his wife and children; (15) he is thrown overboard and his wife taken hostage; (22) Eustace is reunited with his wife; (29) the whole family suffers martyrdom in the cauldron. What seems a flagrant contradiction to us today can be formulated as follows: the readability of each scene taken individually counteracts the unreadability of the narrative thread as a whole. Never before in the already long history of stained glass had an artist achieved such homogeneity.

The harmony of the colors reinforces the expressivity of the figures' gestures and movements. Yet the nobility of the individual faces never changes, even in the scene of martyrdom. While the choice of episodes from the legend could have justified greater animation in the gestural language, more suggestion in the mime, there are no histrionic poses. Every draped garment, on the other hand, and every head of hair is drawn with exquisite refinement. The new visual values this artist successfully asserts reside in the ultimate resolution of all dramatic tension in formal beauty.

The Master of St. Eustace seems to have exploited all the resources distinguishing stained glass from fresco painting or book illumination. He provides evidence of how quickly glass painters learned to employ luminous color to compose a two-dimensional space governed by what Riegl called the "principle of ambivalence" in the figure-background relationship. While this principle will affect only ornament on opaque supports, it finds its ideal application in stained glass. Certain colored glasses appear to advance or retreat according to the strength of the light passing through them. According to the variations in its intensity—the window faces north—the reds, less numerous in the narrative scenes, are saturated by the dominant blues, the numerous violets grow paler and join in the brightness of the pieces of white glass modeled by grisaille; when the light fades balance is restored in the chromatic relationships as they are in a photograph. All the forms seem to be flattened on what Pächt termed "the imaginary plane of the optical surface," thanks to the uniformly blue background that enables this plane to be localized optically. The effects of raised lines and superimpositions, the overlapping of figures onto borders do not really create depth; it is tempting to say that the absence of spatial realism gives the representation a heraldic character. The close-knit ornaments of scroll and leaf between the medallions, which are more opaque because of the dominance of red, help to make each scene stand alone.

Two-dimensional space makes the scenes easier to read, of course, but the tendency they acquire to "float" in the two dimensions at the same time detaches them from all sensory reality. Each scene is an apparition, a pure

"vision." The exceptional development of the art of the stained-glass window during the twelfth and thirteenth centuries in particular cannot be explained other than by the total readability of the scenes and figures depicted within a two-dimensional space where a sort of "continual palpitation," to use a phrase of Claudel's, modifies the figure-background relationship while maintaining its ambivalence—the ambivalence Riegl called a principle of modernity. It is solely within the narrow limits of the projection plane that the forms can gain or lose closeness to one another, without the artist making any suggestion of the third dimension.

I have already mentioned a discernible change that began to take place around 1300, when architectural polychromy was frequently reduced to white and decorative grisaille encroached on windows. Furthermore, glass was no longer merely translucent; it became transparent. I am aware that formulating things in this way is to simplify, even schematize, evolutionary processes of infinitely greater complexity. But the study of color in architecture, which needs to take architectural polychromy, representational mural painting, and stained glass into consideration, is in its infancy. Attention should also be paid to grisaille in some manuscript illumination, the work of Jean Pucelle, for example. All these changes are indicative of some sort of reaction against the art saturated with color which was predominant during the reign of St. Louis.

The picture will only be complete with some input with information from certain texts, such as the *Pontifical* of William Durandus, about the colors of the liturgy. A somewhat less well-known source, providing especially telling information, comes from the pen of Pierre de Roissy, chancellor of Chartres at the beginning of the thirteenth century. Three veils covered the altar during Lent and Passiontide: black, pink, and red, which were removed one at a time at the end of the Office for Easter Day. They represented respectively the eras "before the Law" and "under the Law" and the era "of Grace." Roissy also tells us that the interior walls of the church were hung with cloths of linen and colored silk, embroidered or woven with images of animals, narrative scenes or decorative motifs.

Let us review the facts embedded in the artifacts themselves. The first example of the use of yellow made with silver nitrate is in a window in Normandy, at Mesnil-Villeman, dated 1313, so we can place the invention of this painting technique at about 1300. Supplementing grisaille, it allows one area only of a piece of white glass to be colored yellow. This augments the pictorial values at the same time as it reduces the amount of lead. Another innovation is the use of a brush to apply color washes to pieces of glass in order to suggest a more nuanced modeling. At the same time, areas of decorative grisaille

increased in quantity, as I have mentioned, to the point of constituting the window's "background," on which the panels of representational scenes stood out: this was already the case in Saint-Urbain in Troyes around 1270, and even a little earlier in Rouen Cathedral. At any event, decorative grisaille became more common at the same time that windows were profiting from a quite remarkable refinement in coloring. But the narrative function of the large stained-glass windows of the thirteenth century gave way to more concise versions of legendary tale-telling, reduced to a few images, as in Saint-Ouen in Rouen.

Also around 1300, it became common practice to frame scenes with architectural elements drawn on the glass: pedestals, daises, and elaborately crenellated gables illustrate the debt of such compositions to the development of architectural drawing since the middle of the thirteenth century. This representation of architecture, which became equally common in architectural polychromy, was often intended to duplicate the real structure, with the help of very elaborate painted forms; this is so in the Franciscan and Dominican buildings of southern Germany.

The increase in decorative grisaille and pale wall surfaces corresponds to improved light inside the buildings. It is not surprising, therefore, to see architectural forms present an ever greater opposition of convex volumes and concave forms. The resulting interpenetration of profiles, which began between 1280 and 1320 and increased steadily during the fourteenth and fifteenth centuries, is only visible in spaces better lit than those that preceded them.

# The Carved Image and Its Functions

A history of art concerned too exclusively with the history of form can lead to neglect of the specific function of individual works. This is particularly likely in the case of medieval sculpture; a three-dimensional, representational work of the twelfth century, such as the Virgins of Auvergne, placed inside a building where it had a religious function, has nothing in common with another piece set in the embrasure of a Gothic portal. Two such works can be compared or contrasted in terms of style and formal evolution, to be sure, but great caution is required because the relationship each was deemed to have with the worshipper was so specific that the choice of gesture or facial expression depended on it. In this chapter I propose to differentiate categories of carved images, paying due regard to their places in the church—places determined by their function. If sculpture is so important in the art of the twelfth and thirteenth centuries, it is because, unlike painting, its dimensions and corporeality make it distinctly closer to human beings. Man and sculpture occupy the same space and, with the help of polychromy, the carved effigy can make an impression on the viewer that is all the more intense for its mimetic quality. The very fact that, in his description of the statue reliquary of Sainte-Foy in Conques, Bernard d'Angers recalls that this type of statue originated in the pagan tradition that was still alive in the population of the Massif Central testifies to the singular light in which carved images might be seen at that period.

I shall look at these categories according to the functions of the objects under scrutiny, rather than their materials or placement, although materials and placement may be closely connected with their functions. The devotional image is the most "active" among all these sculptures, its use being the most

constant. The intrinsic property of carved images of a liturgical—or more often paraliturgical—character is that they are on view only on certain occasions, but nevertheless they join devotional images in a homogeneous group connected with worship. Later, I shall consider whether the definition of a church building as a Bible for the laity is justified and can be verified. Finally, I shall examine the extent to which sculpture—the most extreme expression of the Gothic idea of representation—resorted to particular expressive procedures in order to achieve its ends.

## THE DEVOTIONAL IMAGE

A devotional image is a painted or carved representation of Christ or a saint before which a believer prays. Looking at the image forms part of the act of praying, just as the subject and form of the image are determined by its function. Although the devotional image appears relatively late in the Middle Ages, I will study it first because it allows me to define precisely what I mean by an image's "function."

There are no medieval texts describing the experience of an act of contemplation before a devotional image, so we can only attempt to reconstruct it on the basis of what we know about prayer and mystical contemplation, and on the basis, above all, of the subject and appearance of devotional images in whatever medium—painting or sculpture.

The oldest and most widespread devotional image is undoubtedly that of Christ on the Cross. Textual sources and a few rare surviving examples testify to the existence of large crucifixes since the seventh century.[1] It is known that there was one in Mainz Cathedral in the tenth century, that it was taller than a man and gilded, held relics, could be dismantled, and was assembled only during certain seasons of the year. There was also a crucifix worked in gold and silver at Bury St. Edmunds in 1107, and the celebrated cross of St. Gero, Archbishop of Cologne (standing at 6 feet, 1½ inches high) still survives, suggesting that such large effigies were quite common in that period. There is also evidence of the industrial production of small crucifixes from the early eleventh century onwards.

The Synod of Arras (ca. 1025) mentions the crucifix and speaks of the sentiment the image ought to arouse in believers: "While they venerate the figure, they worship Christ raised on the cross, Christ suffering on the cross, Christ dying on the cross, Christ alone and not a work made by the hand of man. It is not a block of wood that is adored, but the soul within man is aroused by this visible image, whereby Christ's passion and the death He suffered for

our sakes is inscribed on the fibers of the heart, so that each may recognize in his heart how much he owes to his Redeemer." In France, monumental wooden crucifixes existed already in the twelfth century, such as the one at Moissac and the one of Burgundian origin, now in the Louvre, which probably belonged to a group depicting the Deposition, as it is known in Italy and Spain. The celebrated Volto Santo of Lucca Cathedral, which perhaps dates only from the beginning of the thirteenth century, was the object of particular devotion. It replaces an older crucifix, probably of similar appearance, which constituted a prototype much copied throughout the Western Church, notably in Catalonia, from the end of the eleventh century onward. The tale of its miraculous origins acquired embellishments over time: in the ninth century it was alleged to have been carved by Nicodemus, who was present at the crucifixion. For this reason the Volto Santo came to be regarded as an image inspired by the divine will, like the Veronica and St. Luke's portrait of the Virgin. According to Matthias von Janov, who condemned the idolatry unleashed by Emperor Charles IV's love of images, these representations lacked the energy (*virtus*) that filled the saints, being only their images or copies. He referred in particular to the terrifying nature of the face of the crucified Christ as opposed to the sweetness of the Veronica's face; in this respect they conform to Christian teaching, the Veronica recalling divine mercy, the Volto Santo the stern justice of God. Janov insisted on the expressive value of the representation because of the direct impression it made on the believer.

Around 1136, giving advice on how to run the Benedictine oratory of the Paraclete, Peter Abelard wrote in his third letter to Abbess Heloïse: "There should be no carved images. A wooden cross should be set above the altar, nothing more, with a painting of the Savior, if desired, but no other images."[2] The English Cistercian Aelred of Rievaulx wrote his *De institutione inclusarum* around 1160. In it, he enjoined nuns to cleave to "true virtues, and not to paintings or images," but a crucifix might be tolerated: "As touching holy images, have on thine altar the image of the crucified hanging on the cross, to represent to thee the passion of Christ, which thou shalt follow. He is outstretched to clasp thee in his arms, in which thou shalt have great delight; and his bare nipples will pour forth and nourish you with the milk of spiritual delight and consolation."[3] The image of the suffering Christ encourages an *imitatio*, through the particular functions assigned to the body as a whole, the arms, and the breast.

A relatively abundant literature began to grow up around 1200 that would enable Christians to visualize what was conveyed, historically, by the simple words of the Evangelist: "they crucified him" (*crucifixerunt*[4]). Previously this

historical problem had not been given such attention. Two different versions of the crucifixion were then current, which henceforth were seen as opposites or complements: the simplest form of one—*jacente cruce*, "the cross lying on the ground"—is found in the writings of Pseudo-Anselmus, the other—*erecto cruce*, "the cross upright"—is related at greatest length in St. Bonaventure's *Meditationes*. Here, and later in the *Revelations* of St. Brigitte of Sweden, the focus on Christ's sufferings enriched a theme that St. Bernard had placed at the heart of his mysticism.

It becomes easy, therefore, to understand the appearance, around 1300, of *crucifixi dolorosi*, figures of Christ marked with His sufferings and hanging on the cross, which were particularly prevalent in the territories of the German empire and Italy. The type can be defined relatively clearly. Geza de Francovich established a corpus of crucifixes with their crosses in the form of a capital letter "Y," and of numerous others without any particular feature enabling them to be assigned to earlier types.

In the *crucifixi dolorosi*, the body of Christ, marked by His scourging, is slumped, hanging from stretched arms, the head falling on the breast, blood flowing from the wounds. The cross is usually in the shape of a "Y." This type was widespread in Dominican and Franciscan convents. A *crucifixus dolorosus* of the second half of the fourteenth century from the church of Corpus Christi in Wrocław is an especially eloquent example of this type of devotional image (fig. 56); other, older specimens exist in Cologne and Perpignan.

The anatomy, represented in a highly conventional manner, seeks to show the unsightliness of the pathetic martyred body. Only the facial features are strikingly beautiful, distorted though they are by pain. The distended veins are made from pieces of string soaked and coiled round the limbs in a regular network. The marks of the scourge are obtained by relief modeling, and blood still spurts from the wounds caused by the nails. The crown of thorns is woven from buckthorn. The networks of veins and wounds obey a concern with ornament, like the *perizonium*, the folds of which fall symmetrically on either side of the body, showing the blue underside of the white cloth. The color of the flesh is dominated by gray and white tones with green shadows.

Certain works that may perhaps be regarded as prototypes of the *crucifixus dolorosus* reveal a quite extraordinary sense of form; the crucifix of Sankt-Maria-im-Kapitol in Cologne (1304; fig. 57) and the very similar Perpignan crucifix show that the theme of suffering is nowhere reinforced by any kind of realism in the representation. Quite the contrary: the strongly marked ribs are parallel lines, the network of protruding veins spreads across the surface of the limbs with the regularity of netting, the facial features are treated in a manner

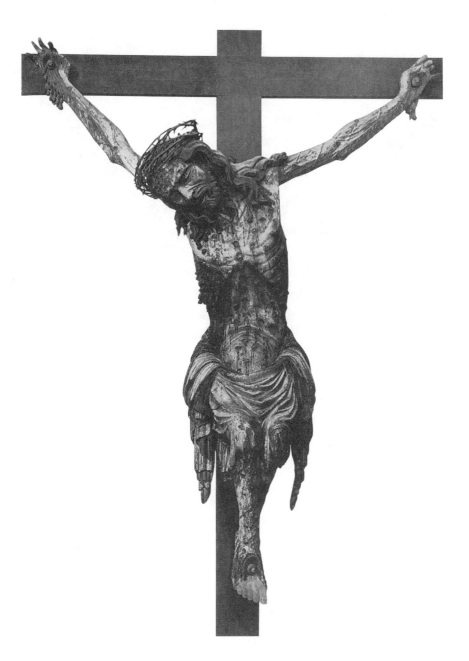

FIGURE 56. *Christus dolorosus*, second half of the fourteenth century, from Corpus Christi Church, Wrocław. National Museum, Warsaw.

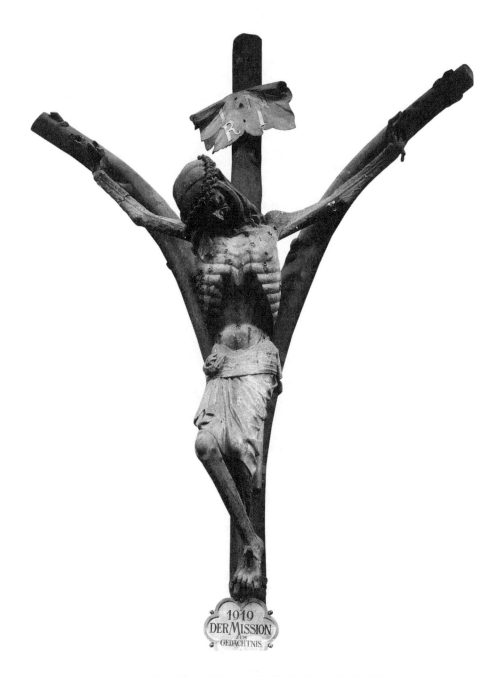

FIGURE 57. *Crucifixus dolorosus*. Sankt-Maria-im-Kapitol, Cologne.
(Photo credit: Foto Marburg/Art Resource, New York)

it is tempting to call neo-Romanesque, down to the little tufts of the beard of the Perpignan Christ, which curl with a dry regularity. It was the function of polychromy to lend these carvings a "dolorous" character. Figures in such a style were deliberately archaic in 1300, perhaps because they were derived from a thirteenth-century Italian prototype (possibly Franciscan). It is only in a work like the *crucifixus dolorosus* of Sankt Severin in Cologne (1370–1380) that the backward-looking characteristics are abandoned in favor of a more "naturalistic" conception.

There was one devotion in particular that believers were able to pay to such figures: adoration of the five wounds, a cult which developed essentially after the stigmatization of St. Francis in September 1224. Catherine of Siena called the grape-like drops of blood "*barile de vino.*" The wounds were called "*minzaichen*" in medieval German—literally "love-marks." A prayer in the form of seven rhymed verses, beginning "*Ave caput Christi gratum*" ("Hail gracious head of Christ") was addressed first to the head and crown of thorns, then to each of the five wounds in turn, and finally to the whole, scourged body. In these figures, the representation of the body was a guide and aide-mémoire for the devotional exercise. The sagging posture of the body as a whole, accentuated in the Wrocław crucifix by the way the *perizonium* droops, is a particular characteristic of the *crucifixus dolorosus*. Literally, Christ hangs ("whom ye slew and hanged on a tree" as the apostle Peter says[5]). It was the most shameful form of capital punishment under Roman law, and the apostles emphasized it as a means of contrasting the fact with the resurrection that followed it. Poetry found a way to translate the image of the body hanging on the cross and the cross echoing the movement of the body: "Bend your boughs, tall tree of the cross" said the Bishop of Poitiers, Venantius Fortunatus (d. 600). Peter of Breslau (Wrocław), preaching to the Dominicans of Saint-Nicholas-aux-Ondes in Strasbourg, describes Christ who "is suspended and dangles from the Holy Cross, like a string on a harp."

Another form of crucifix follows where the *crucifixus dolorosus* points: the slumped or sagging body gives way to the taut body, "stretched" by the three nails. One probable early source for this form is found in Godefroy d'Admonts, who compares the crucifix to a drawn bow and Christ's body to the "noble bowstring" (*nobilis haec chorda*). Both the *Meditationes de vita Christi* and the *Vita Christi* of Ludolphe le Chartreuse speak of Christ's body being taut, tightened like the strings of an instrument. Heinrich Suso, too, invokes the "outstretched arms and the twisted veins in all [His] limbs."[6] Heinrich of St. Gall writes at the end of the fourteenth century that Christ's body is so stretched that his arms and legs are dislocated and his veins drawn taut

as strings. Similar metaphors seem to inform Cassiodorus's commentary on Psalm 57:8: "Awake, lute and harp: I myself will awake right early." The harp, according to Cassiodorus, signifies the Passion, which makes Christ's suffering resound like a sacred song, with the help of the taut nerves and obtruding bones. Metaphors of this kind multiply from the end of the thirteenth century onward, becoming especially popular with the preachers—the text of Heinrich of St. Gall cited above was actually delivered in the vernacular.

The poetic imagery was first realized in carved images around 1400. It fell to the Dutch sculptor Nicolas van Leyden to create two versions that determined the type once and for all: the wooden Nördlingen altarpiece and the stone crucifix in the burial ground in Baden-Baden, which was 17 feet, 9 inches tall. The extreme muscular tension, especially apparent in the legs, is discerned less as violence done to the body than as a last mastering of pain. This almost ascetic representation of death is thus exactly the opposite of the *crucifixus dolorosus*. Christ's face does not show death or signs of suffering: He has become God, leaving His suffering humanity below on earth.

Another devotional image spread through the German Empire at the same period in those regions where Franciscan and Dominican nunneries were proliferating: this was the *Pietà*. Once again, Christ's physical suffering is emphasized by means of sculptural techniques identical to those used in crucifixes, but in this image devotion to the passion, and the five wounds in particular, is augmented by devotion to Christ's mother, whose own suffering and sorrow were expressed in the sequence *Planctus ante nescia*, attributed to Geoffroy de Saint-Victor in the twelfth century: "Return the lifeless body to the much afflicted mother, so that, its suffering being so lessened, it may grow under her kisses and embraces."

The burning devotion to Christ's passion, seemingly begun with Bernard of Clairvaux, culminates in the writings of Suso. For Suso, "the devotion which surpasses all other . . . is that given to the dear image of Jesus Christ and His dear Passion." Such is the supreme imitative model which will lead to the "direct union of the soul." In the *Minnebüchlein* (*Little Book of Love*) attributed to Suso, the writer addresses the suffering Christ directly: "How could they beat you so cruelly, when they saw your well-framed body, your flawless limbs . . . ? Well, my soul, I desire you also to gaze on his lovely face where all the graces dwell, reddened by the drops of blood running from the celestial paradise, his charming, gracious head, whence flow the streams made by the cruel thorns forced on his brows." The servant empathizes with the Virgin's sorrows: "What else can I do, fountain of life, but enfold you tenderly in the arms of my heart, with doleful heart and tearfilled eyes, press you to me

and . . . cover you gently with kisses? The blue commissures of your lips do not disgust me, your bleeding arms do not repel me." Suso's description, like his other texts, attests his familiarity with the world of religious images.

Defining the nature of that familiarity involves understanding the role images could play in the practice of fourteenth-century mysticism. First, it is necessary to try to describe the mystic's prayer and the ecstasy that was its objective. Of course, this form of devotion had nothing in common with what was expected of a congregation attending mass. The practice that concerns us now is that of the religious institutions, the devotion which entered into the *cura monalia* that a spiritual teacher could demand of his disciples.

Some general conclusions can be drawn from single observations, for mystical experience is not the exclusive experience of one religion or even of one group of people: it is the experience of men and women who perform certain devotional exercises and reach differing degrees of illumination. St. Augustine considered that there were three categories of visions: corporal, spiritual, and intellectual. The first is based on sensory perception and therefore includes the sight of pictures and other images. The second consists of a collection of perceptions; it is an "imaginative vision." The third is in the mind and has gone beyond sensory realities. The Augustinian categories are the foundation of all medieval theology when it turns to defining the place of images in the mystical ascension. An analogous hierarchy is found in St. Bonaventure's definition of four kinds of light.[7]

The mystic seeks to kill all sensuality in himself by a slow course of asceticism, that is, by separating himself from everything that appeals to his senses. This ambition might appear to put pictures and images in an unfavorable position, yet as we shall see they can assist in the ascetic exercise itself. The other arts can play a role in this spiritual quest, too. In the case of music, we have the example of the fifteenth-century Dominican nun Clara von Osteren, who taught music to the sisters at the Catherinette convent at Colmar. To help them understand the significance of the notes of the chromatic scale, she told them to use the figure of Jesus: contemplating it would give them the tones of self-abasement, love, patience, and obedience, the tone of renunciation with which they should meditate on Christ's renunciation on the cross, and the tone of humility which would strengthen them in renouncing all earthly things.

The first stage on the path toward mystical union is prayer, and prayer will lead to contemplation and meditation.[8] The simplest form of prayer is conversation with God. Later in the exercise comes another form of prayer, silent this time, which is born from meditation.

Meditation begins with "collection," a process of concentrating on something until the spirit is able to detach itself from all contingency and enter into the special time of mystical experience. In the fourteenth century, a preacher in the Black Forest encouraged the devotee to look at an image in order to find the "way of his heart," a discovery which should precede the moment of union. The object of concentration can be a word or a visual image; if it is the second, it should be as disembodied as possible, so as to aid concentration. The *Arma Christi* offer a group of objects from which the mystic may select. The resultant meditation can be imaginative—centering on one precise moment of the Passion—and thus can excite an empathetic relation with the devotee.

Issuing out of prayer, meditation leads back to prayer, but this time silent. Now the mystic is in the presence of God: consciously so, just as he is conscious of his own nothingness. This is the stage of contemplation. The dialogue is accompanied by a particular state of the whole body. A Dominican treatise of the thirteenth century has this to say: "The soul makes use of the limbs to raise itself more devoutly towards God, in such manner that the soul, even as it sets the body in motion, is moved by the body." There will still be two parties in contemplation: the contemplator and the contemplated. The final stage, which the mystic does not necessarily reach every time, is ecstasy, the union annulling all distinction between the mystic and the sovereign good. In this last state, there is no longer any place for anything, because the being itself is wholly absorbed by the mystical union.[9] The devotional image has its place only in the earlier stages: normally, indeed, only in the first.[10] There it assists the effort of concentration, but for that reason it should not be too rich or overburdened with corporeal or sensory materiality. The *Arma Christi* serve the purpose all the better, because in their compressed representation of successive moments of the Passion they are all the nearer to serving as signs. One devotional work of 1330–1350 displays a diptych depicting the *Arma Christi* with elementary realism and without any captions (fig. 58). These ideograms, simultaneously suggestive and pared to their essentials, facilitate concentration on any one episode in the Passion narrative.

When mystical ecstasy was fully realized, there was no longer any place for the image. Was it necessary to travel a long journey before arriving at that ultimate goal? Devotional exercises practiced every day were meant to bring the disciple closer to enlightenment, and the image played a part within those exercises.

The celebrated Dominican manual of prayer, *De modo orandi*, preserved in the Vatican Library, and probably originally intended for novices, features

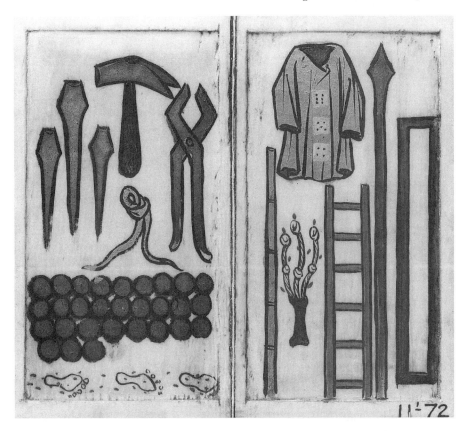

FIGURE 58. *Arma Christi*. (Victoria and Albert Museum, London; Inv.11–72 42)

St. Dominic's own nine modes of praying. The illuminations depict him in a series of oratories before an altar surmounted by a diptych (showing the Virgin and St. John) behind a large crucifix. The saint's gestures and movements are thought to induce different interior states, some of which are frequently invoked by mystics. For example, the illustration of the fifth mode shows a sequence of three stances with the hands and the head in different positions (see fig. 59). The first, on the left, with the open hands "lifted to shoulder height" and the head raised, could signify talking to God; the second, with the face lowered and "the hands joined and firmly clasped before his closed eyes," depicts extreme concentration, silent prayer; the third stance shows "the hands held out before the breast in the manner of an open book," and the saint concentrates on these. We see, in this account of the saint's private

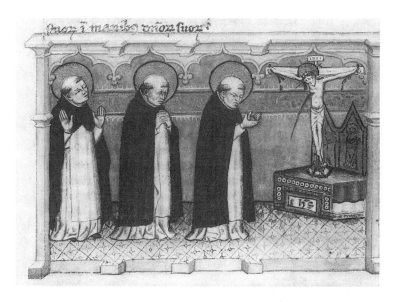

FIGURE 59. *De modo orandi*, the fifth mode. (Biblioteca Apostolica
Vaticana; Ms.lat. Rossianus 3)

and silent devotion, that the crucifix can alternately play a role in the exercise
(as in the first position) or be excluded. In the third mode of prayer, the saint
is shown as a penitent, scourging his bare torso, with his eyes raised towards
the body of the crucified Christ, as they are again in the fourth mode, which
depicts him twice as *orans*. On the other hand, in the seventh mode, which
represents the ecstatic experience, the clasped hands and the face alike are
turned up toward heaven.

The third mode can be compared with a passage in Suso's *Life of the Ser-
vant*, describing himself in an act of penitence. He tells us that the Servant plied
his whip so hard that it broke and "he stood there and saw himself bleeding—
it was a most doleful sight—almost like the beloved Christ when He was savagely
scourged."[11]

St. Dominic's attitudes were meant as *exempla* for the instruction of novices.
This explains the presence of the crucifix, while in other copies of the manual
it is replaced by a simple cross marking the altar. We can suppose that anyone
who regularly reached the state of ecstasy would no longer need physical images.

But the devotional image can fulfill another function; its constant presence
constitutes a sort of permanent summons to devotion. That emerges from an-
other passage in the *Life of the Servant*:

At the beginning, [Suso] chose out as his secret place of refuge a chapel, where he could do his devotions in artistic surroundings [*nach bildricher wise*]. In particular, there was a painting on parchment of Eternal Wisdom, which he had made in his youth. She has heaven and earth in her power and in her fair loveliness she surpasses all earthly creatures in beauty. . . . He carried this lovely picture with him when he went to school, put it in the window of his cell, and looked at it with eyes full of love and deep longing. He brought it back home with him, and hung it in the chapel for loving memory. The other pictures and images that were there, which related to the spiritual life, as it pertains to him and other beginners, may be illustrated by the paintings and sayings from the ancient Fathers.[12]

After listing some of those sayings, Suso continues: "The Servant sent these maxims and precepts of the Fathers to his daughter in religion, and she took it to heart and thought it meant that she should exercise her body with great austerities, according to the strict example of the Fathers."[13]

The image as an exhortation to piety met with the approval of the Dominicans, as the order's Chapter General signified in 1260: "[The brothers] have the image [of the Virgin] and that of her Son in their cells, so that reading, or praying, or sleeping they can simultaneously contemplate them and be seen by them with a gaze of piety." Suso, in *The Little Book of Eternal Wisdom*, recommends the use of images to religious communities as being comparable to relics, rendering assistance to man's fragile memory. Suso's meditation is turned entirely to two dominant themes: that of the "lovable" image of Jesus (*minnekliche bilde Jesu Christi*) and that of the suffering Christ. The imagery of the lover is clearly inspired by St. Bernard of Clairvaux's commentary on the Song of Songs, but also by secular courtly literature where love is described as the union of two beings: the mystical relationship is treated as "a game of love" played by the "loving God" and the "loving soul."

We have seen, therefore, that one devotional image had two distinct functions: as an object assisting concentration during the successive stages of mystical elevation, and as an aide-mémoire or mnemonic.[14] But in the context of devotion as practiced by members of enclosed orders, for example, they could easily merge or alternate in the course of one and the same exercise.

There is a third function that I shall call empathetic. It relates directly to the question of *imitatio pietatis*. The *Pietà* showing the dead Christ lying across his mother's knees, or the group formed by the disciple John leaning on Jesus's breast, is a devotional image that excites the devotee's sorrow or love by the

*exemplum* given by the Virgin in the first case, St. John in the second. When the Dominican nun Clara von Osteren spoke of the *imitatio Christi*, she held her arms out like Christ on the cross and contemplated the sorrowful eyes of Christ looking at the eyes of His mother watching her Son's martyrdom, while John's eyes contemplate the suffering of them both. The nun in turn gazes at the whole scene. The mimetic function attributed to representations of this type is clear, even though the gazes are as if ordered according to a hierarchy of proximity—a very important component of private devotional practice in the late Middle Ages.

None of these devotional images linked to the life and death of Christ belongs to any iconographic tradition based on the Gospels. They are medieval creations, nearly all of them later than 1300. Attuned to a strong and exacerbated religious sensibility—erotic, even, in cases like Suso's—these creations demanded of artists a taste for an expressivity able to stimulate a precise kind of devotion in the believer. It was by that taste that the Middle Ages measured an artist's genius, sometimes seen as miraculous, there being no other possible explanation for a work's exceptional character. There was said to be a crucifix in the Church of the Holy Sepulchre in Jerusalem, around 1170, painted so vividly that all who saw it were overcome by profound compassion; and a group of Christ with St. John at Katharinental, the work of a certain Master Heinrich and dating from the early fourteenth century, was reportedly so beautiful that everyone marveled at it, beginning with the sculptor himself. The aesthetic aspects of devotional objects cannot simply be set aside, therefore, even if they were of no account in "practical" usage.

Another remarkable characteristic of these devotional images was their adaptability. They could be the object of private devotion at any time, independent of ritual, a factor favoring their installation anywhere: in a church, a convent cell, or a lay person's private chapel. We need to be much more sensitive about this than commentators were in the nineteenth century, who liked to differentiate between official observances and mystical devotions conducted in private. The *Christ with St. John* at Katharinental was placed in full view in the chancel, on the high altar.

## THE CARVED IMAGE AND THE LITURGY

Another type of carved image, older than the devotional image and directly linked to the liturgy for Eastertide, is the *Depositio*, representing the act of taking the dead Christ from the cross. The figures are fully sculpted in wood. The arms of the Christ on the cross are already lowered, and Joseph of

Arimathea and Nicodemus are busy freeing the legs, while Mary and John stand a little way back. This is the composition found in Tuscany and central Italy; some fifteen examples are known, datable between the late twelfth century and the late thirteenth. A Catalan version has the two thieves on their crosses as well, but the *Courajod Christ* in the Louvre proves that the latter type was also known in Burgundy.

The *Deposition from the Cross* (ca. 1200), in Tivoli, is a symmetrical group, its structure determined by the direction of Christ's arms. The body is still attached to the cross only by the feet, which Nicodemus and Joseph are at the point of loosing. Mary and John hold their open hands up towards Christ (fig. 60). In fact, the existence of a liturgical drama connected with Good Friday, probably imported from southern Germany, provides the explanation for this group's surprising conception.

Commemoration of the *Depositio* is not mentioned in liturgical books from Italy until around the turn of the thirteenth century, and the *Lauda* seems to have served as its completion. In the vernacular and taking the form of laments, *Depositio* and *Lauda* must have arisen in Italy during the twelfth century and been spread by the Franciscans. Their popular lyricism is very close to the *Planctus Virgini*, another twelfth-century poem recounting the Virgin's mourning at the side of the dead Christ. *Lauda* and *Planctus* were probably sung at the same time as commemorative scenes enacted around these Italian groups depicting the Deposition, thus forming the accompaniment to a paraliturgical ceremony. Not surprisingly, therefore, the guilds soon instituted a procession from one site to another, in part independently of the clergy and without the Host, of course.

An inventory of San Domenico in Perugia mentions various scenic props used for these actions, but also flesh-and-blood actors augmenting the carved group beside which they played. The sculpture is often constructed in such a way that the gestures of the Virgin and John could be combined with the Christ to form a separate group, a *Lamentatio*, like the one by Giovanni da Milano in Florence.

To grasp the full dramatic intensity of these carved groups we need to consider still other elements, the significance of which have been recognized only in the past thirty years. There are crucifixes on which the figure has movable arms: the shoulders are articulated, enabling the arms to be laid against the body so that it can serve in another episode in the Passion narrative, the Entombment. The oldest of these figures date from around 1340 and come from Italy (the one in the baptistery in Florence, by Giovanni di Balduccio, dates from 1339), Germany, and central Europe. Sometimes the head is also

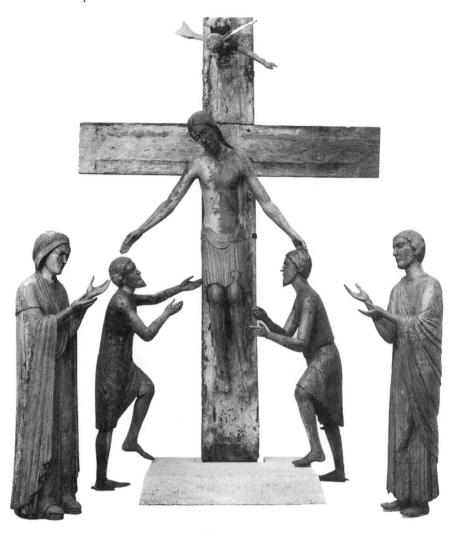

FIGURE 60. *The Deposition from the Cross*, San Lorenzo, Tivoli, ca. 1210–1220.
(Photo: Hirmer Fotoarchiv, Munich)

articulated.[15] In a late crucifix (1510) there is a cavity in the back connected
to the wound in Christ's side so that red liquid could be poured into it to
make the wound "bleed" (fig. 61). The figure also wears a wig of real hair. An
Austrian crucifix of about 1380 contains a lidded receptacle behind the wound
in the side, intended to contain a Host. On another specimen, dating from the
fifteenth century, a string could be used to open the mouth and close the eyes.

The wooden crucifix from Lage (North Rhine-Westphalia) stands on a curious mount forming three little "boxes" in which the body and the two separate arms can be put. It is easy to imagine such containers being used in a *Depositio* to transform the Christ on the cross into the Christ lying in the tomb.

The *Adoratio crucis* celebrated on Holy Thursday was imported from the Eastern Church in about the eighth century and entered the Roman liturgy, covered in the prescriptions of *Ordines Romani*. This was not the case with the *Depositio crucis* and the *Elevatio crucis*, however, and the practices surrounding them varied from diocese to diocese. The *Elevatio*, especially, gave rise to notably rich dramatic treatments.

A goodly number of studies have been published about these ceremonies, but the role of figurative works of art has been largely overlooked by their various authors, specialists in theater history, liturgical drama, or sacred music. In a formidable philological monument, Karl Young assembled virtually all the dramatic compositions used by the medieval Church in Western Europe.

FIGURE 61. Swabian crucifix with articulated
arms, detail. Johanneskirche, Memmingen,
ca. 1510.

His work's principal weakness is the frequent confusion of liturgical drama and liturgical rite. In the attempt to demonstrate that the *Depositio* was never the subject of dramatic development, Solange Corbin, in what is undeniably an important study, simply neglected the artistic testimony of the articulated crucifixes, although these provide the proof that, in some cases, a dramatic action did indeed theatricalize the liturgical ceremony of the *Depositio*.

The *Depositio crucis*, unfolding after Vespers on Good Friday and commemorating the Entombment, included a certain number of episodes leading the participants from the altar, where the cross or crucifix stood covered with a cloth, to the sepulchre in which it was laid. The *Elevatio*, following during the night of Easter Saturday, commemorated the Resurrection and might be followed by the *Visitatio sepulchri*. All these scenes were performed by clerics[16] and were generally accompanied by singing. It should be noted that the dramatic texts in which these ceremonies survive mention three different objects in connection with the *Depositio* and the *Elevatio*—a Host on its own, a crucifix, and a crucifix accompanied by a Host. The presence of a Host requires an explanation.

A onetime practice relating to Holy Week ceremonies consisted of reserving a Host from mass on Holy Thursday for the *Missa praesanctificatorum* on Good Friday, because the *Ordines Romani* had, since the fifth century, forbidden the consecration of the *species* on that day. The "Mass of the Presanctified" took the form, therefore, of a shortened mass incorporating the *Adoratio crucis*. This corresponded to the commemoration of the crucifixion; the *Depositio* and *Elevatio* then followed in the correct order of events, as increasing importance was placed on observing the unfolding Passion story. The two dramatic enactments were recorded in the *Regularis Concordia* composed for English Benedictines by St. Ethelwold between 965 and 975.

In the *Depositio*, deacons sang anthems while they wrapped a cloth round the crucifix they had carried in for the *Adoratio* and then placed it in a niche— the *sepulchrum*—contrived in the altar. The cross was left there until the night of the Resurrection, watched over by monks singing psalms. A fourteenth-century missal describes the *Depositio* at Durham as it unfolded during the Offices for Good Friday: the crucifix was carried to the sepulchre in procession, with the Bishop preceded by two monks bearing candles and a third with a censer, their progress accompanied by singing. Another text, "The Ancient Monuments, Rites and Customs of the Monastical Church of Durham before the Suppression," written in 1593 (that is, before Henry VIII's dissolution of the English monasteries), contains a wealth of information.[17] The cathedral possessed "a maruelous beautifull Image of our Sauiour, representinge the

Resurrection, with a crosse in his hand, in the breast wherof was enclosed in bright christall the Holy Sacrament of the altar." On Easter Day this image was carried from the sepulchre by two monks on "a faire ueluett cushion, all embrodered" and placed on the high altar. The two monks knelt there, while the choir sang *Christus resurgens.* Then the figure was taken in procession all round the cathedral and brought back to the high altar, where it remained until Ascension Day. At other times it was housed inside a larger sculpture called the Lady of Boultone: "a merveylous lyvelye and bewtifull Immage of the picture of our Ladie," which opened to reveal the image of the Saviour "merveylouse fynlie gilted," with upraised hands holding a large crucifix, which could be detached on Good Friday. Karl Young considered that this must have been two complementary representations in one, the *imago resurrectionis* and the *imago Crucifixi*, removed from the image of Our Lady and laid together in the sepulchre on Good Friday. In some places, such as the monastery at Prüfening, only the latter was used in the *Depositio*, the former being shown only in the *Elevatio*.

Articulated figures were indispensable to the Prüfening *Depositio*, mentioned in a late-fifteenth-century *ordo*. After the crucifix had been carried to the curtained receptacle set up near the altar of the Holy Cross, the body of Christ was removed, covered with a linen cloth, and placed in this "tomb." In a second ceremony following the mass, a Host was placed in the tomb beside the *imago Crucifixi*. At the *Elevatio*, the Host was taken from the tomb together with the *imago resurrectionis*, which had been put there surreptitiously. The crucified body was simply forgotten, and a beadle was responsible for returning it to its normal place.

For the Prüfening Christ to be transformed in the sight of the congregation, it had to have articulated arms. It is not difficult to imagine the intense effect produced by this enactment of the Deposition and Entombment, by the light of innumerable candles and accompanied by singing.

Undoubtedly, the general trend of these ceremonies was toward ever more convincing realism: not simply in the actions, such as the transformation of the body of Christ, but also in the dramaturgy itself, such as the wearing of Jewish dress by the four clerics who, in the roles of Nicodemus, Joseph of Arimathea, and their helpers, took the body down from the cross in the Prüfening *Depositio*. At Wels in Austria, the person playing the role of Joseph of Arimathea spoke directly to the crucifix in the vernacular. The Wels liturgical play is an instance which contradicts the thesis of Solange Corbin; the liturgical chants accompanying the *Depositio* prove that, although dramatized, it was integrated into the liturgy, unlike the practice in Italy.

But this realism spread also to the carved figures. By the late fourteenth century, some crucified Christs wore wigs made of real hair. A number of examples from the fifteenth century still exist in Franconia. And on this hair, naturally, a crown of thorns was placed, woven from real willow or blackthorn twigs, so reinforcing the image's dramatic character.

There was a quasi-magical dimension to this use of real hair, reserved for the crucifixion. An extraordinary text tells the tale of a certain Andreas Wunhart, a sculptor, and his honoring of his daughter, a nun in the convent at Ridler, who died in 1417. Wunhart used her hair to adorn the head of a crucified Christ that he had carved and presented to the convent in her memory. We can infer from this that there were other cases in southern Germany where such wigs were made from the hair of known people and that, in this way, the *imago Crucifixi* commemorated two events: Christ's sacrifice and the death of a person who, in the case of Andreas Wunhart's daughter at least, had been His "bride."

One essential element in these ceremonies is still conjectural: the place where the Host or the crucifix was laid. We have seen, from the liturgical texts and dramas, that the place might be a quasi-abstraction—as when there is no indication to specify its function—or it might be a real location taking an explicit artistic, occasionally even architectural, form. Some architectural examples survive, at Aquileia, Constance, Eichstätt, Augsburg, and Magdeburg, where the dramatic texts have also been preserved. There are other instances, like the sepulchre in the cloisters at Vienna in the Dauphiné, for which no other evidence of a *Depositio* ceremony has been found, but sepulchres could equally well have served for other ceremonies such as the elevation of the Host or visit of the three Marys to the empty tomb.

A dramatic treatment of the *Depositio* in St. Stephen's Cathedral in Vienna is especially interesting for its use of a wooden sepulchre mounted on wheels, of the same type as one that has been preserved at Esztergom and bears the date 1437. This has a receptacle for the Host with a glass window and was used to carry a Christ with articulated arms. The connection between the *Depositio* and the sepulchre is thus fully attested, and the presence of the Host confirms that the dramatic treatment was not, as in Italy, a *sacra representazione* of the type left to the lay guilds, but a liturgical Deposition.[18]

The carved stone group representing the three Marys standing beside the tomb and the sleeping soldiers alongside it, known in the German-speaking world by the name *Heiliges Grab* (*Holy Sepulchre*), can be related directly to the *Quem Quaeritis?* plays representing the visit to the empty tomb. Some of these sepulchres also contain a stone figure of Christ, often with a windowed

receptacle for the Host hollowed in the breast. In the case of the stone sepulchre in Freiburg im Breisgau, we know exactly what significance it had during the liturgy at Eastertide. But these monuments were permanently on view, unlike the wooden ones which were seen only during Holy Week, and they had another, permanent function as devotional images with the *Visitatio Sepulchri* becoming the mimetic model for the devout.

Stone *Heilige Gräber* are found all across southern Germany, as far as the Vosges. West of there, another sculptural group is found, depicting the Entombment. The most fully developed type is represented by those at Tonnerre, Pont-à-Mousson, and Fribourg in Switzerland: Joseph of Arimathea and Nicodemus support the cloth on which Christ's body is laid for shrouding, and the three Marys, the Virgin, and St. John stand behind the sarcophagus. The weeping women may excite *imitatio pietatis*, but other forms of piety are suggested by the posture of others in the scene; for example, in the Molesme Entombment, Mary Magdalene kneels in prayer beside the sarcophagus. These carved groups are often placed in small votive chapels, allowing the devout to get closer to them. The Italian groups known as *Compianti sul Cristo morto*, by Niccolo dell'Arca or Guido Mazzoni, require a more spacious scenography because of their more extravagant expressions and gestures. Although these monumental groups can be tied in with the liturgy, their scale and their mise-en-scène suggest liturgical drama. In most cases, however, they should be regarded as devotional images. Subjects associated with the Passion are not the only ones to have experienced this kind of sculptural development. It is likely that there were once many other compositions in churches, carved in wood or stone, fulfilling a paraliturgical function, but with an iconography honoring the church's patron saint. The "tomb of Lazarus" in Saint-Lazare in Autun provides a relatively well-documented example, although it survives only in fragments.

A saint's tomb similar in form to a Holy Sepulchre existed as early as 1077 in Saint-Front in Périgueux. Placed at the east end, behind the high altar, the Autun tomb took the form of a basilica with transept, crossing tower, and apse. The front of the aedicule (19 feet, 8 inches high, 11 feet, 8 inches long, and 9 feet, 8 inches at its widest point) was visible above the high altar. It held the remains of St. Lazarus, whose cult developed at Autun probably with the intention of rivaling Vézelay and its cult of Lazarus's sister, Mary of Bethany, identified at Vézelay with Mary Magdalene. Pilgrims flocked from all over Europe to the shrine of Lazarus, whom Christ raised from the dead. On reaching the choir, they could actually get beneath the sarcophagus and the monumental mausoleum on their knees, by way of a narrow passage. By

this act of devotion the pilgrim participated personally in a "theatricalization" replicated inside the mausoleum.

What the pilgrims saw there was the raising of Lazarus. The carved figures were about 14 feet tall; the lid of the tomb in which Lazarus lay, wrapped in strips of cloth, was held up by what are thought to have been four atlantes. Christ, holding a book and raising His right hand, stood with Peter and Andrew at the dead man's feet. Mary and Martha stood on the other side of the sarcophagus, the latter covering her nose with her sleeve because of the smell of putrefaction (fig. 62). Six of these figures, although damaged, survive; the realization of the two women and St. Andrew is relatively compact, despite the expressive gesture of the two women raising their hands palm up in thanks for Divine mercy. The scene was complemented with inscriptions, notably the gospel words "*Lazare, veni foras*" (John 11:43) on the sarcophagus.

The miracle of Lazarus's raising from the dead was the subject of exegesis by St. Bernard, Rupert of Deutz, Isidore of Seville, and Honorius of Autun, all in the spirit of St. Augustine. Honorius tells us that the harmful influence of anyone who has done wrong spreads like a fetid smell. Martha and Mary symbolize active and contemplative lives, respectively. St. Peter supposedly removed Lazarus's bandages and thus took away his sin, because death, according to Augustine, is a kind of metaphor of the soul slain by sin. The three stages of liberation from death (resurrection) are the lifting of the lid, the command to "come forth," and the removal of the bandages. At Autun, Christ's gesture and the inscription "*Lazare, veni foras*" show that the emphasis was laid on the symbolic significance of the miracle, not the spectacle itself. The sacraments of Baptism and the Eucharist are cited in evidence as guarantees of eternal life, of which the resurrection of the dead is the visible sign. The Lamb of God that takes away the sins of the world (John 1:29) was placed on the very top of the shrine. In St. John's Christology, the miracle of Lazarus represents the pinnacle of Jesus' ministry, the preamble to His own death, and the assurance of the resurrection.

The gesture of the figure of Christ has an eloquence rare in sculpture of this date and gives the scene its dramatic focus. All the figures, as well as the architecture of the mausoleum, were picked out in color and made from some surprising mixtures of materials; a fifteenth-century record states that the (surviving) raised arm and the head of Christ were made of marble. This extraordinary dramatic scene must have made a deep impression on Christian souls. A sermon on the raising of Lazarus, by Maurice de Sully, Bishop of Paris, ended with this exhortation: "Good people, examine yourselves, whether you are alive

FIGURE 62. Statue of Saint Martha from
the tomb of St. Lazarus. Musée Rollin,
Autun.

or dead by sin" (*Bones gens, esgardés vers vos meismes, se vos estes ou vif or mort par péchié*).

We know that some religious theatrical activity took place on the Place du Terreau in Autun, at the time of fairs, during the fourteenth and fifteenth centuries. But there is also some testimony of older Lazarus "plays" held elsewhere: at the monastery of Fleury, and in a work by Hilaire (Hilarius), a disciple of Abelard, called *Suscitatio Lazari*. The latter has some passages in the vernacular, focusing on the tears and lamentation of the two sisters, but the symbolic significance of the death is not overlooked, for the matter of original sin is also raised.

The extraordinary monument at Autun, which has no known parallel, was intended to dramatize symbolic characters by means of gestures, attitudes, and scenography, all of which must have been very effective. The crucifix at the end of the mausoleum closest to the altar served to integrate it into worship in the church. The presence of the earthly remains of Lazarus made it equally a giant reliquary, and as such its place was directly behind the altar and visible above it.

The late Middle Ages saw the proliferation of a type of object that was not directly associated with the liturgy although physically linked to the altar, the very place where Christ's sacrifice is commemorated: this was the altarpiece made of stone or wood, carved or painted, or sometimes both. The function of the altarpiece is paraliturgical rather than liturgical and will reward examination.

In certain instances, relics were placed inside altarpieces, and indeed it was thought at one time that they originally developed from the closet where relics were kept. Although some featured tabernacles and many presented an iconography associated with the Eucharist, it is a reasonable assumption that, in general, the function of the painted or carved altarpiece from a very early date, during the thirteenth century, was to commemorate a patron saint and depict certain narrative cycles from the scriptures or apocryphal literature, telling the story in a way that served a more "popular" application of these works. Individual devotion was becoming more demanding, and the Church submitted to the demand while keeping strict control over its development. The ultimate purpose of an artist's work was to render subject matter from the Passion narrative or the lives of saints visible, and hence, the altarpiece can be regarded as providing the framework within which painting and sculpture would develop in the late Middle Ages.

It is of some significance that one of the earliest surviving examples of an altarpiece with folding shutters (volets) is Cistercian in origin. It comes from

the church at Bad Doberan (Mecklenburg) and dates from approximately 1310–1315. That of Cismar (Holstein; ca. 1320) has shutters carved on its inner surface. Relics appear to have been placed there only on certain occasions. The shutters on the Altenberg (Saxony) altarpiece, an especially elaborate example, are articulated in two stages: partly open, they show the Annunciation, the Nativity, and the Coronation and Assumption of the Virgin, surrounding a Virgin and Child; completely open, the Visitation and the Adoration of the Magi are also to be seen, as well as the convent's patron saints, St. Michael and St. Elizabeth of Hungary. This group of scenes centering on the Incarnation is complemented by the Passion cycle depicted on the outer surfaces of the shutters, with the Coronation of the Virgin forming the culmination of both the Christological and the Marian programs. This altarpiece was closed during Lent and Holy Week, therefore, partly opened for festivals of the Virgin, and opened fully for Christmas and the Epiphany. The altarpiece of the collegiate Liebfrauenkirche at Oberwesel (Rhineland-Palatinate; 1331) includes a crucifix on the outer surface which was detached for use in the ceremony of *Adoratio crucis*.

Archival documents, more numerous in the fifteenth century, contain information about one societal aspect of the altarpiece in which it is kin to the great showcases commissioned by the trade guilds in Bourges or Chartres. Often such works were ordered by a particular social group, sometimes by an entire urban community. This was the case in Gries in the Val Venosta, whose citizens commissioned an altarpiece from Michael Pacher of Bruneck in 1471, expressly telling him to model it on the one in the church in nearby Bolzano, carved by Hans von Judenburg nearly fifty years earlier. In 1477, the German community in Kraków in Poland asked Veit Stoss for an altarpiece for the high altar of St. Mary's Church, although the huge cost, 2,808 florins, could be met only through donations. There is a record of the solemn but joyful procession that accompanied Duccio's *Maestà* through the streets of Siena from the painter's studio to the cathedral. Other altarpieces were ordered by fraternities (that of Saint-Martin in Strasbourg, for example, by the locksmiths), by the town's ruling class, or by the nobility. The knight Christoph von Zelking, for instance, set out precise conditions in his will for the sale of wine and grain to finance an altarpiece for the church in Kefermarkt in Austria, although he did not name an artist. And, of course, other altarpieces were commissioned by abbots or abbey chapters.

The articulation of an altarpiece with a system of folding shutters makes its structure relatively complex. Placed on the high altar of a church, it was not visible in its entirety, and certain parts were not opened except on certain

days in the liturgical year. A rood screen was a substantial barrier blocking the view of part, or even the whole, of an altarpiece from the nave. In the case of conventual churches, such as that of the Antonines at Isenheim, the original home of the altarpiece painted by Matthias Grünewald and carved by the Strasbourg artist Nicolas de Haguenau, we do not know if the congregation was allowed into the preceptory choir or, if they were, when and on what conditions.

The votive image of St. Antony occupies a commanding position at the center of the Isenheim altarpiece. When the polyptych is open, two statuettes are revealed bearing offerings to the guardian saint. This bears out the early-sixteenth-century testimony of Wimpheling, who grumbled about the laity turning chapels into veritable "flea markets" with their ex-votos and offerings. This and many other cases help us to estimate how difficult it must have been to contain public devotion. A reformer like Sébastien Franck recorded a usage that seems to have been common before the Reformation. On the occasion of every major festival, altarpieces were opened and the saints dusted and adorned; the patron saint in particular was dressed and "put in the church porch to beg, and a man was set beside him to speak for him, because the statue cannot speak. He said 'In God's name, give to St. George, or St. Leonard, etc.'" It is perfectly feasible that the statue of St. Antony from the Isenheim altarpiece was used in this very way.

In the attempt to establish the genealogy of the altarpiece we come up against a highly complex problem but one that is central to our purpose. Pictures painted on portable panels—in diptych or triptych form—existed already in Byzantine art well before the fifteenth century. There were "portraits" of the Virgin in thirteenth-century Italy, showing the head and shoulders. Such images, probably influenced by Byzantine icons, necessarily imply greater proximity of the believer to the Virgin in both public and private prayer. This Marian image, portable and foldable when it is combined with an image of Christ, for example, is one of the origins of the northern altarpiece. The Synod of Trier stipulated in 1310 that every altar should carry an inscription or an image invoking the saint to whom the altar was dedicated. Such images, carved or painted, were full-length and could also contain a relic or serve as a devotional image. There was always an image symbolizing the Eucharist, but it could be relegated to the altarpiece's crowning. The decisive change was the transition from the little stone or wooden retables, of low rectangular format, placed at the back of the altar and known in France from the thirteenth century, to these immense, elaborate structures, furnished with carvings and shutters, as high and as wide as the sanctuary itself, which are found particularly in German-speaking

countries and in Spain. The change of scale meant that the large sculptural programs on the exterior of church buildings were now to be seen on altarpieces also and therefore more directly—more visibly, I submit—associated with worship, which is not to say that they played a liturgical role. In fact, we find innumerable local saints incorporated in Mariological or Christological programs on altarpieces.

The change of scale was not general, it should be said. Carved altarpieces of Low Countries origin, which became widespread throughout Europe during the fifteenth century, remained content with little scenes produced in sequence and easy to assemble. In the Low Countries themselves, it was painted altarpieces that grew bigger from the fifteenth century onwards.

To comprehend the unique quality of these large carved altarpieces it will serve to examine one—the one carved and painted by Veit Stoss for St. Mary's Church in Kraków. Its iconographic program is highly original, with the Death of the Virgin and her Coronation in the center panel, seen when the case is open. The Joys of Mary are represented on the open volets: on the left, the Annunciation, the Nativity, and the Adoration of the Wise Men; on the right, the Resurrection, the Ascension, and the first Pentecost. These panels simultaneously illustrate the Incarnation and the hope of salvation. Closed, these shutters compose a group of six scenes which should be read in company with the two fixed volets. That gives four columns of three panels each, to be read boustrophedon-wise, interrupted after the third series:

First series (left fixed volet): meeting of Anne and Joachim at the Golden Gate and annunciation to Joachim, birth of the Virgin, presentation of the Virgin in the Temple.

Second series (left movable shutter, closed): presentation of Jesus in the Temple, Jesus among the doctors, arrest of Jesus.

Third series (right movable shutter, closed): Crucifixion, Deposition, Entombment.

Fourth series (right fixed volet): Christ in Limbo, the three Marys at the tomb, the *Noli me tangere.*

The fixed volets illustrate episodes preceding Christ's birth (on the left) and following His death (on the right). Certain elements in the program seem to be not wholly coherent: it is hard to see why scenes of Mary's life on a fixed volet needed to be concealed on Marian festivals when the altarpiece had to be open to show the principal scene. It is yet more difficult to explain why two scenes from Jesus' childhood are included when all the others relate to the Passion. The inclusion of the dispute with the doctors, which is less frequently depicted

than other episodes in cycles of the childhood of Christ, alludes perhaps, in the context of prehumanist Kraków, to the circle of scholars and intellectuals (Italians, Germans, and Poles) that enlivened the Jagiellonian University and Kraków society (fig. 63).

But let us return to the central case and the two complementary sections: the predella (a Tree of Jesse) and the crowning, the present-day appearance (which is due to modern restoration). Originally, the overall height of the whole altarpiece was somewhere between 52 and 59 feet. The case itself is 23 feet high and 18 feet wide (36 feet, if we add the width of the shutters when open). The composition of the scene of the Virgin's death is entirely horizontal; as in no other carved altarpiece, the floor of the case is effectively a stage on which the scene is enacted. The depth of the case suggests that the two apostles at the extreme ends of the group are entering as from wings. The central group is composed of apostles wholly preoccupied with supporting the dying Virgin by words or gestures. One has raised his hands above his head and wrings them in anguish, and five of them look up toward the other scene represented in the axis of the case, the Coronation of the Virgin, surrounded by a joyful band of angels, placed below ornate baldachins supported by very slender colonettes against the back wall. This scene, on a scale infinitely smaller than that of the Assumption, was executed by one of Stoss's coworkers. All the dramatic tension resides in the expressivity of the apostles and the wonderful opposition between the Virgin's collapse to the ground and her glorification in Heaven above. The turbulence of the figures' garments and their multiple folds emphasizes the earthbound character of the scene, but some eyes gaze only upon the Coronation where Mary, in conformity with an exegesis that was already old, represents the Church with her Bridegroom, Christ.

The incongruity of this pair of scenes on two different scales has been remarked on more than once. It is easy to forget that the altarpiece forms the closure of the perspective view along a very long and narrow chancel. When it is open, a person entering the church sees only the large-scale, horizontal scene of the Virgin's death. Not until one draws closer and enters the choir does the Coronation become visible beneath the vaults of the baldachins. The vertical axis of the Redemption comes into view only at a second stage, in terms of time, even if it is proclaimed at the moment of entering the building by the huge crucifix suspended in the arch between the nave and the choir, executed by Veit Stoss in 1491. One must enter the church and approach the altar in order to see the Coronation of the Virgin. Furthermore, Stoss deliberately placed his altarpiece at the very end of the apse, making it impossible to open the shutters completely so that they are always at an angle; the believer is

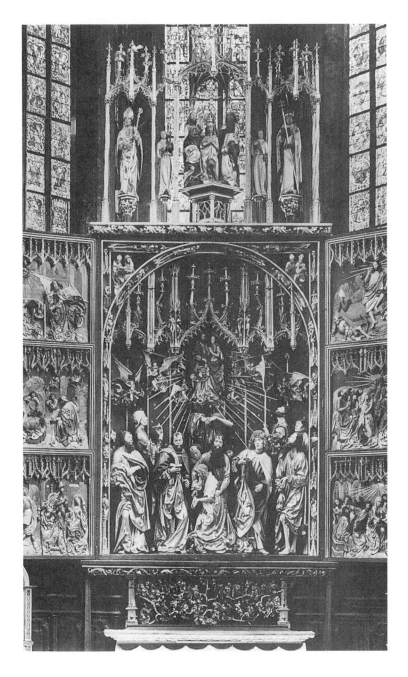

FIGURE 63. Altarpiece of St. Mary's Church in Kraków, by
Veit Stoss; partial view.

thereby forced to stand close to the altarpiece to read the scenes and even then the main emphasis falls on the central group.

Stoss's work should be recognized as a challenge: his was the first entirely carved altarpiece in a region where painted ones predominated. The Kraków altarpiece can be regarded as the affirmation of woodcarving as a noble medium, much as Rogier van der Weyden wanted to demonstrate the superiority of painting to carving in his Louvain altarpiece (now in the Prado; see fig. 72 on p. 255). The function assigned to sculpture by Stoss, who, we should remember, was a painter and engraver as well as a sculptor, is confirmed by the distinction in his treatment of the obverse and reverse faces of the panels. The inner surfaces are carved in high relief, the outer ones in low relief, but these are the more pictorial in character. Stoss's intention was certainly to use carving alone to refashion a distinction quite common in late-fifteenth-century altarpieces, where shutters are carved on the inside and painted on the outside.

Stoss chose to paint the background of the whole altarpiece a uniform blue sprinkled with gold stars, panels included. Even the concave molding surrounding the case, topped by a semicircular arch and lined with figurines of prophets, has this blue background. The arch itself can be interpreted in this context as a *porta coeli*; symbolism is the only explanation for the exceptional choice of a round arch in this Gothic work.

Gold is the color of all the garments in the death of the Virgin, in contrast with the reliefs, where the palette is more varied. The luminosity of the gold reinforces the visual impact of the scene. The large figures of the apostles appear to be of a higher formal conception than the reliefs; the difference cannot be imputed to the intervention of associates in the work, as used to be suggested, but to the difference in scale. In any case, they are not meant to be seen from a close standpoint.

The originality of the Kraków altarpiece can be measured by comparing it with two others also dedicated to the praise of the Virgin. At Creglingen (Württemberg), Tilman Riemenschneider represented the Assumption in the case and the Coronation of the Virgin in the crowning above. The result is a Virgin whose physical ascension is underlined by the contrast with the apostles, whose garments, draped in complex folds about them, play the same role as at Kraków. Windows let into the case make the setting for the scene look like the sanctuary so that the case represents the church. Michael Pacher's altarpiece for the parish church of Sankt-Wolfgang presents an immense Coronation of the Virgin, surrounded by a troop of angels with St. Wolfgang and St. Benedict in niches alongside. The scene is set in an unreal space where everything seems weightless. Riemenschneider and Pacher both exploited the fairytale quality

of baldachins and interlocking gables. The human form is as if turned to stone in the sinuous coils of an implied architecture, especially in the Pacher altarpiece. In Sankt-Wolfgang the bodies emerge from the mystery enclosed in the altarpiece, shot through by rays of light coming through the windows on either side. At Creglingen, the little windows in the case itself allow only an attenuated light to penetrate, with the effect that the space of the scene duplicates the sanctuary space. Thus both Pacher and Riemenschneider resorted to the reversals of scale and theatricalization that the carved Gothic altarpiece had exploited so well during the second half of the fifteenth century, while maintaining—as was essential—a single axis around which the image was arranged, vertical and ascending.

Stoss, by reinterpreting the case as a frame enclosing a stage, introduced a horizontal axis, and it is this that really thrusts the vertical axis upward. But such an innovation only has meaning by virtue of what is represented, that is, an iconographic program where incarnation and celestial glory are ultimately united in a symbolic vision of the Church. Stoss's language is profoundly marked by the two-dimensional conception of the world that is expressed insistently in Gothic imagery. We might even say that in the Kraków altarpiece he loudly reaffirms its validity, as if it was the only instance through which the invisible could be represented. For this reason, Stoss's altarpiece constitutes the true "Gothic" counterpart to the Trinity painted by Masaccio in Santa Maria del Carmine in Florence fifty years earlier.

## THE CATHEDRAL AS A THEATER OF MEMORY

Introducing his great iconological *summa* of the thirteenth century, Émile Mâle insisted on what he called the "passion for order" that characterized medieval man.[19] His intention was to study the great decorative programs of religious buildings from three angles: as "sacred writing," as "sacred mathematics," and as "symbolic language." In this he did no more than adopt a very ancient definition, first encountered at the time of Gregory the Great. Pope Gregory was the first to emphasize the need to help the illiterate by recourse to images. The Synod of Arras proclaimed the need shortly after the year 1000: "What the more simple in the church and the unlettered cannot read in the scriptures, let them look on it in the lineaments of painting." Visual images came thus to be defined as the "letters of the laity" (*litterae laicorum*, according to Sicard of Cremona) or the "books of the laity" (*libri laicorum*, to use the term of Albertus Magnus). Paintings, according to Guillaume Durand, moved the mind more than words. Later, St. Bonaventure explained the usefulness

of pictorial images in counteracting the ignorance of simple people, emotional apathy, and weakness of memory. When the Dominican Étienne de Bourbon (d. 1261) explains in his treatise on preaching that the preacher's chosen text (*exemplum*) should directly reach the listener's senses in order to register in the imagination and thence be imprinted on the memory, he illustrates a psychological application of St. Bonaventure's definition.

While a chasm separated lay people from churchmen, as we know, the clergy in turn included many who were poorly educated. Numerous reformers sought to help them acquire some of the learning they had never received; it was for them that Guillaume Durand wrote his *Rationale Divinorum Officiorum*. Traces also survive of the exhortations addressed to artists, enjoining them not to confuse people with meaningless images: such was the ambition of the author of *Pictor in carmine*.

Before addressing the subject of sculpture on the exteriors of church buildings, I should mention the sculptural programs found in the cloisters of collegiate churches and monastic communities. These were created in the desire to give the monks *exempla* of the communal life drawn from the lives of the apostles, whose frequenting of the Porch of Solomon was taken as a symbol of the cloister. And so Christ's washing of His disciples' feet is a subject illustrated in this particular space; we also know that the rite of washing feet was sometimes performed in cloisters, at Notre-Dame-en-Vaux at Châlons-sur-Marne, for example, below the capital on which the scene was carved. The Last Supper or the Fast of St. Nicholas was found in or near refectories, and narrative scenes relevant to the abbot's duties in chapter houses. In general, however, cloisters cannot really be said to have sheltered an iconography significantly different from that found in or on parts of religious buildings accessible to lay people.

From around 1140 onward, sculpture began to spread across the exterior facades of buildings, especially in the form of the columnar statues placed in the embrasures of the doorways. Here they supplemented the carved cycles on tympana: on the west front of Moissac or Saint-Gilles, very tall, full-length human figures were to be seen already, in niches or carved in high relief on the lower parts of the wall, but not threatening to disrupt the plane surface. The apostles lining the portals at Vézelay likewise adhere closely to the wall. The great innovation introduced by columnar statues is twofold: the architectural fabric is in a sense extended by the sculpture, and the scale of the figures is increased by the building. On the other hand, in adopting the harmonious tripartite arrangement of the west front from early English architecture, the architecture of northern France inaugurated a new accord between sculpture

and architecture; before long there were three west portals corresponding to the three aisles, causing a threefold division of the external elevation. Accentuation of the middle segment established a hierarchy centered on the main entrance, which was aligned with the building's axis. By around 1200, the west front of a church offered a number of fields for the sculptor: portal statues, their bases and their canopies, coving, the tympana, wall surfaces between the windows, gables, niches in the abutments, and arcades at the top of the wall—not to mention cornices, gargoyles, capitals, and pinnacles. The sculptor graded the size of his carvings according to their position, proximity to the viewer, and iconographic import. A vast scenography filled the entire lower story, sometimes extending to the upper; seeking to interpret it, the viewer can no longer tell whether the initiative lay with the architect or the sculptor, or which of the two seized the opportunity presented by the need for images to transform the facade into a "book," the "text" requested by the theologians to illustrate a program.

If we take the comparison to a book literally, we are bound to agree that the arrangement of scenes and isolated figures on a west front or a screen is analogous in every point to one type of page layout in illuminated books, that is, the full-page illustration in registers, used as a rule to illustrate an intellectual construction, with the essential difference that architecture favors vertical accentuation.

It is clear that architecture imposes, if not quite the complete frame sculptural images need, at least the principal subdivisions and general forms of such a frame. Some very precise concepts are responsible for the exceptional development of the transept fronts at Chartres or the suppression of tympana on the west front at Reims. Theology itself submitted to the authority of architecture, and the tripartite structure of the body of the church, for instance, can be said to have had numerous consequences, not only for the structure of Gothic elevations but also for their iconographic subject matter.

Subject matter combined lessons taken from the scriptures with sequences about local saints. Therefore, a cathedral, the seat of a diocesan bishop, brought the saints of that diocese together with some of the major dogmas. The local saints became familiar intercessors, assuring believers that these scenes and figures carved in stone, all of them serving the common purpose of telling the story of salvation, directly concerned them. By this means a channel was set up between the terrestrial world—let us say, the world of the diocese, and of the parish within the diocesan framework—and the heavenly world, between the past and the present. An immense structure reared up in front of the place of worship, in which every significant scene or figure had its place,

capable of exciting some degree of astonishment in a spectator. For example, in the three portals of Amiens, the *Last Judgment* in the middle tympanum is flanked on the right by the Coronation of the Virgin, and on the left by the legend of St. Firminus, an obscure bishop of Amiens. It was not just a concern for aesthetic order that determined symmetrical and hierarchic structures like that. The wish to imprint a particular lesson on the memory was also a factor—more so than has been recognized until now. In any event, that is what some theologians said, among them St. Bonaventure, and I am inclined to believe them.

Memory training was practiced in the Middle Ages, as it had been in classical antiquity. The Greeks—Plato and Aristotle alike—recommended recourse to two givens: image and place. To put it rather simply, memory was above all topological for the Greeks and Romans. The Aristotelian theory, expounded in *De Memoria et reminiscentia*, reached the West in the Middle Ages by way of Arab philosophers, and commentaries exist by Aquinas, Albertus Magnus, and Roger Bacon. Where Aristotle wished to separate memory and imagination, Aquinas put them together, holding the second responsible for registering the impressions received from the external world in order to memorize them. Techniques of memorization such as those formulated by Cicero were also familiar to medieval writers, but a treatise on rhetoric also attributed to Cicero, the *De ratione dicendi ad Herennium*, was to be the most influential text from the twelfth century onward and especially from the thirteenth: John of Antioch translated it into French in 1282. Following the lead of *Ad Herrenium*, Aquinas recommended thinking of unusual images to stand for whatever it is we want to memorize, as the first step. Then we should place them in a certain order that will enable us to move more easily from one to the next. Thirdly, the memory will latch more firmly onto an object if it is associated with an affect, and it requires constant repetition of what has been memorized.

The important point is that while the ancients linked memory to rhetoric, for the scholastics it had more to do with ethics: it was an attribute of Prudence, as the *Ad Herrenium* had already stated. Memory was thus associated very directly with one of the cardinal virtues, which meant that it also had a role assigned to it in the immense program of Salvation. Boncompagno da Signa, author of a *Rhetorica novissima* (1235), includes the memory of paradise and of hell in memory, with virtues and vices becoming mnemonic devices.

The manner in which the exterior of a church with its sculptural program, in addition to the interior, particularly the windows, could come to exercise a mnemonic function has a parallel in *mappae mundi*. I am not referring to

portolanos—coastal charts with a purely practical application—but to those encyclopedic maps of the world—*imagines mundi*—derived from classical and biblical authority. The Ebstorf *mappa mundi*, dating from about 1235, is a particularly remarkable example. It presents a virtual chronicle of the history of the world associated with the places where things happened, augmented by a history of Salvation. The period covered starts with Eden and extends to the *Last Judgment*: even places relating to pre-Christian times have reasons for their inclusion. Christian belief is symbolized by the world in the shape of the crucified body of Christ.

The most widespread schema of the figuration of the world is the Greek letter tau ($\tau$) inscribed in a circle and oriented to the east (at the top). The vertical stem of the tau is formed by the Mediterranean Sea, the crossbar by the River Don pointing north (the viewer's left) and the River Nile pointing south (right). Asia occupies the upper half of the circle, Europe the lower left-hand (northwest) quarter, Africa the lower right-hand (southwest) quarter. The Greek model of the ecumene (οικουμενε) underlying this schema found a Christian justification in the Middle Ages in the belief that the tripartition went back to the sons of Noah, Shem inheriting Asia, Ham inheriting Africa, and Japhet inheriting Europe.

Maps designed like this fix the image of the world as somewhere enclosed and symmetrical and therefore easy to memorize. And yet they contained everything in terms of space and time that medieval man could know: past, present, and future. From this standpoint, the *imago mundi* is the only image with the encyclopedic scope to match the cathedral.

According to Albertus Magnus, in order to follow the advice given in *Ad Herennium* and choose *loci* for your *imagines* as a help in memorizing them, you should choose "real" places, "solemn and rare" ones, in "real" buildings. The historian Frances Yates concluded that he meant churches, first and foremost. There are Renaissance treatises about artificial memory that mention real places such as Bamberg Cathedral. We know of nothing comparable from the immediately preceding centuries. It has been long established, certainly, that the art of preaching, as renewed by the Franciscans and Dominicans, certainly reawakened interest in the *ars memorativa*, but in my view the preeminent area where medieval memorization techniques were applied was not oratory. As St. Bonaventure stated so clearly, it is the visual image that corrects failing memory. Even though he does not prescribe any modalities, we can find them in the sculptural programs of thirteenth-century churches.

The argument for resorting to space as a useful aid to memory training is reinforced in the case of architectural space by the meaning induced by order, as

advocated by Aquinas. If we supplement that with the recommendation in the *Ad Herennium* that it is better to choose *loci* that are neither too brightly nor too dimly lit, we see taking shape before our eyes an ensemble of images arranged across a space in a coherent order and exposed to enough light to facilitate reading them. Considered in these terms, a cathedral's west front becomes a vast "theater of memory," proclaiming its message with a clarity that must be indebted to mnemonic techniques. Displayed in an order of importance confirmed by differences of scale, the fully rounded carvings and reliefs are there for the purpose of stimulating the memory. Gothic architecture, with its orderly array of motifs, creates the necessary *loci*, and sculpture fills them with the *imagines* that are to be memorized. One element in particular will serve to confirm this interpretation, namely the niche (Henri Focillon's *espace-milieu* or Sedlmayr's "baldachin"—which is perhaps more expressive despite being less appropriate). Setting an isolated figure in its place, a Gothic artist gives it a frame that encloses it in two of its dimensions and limits it in the third; in practice, even a fully sculpted figure is never sufficiently far from the wall to be seen in the round. Each figure stands, therefore, not against an "empty" space but against a dark background by which it is enhanced. In the case of portal statues, pedestals and canopies become the top and bottom of the frames. The same is to be seen in the archivolts. It has often been said that Gothic architecture subjected the sculptural program to its own logic, but I think it is essential to add that the appearance of subjection is deceptive, because above all the sculpture is easier to read. The ultimate example of a sculptural program distributed across an array of niches, a veritable "iconostasis of memory," is the inward face of the west front of Reims Cathedral, dating from around the 1250s.

The Gothic niche probably made a big impression on the authors of treatises on memory. Peter of Ravenna, in the most celebrated of the manuals devoted to artificial memory, prescribed the dimensions of the human body as a *locus* for memory. Johannes Romberch adopted Peter's idea and also recommended, among other things, the mnemonic technique of memorizing real places, monastic buildings, for instance.

We have an example, in fact, in which the layout of a convent served as a kind of memorandum of the Passion: memory certainly played a part both in the action itself and in what it was intended to evoke. This is a passage in Suso's *Life of the Servant* where he speaks of utilizing the convent precincts in order to mark the principal stations in a Way of the Cross on which he accompanied his Savior: an *imitatio Christi* taking him from the chapter house to the four arms of the cloisters in turn, eventually into the choir inside the church, and

finally to the altar where he found the crucifix. The account exemplifies the mnemonic function that falls to images generally in the mystic way: they helped memorization, or imitation, of moments in the Passion. Having arrived before the crucifix on the altar, Suso "did penance, nailing himself with heartfelt love to his Lord on the cross."[20] The mnemonic function of images is all the more evident in Gothic art because of the decrease in representations of an allegorical or typological character, while the relating of real or historical facts accounted for a growing majority of both painted and carved decorations. The image served as a memorial or reminder and the believer needed to register it so as not to forget the incidents in Holy Scripture that were represented.[21]

We know that eucharistic piety developed during a period when Christ's humanity and hence His Passion were at the center of attention. It invoked the physical presence of Christ and excited the memory of His Passion. For St. Bonaventure, the two aspects were suggested by the beautiful image he took from St. John Damascene and used frequently: the "glowing coal" (*carbo ignitus*), which kindled fire in the believer who experienced the Passion. The mnemonic function of the glowing coal is compared to that of images representing the Passion. According to Bonaventure, the reminder of the Passion came in three forms: written, oral, and sacramental. "Written: as when the Passion is described or recounted by scripture, or when it is expressed in images, as it were a dead memorial, apt to be made for the sight, which apprehends from further away." The oral memorial, made for the hearing, "is partly living and partly dead," according to whether it issues from good or bad preachers. The sacramental memorial is living, Bonaventure continues, and is "to be tasted . . . so that we remember His Passion, not as a thing seen and external but through a kind of experience."[22]

The visible image is therefore considered dead by comparison with the sacrament. But sight is not dismissed altogether; the glowing coal may after all bring to mind the burning bush in which God *appeared* to Moses. When Suger wrote of the scene, depicted in the allegorical Moses window in Saint-Denis, that "he who is full of this fire Divine burns with it yet is not burned,"[23] he seems to have anticipated Bonaventure's eucharistic piety. For Aquinas, the memorial of the Passion is given as nourishment, in the sacrament of the Eucharist, instituted "as a perpetual memorial of His Passion."[24] The apostles were able to keep the *memoria* of the Passion because they had witnessed it, but since their time the memory has had to be transmitted through a "memorial." We can measure, in regard to this point of Thomist doctrine, the degree of unimportance to which such theological enquiries relegated images. Which of them would ever have communicated the incandescence of eucharistic coal?

As yet, the discussion has referred to only two of the registers of memory: that which concerns visual images as representations of past events and defines memory as a safeguard against forgetting, and that which concerns the positioning of *imagines* in the *loci* distributed across a building's facade and defines a memory of the intelligibility and meaning of the images. We are back with the distinction made at the start of this part of the chapter: the first register addresses itself to the illiterate public and poorly educated members of the clergy—and the more expressive it is, the more successful it will be; the second is the preserve of an elite. Preaching might help to cast light in the direction of the second, for ultimately it was only after having interiorized a program as vast as that of the west front of a cathedral like Reims or Strasbourg that a person would be able to comprehend each image's reason for existence.

We should also bear in mind that color, an essential factor in our understanding of medieval art, also had a not-insignificant part to play in the exercise of the memory. A fifteenth-century treatise advises the reader to (mentally) change the color of the *locus* if he wishes to separate a given image from the one with which he had associated it. Although he was referring to the art of book illumination and not to monumental sculptural cycles, the Augustinian Jacques Legrand, in his treatise on rhetoric, wrote that "one may observe very well in illuminated books that difference in colors gives remembrance of difference in lines. . . . The ancients, therefore, when they wished to record something and commit it to memory, used divers [*sic*] colors and divers pictures in their books, in order that the diversity and the difference gave them better remembrance."[25] Similarly, in the case of the sculpture on a church exterior, the colors of the figures, and also those of their niches or other backgrounds, constituted an important tool of artificial memory.

Form, too, has a bearing on memory. The more legible a relief is, the easier it will be to memorize, and that depends on the skill of the artist who had to shape the narrative by stripping it of elements liable to hinder perception while embellishing it with those that would make it more effective. Parisian sculpture between 1240 and 1260 provides several particularly telling illustrations of this art: the statues of La Sainte-Chapelle, the reliefs on the screen at Bourges, the fragments of the south portal of Saint-Denis—the list is longer than that. Let us opt for the screen at Bourges (fig. 64).

Positioned at the west end of the choir, the screen marks the separation of the space reserved for the clergy—the cathedral chapter in this instance—from that occupied by the lay congregation, toward whom its sculptural program was turned. It was from the screen that sermons were delivered, in the vernacular, and the epistle and gospel were read. The iconographic content of

FIGURE 64. Reliefs on the screen of Bourges Cathedral, a fragment.
(Photo: Hirmer Fotoarchiv, Munich)

the screen was therefore determined by the fact that it was a barrier; prophets and apostles adorned the angles above the colonettes, the Crucifixion, with Longinus shown piercing Christ's side, was at the center. The scene represented the central moment in a continuous narrative frieze which started on the screen's left-hand return (facing north) with Judas's betrayal, and finished with the cauldron of Hell on the right-hand return. On the front, in the left half, were Pilate and the Serving Maid, the Scourging of Christ, and the Climb to Calvary, and after the Crucifixion, on the right, came in due order the Descent from the Cross, the Entombment, and the Visit of the Three Marys—these are all still identifiable, while the relief showing the Resurrection has been obliterated. The important question for us concerns the particular qualities that made these images crucial works at a decisive moment in the evolution of thirteenth-century art. Their legibility was new at the time; it is not due simply to the treatment of the episodes themselves, governed by a wholly new economy, unencumbered by a single superfluous detail and indifferent to spectacle. Rather, it springs from the new sense of form revealed in each and every figure; there seems to be agreement between a body performing a specific action and the garment accompanying the action, which acquires an appropriate plastic resonance. Unlike a tympanum, which necessarily divides a narrative into episodes and consequently imposes a certain compactness on the groups, a frieze offers the sculptor a continuous support where each figure can be deployed freely in accordance with the ample breathing space

provided by the two dimensions. All the figures in the Bourges screen are depicted in high relief against a uniformly abstract background, like a stained-glass tapestry decorated with little squares of colored glass.

In an article published in 1969, Cesare Gnudi demonstrated all the epic grandeur of these fragments and evaluated their true status as the expression of a "classical" phase of Gothic sculpture which came to an end in 1260, but provided the point of departure for the classicism of Italians such as Nicola Pisano, Arnolfo di Cambio, and Giotto.[26] The *Christ of the Last Judgment* and the adjacent *Angel of the Nails* in the central tympanum of Notre Dame of Paris form perhaps one of the very first indexes of what has been called an aesthetic revolution that appears to have taken place in the Parisian circle of influence by the early 1240s at the latest (fig. 65).

The revolution in question broke out at a moment when, in a grandiose series of masterpieces, the so-called *rayonnant* style of architecture seemed to formulate the last word of a concern to visualize all the energies activated in a stone structure. Here, in a completely different register, sculpture appears to be preoccupied with the legibility of its own discourse. Later it would yield to a mannerism that already started to develop toward 1300 and continued throughout the fourteenth century, but in the 1240s Parisian sculpture aimed to impress with a formal sovereignty and monumentality exhibited in the highest degree by the apostles of La Sainte-Chapelle.[27] It is tempting to attribute this "attic" classicism to a definable context, that of the French court, and to see in the growing influence of the Franciscans a ferment that perhaps encouraged its flowering—not the ideal of poverty or the drama of Passion narratives, but the sense of visual, live witness essential to the evangelism of St. Francis. Louis IX, educated by Franciscans, built them a new convent in Paris where they established themselves in 1216. The sculptural program of La Sainte-Chapelle, the chapel of the royal household, was commissioned in a style using arguably the most refined idiom of the artistic language of the time.

The formal qualities common to these works executed in Paris and in Bourges do not diminish their singularity when considered individually. An appropriate analogy might be to the stylistic levels of poetry. John of Garland, in his *Parisiana poetria* (ca. 1250), distinguishes between three styles corresponding to three levels of society: the low style befitting shepherds, the middle style for farmers, and the high style for persons of higher rank.[28] The differences of style perceptible within a corpus as homogenous as that of a single artist or a studio should not necessarily be imputed to differences of hand or date or even to the evolution of one personality. Even the client's rank and the nature of the commission have a decisive effect on the artistic form.

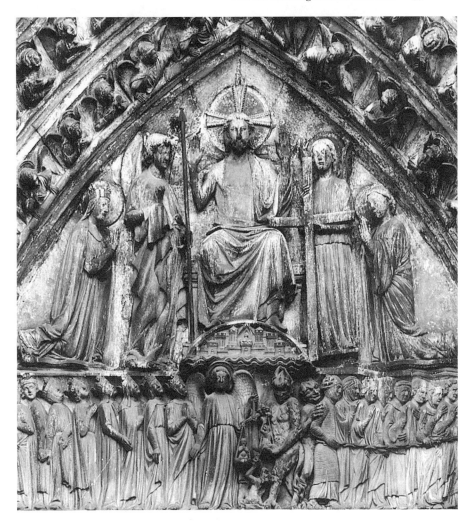

FIGURE 65. "Last Judgment," the central tympanum on the west door of Notre Dame, Paris. (Photo: Hirmer Fotoarchiv, Munich)

It is not very important in the present instance to know whether or not the sculptures on the Bourges screen date from before 1237. Their characteristic syntax is a response to their function, and the aesthetic standard of the apostles of La Sainte-Chapelle would not necessarily have served that function so well. Placed in front of the choir, facing the congregation, the carvings on the Bourges screen meet a need for legibility, to which the style adopted by the executant artist or artists was perfectly appropriate. This does not mean

that a single artist was the author of both the sculptures of La Sainte-Chapelle and Bourges. Simply, one stylistic level was judged fit to meet one type of commission. The apostles in La Sainte-Chapelle, commissioned by the king, are executed in the "heroic" style, while the sculptures of Saint-Denis, Notre Dame, and Bourges are in a more "humble" style. Evidently, the differences are not due to subject matter but to the people for whom they are destined. If we concern ourselves with differentiating the "hands" in great monumental programs such as those of cathedrals, we must also be prepared to take into account the nature of a commission and the organization of work in an atelier (fig. 66).

The question of the formal beauty of the carvings, prompted by the concern for their legibility and their mnemonic function, raises that of their use by the clergy. The case of the Bourges screen shows that someone like Philippe Berruyer could have referred to images on it when he was preaching to the congregation from it. Doing so would certainly have reinforced their power, but did it actually happen? Did great preachers, such as Berruyer or Maurice de Sully, really have recourse to the painted or carved images near them?

It seems to me that the role of preaching in transforming dead images into (as it were) living realities, to cite St. Bonaventure, has been overstated. For one thing, many of the pictorial cycles in medieval churches—those in windows, for example—are not easily seen in their entirety and also require a complicated commentary if they are to be intelligible. For another, there is a tendency to project the custom of preaching as attested in the final phase of the Middle Ages as if it applied to the whole period.

In reality, a sermon in the vernacular was still subject to some very strict rules at the beginning of the thirteenth century. Unlike a learned sermon, delivered in Latin, it was very short. Its structure, usually in three parts, followed the teaching of Hugh of Saint-Victor, who enjoined the examination of a passage from Holy Scripture according to its literal, allegorical, and tropological meanings. Most of the time, however, such commentaries contented themselves with paraphrasing the biblical text. Indeed, all personal interpretation was excluded; the essentially patristic training of preachers decked them in a type of conservatism that ruled out any recourse to intellectual subtleties. Finally, these sermons in the vulgar tongue were not conceived to take the hearers into consideration. It is hard to see, in the circumstances, how they could have mentioned works of art at all, even ones directly next to the pulpit, much less indulged in any kind of commentary on them.

And yet we do know of sermons that allude to works of art. In a commentary on St. Matthew's Gospel, in order to reinforce the idea that at the

FIGURE 66. *Apostle Holding the Host*, La Sainte Chapelle, Paris. (Photo: Hirmer Fotoarchiv, Munich)

Transfiguration it was not the Body of Christ but the air about Him that was transfigured, Pierre le Mangeur refers to painters who would represent the scene in such a way. That is, he draws on painting in order to justify an interpretation of scripture. What the art historian today expects from these sermons is that they should illuminate a picture by exegesis, or at least by a description of it, but the majority of them seem not to do so.

Although the situation evolved during the thirteenth century and the school-man's sermon became less and less constrained, there is still no reason for thinking that preachers made any use of the images that could be seen in the nave or adorning the west front. The theological subtleties embodied in the programs of the great cathedrals were far beyond the scope of the sermons given in the vernacular and would have found their proper place, at a pinch, in a synodal sermon in Latin. But in that case, were the images really intended for the illiterate?

What did it mean to be "unlettered" in the thirteenth century? In practice, the term covered several different states of illiteracy: a person unable to read at all, a person unable to read well or unable to read Latin at all, a person needing the help of a third party to read no matter what the language—all these were *illiterati* in some sense. Someone who did not have access to the truths of the Christian faith might equally be regarded as illiterate. The clergy included some very poor Latinists; when the Archbishop of Rouen, Eudes Rigaud, examined clerics who had applied to be parish priests in the middle of the thirteenth century, he frequently discovered candidates incapable of understanding the majority of the terms they were questioned about.

When treatises on preaching tried to define the public for whom the sermons are intended, they referred to people who were "simple" (*simplices*), "ignorant of the faith" (*in fide rudes*), "weak" (*debiles*), or "rustic" (*agrestes*); these were contrasted with "men of great learning" (*viri alte sapiencie*) or the "erudite" (*eruditi*). The purpose of a sermon was "edification" (*edificatio*) and "instruction" (*eruditio*). Jacques de Vitry saw *simplices personae* as the lucky recipients of *exempla* expounded by preachers. But the need to raise the standard of the preachers suggests that all too often the *simplices* were found in the pulpit as well as in the nave. In any case, the line drawn between *literati* and *illiterati* must not be confused with that separating clergy from the laity. Rather, it runs through both groups: there were *illiterati* among the clergy and *literati* among laymen. The sovereign skill with which a goldsmith (perhaps Godefroy de Huy) replied to his client, the Abbot of Stavelot, proves the existence of an elite made up of intellectual laymen, including artists, such as architects and goldsmiths, from the twelfth century onward.

Illiterate clerics incapable of understanding the ideas of the scriptures were also incompetent to penetrate the subtlety of the iconographic programs on the west fronts of cathedrals like Chartres, Paris, or Reims. Reading and understanding the images required help, but only enough to introduce the illiterate to the degree of meaning that was accessible to him. So there were different degrees of literacy, in written texts as much as in images, and both clerics and laymen were admitted to those degrees. It was on these new discriminations established within the general public, on the relative importance gradually accruing to written text, and on a growing demand for "visibility" that an essential part of the development of the art called "Gothic" was founded.

## EXPRESSION, COLOR, AND DRESS

Since the end of the nineteenth century, there has been an interest in codifying the gestures found throughout the whole of human society or within social groups, and a similar interest in the expression of emotion through facial expression or physical movement. In the field that concerns us, this or that gesture of a painted or carved figure has generally been attributed to the artist's expressive sensitivity, setting aside questions of what in the figure might associate it with a language, in other words, with rules of expression. Very occasionally, the gestures of hands are represented with such ostentation that there can be no doubt of a semantic intention, and the clumsier the artistic form, the more explicit the intention. This is the case with the illustrations to the compendium of medieval German law and customs known as the *Sachsenspiegel* (*Saxons' Mirror*; the first part is dated ca. 1290, the second ca. 1375). Franz Kugler claimed to find the elaboration of an entire "grammar" of gesture in these pictures: a symbolic system relating to legal matters, which it has proved possible to decode relatively satisfactorily, because of the regular occurrence of similar gestures in similar juridical contexts.

My concern here is with another function of gesture. In the religious structure of the Middle Ages, where the sacrament of the Eucharist played the central role, the relationship between the visible and the invisible becomes paramount. Although things visible were valued only to the degree that they referred to things invisible, certain gestures were invested with a very particular function—the designation, not of any physically present individual or object, but of an absent reality, the existence of which is attested by gesture. Nothing but the gesture of the hand serves to affirm it.

The full significance of such a gesture can be seen in an example from a paraliturgical ceremony: the whole hand, the fingers together, or the index

alone pointing in a given direction. With this gesture one of the Marys, or an apostle, or an angel, may point to the grave cloth used to wrap the dead body of Christ, in which He was brought out of the tomb to be shown to the people. The gesture does not designate the physical reality of the cloth but that to which it bears witness: the Resurrection.

At a later date, in Passion plays performed in the vernacular, the Resurrection is represented and therefore gestures of designation are reserved for real situations. In these circumstances they lose the suggestive power they had when their function was to designate what was invisible. Gesture moved on from designating to depicting.

It can be said in general that in the Middle Ages, the actor—the priest, in practice—is the narrator of his character. This makes the representation like an *imitatio*, whereas in the modern theater the actor identifies with the dramatic character he or she interprets, and we call it mimesis. Perhaps it is simpler to say that in a liturgical drama an interpreter only denotes someone absent, he is the substitute for that character.

Gestures can be classified according to two very distinct categories: the "subjective," which is linked to emotions or passions, and the "objective," which embraces two subcategories concerned with rank (status) and symbol (or function). The objective category is strictly codified and cannot be understood without knowledge of the social and cultural conventions in use. Thus "spontaneous" gestures aroused instantaneously by affect are distinguished from "slow" gestures governed by codes of usage and meaning.

Within the distinction there are nuances, however. A number of "spontaneous" gestures are also coded: the expression of sorrow, for instance, is not fixed for all epochs or in all cultures. Tearing one's cheeks with one's finger nails is the most intense expression of sorrow (especially for women), and is mentioned by Propertius and Ovid, but it virtually fell out of use in the Western world in the early Middle Ages. Mary Magdalene, standing behind the body of Christ in Duccio's *Lamentation*, raises her arms above her head and joins her hands in a kind of sorrowful convulsion, a gesture not found in art north of the Alps except in work acknowledging an Italian influence. The gesture of lamentation in Cividale's *Planctus*, a matter of beating the breast, if not the whole body, is rarely found elsewhere. Nevertheless, the codification of gestures of sorrow can be regarded as allowing the actor a certain liberty; rubrics proliferated from the thirteenth century onward, recommending, but not prescribing, certain gestures of sorrow or sadness. To judge by all the evidence, expressivity was the preserve of "Gothic" man. In a synodal sermon,

Maurice de Sully asked that the priest should not give absolution unless the believer's repentance was visible: "We should do this when we see that the sinner repents his sin with anguish, and sighs, and weeps, and promises truly that he will refrain from it."

Gestures governed by affect can be integrated into a carved or painted scene only if the viewer can understand them; intelligibility is something they owe either to their intrinsic universality or to the context. Unlike the relatively numerous gestures of the social life of any individual, gestures in art are fewer and must be chosen for their intelligibility and their expressive force. Only the complement of a verbal text—spoken in the liturgy or in the theater, written in a phylactery in a painting—can enhance the efficacy of the gesture on its own.

For the historian of medieval art, the most interesting gestures are not those of the participants in narrative scenes. Each, in isolation, relates to another as interlocutor, watcher, or interpreter, and all these parts are effective, to some degree, under well-controlled direction. The narrative is easy to follow, or it becomes so once all the elements in it have been placed in sequence. The isolated statues that, taken together, form cycles on a church's west front or screen hold far greater interest for us. Free of any dramatic relationship, except in the less frequent cases of an Annunciation, a Visitation, or Adoration of the Magi, which permit some regrouping, they are held in a finespun register of gestures, all of them in the symbolic category. The objects they handle, which most often prompt their single gestures, are themselves also symbolic, whether they are attributes or simple phylacteries. Even though these figures are very close to the viewer, by reason of both their human form and their position, they achieve a high degree of abstraction because they do not address him except in an elaborate language that requires prior memorization of the attribute or decipherment of the words in a phylactery.

The statues of the benefactors of Naumburg Cathedral are very different (fig. 67). Their gestures "speak" a courtly language to which literature provides a key. One of the gestures found particularly often in Gothic sculpture is that of the fingers clutching a girdle that holds the two front edges of a cloak together. There seems to be only one description of this gesture in medieval German literature, in a verse romance by Heinrich von Neustadt, *Apollonius von Tyrland* (*Apollonius, Prince of Tyre*, a source of Shakespeare's *Pericles*). The pose is indicative of noble rank and is often adopted by female figures and is also depicted in the "portraits" of sovereigns at Saint-Denis, Reims, Bamberg, Strasbourg, and elsewhere.

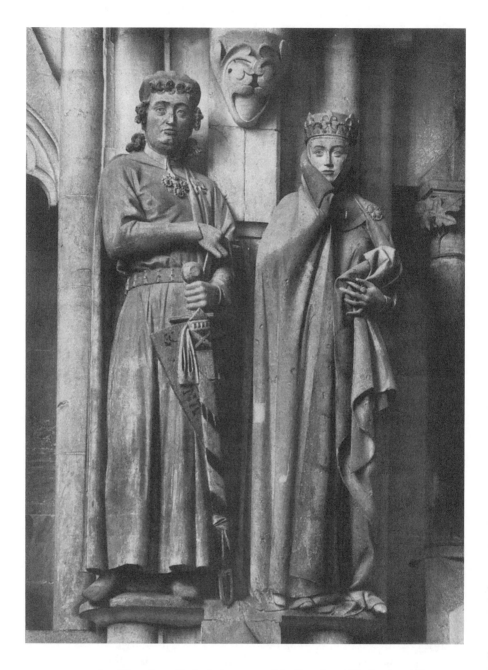

FIGURE 67. Naumburg Cathedral, statues of the founders, Ekkehard and Uta, in the west choir, ca. 1250–1260.

The cloak may also be worn with its two edges parted, while the figure slightly raises one of the panels: this is the gesture of the Queen of Sheba at Reims, of Gerburg and Uta at Naumburg, of Adelheid at Meissen; it underlines their dignity. Uta and Adelheid show a glimpse of the fur lining of their cloaks, a sign of feminine coquetry according to the *Roman de la Rose*:

> Et tout le corps en apert monstre
> A ceus qu'el voit muser encontre.
>
> (And thereby she seemed to show her whole body
> To those she saw idly awaiting her.)

Although it is the most significant example of nonverbal language, gesture is not the only external sign by which a figure may be interpreted; expression and costume are two others. Finally, there is a nonmimetic element that takes us into a verbal category: this is the phylactery, which, as we shall see, belongs wholly to the expressive register of pictorial representation.

The sculptural decoration of Reims Cathedral offers an exceptionally rich display of the huge variations possible in the representation of the human figure. Thanks to recent studies we can now form a precise picture of the chronology of the stages of the work, architectural as well as sculptural. The statuary at Reims includes expressive heads that could be interpreted as actual physiognomic studies, and so uncommon is their formulation for the Middle Ages, at least before the fifteenth century, that they have been regarded as studies from nature. They are reminiscent of the heads illustrating the Temperaments carved by Messerschmidt on the Zeughaus in Berlin in the eighteenth century. In Reims, the heads are those of the figurines of Old Testament characters, found on the archivolt of the rose window in the south transept and on consoles in the north transept and the upper walls of the choir. They all date from before 1241 and probably had a powerful influence on sculpture in Germany; the evidence of this can be seen in Mainz, Magdeburg, Naumburg, and Bamberg, where the borrowings, of varying importance, display an even greater sense of theatricality, it must be said. Relegated to positions where it is often inaccessible to view, we must regard this sculpture as a radical innovation, at least in the present state of our knowledge (fig. 68).

Direct observation from nature, that is, the abandonment of carved or drawn models, introduced innovation to Reims in the carving of the nave capitals where, for the first time, the thirteenth-century viewer could gaze at an incomparably beautiful flora that appeared to have been executed "from life." It is worth remembering that this same Reims workshop also practiced

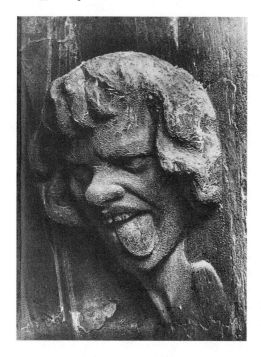

FIGURE 68. Grimacing head in the choir of Reims Cathedral, before 1240.

an art of imitation that had no equal at that date. The celebrated group depicting the Visitation demonstrates one sculptor's ability to appropriate forms from Roman statuary of the age of Augustus—a *commentator* of genius. In the imitation of classical sculpture the combination of motifs taken from a few prototypes sufficed for a whole program, and it looks as though it was practiced at Reims at the same time as study from nature. In other words, the Reims workshop might be compared to the Carracci studio three and a half centuries later.

It is therefore tempting to look on these heads in Reims as physiognomic studies, for "physiognomy," we are told in a French version of one Pseudo-Aristotelian treatise, "is a science whereby we may know the hearts and customs of men and women, by the face, the complexion, and the inner disposition."[29] Such treatises describe the outward physical characteristics whereby individuals are assigned to the four categories of temperament—sanguine, choleric, melancholic, phlegmatic—and their resemblances to animals are underlined. One Pseudo-Aristotelian treatise enumerates the "physiognomic signs" that serve as clues to the different temperaments (complexion, hair, flesh, movement, voice, gesture, and facial expression), adding "in general it is silly to rely on a single sign: you will have more reason for confidence in

your conclusions when you find several signs all pointing one way." This is followed by a description of the body, starting with the feet and finishing with the ears. The last chapters, in which various forms of lip or nose are related to those of this animal or that, follow quite a long passage on the nature and habits of the lion, a creature whose physical traits are claimed to reveal an admirable character.[30] Without placing too much reliance on such texts, it is interesting to note, among the high windows of the choir at Reims, a lion's head with features not too dissimilar to those of the human heads nearby. The metamorphosis of a human head into one sprouting leaves or demonic horns and the kinship of animal and human heads illustrate the extent to which the sculptors shared with the authors of these treatises of physiognomy a belief in an underlying relationship linking the temperaments to the elements, the seasons, the hours of the day, the ages of human life, and also to the animal, vegetable, and mineral kingdoms.

The Reims workshop was not the only one to pursue this course, however, and it may not have been the first. Such studies should be associated with practices going back at least to the twelfth century, which testify to the existence of an art the artists kept for themselves. There is a whole population of grimacing heads in churches, tucked away in places where they are out of the reach of the general public and virtually invisible. Trondheim Cathedral in Norway has some remarkable specimens dating from the years 1220–1235, and those in the nave and on the exterior of the choir of Lincoln Cathedral in England date from 1220–1240. These faces appear to belong to a large repertory, transmitted in model books that must have had a wide circulation. What is particularly noteworthy about the Reims heads is the extraordinary liberty with which they are presented, their variety, and the expressive force they emit, without being caricatures.

Another feature of the sculpture at Reims is the illumination of human and angelic faces as never before—by a smile. This smile should be understood as something more than the manifestation of an affect. It is, by definition, the mark of a particular kind of social behavior. The serenity typical of the majority of statues flanking the portals of Gothic churches is not addressed to anyone in particular; it does not assume the existence of an interlocutor. When the two angels of Reims smile, however, they manifest an intention.[31] The evocation of a "bright" face, shedding light by its color as well as by the eyes or the smile, is extremely frequent in romances of the twelfth and thirteenth centuries.[32] The statues of the founders in the choir at Naumburg are smiling. Margrave Ekkehard and his wife Uta, like the other benefactors, wear fashionable clothes of the mid-thirteenth century, in a style influenced

by France; the appearance of these lay people in the church—indeed, in the choir—forcefully characterized in their gestures, expressions, dress, and attributes, is a significant event. In an exemplary study Willibald Sauerländer showed that all these elements reproduce idealized types representative of court life. The idealization is itself a response to a stylization of highly codified behavior that should not be confused, as Sauerländer rightly insists, with the stylization that was the product of the artist's work. The classicizing repertory on which the artists drew and the naturalism they introduced into a place of worship, very lifelike and not at all rigid, can perhaps be imputed to the very unusual conditions of this commission. We can be sure that none of their confreres were granted comparable liberty at that date, and the Naumburg sculptors seized on it to compose dramatic characters, a theater of the feudal world, helped by the fact that these types amounted to a species of role playing; the attitudes are exaggerated, just as in thirteenth-century romances, to facilitate identification.

Costume has been the subject of numerous studies emanating from various academic disciplines. Its interest for the art historian is generally as a guide to dating figurative works of art, more rarely as an indicator of specific social situations or relationships. It must be said, however, that although the figurative arts are the most precise source for the history of costume, they can hardly ever be taken as representative of the totality of behavior or forms. The clergy are known to have denounced extravagance in dress, showing it little or no tolerance, and the costumes chosen for sculpture in church buildings did not fully reflect a given historical situation but rather an attitude of the Church, which desired to designate this person or that by means of one style of dress or another, consequently charging costume with moral significance. Looking at the dress in thirteenth-century sculpture, the viewer forms an impression of great conservatism: it is not at all the same with works of literature which devote a great deal of space to styles of dress. The toga of antiquity had a long career in monumental sculpture, continuing even when modern fashions became more visible.

The carvings of Wise and Foolish Virgins on one of the west portals of Strasbourg Cathedral provide a good example of the expressive—and moral—exploitation of costume. Representations of this particular subject had made use since the first half of the twelfth century, of current fashions as the preferred mode of dress for the Foolish Virgins. Often, as at Laon Cathedral (ca. 1230), their worldliness is emphasized and contrasted with the more modest and dignified deportment of the Wise Virgins, who cover their heads like married women—for are they not Brides of Christ the Bridegroom?

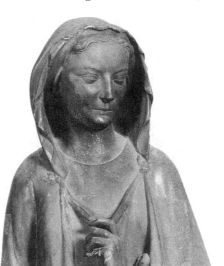

FIGURE 69. *Wise Virgin*, in the right-hand west portal of Strasbourg Cathedral. Musées de la Ville de Strasbourg.

At Strasbourg, after 1277, the sculptors seem to have borrowed a certain expressivity from the Magdeburg cycle, dating from the 1240s. The Strasbourg Wise Virgins wear dresses and cloaks which are either buttoned or held by a cord fixed to two tasseled buttons.[33] One wears a hood and holds, with two fingers of her left hand, the horizontal tie of the cloak at the height of her breasts in a gesture we have already observed that denotes dignity (fig. 69). The Wise Virgins cover their heads with hoods either held in place by a chaplet or left free. Facing them, most of the Foolish Virgins do not wear cloaks at all and are bareheaded; their hair falls down their backs though it is held at the crown of the head by a circlet. The one standing beside the Tempter uses her right hand to part a surcoat she wears over her dress, turning an unambiguous smile on the viewer. The Tempter also wears a kind of coat called a *cote hardie*, slit at the side and buttoned. It shows his legs, which medieval poets considered an attribute of manly beauty (Tristram is one example). The Tempter wears a crown on his head; his shoes are fastened by a buttoned strap. Seen from the front, therefore, the Devil is highly prepossessing, but toads and snakes are also to be seen writhing over his back. The *fabliau Le Chevalier au barisel* has a passage describing the Devil's beauty that is close to that of the Strasbourg figure:

Et li haus hom, dont je vous di,
Estoit, si com je l'entendi,
Trop biaus de cors et de visage

Mais fel estoit et desloiaus
Et si traïtres et si faus
Et si fiers et si orgilleus,
Et si estoit si très crueus,
K'il ne cremoit ne Diu ne homme.

(And the lordly man of whom I tell you,
Was, as I have heard,
All too fair of form and face . . . But he was perfidious and faithless,
And so treacherous and so false
And so proud and so puffed-up,
And was so arrogant
That he feared neither God nor man.)

In other churches, the Wise and Foolish Virgins are even more strikingly dressed in the fashion of their times. The group that used to adorn the church of the Dominicans in Lübeck is a case in point: extravagant hairstyles and elegantly cut dresses and cloaks, but also belts and brooches of remarkably refined workmanship turn the figures into noblewomen with polished gestures. In a church of one of the mendicant orders the moral lesson is made all the stronger by the bestowal of attributes of high rank on the characters in the parable.

Dress directly inspired by contemporary fashion often goes hand in hand with another feature issuing from the style of the artist. St. Theodosius (the identification is not certain) at Chartres, the Queen of Sheba at Reims, King Childebert (allegedly) in Saint-Germain-des-Près, Countess Gerburg at Naumburg, Empress Adelheid at Meissen: all these figures have a suppleness, a "countenance" of great elegance, derived from an emphatic *contrapposto*. Countenance and dress together are enough to distinguish these secular figures from other representations and to bestow a certain rank on them. They speak all the more directly to the congregation in the church.

Before leaving Strasbourg I want to mention one final expressive element with a unique significance: the phylactery. In the shape of a long sheet of parchment it is held rolled or more often unrolled. In virtually every case, the verse from the Bible originally painted on it has vanished irretrievably.

The phylactery is thus a material object and is treated as such; its sole function is to be unrolled so that it can be read. While it hinders the liberty

of movement of an actor in a scene, it serves to introduce an alternative in the form of a verbal element: dialogue or simply the expression of a thought. This role characterizes the phylactery in painting or tapestry, since in sculpture it accompanies only individual figures and is scarcely ever found in the scenes assembled on tympana. In painting, the phylactery may even issue from the mouth of a protagonist shown addressing another directly.

Also in painting, the phylactery benefits from a kind of weightlessness allowing it to be placed anywhere at all in a scene and to make a contribution to the style of the picture by means of its own characteristic shape. On full-length portal statues, its position and relationship to the carved figure are determined by physical laws. Phylacteries help to identify statues, but at Strasbourg certain prophets hold them out ostentatiously in front of the breast as if encouraging the viewer to read them. Such recourse to scripture is reserved for monumental figures, unlike the reliefs in the tympanum, where the narrative thread is depicted by gesture, expression, and grouping alone, without the assistance of any verbal element. At a time—the second half of the thirteenth century—when it might be said that the illuminated manuscript scarcely resorted to verbal discourse any more, monumental sculpture used it but in accordance with modalities that distinguished it from the narrative images of books, stained glass, tapestries, and murals. In such cases it fell to the phylactery to insert elements in the narration that were not descriptive (that was for the painter) but supplementary—to do with time: action previous to the one represented, action yet to come, the link between two actions, and so on. In one instance the verbal element makes the painted picture an illustration to a text that continues for the entire length of the book. In the other, the carved image is not an illustration and the function of the text, which comes after it, is only one of identification.

Something that makes Strasbourg Cathedral all the more interesting an example is that even before the Prophets' Portal was erected, the apostles on the screen (after 1250) and the evangelists on the Pillar of the Last Judgment (ca. 1225–1230) already handled their phylacteries with a certain theatricality. The expressive function of the phylacteries is particularly insistent here as if, even after 1275, the Strasbourg cycle still felt the influence of narrative miniatures from the first half of the century.

Elsewhere, however, the phylactery plays a complementary role. At Chartres, for instance, in the north portal, on the right, in the depictions of the Annunciation and Visitation, each couple is attended by a prophet holding a phylactery. We can surmise that the now-headless figure accompanying the Annunciation is David, and that his phylactery might have borne the words "Hearken, O daughter, and consider, and incline thine ear" (*Audi Filia et vide,*

*et inclina aurem tuam*; from the Vulgate, Psalm 44:11). This is the figuration on the ambo at Klosterneuburg, by Nicolas of Verdun, where a narrative sequence is introduced among the pillar statues by the two protagonists being turned to face each other, while the prophets' presence underlines the fulfillment of the prophecy, that is, the concordance between Old and New Testaments.

The existence of the polychromy complementing architecture as well as carving in stone and wood has been mentioned several times already. It played a role in creating a higher degree of illusion that would strike us today, were it reconstructed, as wholly incompatible with our conception of a Gothic cathedral. If we added the altar cloths, the tapestries in the choir, the colored linen cloths covering reliquaries and their supports, and of course the stained-glass windows, we would see a church filled with iridescent color. Nowhere would the natural color of stone be visible, certainly not in the works of "pure" sculpture that churches display today. Above all, in the twelfth century and later, medieval man loved color; he dressed himself in it and he used it to decorate everything around him. With regard to architectural polychromy, we have noted that colonettes were painted so as to detach themselves visually from the pillars they encircle. It was the same with full-length statues and their dosserets, of course. But the coloring of carved figures did not necessarily go hand in hand with an aesthetics of imitation. It was not until the fifteenth century that color began to work with the plastic form to produce an enhanced "realism." Earlier than that, however, experiments had been made in using color to achieve particular material effects: some of the evidence dates from as early as the twelfth century. Lines painted on the Furstenried crucifix (Bavaria; ca. 1200) were intended to suggest shadow or light to enhance the piece's plasticity rather than its realism; the juxtaposition of a white line and an ocher line gives the impression that the surface they define is in relief. In the thirteenth century polychromy was applied to a carving as if it presented a uniform plane. The polychromist's work was little different from that of a painter suggesting modeling on the surface of parchment. Agreement between the particular nature of the carved support and how it was colored developed gradually, alongside the growth during the fourteenth century of painting's importance as a means of reproducing a world more complete, more diverse than in the past. The discovery of painting's potential, its ability to represent all the most subtle nuances of flora and fauna as well as a wide range of other matter, would open new perspectives for the polychromist. But it would be wrong to suppose that the painter's task was in a way subordinate to the sculptor's. It was the polychromist's job to produce an illusion, for example, by painting the pupil and iris on an eyeball left blank by the sculptor—even,

in the early sixteenth century, adding the reflection of a window. The effect of such illusion was in some sense superimposed on the surface of the stone or the wood, left by the sculptor in a condition such that we might suppose was meant to be left bare. Often the application of a primer, essential before painting a coat of color on wood, actually gums some of the finer points of the carving.

Encrustation with small pieces of glass in the position of the pupil of an eye, as had been done in Romanesque art, or sticking pieces of brocade in relief on the borders of garments were already in the fourteenth century among the most widespread of the practices intended to increase the statue's expressivity and, in the case of the brocade, to accentuate its plasticity by the differentiation of the materials.

It was agreed throughout the Middle Ages that a layer of color enhanced the reality of a carved figure, as this passage from the *Roman de Troie* by Benoit de Sainte-Maure attests:

> Et si estoient colorées,
> Et en tel manière formées,
> Qui en chières les esgardast,
> Que vives fussent li senblast.
>
> (And they were colored
> And shaped in such a fashion
> That to anyone looking at them
> They appeared to be alive.)

The fourteenth century manifests a pronounced liking for the color white and for grisaille painting. The desire for more light in religious buildings explains the predominance of white in architectural polychromy. Grisaille represented a radical innovation in manuscript illumination from the beginning of the century onwards. Images in demigrisaille in the exquisite Book of Hours of Jeanne d'Évreux (1325–1328), which is entirely the work of Jean Pucelle, inaugurate a genre which persisted for the rest of the century: fabric hangings painted in grisaille with flesh tints, hair, and above all, buildings and landscape given color washes. The effect lends a certain unreality to scenes that are in other respects strongly influenced by the naturalistic, expressive trend coming out of Italy. The technique was used in illustrating the works of Guillaume de Machaut, the Psalter of Bonne of Luxembourg, and the *Bible moralisée* of her husband John the Good, to give only a few examples.

Its raison d'être remains to be explained. In the case of the celebrated "Parement de Narbonne," intended to be hung above and behind an altar, the

FIGURE 70. *Parement de Narbonne*, Louvre, Paris. (Photo by Michéle Bellot.
Credit: Réunion des Musées Nationaux/Art Resource, New York)

decision to paint it in grisaille was based on its liturgical function. It was hung during Lent, and grisaille corresponded to the *stilus humilis* appropriate to that season in the church year. Camaïeu was chosen for paintings on the outer faces of altarpieces in the Low Countries for the same reason (fig. 70).

In fourteenth-century manuscript illumination, in any event, grisaille was not confined to certain subjects or to a specific iconography. The choice also had artistic reasons: in the case of John the Good's Bible, we may suppose that resort to the one technique made it easier for the painters working on the book's 5,212 illustrations. But in the *Book of Hours* of Jeanne d'Évreux, the care with which the grisaille was handled certainly did not save the painter any time. It is likely that the emphasis on the plasticity of groups and individual figures was an attempt to make them resemble sculpture; their antinaturalistic character tended to make each scene a picture within a picture. Regardless, it discourages viewers from regarding them as mimetic representations of an event and invites us, rather, to see each image as a kind of aide-mémoire.

The affinity to sculpture is only to be expected in the work of a painter who was also a sculptor, like André Beauneveu, who used demigrisaille to paint prophets in Jean de Berry's psalter. The technique even occurs in portraits, as attested by the dedication page in the *Bible historiale* presented to Charles V of France in 1371 by Jean de Vaudetat; here, only the garments of the King and his counsellor are painted in grisaille. A poem by Venceslas of Luxembourg, quoted by Froissart and dated between 1365 and 1390, refers to a portrait "of black and white" painted by Agamanor.

Although there are instances where the use of grisaille met a need to tone the image down or served a specific liturgical function, as with the Narbonne altarcloth, it does not mean that other reasons can be dismissed: for example, in the choice of painting or sculpture as *modi*, the muted, "low" character of

grisaille painting would have less influence than the desire to reserve grisaille—that is, a representation of sculpture—for one kind of image in order to distinguish it from another, polychrome, one.

On occasion this modal distinction may even be a response to the theoretical intention of illustrating the predominance of one medium over another. We saw, in the case of the altarpiece of Our Lady in Kraków, the techniques whereby Veit Stoss asserted the primacy of sculpture. Works by Robert Campin and Rogier van der Weyden explicitly champion the other case: the sovereignty of painting over sculpture.

A large painted altarpiece by Robert Campin presents an iconographic program associated with the paraliturgical ceremonies of Eastertide. This is the triptych in the Courtauld Institute Galleries in London, once owned by Count Seilern and dated 1410–1415 by scholars (fig. 71). The middle panel depicts the Entombment, that on the left shows the donor praying beneath the empty cross, and that on the right shows the Resurrection. The donor's worship is directed toward the Entombment and the connection is made through the figure of the angel behind Joseph of Arimathea, on the left, holding a spear; raising his hand to his lips, this angel casts a sorrowful gaze back

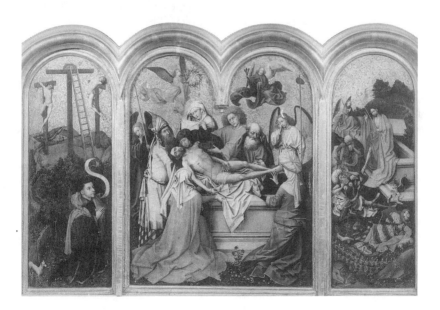

FIGURE 71. Robert Campin (the Master of Flémalle), the *Seilern Triptych*: "The Donor," "The Entombment," and "The Resurrection." The Samuel Courtauld Trust, Courtauld Institute of Art Gallery, London.

towards the donor. The painter gives a comparable role to another figure in the Entombment scene; one of the Three Marys, seen wholly from behind, is kneeling beside the sarcophagus and holding the grave cloth. Campin makes the figure exceptionally ample: this body with a hidden face has the most visible physical presence. Letting our eyes travel from the left-hand panel to the middle one and then to the one on the right, following the order of the narrative, we observe how plainly the central scene with its monumental figures is conceived as the nearest to the believer, and more important than the empty cross and the resurrected Christ on either side.

Campin's style derives from a sculptural tradition—the observation is not new. In the case of the Seilern triptych, however, the plasticity intrinsic to his style finds a supplementary justification. Undoubtedly, in the dawning fifteenth century, the ceremonies observed at Eastertide—Adoratio, Depositio, and Elevatio Crucis—were better suited to three-dimensional representations of the crucifix. Claus Sluter's Entombment for the Champmol charterhouse, known from a mention of 1408, must have constituted a prototype for the long line of monumental Entombments found in Burgundy and territories coming under Burgundian influence. Campin probably knew it, just as he knew twelfth-century staurothecae of the Meuse region, which gave him the four semicircular arches forming the frame of his triptych. The gold background of the three panels strengthens the hypothesis of an explicit reference to reliefs in precious metals.

Approaching the same subject for the Louvain company of archers, Rogier van der Weyden would also make a very clear allusion to a plastic tradition of the Deposition (fig. 72). In fact, unlike Campin and his choice of a gold background, Rogier gives it a wholly unexpected real "setting" and paints his Deposition on the case of an altarpiece in trompe l'oeil low relief, with an arched surround that is also painted. Rogier depicts not so much the event as a representation of the event giving the illusion of the third dimension. He thereby demonstrates painting's superiority to sculpture as an art of illusion. The gesture expresses his wish to hallow the art of painting as better fitted than its rival, sculpture, to represent a scene that was so central to the paraliturgical ceremonies celebrated in the waning Middle Ages.

Let us return to grisaille: its use on the outer faces of the shutters of the Ghent altarpiece, the Adoration of the Mystic Lamb, allowed the Van Eyck brothers to introduce a new degree of reality (fig. 73). Painted in this manner, the figures of saints are no longer mimetic representations of historical people but almost sculptural images. The place and the space they occupy in niches painted in

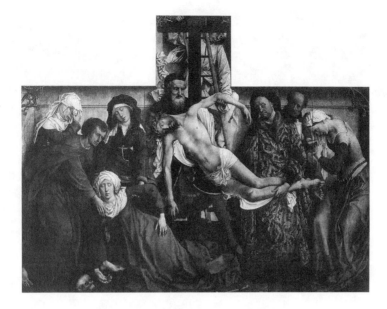

FIGURE 72. Rogier van der Weyden, *The Deposition from the Cross*.
Prado Museum, Madrid.

trompe l'oeil reproduce the church in the altarpiece, with a sculptural program decorating its exterior. Thus the altarpiece becomes a sort of reflection of the church itself.

From the end of the fifteenth century onward, Germany witnessed a proliferation of carved altarpieces that were not polychrome: more precisely, their monochromy served simply to underline flesh tints and the pupils of the eye, sometimes the edge of a garment. The technique links these sculptures to pictures painted in demigrisaille. It was not used for the sake of economy but seems to have satisfied a desire to reform images in churches; polychromy was judged negatively as the symptom of a taste for luxury and expense. Figures and scenes preserving the natural hue of the wood, sometimes lightly painted, tend to dematerialize and to recover a spiritual significance that religious art had lost during the fifteenth century. The Reformation would of course encourage the development of this new kind of image.

The fall of a figure's garments is not, strictly speaking, an expressive element. It is a major indicator of style and in my view has come to be invoked too often independently of its relations to other factors. In fact, it has been identified so closely with style that its mimetic relationship to given fabrics has

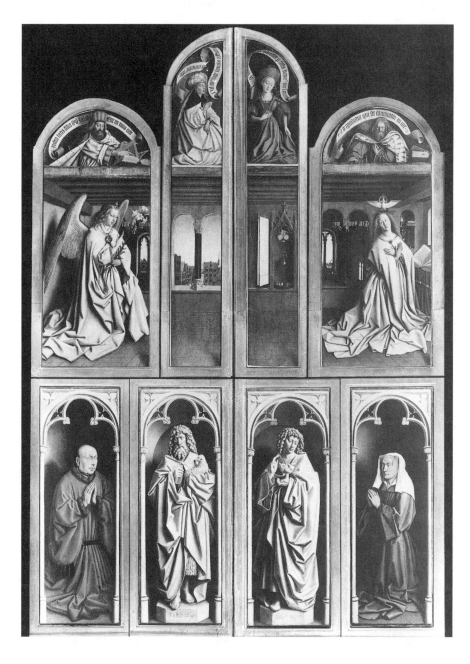

FIGURE 73. Jan and Hubert van Eyck, altarpiece of the Adoration of the Mystic Lamb, shown with the shutters closed. Church of Saint Bavo, Ghent. (Photo credit: Scala/Art Resource, New York)

been overlooked: fine cotton and silk do not fall in the same folds as a thicker, heavier cloth like linen. Changes in cloth manufacture therefore constitute elementary givens to which the sculptor's treatment owes much.

Contrariwise, exaggerated folds so thick that they hamper the movement of the bodies wearing them scarcely correspond to any historical reality. When they first appear, from the 1420s onward in painting in the Low Countries, some twenty years later in sculpture, they are the expression of an aesthetic intention that drew artists into an elaborate formal game of which Dürer would prove to be the ultimate exponent.

The treatment of garments plays a determining role according to how far sculpture seeks to efface the body itself or, at least, deny its worth. The overall arrangement of figures in Gothic art, unlike that of the Renaissance, is not governed by the structure of the human body. Only the line of the hips inherits anything of classical *contrapposto* and defines the broad lines of the composition of garment folds. In Gothic art it is a nonmimetic system, its form self-referential, producing its own logic and concentrating an artist's characteristic formal values. It is easy to verify that in the large ensembles decorating the west fronts of Reims and Amiens or the transept at Chartres the statues maintain a rhythmic balance among themselves that is attributable to the play of folds. The nature of the fabric makes only a minor contribution. One may well feel, rather, that as garments became more pliable, allowing greater freedom of movement to the men and women who wore them, so too the representational arts tended to impose on the clothing of lay people forms that were increasingly structured and independent of the body.

But garment folds constitute more than a strong accent in the rhythm of portals: they also have a relationship with the architecture, specifically with the modenature. Concave pleats can make folds stand out with varying degrees of sharpness, giving an appearance of pipes or fluting, thus creating a system analogous to torus moldings alternating with gorges. Although no one has ever explored this type of analogy, the pleat may be said to be almost the abstract version of the architectural profile. Each affects the convex form—the outturned pleat or the torus—optically by containing it between two heavy lines of shadow. Once again, we should remember that color could reinforce the effect of depth in the inverted pleats or enhance the relief of the projecting ones, according to how it was applied. It was the same with colonettes standing out from their dosserets.

Such analogies should not be pushed too far. The very fine pleats of the robes worn by a large number of carved figures of the early thirteenth century hardly have an equivalent in modenature, even if the facet on the crest of an

almond-shaped profile, which we encounter in architecture of the same pe-
riod, presents a form of delicate outline close to the "latest fashion" of 1200. It
is in the 1240s that the pleats of garments seem to begin to swell and produce an
autonomous formal system independent of the body beneath. Not for the first
time, the most eloquent examples are found among the figures of apostles in La
Sainte-Chapelle in Paris. Convex folds take on the profile of a veritable vertical
torus, like a kind of organ pipe (see fig. 65 on p. 235). This increased plasticity
leads straight towards their ultimate architectonic development which, fol-
lowing the emergence of a Claus Sluter, would stamp the whole final phase of
Gothic art in northern Europe. Once again, different formulations within the
system as a whole observe laws similar to the *genera dicendi* of classical literary
theory. Strange to say, the proof comes from painters: Hubert and Jan van
Eyck, on the shutters of the Ghent polyptych cited earlier, which was finished
in 1432 (see fig. 73, above). Of the four figures in the bottom row, the two real
historical characters—the donors Joos Vyd and his wife Isabelle Borlunt—
wear garments with thick, heavy folds, executed with a certain realism that
concentrates the angular "breaks" in the cloth at the bottom, where the skirts
reach the floor and spread out. But with the figures of the two saints, John
the Baptist and John the Evangelist, painted in trompe l'oeil to look like stone
statues, the robes are treated like a kind of shell, constructed of organ-pipe
pleats, completely hiding the body, and covering it from shoulder to foot. The
law of gravity does not apply here, although it seems to do so in the clothes
of the lay couple. From this time forward, the representation of saints would
give rise to a kind of *stilus gravis* which followed the path of an antinaturalism
where the painter would indulge in pure speculation about forms.

Not long after the Van Eycks' altarpiece was installed in Saint Bavo, Alberti
published *De pictura*, which contains a very interesting passage about garment
folds, in Book 2 where he writes in the context of the "movement of living
creatures."

> Since by nature clothes are heavy and do not make curves at all, as they
> tend always to fall straight down to the ground, it will be a good idea,
> when we wish clothing to have movement, to have in the corner of the
> picture the face of the West or South wind blowing between the clouds
> and moving all the clothing before it. The pleasing result will be that
> those sides of the bodies the wind strikes will appear under the covering
> of the clothes almost as if they were naked, since the clothes are made
> to adhere to the body by the force of the wind; on the other sides the
> clothing blown about by the wind will wave appropriately up in the

air. But in this motion caused by the wind one should be careful that movements of clothing do not take place against the wind, and that they are neither too irregular nor excessive in their extent.[34]

In Alberti's description the folds of clothing function like "accessories in motion," in Aby Warburg's phrase (*bewegtes Beiwerk*[35]), introducing movement into a picture while allowing the body to be displayed. The heavy fabrics arranged by the Flemish painters are not stirred by any outside element; they form immobile architectural masses, taking their rhythm from the play of complex decorative demands. There is something cubist about their treatment, not just because of the parallels that might suggest themselves between the straight lines and angles of these folds and the network of intersecting lines in a painting by Braque or Picasso, but even more because it results in a treatment of space that is the opposite of what Alberti defines. As depicted by the Van Eycks, the folds tend to gather the volume of the cloth into a plane. In its amplitude, the material seems to wish to spread itself over the picture plane in order to submit to the pure play of forms that is a sign both of the *stilus gravis* appropriate to the representation of a saint and of the acme of an artistic mastery which, as such, is laid before connoisseurs for their scrutiny.

Similar formal techniques appear in other works by Jan van Eyck, for example, the *Virgin and Child with Saints and Canon van der Paele* (Bruges) or *Virgin and Child with the Chancellor Rolin* (Paris, Louvre), in which the Virgin is seated, her cloak treated as if it were an object in isolation responding to a singular ornamental logic. Virgins by the Master of Flémalle (in London and Madrid) and the Frankfurt Veronica are executed in the same "style." The strong contrasts created by the way these garments form their folds allow the painter to gather the whole forward surface of a cloak into one plane but make an ornamental pattern from the breaks in the pleats at the same time. Dürer took this principle of abstraction to its most radical extremes; for him the system is so self-referential, so free of any relation to the body and detached from all physical laws, that he uses it to depict not skirts or cloaks but cushions.

There are six such cushions drawn on the right-hand side of a page, displayed at the Metropolitan Museum of Art in New York; the left-hand page has a self-portrait of the painter beside a drawing of his hand, on a larger scale, with the thumb and index and middle fingers touching as if they held a pencil (fig. 74). The juxtaposition of the self-portrait as graphic artist and the cushions reinforces the hypothesis that the creases in the cushions are the result of the pressure of a figure. When one thinks of the history of folds in fabric since the beginning of the fifteenth century and the sovereignty of their

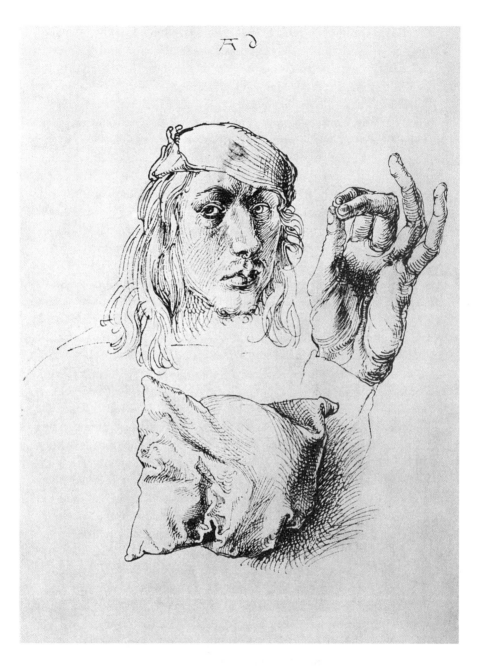

FIGURE 74. Albrecht Dürer, *Self-Portrait, Studies of a Hand and a Cushion*.
(Image © The Metropolitan Museum of Art, New York)

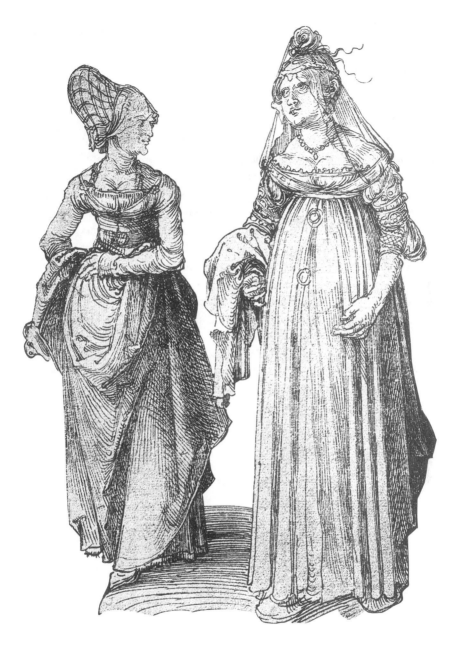

FIGURE 75. Albrecht Dürer, a drawing of two women. (Frankfurt am Main, Städelsches Kunstinstitut. AKG Paris)

intervention in *stilus gravis*, it is tempting to interpret Dürer's exercise, a kind of physiognomy of folds, as verging on blasphemy.

Dürer exposes the ambivalence between the representation of dress and plastic form, as a painter seeks to suggest it, with breathtaking lucidity. In a drawing bought by Passavant in the nineteenth century, he shows two women, one from Nuremberg and one from Venice, out walking side by side (fig. 75). The smaller German woman turns her head to look admiringly at her companion. For her part, the Venetian pays the other no attention whatsoever. Both are wearing their very finest clothes, but the Venetian's dress, drawn in immediately below the breasts, falls in long straight folds to the ground, while the Nuremberg woman raises her hem by tucking a fold of the skirt under her left forearm. By this gesture, very common in fifteenth-century carved saints, she causes a large triangular pocket to form, enclosing a network of folds and creases, at the level of her pelvis. As Panofsky noted, Dürer contrasts not only two different societies but also two feminine types: above all, the figure of the Nuremberg woman enables him to evoke a physiognomy of late Gothic style. These two analogous representatives of pretty urban womanhood are matched by two distinct stylistic formulations. The *stilus humilis* of Germany is humbled further at the side of the fashionable Venetian. The woman of Nuremberg is the descendant of a long line born in Northern France in the first half of the thirteenth century.

# Models, Transmission of Forms and Types, and Working Methods

The only evidence that nature was ever taken into account in the twelfth century is found in art indebted to classical precedents. The baptismal fonts at Liège made by Reinier of Huy, a goldsmith of genius from the Meuse Valley, reveal an appreciation of human anatomy nurtured largely by knowledge of antique bronzes. But such familiarity would not be enough on its own, of course, to explain the exceptional ease with which bodies move in space; Reinier de Huy must also have observed the human body directly. The date of his work at Liège is incontestably 1117 and therefore is contemporary, to within a few years, with the bodies of the sinners in the tympanum at Autun.

A similar sensitivity to natural forms is found in the work of Nicolas of Verdun, also from the Meuse region, although his contact with classical antiquity was less close. Knowledge of antique sculpture had a more direct influence on a group of artists who worked in southern Italy for the Hohenstaufen emperor Frederick II, whose works reflect the idealization found in late classical portraiture; in a bust now in Berlin (ca. 1240) the strands of the mustache and beard are stylized in the manner of Romanesque sculpture. This piece is close to the carvings commissioned by Frederick for the monumental door at Capua, the most immediate model for which is to be found in Antonine art. Despite the use of trepans for some parts of the head, the locks of hair are executed like goldsmith's work. Thus, geometrization of forms remains a constant in this art, even in the celebrated bust in the antique style by Barletta, which is thought to represent Frederick himself. The earliest known thirteenth-century portraits were carvings, and painted ones were unknown before the middle of

the fourteenth century. There is probably a simple reason for this: sculpture presents something equivalent to the physical body and is considered better suited to rendering the truth of features, gestures, and bearing.

But the art of portrait sculpture has some surprises for us; physiognomic resemblance is not the sculptor's goal even when he claims to execute a portrait. Forms circulate, perpetuate themselves, undergo small inflexions that become customary in their turn. Conformity to representational tradition is not only something to which every artist aspires, but it also imposes particular procedures that profoundly affect the formal conception itself. The transmission of models is well attested, but its mechanism is still mysterious. Only close examination of each notable work, its facture, and, at the same time, its overall character will enable us to venture a tentative solution.

### A NEW MODEL: THE ROYAL PORTRAIT

In the long history of the evolution of royal portraiture, the reign of Philip IV of France (1285–1314) plays what, in the light of recent research, seems to have been an absolutely central role. Few works survive, but with the help of textual evidence we can reconstruct an idea of the totality, which appears to have been informed by an ideology of royalty more extreme than any previous king of France had ever developed. Throughout his life Philip, known as "the Fair," took good care both of his own portrayal and that of his predecessors. He commissioned full-length statues of all the French kings since the legendary Pharamond for the great hall in his palace on the Île de la Cité. This group, attributed to Enguerrand de Marigny, was entrusted to Évrard d'Orléans. Most of the statues are supposed to have been in position by the time of Philip's death in 1314. Around 1300 Philip had statues of Louis IX (St. Louis), six of his children, and his wife Marguerite of Provence erected in the priory church at Poissy. His own statue, flanked by Enguerrand de Marigny, was placed on the *trumeau* in the Galérie Mercière of his own palace on the Cité. Another was installed in 1304 in the Collège de Navarre, which he founded; and Philip was also represented in a side aisle of Notre Dame of Paris, this time as a benefactor of the church, kneeling beside his wife, Jeanne de Navarre.

In death, Philip wanted to put the final touches to the already abundant iconography of his person. Traditional practices were altered at his funeral; having died in his own country, unlike St. Louis, he was embalmed and his face left uncovered. The body was dressed in coronation robes common to the era of the 1260s, the scepter was placed in the right hand, the *main*

*de justice* in the left, and the crown on the head. This is how Philip was represented on the tomb at Poissy where his heart was interred, carved before 1327. The exposition of the regalia and the *main de justice* became the standard iconography of the monarch for the remainder of the Middle Ages.

In 1300, Philip's cousin Robert, Count of Artois, had a row of plaster heads of kings and queens put up in his castle at Hesdin. This gallery was kept up to date, for there is a record that some time after the accession of Charles IV in 1322, "a new king's head, for the king who now is" was made.[1] In 1308, Mahaut, Countess of Artois, commissioned a likeness (perhaps a statue) for the church at Boulogne showing Count Robert mounted on horseback "in remembrance of my lord of Artois."

The most innovative trait in several of these programs is the contemporaneity. The sculptor was charged with representing people who in some cases had been dead for decades alongside others who were still alive as he worked. Robert de Clermont, St. Louis's youngest son, was still alive when Philip IV had his portrait placed in the transept at Poissy and Philip himself was depicted in several of the buildings he founded or enriched. There are two distinct conceptions of the royal effigy at work here: one reflecting a general principle of idealization—the retrospective portrait; the other tending to integrate observation from life (*ad vivum*), to the extent that Jean de Jandun could write about the kings in the great hall of Philip's palace, around 1323, that "there are also some [statues] so perfectly exact in their representation that at first sight one judges them almost alive." In the same period, Dante praised the portraits on monuments in church floors because they were so lifelike.

Funerary monuments provide the best sources for study of the preoccupations that emerged around 1300. According to the chroniclers, it was then that sculptors began to rely on their observation of living models; one known example is the bishop of Regensburg (d. 1296), who ordered a tomb in his own likeness (*sepulchrum similiter sibi*). Another instance is the tomb of Rudolf von Habsburg, described at length in the *Österreichische Reimchronik* of Ottokar von Steiermark. No one had ever seen so faithful a likeness of a man before (*daz er nie bild hier gesehen/einem manne sô gelîch*); the skilful stonemason (*kluoger steinmetze*) had gone so far in his pursuit of verisimilitude that he had counted the lines on the emperor's face in order to reproduce them all. As Rudolf grew older, the artist modified the portrait of him that was to survive. Then the chronicler compares the portrait to the epitaph that the emperor had made: the surface of the entire wall of the cathedral would not suffice, Ottokar says. Reproducing the physical traits of the emperor and praising his

moral virtues seem to be two complementary tasks, though differing in difficulty.[2]

The taste for spectacular funeral ceremonies and handsome tombs grew during the thirteenth century and is much discussed in the records. Alluding to St. Augustine's words—"Whatever service is done the body is no aid to salvation, but an office of humanity"—St. Thomas Aquinas says the motives for burial are twofold. "For the sake of the living, lest their eyes be revolted by the disfigurement of the corpse, and their bodies be infected by the stench, and this as regards the body. But it profits the living also spiritually inasmuch as our belief in the resurrection is confirmed thereby. It profits the dead in so far as one bears the dead in mind, and prays for them through looking on their burial place." Seeing a fine sepulchre, "men are aroused to pity thereby and consequently to pray." A man feels a "natural affection" for his own body and that is why he has "a certain solicitude for what will become of his body after death."[3] The development of funerary art should be seen in relation to the great philosophical debate about the soul and the body, and to the position accorded to the latter by Aquinas—the body serves the soul as a tool serves a worker[4]—and Albertus Magnus. To see it as no more than an eschatological background, as Panofsky does, is excessively reductive: the supplement to Aquinas's *Summa Theologica* employs the Augustinian etymology of "monument" as combining *monere* and *mentem* to mean something that recalls someone to mind, a concise affirmation of the commemorative function of funerary monuments.[5] Moreover, the positioning of tombs reflected a veritable historic topography: the cyclical ordering of the royal tombs in Saint-Denis by Louis IX in 1264 paid strict regard to the historical importance of each former monarch. St. Louis's successors sabotaged the arrangement, but it had served to lay out a kind of historical tableau in the abbey that aspired to demonstrate the unity of the monarchic principle and perhaps also had a mnemonic function, in that it facilitated spatial memorizing of genealogies and dynasties.

Philip II (d. 1223) was the first French king to receive a sumptuous funeral ceremony. Royal obsequies began to take on a specific character from the time the early Plantagenets acceded to the English throne in the second half of the twelfth century. The dead king was dressed in his mantle of state, wearing the crown, with scepter in hand and face exposed. The presence of the regalia demonstrated the link between the rites of coronation and burial. Similarly, on his death in 1218, the German emperor Otto IV lay in state in his coronation robes and with the regalia. In France the same ceremonial was extended to Queen Blanche in 1252 (she was regent at the time of her death, while her son

St. Louis was on a crusade). If the monarch died abroad in the course of a military campaign, there could be no question of his body being displayed lying in state with the regalia. Philip III (d. 1285 in the course of a Spanish war) was eviscerated and his entrails buried in Narbonne, while his embalmed body was taken to Saint-Denis. It was in opposition to such practices that Guillaume Durand declared that "no man can have two sepulchres."[6]

However, the multiplication of sepulchres became frequent in the early fourteenth century, even for monarchs who had died at home. Philip IV died at Fontainebleau in 1314, but was buried in accordance with his will of 1311, where he stipulated that his body should lie in Saint-Denis and his heart at Poissy. In England, the delay between the death and burial of Edward II in 1327 led to the introduction of new practices: the body, eviscerated and embalmed, was accompanied by a "roial representation" (an effigy) placed on top of the closed coffin with the insignia of power. The use of an effigy was not exported to France, it appears, until the occasion of Charles VI's funeral in 1422. The sculptural representation of the dead king on his tomb was thus an attempt to establish a definitive image, while the effigy was displayed during the lying-in-state, as a kind of substitute for the actual body in the coffin.

The idea—intrinsically irreligious—of deconstructing a body, so to speak, in order to distribute parts (heart, entrails, flesh and bones) between several tombs is worth examining in the larger perspective of late medieval anthropology. First of all, the role of the representational image is precisely to reconstitute the body's organic identity, lost in death, in order to pay the dead person the respect owed on the occasion of his or her death. These funeral practices led, therefore, to the removal of the body's innards—a kind of symbolic dissection which historically preceded scientific dissection. In the cycle of royal tombs in Saint-Denis, the interaction of monumental sculptures and tomb carving is very clear. Most of the sculptures are pseudogisants. It was only at the end of the thirteenth century that a formal distinction began to be made between standing and recumbent figures. The first instance seems to be on the tomb of Isabelle of Aragon in Saint-Denis: the folds of the dress no longer fall according to the vertical axis of the body but are flattened on the slab on which the figure lies. Another innovation (as can be seen on the tomb of Philip III) is that the *gisant* is carved in white marble but the slab is black marble. These two features characterize an aesthetic of funerary carving that distinguishes it very clearly from the monumental sculpture of church exteriors: the figure on the tomb lies relatively flat, but the modeling of the

materials prevents it from making an impression of flatness. This illusionism is a major index of what I would like to call the "reality principle."[7]

The funerary mask came into use later, if we are to believe the written sources; however, the gallery at Hesdin indicates that around 1300 a head on its own was recognized as representative of the whole person. The head's symbolic function is attested to by the attempt of Henri de Mondeville, physician-surgeon to Philip IV, to outline a hierarchy of the different parts of the body, with the head at the top but the heart at the center. Certain parts of the body, such as the face, are more noble because they are more fragile. In the hierarchy of sacred relics, the head is among the most important. Finally, the choice of the head to represent the entire person of a king is not arbitrary, as we shall see below; in twelfth-century literature it is already a metaphor of the king in relation to the body standing for the rest of society.

The author of the Hesdin cycle possessed an ability to individualize features that the sculptors who carved the tombs in Saint-Denis lacked. The study of individual physiognomy was considered a science in the thirteenth century. A treatise on astrology by one of the learned men at the court of Emperor Frederick II, Michael Scot, also included physiognomy. Early in the fourteenth century, a certain Albertus Mussatus used a particularly precise vocabulary to describe the Emperor's physiognomy. Terms for parts of the body and face multiplied in the courtly poetry of the period—Konrad von Schenck found no fewer than eight different ways to refer to the mouth. Leaving the face uncovered while the dead body was taken to its resting place (as in the case of Philip IV) reinforces the idea that increasing importance was attached to a person's features. Even if we admit today that the rictus of Isabelle of Aragon at Cosenza is only the result of a fault in the stone, we cannot overlook the use of the mortuary mask in this period. To the best of our knowledge, it was in funerary sculpture that the lure of the portrait first made itself felt, over the period 1320–1380, although thirteenth-century principles of idealization were still obeyed. The *gisant* of Philip III reveals, if not respect for the dead man's features, at least the wish for a degree of individualization, such as can also be seen in the case of the tomb of Wolfhart Rot, Bishop of Augsburg (d. 1302), and the monument to Pope Clement IV at Viterbo, erected in the 1270s (see figs. 76 and 77). In fact, the wish to render individual features probably first manifested itself outside funerary sculpture. The makers of funerary images must have strongly resisted abandoning idealization; reproducing an ugly face was acceptable only in the register of expressivity, as in the grimacing heads at Reims, not on a tomb. In the "Treatise of the Resurrection" in the supplement to *Summa Theologica*, St. Thomas's disciples asked

FIGURE 76. A *gisant* of Philip III ("the Bold "), ca. 1300, Saint-Denis. (Photo: Giraudon)

FIGURE 77. Bronze *gisant* of Bishop Wolfhart Rot (d. 1302), Augsburg Cathedral. (Photo credit: Foto Marburg/Art Resource, New York)

the following questions: Will all the risen dead be the same age (in the bloom of youth)? Will they all be the same stature? Will they all be the same sex (male)? Will the damned be raised with their former physical deformities?[8] Preoccupations of this kind illustrate the importance the "image" of the dead assumed in the imagination during the thirteenth century. The interest in physiognomy inspired by the treatise of Pseudo-Aristotle grew precisely in the second half of the century thanks to the translation by Bartholomaeus of Messina (1258–1266). *De animalibus* by Albertus Magnus and *De physiognomia*, attributed to Aquinas, prove that the schoolmen also addressed the issue.

There is yet another aspect to the interest in individual physiognomy. Some exceptional artists working in the transept at Reims succeeded in individualizing faces by resorting, more often than not, to expressive mimicry. This is a strand that can undoubtedly be traced back to classical precedents and goes forward through Reims in a direct line to the statues of the benefactors of Naumburg Cathedral. The galleries of kings arrayed on the facades of Paris, Chartres, Amiens, and Reims played a fundamental part in the genesis of the group in Philip IV's palace on the Île de la Cité, for example. Did they represent Old Testament kings or former kings of France? Whatever the answer may be, the transformation of the royal portrait cannot be explained without envisaging some interplay between the modern image of a sovereign and that of "historical" characters.

The interplay between the "real" and the "imaginary" is most evident in costume. Some of the kings in the gallery of Notre Dame in Paris wear the Roman toga, others a belted robe under a cloak secured by ties. The regalia are limited to the crown and the scepter. This mixture of ancient and modern clothing was perpetuated until the transept at Reims. The *gisant* of Louis VII (d. 1180) at Barbeau Abbey was one of the first to wear coronation robes and a cloak hung over the shoulder in the ancient manner. The *gisant* (1220–1230) of the Frankish king Clovis shows him wearing a cloak with ties and holding a scepter, like the royal statues at Notre Dame and Chartres. Philip IV, on the tomb made for his heart, is represented with the coronation dalmatics and the regalia. Durand protested against such practices, which had grown up during the thirteenth century: man ought to appear naked on Judgement Day, adorned only in his virtues. Christians should be buried in a shroud, not in their clothes, as was the custom in Italy. Only ordained clergy should be dressed in the robes of their order, which would suffice to signify their virtues.[9] The representation of contemporary costume has a useful historical

value. In 1320, Mahaut of Artois ordered, for her castle at Conflans, "images of knights, painted in several colors and their shields, where they appear, shall be furnished with their arms, and it shall be ascertained what arms they bore when they lived." This precision is very important and should encourage us to regard costume—armor in particular, in this case—as subject to "archeological" or consciously historical intentions.

A radical distinction must be made between the tombs of men and women. The former emphasize dress in its role as an attribute of rank or title, while fashion is of secondary importance. Women's tombs raise different issues. Like the tombs of children, their tradition was of relatively recent date, and Marian iconography exerted a powerful influence; consequently, the representation of a woman paid greater attention to fashion inasmuch as it was felt to confer a distinctive character. Because of canons of beauty imposed by courtly literature on the one hand and the Marian image on the other, the female figure seems to have resisted the lure of the portrait longer than the male but to have yielded faster to the reality principle.

Dress and insignia of rank thus implement the reality principle very clearly, serving to distinguish people at a time when the representation of their physical features still had little or no intrinsic individuality. It can be said that they fulfill a historical function, first and foremost, as a corpus of recognizable signs that, with the inscription on the tomb, assign an identity to the dead person. As it can be taken for granted that the identity is coupled with an exemplary worth, these outward signs embody the deceased person's "virtues," to use Durand's term. Growing precision in their representation meant that gradually the persons represented ceased to be interchangeable. Medieval historians have long used such monuments as epigraphic or heraldic documents of the first importance in ascertaining biographical data. As Burckhardt noted already, the social group to which a dead person belonged was more important than his or her individuality.

The genesis of the Gothic portrait deserves more thorough investigation than it has received. One question concerns the "crypto-portrait"; this type of concealed portrait is relatively easy to detect throughout the fifteenth century, but that is by no means the case in the thirteenth. The *Bamberg Knight* (also known as the *Bamberg Rider*, 1235) certainly does not represent the features of Frederick II any more than one of the kings in the transept at Reims merits to be considered a portrait of the last Hohenstaufen emperor. His features as presented on the gate at Capua bear a strange resemblance to the alleged "portrait" of St. Louis in the church at Mainneville. These are all types, of course, like the images on coins, that are not considered portraits.

The artist always resorts to two or three forms of nose, chin, and so on. A distinction must be made at this juncture between portrait and expression. The work of Nicolas of Verdun, or the sculpture produced in Reims around 1230, inspired by classical models, is characterized by a search for expressivity which necessarily implies a rendition of strongly marked features but is remote from portraiture. The statues of the benefactors of Naumburg (see fig. 67 on p. 242) offer a particularly eloquent example of the need for this distinction; it is enough to notice the resemblance of Uta's head to that of a woman in the Last Judgment on the screen at Mainz to dismiss definitively any notion of portraiture in that cycle. A whole current in sculpture resists the idealization that was predominant in the thirteenth century: it is evident in the Wise and Foolish Virgins at Magdeburg and Erfurt, in the Naumburg statues, the Strasbourg prophets, and also in the art of Pisano. But this expressive and dramatic current was eventually challenged for the same reason as ideal beauty: to yield to a new conception, according to which men should be represented as they are rather than as better or worse, to use Aristotle's distinction in the *Poetics*. This is what gave birth to portraiture.

We have seen how the reality principle gradually turns the tomb away from an abstract or purely epigraphic character. The successive phases are, first, the figuration of the pseudogisant or *gisant*, accompanied by increasingly exact representation of dress and insignia; the transition from pseudogisant to *gisant*; the substitution of closed for open eyes;[10] and finally, the portrait. The evolutionary process was not the same everywhere: in England and above all in Italy, closed eyes are found on metal tombs earlier than in French sculpture.

The ideology of royalty found a direct medium of illustration under Louis IX with the program of royal tombs, and under Philip IV with that of the palace statues. In both cases, the terms were probably determined by the historiography issuing from Saint-Denis. The installation of the tombs in 1264 was undertaken with the aim of creating a necropolis of the French kings who had been founders and benefactors of the abbey, while those of royal descent who had not worn the crown were banished to Royaumont.[11] The palace cycle was worked out on the basis of a chronology in the official account of the life and miracles of St. Denis. Commissioned by Philip IV but not completed until 1317, the text, by Yves de Saint-Denis, undertook to demonstrate the effects of the saint's intercession on the destiny of the kings of France. The *Chronicon abreviatum*, by another monk of Saint-Denis, Guillaume de Nangis, essayed a genealogy of the kings, while the verse chronicle of Guiart d'Orléans is

actually entitled *La Branche des royaus lingnages* (*The Royal Family Tree*). The lawyer Pierre Dubois pronounced that it was the king's duty "to stay in his own country in order to devote himself to the procreation of children, their education, and their instruction, and to the preparation of armies—for the honor of God." All these texts, therefore, set great store by the dynastic principle; the cycles of tombs and statues flesh out the fictions. But Louis IX and Philip IV had different attitudes toward Saint-Denis. While the former seems to have left it to the abbey to make known the royal protection on which it prided itself by the installation of new tombs, Philip disputed with it over the possession of his father's body. As we have seen, he ordered his own heart to be interred at Poissy. And while Louis IX chose Mathieu de Vendôme, abbot of Saint-Denis, as regent, under Philip the Fair no one from Saint-Denis was allowed any role as a political advisor—a circumstance deplored by the monk Yves. Even if Philip followed the example of his ancestors in always looking to Saint-Denis when he sought a new historian, it is plain that he remained far from granting them anything resembling a monopoly.

Together, these facts reinforce the idea that patriotic sentiment was increasing, but at the same time, as has been shown, an awareness of the individual was developing. The proliferation of tomb figures and statues casts a kind of reflection which refracts this sense of self-awareness. In Philip the Fair's case, the numerous effigies and the concern for proclaiming his dynastic descent look, in a psychological light, like two symptoms of a belief in immortality. In the theologico-political context of his reign, it is not surprising that a conception of the royal image evolved, and if this image took effect it was because it borrowed its appearance from the effigies of saints—no one could fail to observe the analogy between the statues of French kings in Philip's palace and the glorious company of the apostles in La Sainte-Chapelle next door. The significance of the elision was augmented by Philip's exercise of the saintly office of healing by his royal touch. This is the birth of an idolatry of the individual figure as the incarnation of power; at the very moment when the modern state begins to emerge, we see manifested its essential corollary the image of the statesman. And the image at once starts to mold reality itself to the point at which henceforth it will not be possible to distinguish what the image owes to the monarch from what the monarch owes to the image. Bernard Saisset, one of Philip's bishops, found a strange way of formulating this appropriation: "Our king . . . is the fairest man in the world, but he has no recourse other than to stare at people, without speaking. . . . He is neither man nor beast, he is a statue."[12]

### THE TRANSMISSION OF FORMS AND TYPES

In the first version of *Émile*, Jean-Jacques Rousseau wrote:

> I will therefore carefully avoid giving him a drawing master who would give him only imitations to imitate and would make him draw only from drawings. I want him to have no other master than nature and no other model than objects. I want him to have before his eyes the original itself and not the paper representing it, to sketch a house from a house, a tree from a tree, a man from a man, so that he gets accustomed to observing bodies and their appearances well and not to taking false and conventional imitations for true imitations. I will even divert him from drawing from memory in the absence of objects until their exact shapes are well imprinted on his imagination by frequent observations, for fear that, by substituting bizarre and fantastic shapes for the truth of things, he will lose the knowledge of proportions and the taste for the beauties of nature.[13]

Rousseau claims that this educational program would be a break with a tradition of artistic apprenticeship attested since the Middle Ages. He wants to bar the student's access to two possible sources for his drawing practice: one external (an existing representation) and one internal (memory). His intention is to sweep away the Platonic concept that art has no other ambition than to imitate appearances, not essences. For Plato, the artist is the imitator of an imitated form, because he grasps only the appearance of a reality which is the fugitive reproduction of existing archetypes. Moreover, a work of art remains mute unless an interpreter makes it speak. It is the fundamental question of hermeneutics, examined in *Phaedrus* and reopened by St. Augustine, in whose view art reveals a form of beauty that is not the simple reproduction of a creation of nature by the fact of the artist's copying it; the form lives *in* the artist and the visible beauty he produces is only mediation between God and the material world.

It is with this question of the idea or image the artist has within himself that a long debate begins, conducted by artists and by philosophers and mystics. If the internal image determines the production of every work of representation, it follows, as Meister Eckhart admits, that even God himself creates on the basis of anterior images (*vorgëndiu bilde*). By comparison with the divine example, man has not ideas but "quasi-ideas," says Aquinas, in his *Summa Theologica*. "Idea in Greek is what we call *forma* in Latin. So by Idea we mean the form

of things existing outside the things themselves. The form of a thing, beyond itself, can assume two roles: either serving as an example (*exemplar*) to the thing of which it is called the form, or being a principle of knowledge in that respect, as we say that the forms of knowable beings are in the being that knows them." Further on, St. Thomas mentions certain thinkers who believe "God created only one first being; this being created a second, and so on up to the multitude of beings existing now." He disputes this view, naming Avicenna in particular, and argues instead that at the moment of creation God had the idea of order and universal harmony. In other words, Thomism rejects the idea of a causal chain and propounds a universal plan. As an analogy, it could be said that Avicenna's conception is closer to that of the *exemplum* in the Middle Ages than Thomism is. But the difference is due precisely to the fact that St. Thomas made a very clear distinction between the idea and the "quasi-idea," corresponding respectively to divine creation and human creation.

When the schoolmen make art dependent on a visible model, they understand by it not so much a particular object in the natural world as a work of art similar to the one that is to be produced, "as when an artist conceives a form according to which he seeks to create his own," writes Aquinas in *De veritate*. Johannes Tauler writes that when a painter wants to paint a picture, "first of all he studies another picture and draws all the points and all the lines on his support, and then he forms his picture according to the other, as faithfully as he can." Meister Eckhart relates the mystical experience to a constant passage from the exterior object to its interior image; we think in images, we express ourselves in them, we recognize and memorize the world thanks to images. Tauler defines the wise person as *bildlos* (imageless), incapable of mental representation. In other words, the wise man lives in a total present, without memory and thus without consciousness of time. Mystics took a great interest in images; none ever categorically denied their edifying function. As material reality, the image should conform to the *exempla* provided by artistic tradition; as devotional support, the image should be in conformity with spiritual tradition.

We owe at least some of the light that falls on our knowledge of medieval art to the pioneering work of Julius von Schlosser. Many of his publications concern artistic tradition, chief among them "Zur Kenntnis der künstlerischen Überlieferung im späten Mittelalter" (1902). Turning his back on a "biology" of art and claiming rather that an "empirical psychology" in art studies was dawning, Schlosser surveyed the ontogenesis of the work of art according to two modalities. One he considered intrinsically medieval, entailing the interposition of the *Gedankenbild* as the determining lever of creative psychology (Schlosser used the word *Gedankenbild* to designate sometimes the mental

image, sometimes the mnemonic image or *Erinnerungsbild*). The other modality, appearing at the end of the fourteenth century, was founded on direct observation of nature. Schlosser had assimilated a series of scientific observations made by Wilhelm Wundt and Emmanuel Loewy, among others, as well as the writings of Gottfried Semper. In their different ways, employing distinct methods and targeting distinct ends, all these writers drew attention to the necessity of interpreting stylized or pictorial representation from periods dubbed archaic or societies said to be primitive. The recourse to geometrical structures made it possible to account for artistic production as a system of reproducing archetypes, which knowledge of geometry enabled the artist to both understand and reproduce. The *Gedankenbild* then intervened like a "thin veil of mist" between nature and the eye and guided the artist's hand. Referring to fourteenth-century mystics, Schlosser saw in this mental projection the exteriorization of the *Gestalt*, the *Bild*, or the *Form* that is found in man, if we recall Meister Eckhart's formulation.[14]

In the works of Semper and, above all, Wölfflin the notion of polarity came to constitute a paradigm of writing the history of art as the history of style. According to this theory, styles oscillate in every period between the two poles discerned already by Vitruvius and designated classical and baroque by Wölfflin. The nineteenth century witnessed general acceptance of the belief that every artistic form launches itself with a certain stylization only to evolve towards naturalism; the artist disengages gradually from geometrical principles and resorts to increasingly faithful observation of nature. When Riegl defined tactile and optical tendencies, he had not moved appreciably far from this bipolar pattern.

This schema, according to which artists turned their backs on "stylization" (according to Focillon) in favor of naturalism or realism, was thought to be validated by the definition of the two great periods of the Romanesque and the Gothic. It was thought even that two poles were detectable within the Gothic: "idealism" at the beginning and "naturalism" at the end (in Dvorak's estimation).

The actual evolution of "Gothic" sculpture—from the Royal Portal of Saint-Denis (1137–1144) to around 1500—puts the fallaciousness of the schema beyond doubt. With regard to portraiture, it is true, we have to recognize that a certain reality principle directs the artist toward more meticulous observation of physiognomy. The reasons lie, in particular, in the twofold influence of courtly poetry (in descriptive vein) and astrological treatises in which physiognomy held an important place. But with regard to what truly determines the

plastic quality of sculpture—the fall or folds of drapery—it must be admitted that the naturalistic tendency predominates in the early period and is gradually supplanted by a general tendency toward abstraction. In studying the literature of the period, Georg Weise demonstrates that a kind of "spiritualizing 'deconcretization'" came to be characteristic of Minnesang, as well as the language used by mystics, and that both subscribe to a definition of "Gothic man" represented in the ideal form by "extreme refinement, delicacy, and frailty of physical constitution, a suppression of all self-conscious strength, with which . . . a mannered artificiality of demeanor and gesture is combined."[15] Drapery in sculpture developed within an architectonic framework that was intrinsic to it and profoundly antinaturalistic. Formal theorizing triumphed over concern with nature or even verisimilitude.

The question of Gothic *exempla* appears to present itself differently, therefore, according to whether the issue under consideration is the birth of portraiture or the treatment of drapery. Let us attempt to address this apparent contradiction.

By model, I mean that which the sculptor undertakes to imitate, that which serves to guide him in his own work. The model may be taken from nature (a man or woman posing in a studio or an animal) or from various artistic domains (painting, mosaic, miniature, or fabric). It can be a sketch or finished drawing by the artist himself; an original model in clay, plaster, or wax, actual size or reduced; a definitive work in any medium whatsoever; or again, it may be a reproduction. Every sculptural technique demands the choice and use of a particular model.

Thus the model can be a work of art similar in kind to the one the sculptor wants to make, or it may require to be transcribed—as when the model is a drawing or sketch and the projected work is to be realized in stone or wood. When the model is imposed by the artistic tradition to which it aspires to belong it is "typological"; when imposed by the nature of its specific content, considered as a vehicle of particular ideas or significances, it is "cultural." Of course the existence of the work of art takes precedence over these definitions: the typological and the cultural are so closely mingled that distinguishing between them remains an academic exercise.

The late Middle Ages provides numerous testimonies to the link between the typological and the cultural, especially in the realm of funerary sculpture. The will of Louis de Male, Count of Flanders, for example, written in 1381, contains the following direction: "We choose to be buried in the collegiate church of Courtray, in the chapel of my lady St. Catherine that we had made,

and wish a tomb to be raised over our body as directed by our executors named below, as they shall think fit." The contract for the tomb of John the Fearless (d. 1419), Duke of Burgundy and son of Philip the Bold, as first agreed with Claus de Wervé in 1410, specifies: "a sepulchre similar to that of my late father," and in the contract dated 1443 Jean de la Huerta is charged with executing a tomb for Duke John "as good or better, of the same length and height, and of the same and equally good stone and materials as that of the late most excellent prince of noble memory My Lord Duke Philip," while introducing some modifications: "Further, he will make at each corner a tabernacle, which is not there on the said tomb of the said late Duke Philip."

The tomb of Philip the Bold is regarded as a cultural model and therefore as a typological one; it constituted a prototype, probably for a whole series of royal sepulchres. All the same, the model was subject to alteration in the name of improvement. Its validity was never absolute; its relativity is the explanation for the interplay of innumerable variations, unceasingly continuing to enrich the world of forms. Even if the funerary monument is better documented than any other field, because of the quantity of testamentary and contractual source material, it would be possible to cite many more examples of works commissioned with reference to preexisting models. In 1390, Jacques de Baerze undertook to make two altarpieces for Philip the Bold, identical to those he had already made for the church at Termonde and the abbey of Byloke near Ghent.

Very detailed contracts providing an exhaustive description of the work to be realized are relatively rare. The one for Saint-Jean in Dijon, signed by Jean de la Huerta in 1444, and those for the high altar of Saint-Martin in Colmar (to be done by the painter Caspard Isenmann) and for the altarpiece in Münnerstadt (signed by Tilman Riemenschneider) contain particularly precise specifications, and it can be assumed that they lacked drawings. In contrast, Jean de la Huerta's 1443 contract for the tomb of John the Fearless not only contains much detail but also, so the sculptor specified, was to be carried out according to his own drawings on a signed sheet of parchment. This case is all the more notable because, as we have seen, the artist had received the express instruction to take Philip the Bold's tomb as model. The document indicates the limits of the conformity to a model and the innovations the artist was expected to introduce.

It is not at all surprising that royal tombs might be taken as models for others. The tomb is the ultimate, definitive form assumed by the sovereign's image, which is enough reason for the care devoted to it. Sometimes only the model's dimensions are specified, as in the order, dated 1448, for the double

tomb of Charles de Bourbon and Duchess Agnes at Souvigny, which, once again, refers to the Burgundian tomb.

The artist's choices within a given program are sometimes surprising because they entail iconographic options so distinct that it might be expected that only the client would decide them. Ludwig the Bearded, Duke of Bavaria-Ingolstadt, left it to the sculptor to represent him kneeling in prayer before the Trinity "supported on one or both knees" on his tombstone of 1435.

The model specified in a contract is of course a cultural model. It indicates the deliberate choice of a type of work, but aesthetic judgment is not excluded from this, even if it is only indirectly inferable. If Philip the Bold's tomb was so often invoked as a prototype it was partly on account of its formal excellence, to which Jean de Marville, Claus Sluter, and Claus de Werve all contributed.

The mutual emulation of towns and cities in the late Middle Ages was reflected in a vast range of artistic forms. The city council of Basel, for example, asked the painter Hans Tieffenthal for a decorative scheme modeled on that of the charterhouse in Dijon. In 1511 the town of Köfering in Bavaria commissioned a master glazier to make an armorial window, with the contract specifying that it should be similar to those made for the towns of "Nuremberg, Ingolstadt, Landshut, Straubing, and Regensburg." Adriaen van Wesel was asked in 1484 to execute an altarpiece for the New Church in Delft, on the model of the one he had already made for Our Lady in Utrecht. Even more surprising is the document of 1546 revealing the conditions on which the abbot of Vauclair near Laon ordered an altarpiece from the Antwerp sculptor Pierre Quintin, which was to resemble one that a commission of three people had traveled to Antwerp to inspect only recently. If those on a lower social level chose a model from a higher level when they commissioned work, it illustrates the natural mechanism of self-affirmation and the desire for legitimation. What is more surprising is the repertory of slavish copying and plagiarism existing in the costliest commissions, judging by the evidence. Such is the case with the sumptuous *Book of Hours* formerly in the collection of Count Antoine Seilern, the illuminations in which plagiarize the compositions of its sources, notably the *Belles Heures* and the *Très Riches Heures* of the Duke of Berry. Remarkably, the painter of the Seilern *Hours*, truly a *compilator*, was not content with typological borrowings alone but in many cases effaced his own style beneath that of his models. As in the instance of the scenes added in the fourteenth century to the Klosterneuburg altarpiece, it is a testimony to an artist's knowledge of style history.

The person who commissioned a book like that represents a certain type of medieval client: someone not very familiar with the notion of a work possessing

stylistic unity; indeed, we can venture that often it was wholly unknown to him. Late medieval altarpieces provide numerous eloquent examples of such ignorance, even though the guilds and corporations were greatly concerned with this very unity.

As we have seen with Mahaut d'Artois, historical reconstruction was taken very seriously: it seems that armor, for example, had a "heraldic" function to some extent and consequently it was all the more desirable that it should be represented accurately. Such a principle, generally regarded as contrary to the spirit of the Middle Ages, necessarily encouraged a different attitude in the sculptor faced with the *exemplum* of the knight in armor, which already had a long representational tradition behind it by 1320.

In the case of tombs featuring *pleurants*, the model provided by that of Philip the Bold can be regarded as both cultural and typological; the type is here the vehicle of the cultural intention. It is the same with all the great series of funerary monuments. I am thinking in particular of those of the bishops of Mainz. The dead man is shown standing on a console, richly robed, holding crozier and book. The figure is surmounted by a canopy and flanked by vertical members in the form of niches one above the other containing statuettes of saints. Only the architectural motifs and the style of the figures reveal the differences of date. The power of the original model, attributed to the circle of Madern Gerthner, lasted nearly a century, to the effigy of Berthold von Henneberg, executed by Hans Backoffen. Its interest lies not only in the typology of the funerary effigies it influenced but also in the fact that these examples all came from the same workshop. Every Gothic mason's lodge maintained an artistic tradition of its own, revealed more in typology than style; the artists respected (arguably for too long) models handed down by their predecessors over several generations. The statues in St. Catherine's Chapel in Strasbourg Cathedral use motifs borrowed from the prophets of the west door, even though the two ensembles are separated by at least fifty years and their styles have nothing whatsoever in common. In Cologne Cathedral, the brilliant sculptor who carved the statuettes in the spandrels of the right-hand west doorway took for his inspiration the angel with a little bell from a figurine in the choir stalls, here too, more than a generation separates the two ensembles. A large building contained a major concentration of images and thus constituted a large reservoir of accessible motifs.

Often, the parts of funerary monuments are more help to us than the ensembles themselves in apprehending the notion of a typological model and the use made of it. One of the most interesting instances is provided by the statuettes of *pleurants*[16] surrounding the tombs of Philip the Bold and

John the Fearless. We should bear in mind the express statements in the written sources that the former served as the model for the latter. But when we compare the theory of the *pleurants* on the two tombs, figure by figure, two facts emerge. First, eight statuettes on John's tomb reproduce eight on Philip's, almost one by one; then the sequence is interrupted and the parallel is maintained in only five more figures. In general, however, the existence of a correlation between the iconographic type and the style of the statuettes within each of the two ensembles cannot be affirmed: for the deacon, bishop, and lauders who lead the procession, the formal treatment is appropriate but hard to accommodate with the typology. The comparison of the two tombs helps, rather, to appreciate the role of style in differentiating the model and the copy. The copy being inferior in execution to the model, in the present instance, the difference between them could be attributable to a difference of hands, if we did not know the respective dates of the two ensembles. Here, the issues of model and style arise. When we consider Duke Philip's *pleurants* in isolation, it is impossible to divide the statuettes as a group between two or more well-defined artistic personalities. Sluter probably carved only two of them, and we do not know if he left drawings—that is, a typology—for Claus de Werve to work from. All we can do is note that the sorrowful angels from the Champmol calvary, attributable to Claus de Werve in all probability, on the basis of the textual sources, are characterized by a gestural language that is also to be found in some of the *pleurants*, for example, but the style of their drapery with its sharp folds is found, rather, in the two statuettes now in Cleveland.

Other statuettes from the tomb of John the Fearless offer simple variations on those from the tomb of Philip, testifying to the process of simplification that transformed the model by reducing its plasticity: the left side of the two *pleurants* whose cloaks are raised by the forearm shows that the same folds depict the cloak's fall to the ground.

Studying the *pleurants* shows how certain formal motifs generate variants and how they are connected to others in a system close to collage. Such is the case with the motif of the long, narrow triangle formed by the cloak lifted by the arm beneath it and falling from the face to the ground. It is a feature of two statuettes from Philip's tomb, and of four from John's (see figs. 78 and 79). To be more precise, this form can be said to become a motif only in the latter case; it is so perfectly integrated into the general architecture of the drapery of the statuettes on Philip's tomb that it is indissociable from it; and it is only among the statuettes on John's tomb that we can ascertain both the extent to which such a form can be associated with others and the discernible cost to the internal coherence of the form. Isolated from the formal ensemble to

 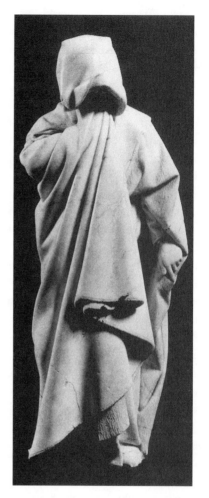

FIGURE 78. *Pleurant* (no. 11) beside the tomb of Philip the Bold. (Photo: François Jay © Musée des Beaux-Arts, Dijon)

FIGURE 79. *Pleurant* (no. 51) beside the tomb of John the Fearless. (Photo: François Jay © Musée des Beaux-Arts, Dijon)

which it originally belonged, it becomes a motif alongside others. Unlike the author of the model, the sculptors of Duke John's tomb conceived form as the product of adding motifs together.

This additive conception can be confirmed with particular clarity in the large types of devotional images such as the Pietà or Virgin and Child. In her 1933 dissertation on the Virgin and Child in northern France between 1250

and 1350, Johanna Heinrich applied a system of interpretation and of bipolar classification, proceeding from a "classical" tendency—the Virgin of the north door of Notre Dame in Paris—and a "baroque" tendency—the gilded Virgin. This Wölfflinish schematism obviously accounts only for expressive givens and not the typological specificity revealed, for example, by attentive study of the treatment of the Child in both cases. Robert Suckale showed that attempts to group the enormous production of the fourteenth century into genealogies deriving from one or other general prototype were not viable, given the fragmentary nature of the corpus. Such works can be grouped according to pertinent elements, such as the choice of garments and their execution, but again this needs to be related to the motif of the Child: His position in relation to His mother, His movements. Thus, after 1270 figures of the Virgin and Child no longer constitute an iconographic type, like their predecessors, but a compositional type (*Kompositionstyp*). Compositional filiations, as in the case of the Dijon *pleurants*, show precisely that in the late Middle Ages it was enough to combine motifs, redistribute them, and rearticulate them from one figure to another. The more important works are of course those in which the combinatory character of this process remains least obvious, but it is the minor works that give us the chance to observe it with more certainty. If we take the example of the Virgin of Lesches (Seine-et-Marne), we cannot fail to be struck by the disparate formal character: the articulation of the various motifs does not lead to a coherent whole. An inscription gives the statue's date as 1370, which is clearly no help in establishing a chronology. The chronological gap between the figure and its model may be short or long, because everything in the particular type contradicts what we know from other sources about the evolution of forms in the thirteenth century. We must also take into consideration the voluntarily retrospective option illustrated in certain fourteenth-century works, an option much in evidence in court painting. If the *Virgin and Child* now on display in the Louvre can be dated to the first quarter of the fourteenth century, it must be regarded as a replica of the La Sainte-Chapelle figure, also in the Louvre, dating from before 1265.

If we attempt to isolate formal motifs and trace their circulation over a long period, we discover that some of them were created in a given context but not developed or taken to their ultimate state until much later. Comparison of the *Virgin of Palaiseau* at Essonne and the *Beautiful Madonna of Torun* (figs. 80 and 81) shows that, in the second, the large fold of the robe reaching to the ground and the large fold overhanging it are, from a formal standpoint, the ultimate developments of motifs already presented in the first. It is the same with the cascade of material falling below the arm holding the Child.

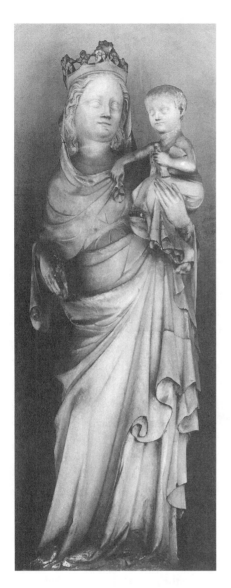 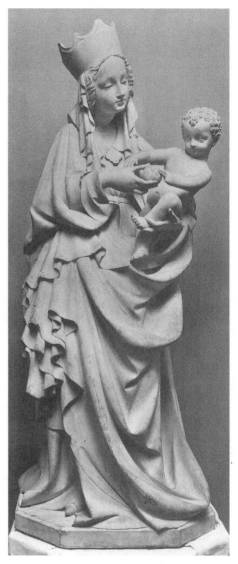

FIGURE 80. *Virgin and Child*,
Palaiseau, Essonne. (Photo credit: Foto
Marburg/Art Resource, New York)

FIGURE 81. *Beautiful Madonna*,
formerly at Torun (destroyed). (Photo: Willi
Birker/Deutscher Kunstverlag, Berlin)

A work like the *Virgin of Neuillé-Pont-Pierre* (Indre-et-Loire), which can be dated to the mid-fourteenth century—that is, midway between the Palaiseau and Torun statues, also shows the cascade motif, but the enfolding cloak gives the figure a more compact and old-fashioned character than the Palaiseau Virgin. There is another fundamental feature separating the *Virgin of Neuillé-Pont-Pierre* from the filiation, and that is the lack of emphasis given to the hips, while the pelvic tilt is strongly accentuated in both the Torun Madonna and the Palaiseau Virgin. The physical reason for the tilt lies in the need to counterbalance the weight of the Child, whom the Virgin holds away from her body. In the matter of plasticity, however, we can see that what links the Virgins of Torun and Palaiseau is the dynamic relation between the cloak and the body, between the casing and the core. The Virgin at Troyes Cathedral shows, on the other hand, that the Neuillé type can be given a more marked pelvic tilt (combined with the Child being held away from His mother's body), without the statue's plasticity being increased thereby.

All these observations tend to underline the combinatory nature of fourteenth-century sculpture. By seeking to single out the issue of style and to pursue the fortunes of motifs as isolated formal units, we come to see that all sculpture of the period is the product of the addition and combination of motifs. This presupposes an additive conception of form and a predominance of two-dimensional vision; we shall return to this point.

The confusion of type and style is nowhere better attested than in the rich domain of the Virgin and Child. It underpinned the entire thesis constructed by Karl Heinz Clasen around the Beautiful Madonnas and his claim that a single sculptor carved them all. Close observation of the motifs composing a Beautiful Madonna or a Beautiful Pietà dating from around 1400 reveals, however, that different combinations of these motifs permit the creation of numerous types: within the field of a given iconographic theme (the Virgin and Child) a combinatory art enables almost infinite variations on the articulation of the motifs. But in the case of the Beautiful Madonnas, the art is relatively restricted, since identical motifs are found in one figure after another in the same combinations, hence the thesis of a single, itinerant sculptor. Today there is more support for the hypothesis that, rather than ateliers, it was the motifs that traveled, sometimes very rapidly. Two technical processes must have acted as catalysts in the years immediately before and after 1400: terracotta and "cast stone" (*Steinguss*).[17] Both techniques imply the existence of "templates" and the use of molds. In the case of votive statuettes of the early fifteenth century it has been confirmed that two molds corresponding to the front and rear halves of a figure might be combined with two other

molds to create four different figures. A store of ceramics unearthed some years ago in Saarburg proved also to contain some double-faced molds, with notches enabling them to be matched up, intended to produce figures of two people; when rearranged and re-matched they give the shape of a third.[18] This "stone" can be molded exactly like terra-cotta, starting with a plaster model; the technique involves making an impression where the form is maintained *in extenso* during the process of transference. That the "cast stone" technique was developed in the heyday of the Beautiful Madonna and Pietà, two types of image whose iconography was relatively fixed for votive reasons, demonstrates that sculptors sought to perfect methods of reproduction at a moment when the working of details reached the highest degree of refinement. This correlation of the care with which the surface was worked—sometimes as finely as engraving—and the production of a replica of the same prototype corresponds to a modification in the social origins of the clientele: court art provided the cultural model for works of art produced for urban patricians.[19] Such works could be produced more quickly while giving the client an object in no way inferior aesthetically to the model, though that was in a more precious material. The famous Virgin and Child groups in Mainz, which probably have a connection with the Guild of the Holy Blood, display the same concern with refinement as the Beautiful Madonnas, even the ones made in "cast stone."

Such figures were probably displayed in front of patrician houses, like the Della Robbia terra-cotta reliefs of Virgin and Child in Florence. A similar formal care can be seen in the works in clay which are so plentiful in the Middle Rhine region, and finally, in all those works realized in an extremely soft and very easily worked sandstone (*pläner Sandstein*) extracted near Prague, which has sometimes been taken for *Steinguss*. A head like that of *St. Peter of Slivice* in the National Gallery in Prague (1385-1390) shows obvious affinities with the terra-cotta works of the Middle Rhine region. Such extreme refinement in the working of the surface at that moment in history is the sign of the impact of graphic art on plastic form. At the same time, however, it must be emphasized that it is generally reserved for hair or beards, while as a rule the adornment of dress is done in colors. The sculpture's outer surface is meant to hold the gaze, it being understood that, from the point of view of realizing the surface, it is easier, following a model, to transpose forms that are graphically circumscribed than three-dimensional ones. Study of the majority of the Beautiful Madonnas and Beautiful Pietàs, as well as of central European sculpture around 1400, brings to light numerous borrowings of formal motifs (hands, hair, facial features, the pattern of drapery in Christ's *perizonium* or the Virgin's cloak) that are easily transposed and transmitted through a

two-dimensional "vehicle" like drawing. The *exempla* in the Vienna book of models show a similar refinement in the forms.

It has been said repeatedly that sculpture of the period around 1400 tended towards greater plasticity and that, as a consequence, new relationships formed between volume and space. But despite an apparent contradiction it can also be said that at the same time sculpture was seeking to accentuate formal refinement from a viewpoint of frontal perception. Certain drawings of drapery in the Uffizi collection in Florence use hatching to suggest shading; evidently the artist was inspired by sculpture or at the least intended a plastic effect. Yet all the volumes are represented as if they had but one facet—we have to wait for Dürer before seeing a form represented from several angles. The works associated with the Master of Grosslobming show different, simplified ways of handling the backs of sculptures. In the majority of works of this period the hair at the back of a figure is represented either by a reduction in its volume or, more even simply, by concealing it under the cloak. A completely different kind of economy governs the working of the visible surface; a sculpture in the round is not regarded as a continuum but as the juxtaposition of a front and a back. In even the most elaborate Beautiful Madonnas (such as those of Altenmarkt, Wrocław, and Moravsky Sternberk) frontality continues to dominate the organization of the forms.

The attention paid to typed physiognomies is another constant in late medieval art. Once again, there are two concepts to be distinguished, which have often been associated with the idea of "Gothic naturalism": the type and the portrait. Looking at the human figures on the Hakendover altarpiece, one notices that an archetypal form lies behind the morphology of the male and female heads. But details of fashion—the caps and hoods—combined with slight changes in the features introduce variety without significantly altering the type. It is the same with the Vienna model book; comparison of the tonsured monk and the St. John above provides a particularly eloquent example (fig. 82). Given the great homogeneity of this collection, it is reasonable to suppose that the artist specialized in the depiction of heads and that the diversity of his models—which remains obvious, despite the homogeneity—is in some sense leveled out by his skill. Style replaces styles. At the same time, the leveling is what enables us to see that it is a matter of types, not portraits. Only certain artists understood how to remodel prototypes on the basis of several models. Their appearance in the historical continuum produces the effect of a kind of restructuring of forms, attributable to the homogenizing effect of their style. This is the difference between, for example, Nicola and Giovanni Pisano; the latter reworks all the propositions suggested by his classical models and adapts

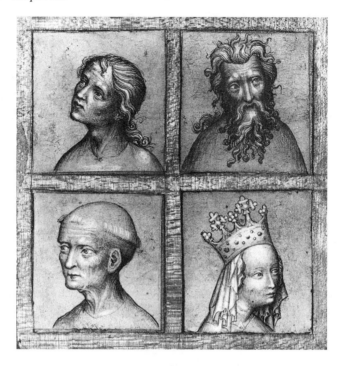

FIGURE 82. Page from the book of models.
Kunsthistorisches Museum, Vienna.

them to his personal formulation, while the former's style remains consciously transparent and his classical models retain all their force. It is enough to look at the *Presentation in the Temple* on the pulpit in the baptistery at Pisa—the great diversity of facial types is matched by that of the models which might have been transcribed literally (fig. 83). Nicola is a *commentator*; Giovanni a true *auctor*.

If it is true that the essential character of a model book lies in the legibility of the images, it can be said that the legibility is never greater than when the artist manages to impose his own style on diverse sources; the collections of the Pierpont Morgan Library and Jacques Daliwe reveal the diversity of sources very precisely, and the result is that scarcely any of the questions of attribution of the different drawings have been solved. The more a drawing subordinates itself to the style of the model, the more difficult it is to distinguish the copyist's style.

In the domain of sculpture, the work of Tilman Riemenschneider presents an interesting illustration of combination of types and the relationship between

FIGURE 83. *Presentation in the Temple*, Baptistery, Pisa. (Photo credit: Foto Marburg/Art Resource, New York)

type and portrait. Few late medieval sculptors left so homogeneous an oeuvre, embracing so large a corpus over so long a period. Let us take the example of the heads of St. Kilian in the Münnerstadt altarpiece (1492) and in the Neumünster in Würzburg (1508–1510). The morphology of the two faces is almost the same: the delineation of the eyes and wrinkles and the shapes of the nose, mouth, and chin. We have no difficulty in recognizing motifs frequently found in male heads by this sculptor. But we also find these motifs on the *gisant* of Bishop Rudolf von Scherenberg in the cathedral in Würzburg (1497–1499; fig. 84). The only new features in this supposed "portrait," to make it differ from the St. Kilian type, are the repeated wrinkles incised around the eyes, on the forehead, and on the neck. The appearance of the face is the outcome of adding separate features to one another, and the product is not a homogeneous whole. The numerous incised lines all over the surface of the material are intended to mask the lack of homogeneity. The sculptor has referred to graphic art, as in the examples we have seen from around 1400, but he no longer does so in order to enrich his work on the formal level: the

FIGURE 84. Tomb of Rudolf
von Scherenberg by Tilman
Riemenschneider, detail. Würzburg
Cathedral. (Photo: Kustgeschichte
Sminar, Marbourg/Deutscher
Kunstverlag, Berlin)

concern here is to make a precise distinction between the type (St. Kilian) and the portrait of a contemporary. The portrait varies only slightly from the type, however, as was already the case with the triforium busts in Prague and the effigies of Bishop Kuno von Falkenstein. The first sculptor of the late Middle Ages to break free from working with types was Nicolas van Leyden; the comparison of Riemenschneider's *gisant* of Rudolf von Scherenberg with Nicolas's turbaned man in the chancery in Strasbourg reveals that the overall form does not result from the addition of details but from their fusion. At the same time, the plastic form no longer appears to emerge from the outer surface, the sculptor does not impose a formal system on the exterior. The form can be said to emerge from the content, which is why we can speak of the psychological intensity of the Dutch sculptor's work. His successors in the upper Rhine region adopted nothing of his but a taste for everyday figures, while remaining loyal to an additive conception of form, like Riemenschneider's: the work of Nicolas de Haguenau, probably the most prolific of them, is an example.

Similarly, Riemenschneider's *gisant* cannot be considered a portrait. He subordinated the physiognomy of a contemporary to the St. Kilian archetype, just as the sculptor of the Prague busts fashioned most of his "portraits" according to a type of head. Nicolas van Leyden's heads, on the other hand,

cannot be anything but portraits (even if executed from memory, as may be supposed) because of their psychological individuality. This did not prevent their use as types, however, as illustrated by a drawing in the Prints Cabinet in Basel, in which an artist reproduced the Augustus and the Sibyl from the Strasbourg Chancery but stripped them of everything innovative.

It is, in fact, style that engenders types, which is the reason why the transmission of types is never neutral but entails a more or less visible process of transformation. In the Middle Ages, unlike the Renaissance, there was a sort of hegemony over artistic production, and the proliferation of types remained subject, ultimately, to strict controls: the senators in Würzburg, for example, specified that the Adam they commissioned from Riemenschneider should not be bearded. The portrait, at the end of the thirteenth century, constituted the first attempt to escape such controls, and so innovative was the attempt that it needed the support of an ideology of royalty.

The word "naturalism" has not ultimately proved very pertinent to the analysis of works of late medieval art. The effort to introduce the portrait was fired, certainly, by a new conception of nature. But it seems to me that the creation of types is the index of a quite different attitude. By definition, a type stabilizes a system of representation according to the content of a work (old age, beauty) to which the artist and his successors conform faithfully as a rule. The emergence of a new artistic personality could cause a major remodeling of the type, but with the object of creating a new one. In this sense, the formation of types is a procedure that runs counter to the observation of nature.

We can gain a better idea of what the Middle Ages understood by "type" from Dürer's unfinished essay, the *Four Books of Human Proportion*.[20] When he wrote of a great analogy to be found between different things, while he sought a single law underlying the diversity of different forms, Dürer was searching for a solution which would leave the Gothic Middle Ages behind. His interest in types was motivated by the desire to discover what structure they had in common, whereas the medieval artist always sought to reassign the visible to a number of fundamental archetypes. Dürer was searching simultaneously for a law governing the whole of the visible world and a law governing the way the artist mastered it, that is, style. The law in question is the law of proportions.

Confusion about the meaning of the term "Gothic naturalism" owes much to the relationships between classical antiquity and the "renaissances" of the Middle Ages. Nicolas of Verdun drew the models for his prophets and apostles from the typology of late antiquity. His own typology, as I have said, was affected by his contact with these works. For medieval artists, the sculpture of late antiquity provided an immense reservoir of forms. Knowledge of medals,

for example, gave them many physiognomic models. Certain sections of the shrine of the Three Kings in Cologne Cathedral illustrate the filiation very well: roundels on the sloping panels of the cover encircle male heads—bearded, clean shaven, bald, in profile or in three-quarter profile—which, in their juxtaposition, anticipate the Vienna model book by two centuries. These heads, which are also encountered in scenes on the ambo at Klosterneuburg, are not so much self-quotations within the oeuvre of Nicolas of Verdun, however, as they are exploitations of a collection of *exempla* which served the goldsmith throughout his career.

Contact with antiquity gave the medieval artist the means to renovate not only form but also his visual curiosity. It provided a standpoint from which he was able to devise new types. But it was not the antiquity familiar to the Italians; northern artists were struck by the physiognomic diversity they found there, but they treated clothing according to a structural principle which moved away from the "classical" system. The difference between north and south stands revealed in Dürer's use of the articulated mannequin (*Gliederpuppe*): he used it to observe the naked body in motion, while Italians used the *manichino* for studies of drapery. For them, drapery belonged to the real world, but in the Gothic world it was an autonomous system. Wood and stone were charged with a plastic function that cloth itself could not have. From the 1240s onwards, in the sculpture of the Île-de-France, drapery came to constitute more and more exactly an autonomous formal system (relating as much to a logical or, let us say, mechanical structure as to the body deemed to support it).

We have seen, in analyses of both drapery and the human face, that the sculptor proceeded by way of working on small formal units, and that the definitive work was the product of adding them together. Such a procedure could not be mastered or memorized without the help of drawing. It is therefore natural that the status of drawing changed during the fourteenth and fifteenth centuries, the period when this additive conception of form was manifested. The change takes us from the model book to the sketchbook. While the former gives *exempla* of the Idea, the latter grasps the Idea in the process of formalization. The model book supposes a singular viewpoint, thus a "closed" form difficult to represent in space. Even plastic volume is always referred back to a single plane. Late-fifteenth-century folios of studies of drapery take account of the break-up of plastic form; this was the outcome of a formal speculation and a taste for "small forms" in train since the end of the fourteenth century. Bit by bit, drawing became the medium *par excellence* for the elaboration and subsequent transmission of formal principles and motifs. But for drawing to fulfill the function of generating forms in the domain of

sculpture, it is clear that the object to be sculpted, even if in the round, had first to be conceived as a juxtaposition of reliefs, ultimately, that is, of planes. This additional new importance of drawing is the explanation for the widespread use of incision on the surface of the material.

Ultimately, there is no rupture between the use made of drawing in the Middle Ages and the Renaissance. Leonardo da Vinci advised the student of painting: "First draw from drawings by good masters done from works of art and from nature, and not from memory; then from plastic work, with the guidance of the drawing done from it; and then from good natural models, and this you must put into practice." Further, the student should ask himself: "Which is best, to draw from nature or from the antique?"[21] Drawing from sculpture had already earlier been recommended by Alberti: copying even a mediocre sculpture taught the artist "to represent both likeness and correct incidence of light."[22] For Vasari, painting is the daughter of drawing, and sculpture the niece of painting. Exhorting the sculptor to work from nature, he says: "Let the hair and beard be worked with a certain delicacy, arranged and curled [as if] they have been combed, having the greatest softness and grace given to them that the chisel can convey; [but] because the sculptors cannot in this part actually counterfeit nature, they make the locks of hair solid and curled, working from manner rather than in imitation of nature."[23] With these two words, "manner" and "nature," Vasari draws the line dividing the late Gothic era from the Renaissance.[24] To some extent they embrace the concepts of "usage" and "art" by which Dürer characterized craftsmanship and the theory that should underpin it. Vasari's nature is thus very close to Dürer's art (*Kunst*); as a theory of artistic practice, he seeks to find in nature the legitimation of the form of beings. In this light, Vasari's and Dürer's concepts are very similar.

Late Gothic sculpture developed above all from *maniera*, that is, from the use of formal combinations conceived for their own sake. It contributed nothing, therefore, to the representation of the visible world to which painting and drawing connected in the fifteenth century. Knowing things is knowing how to represent them, and we know the scientific role drawing played in the process of acquiring that knowledge: it was the pre-eminent instrument of the knowledge. In the countries of northern Europe, however, it was only with Dürer that drawing was invested with that function. Before him, certainly, drawing permitted the apparent unity of objects to be broken down, but the breakdown was not destined to lead to the revelation of laws governing all reality; rather, it isolated formal units in order to redistribute them in other assemblages. Drawing in the north in the fifteenth century was therefore not

an instrument of knowledge but of recognition. It did not assist the advance of objective knowledge, it contributed to the rehearsal and maintenance of representational order. And because it transmitted types and forms belonging to a vision of the world that was old and about to be abandoned, sculpture remained outside the great investigative movement in which two-dimensional art engaged during the fifteenth century. Only Nicolas van Leyden joined it, but at the cost of a "reframing"—extending the bust down to the level of the elbows—which diverted attention away from the infinite play of fabrics and concentrated it on psychological expression.[25] This highly humanistic art did not topple the formalism of late Gothic art: the density it undertook to restore was exteriorized in a world of forms, and at the same time as it implicitly denounced formal mannerism (Vasari's *maniera*) it could not reconcile nature with mannerism.

### WORKING METHODS

Comments on the collective nature of artistic work in the Middle Ages are relatively frequent in recent art history writing, but the sources on which they are based are few in number and, moreover, rarely explicit.[26] In the fifteenth century, the rivalry between workshops and the growing number of commissions, from a broader range of social categories than before, created a new situation: that of large workshops employing several craftsmen and producing work increasingly difficult to attribute with any degree of consistency on grounds of style. If a contract with the sculptor Veit Wagner stipulated that he should work on the project himself, it was because the client insisted on getting the master craftsman's skills. It is easy to imagine that a master was more likely to put hand to chisel himself when the commission came from a client of high rank. In fact, collective work in medieval workshops remains largely a fiction, so far as we know. In the introduction to his book on Gothic sculpture, Willibald Sauerländer singles out the collective work of the lodge at Amiens Cathedral. This was not a random choice, because it has been shown that serialization—a marked rationalization of working practices, leading to demarcation and specialization of labor—was introduced in other areas of the construction process at Amiens. It is probably true that ornate items of clothing or a crown may have been carved by a craftsman who specialized in ornamental detail, but it remains hypothetical as a general rule. One might formulate another—even less consequential. Would a master be able to insert a particular kind of fall in the folds of a garment in the middle of a journeyman's work? In any event, even if the Amiens workshop represents an important

change in the artistic practices of a medieval lodge, we should bear in mind that it could not have achieved so high a degree of rationalization without the essential condition that drawings stamped with the master's own authority had first established both the design of the building and the forms of the stone carving. On the stylistic level, preparatory drawings helped to establish a sort of common language in which realizations attributable to this or that individual hand constitute so many dialects.

Among the sculptures of Reims Cathedral, numerous instances have been found of notorious differences between the working of the heads and the drapery; similar observations have been made in respect of Notre Dame in Paris and Amiens Cathedral. Confining ourselves to just one example, that of the Reims *Angel of the Annunciation*, the softness of the facial modeling undeniably contrasts with the severity of the drapery. Since this difference recurs in work from the same stages, it is reasonable to imagine that a kind of rotation allowed some sculptors to work together without the same pair necessarily being associated with all the carvings in one ensemble, whether that was one of the figures flanking a portal, or the whole portal. In fact, some such way of organizing the work is already discernible in the stained-glass windows at Chartres, where it has been demonstrated that a master glazier might be the author of all the panels of a window except for one, which was entrusted to another master who had worked on other windows. Here again, a very detailed analysis of the styles of the early years of the thirteenth century that avoids the postulate of stylistic unity makes it possible to detect signs of collaboration within one single work. Likewise, it must be admitted that specialist sculptors existed, such as the one who appears to have been responsible for very nearly all the grotesques on the brackets of the doorways at Reims. In the case of Orvieto Cathedral, where the reliefs on the early-fourteenth-century exterior were left unfinished, it has been possible to reconstruct the process of execution relatively precisely. Each sculptor was a specialist in one type of detail, which he was responsible for executing in each relief, and so he went from one to another, without worrying about progress on another detail in the same relief, which was delegated to one of his colleagues. Such a working practice presupposes the existence of a preparatory drawing worked out in very great detail as well as rational organization of the stages of the work. It seems increasingly probable that such analogous working practices were common in the great lodges of the Middle Ages, certainly during the thirteenth, fourteenth, and fifteenth centuries. One sculptor specialized in heads, another in hands, a third in drapery or ornamentation.[27] Only very intricate analysis can bring these distinctions to light, and only (I repeat) if it abstains from harboring any

notion of stylistic unity and biological evolution in the forms. Instead, some kind of synchronic vision of styles needs to replace the diachronic vision.

For example, it can be observed, in comparing the figures of prophets in the Bourges Cathedral with the work of Jean de Cambrai, that the faces of the prophet with the phylactery and the whirling prophet are unquestionably superior in quality to the draperies, and that therefore Jean de Cambrai must have carved the faces himself, leaving the clothing to one or more of his coworkers. As for the royal tombs destined for Saint-Denis that were entrusted to André Beauneveu's workshop, while numerous analogies can be seen in the bodies of Philip VI and John the Good, the formal treatment of the faces is so different that they have been attributed to Beauneveu and to Jean de Liège, respectively.

A similar observation was made about the busts decorating the stalls in Ulm Cathedral. The exceptional quality of the facial features, such as those of the Virgil, is at variance with a certain carelessness in the treatment of the drapery. Here too, the conclusion is that two sculptors were employed on the same work.

A document from the records of the Angers chamber of accounts, dated August 31, 1450, refers to the *gisants* of René, King of Naples, and Queen Isabelle at the moment when a new team of sculptors was about to start work. The state the work had reached is described as follows: "Item, the image of the king is in two pieces with the body nearly ready but for polishing and the head not yet fully rough-hewn. Item, the image of the queen is in two pieces of which the body is half rough-hewn and the head ready to polish." The opinion currently held is that the heads of *gisants*—to be more precise, the busts as far as the armpits—formed autonomous sections which were mounted on the bodies later. So there is nothing surprising about the 1450 document's reference to "two images" (*deux ymaiges*) for each *gisant*. It is more surprising that one section of each—the king's body and the queen's head—had reached the stage immediately prior to polishing, when the king's face had not yet been rough-hewn and the queen's body was still in the process of being rough-hewn. In other words, the rhythms of the work in progress differed between sections and, above all, heads and bodies—a matter of costume and drapery—were worked separately as autonomous pieces. This method of working calls for two comments.

In the first place, the Angers document and many others like it confirm that work on a commissioned sculpture was (and is) usually carried out with a great deal of discontinuity. The more a work lent itself to being divided into sections, the more usual it was for some of these to be left waiting in

the workshop. Spacing work out in this way, as prevalent in the studio of a Brancusi as in a medieval mason's workshop, can have a more or less direct effect on the final outcome. When the logic of this working method is taken to extremes, most of the sections finish by being interchangeable between one work and another, witness the standardized altarpieces produced in Antwerp.

The second point concerns the division of labor. The document about the Angers tomb permits the conclusion that at least two people, probably three, had worked on it before 1450: one who carved the heads, one who worked on the bodies, and the polisher, for it is very likely that one journeyman was a specialist in this final, very delicate operation. Moreover, Charles V's 1364 commission of André Beauneveu for the first Valois tombs in Saint-Denis expressly mentions that the sculptor should give money to "the workers who make the said tombs, and distribute it in what form and manner he thinks fit."

In 1384–1385, Jean de Marville was paid money "for the expenses and wages" of his coworkers on the tomb of Philip the Bold: there were ten of them, and their individual periods of work ranged from eight to fifty-two weeks.

Funerary sculpture must have constituted a type of commission particularly favorable to a form of specialization, even standardization, from a very early date, in both France and England. In such work, the notion of "signature" or "hand" only had the same significance in the most exceptional programs. Even so, the case of Claus Sluter is surprising, given our conception of the homogeneity of a work like the Champmol Calvary (Moses Fountain). The fact that a certain Jan van Prindale was paid for working with Sluter on the Magdalene of the Crucifixion can hardly mean anything other than a close collaboration between two highly qualified sculptors who had both emerged from the Brussels guild of stonecutters and sculptors. It is equally impossible for us to distinguish what the Moses Fountain owes respectively to Sluter and to Claus de Werve, whose contribution the archives confirm beyond any doubt.

A similar field for investigation is the role played by the style of an artist commissioned to finish a work originally ordered from another. It was so, for example, in the case of Jehan Tuscap, *ymagier*, who was entrusted in 1401–1402 with the job of completing work started by Jacques de Braibant, who had died. To this end, he was required to follow a very detailed "device" of what remained to be done.

Collective work in the late Middle Ages is most easily traced in large ensembles such as altarpieces, pulpits, and tabernacles. The fact that a single name is recorded in the archives means only that that person—not necessarily a sculptor or a painter; he could just as easily have been a cabinetmaker— was designated the master of the works. The pulpit in Strasbourg Cathedral,

the circumstances of the commissioning of which are known, is explicitly attributed to Hans Hammer as master of the works. Hammer was the author of other works that can be compared with the Strasbourg pulpit: he was undoubtedly involved in it. But the freestanding carvings inserted in the niches do not have a homogeneous style and, in any case, they differ in style from the integral parts of the pulpit.

It can be verified by stylistic analysis that the integral ornamentation on the pulpit—vegetation, representational elements—is the work of one or more stonecutters, while Hammer had at least two sculptors working on the cycle of statuettes. It is almost impossible to characterize the style of the whole satisfactorily. The integrated carvings are rather mediocre, while the style of the more progressive of the two cycles of statuettes, which I attribute to Nicolas de Haguenau, is of very high quality. The preparatory drawing survives and shows little inventiveness on the formal level in the projected carvings. So the design of the whole is not what determines "the" style of the pulpit: and yet it must be regarded as a homogeneous work, presenting an indisputable formal unity in the eyes of a fifteenth-century master builder and, hence, of his client.

Our concept of the Middle Ages is affected by numerous assumptions derived from aesthetic theories that have emerged from the history of artistic creation in a much more recent era. The idea that numerous "replicas" of one work could exist in the Middle Ages, or that an artist could produce works not to order but for an open market, seems to be the product of a fertile imagination or an anachronistic vision of an age as unfamiliar, we may be sure, with speculation as with mass production.

In particular, the notion of the "copy" or "replica," born with modern art, rests on the particular role played by the teaching of art from the date of the foundation of academies. The existence of copies and replicas presupposes a market that confers a unique value on some works of art and on others a simple valuation of their merit as imitations. But a literal copy is relatively rare in the Middle Ages.

If the copy in the strict sense of the word did not exist then, it is not because each work was claimed to be totally original but, to the contrary, because all works were regarded as copies in a certain sense. In the Middle Ages, more than in any other period in history, the artist took other works of art as models and had very little interest in observing reality. The medieval artist might be called an interpreter, and his creativity is in line with that; Peter Abelard said that texts should be interpreted in accordance not with their usefulness—*per usum*—but with one's own inventiveness—*per ingenium*.

An aesthetic vision claiming to do justice to the singular position of art in the Middle Ages by comparison with earlier eras needs to take this very unmodern definition of creativity into account.

Furthermore, the control exercised by the guilds over the training and professional activity of artists had a normative influence. In most cases, the guilds hindered the free circulation of artists and of works and served only the town or city to which they belonged.

The predominant idea of the age, that every work of art was connected in one way or another to artistic tradition, is the justification, in the end, for the aspects of each work that represent conservation as well as progress.

The fact that several people could play a part in realizing a work gives the drawing for the project a very special function. Along with the contract, it constitutes the document to which all the collaborators, making their special and partial contributions, had to refer, especially if litigation arose. In a minority of cases, the drawing of the project—the *pourtrait* or *patron* in France, the *Visier* or *Visierung* in Germany—may even be the work of someone other than the master builder.

But very few drawings of projects survive that conform strictly to their execution. The sculptor Adam Krafft gives the reason for the discrepancy, saying that to foresee the totality of the work in his preparatory drawing would cause him too much trouble. That is, for a fifteenth-century artist, the logical procedure in the realization of a commission did not go from the project to the work. The cutting itself—not the project—was the decisive stage in formal invention. The dimensions and shape of the block of stone or wood were the prime factors determining the definitive plastic form. That which guided the sculptor as his work progressed was his creative memory, his ability to create new combinations using forms already seen. This creative memory allowed him to feel that he was working within a framework established by tradition, and for him, that feeling was equivalent to the modern artist's feeling when he works from a drawing. For the medieval artist, the project did not determine the outcome but rather was the model, the memorization of which bypassed the drawing.

As the formalization of a concept, the drawing of a project was contrary to the artistic practices current in the Middle Ages. That is the most common reason, throughout periods that are well documented, that the written contract remained the true point of departure for a work: it guaranteed the conformity of the result both to the express terms of the commission and to the regulations and moral code of the work, as laid down by the authority of the guild.

The edicts published by cities concerning the exercise of various trades and professions contain much and often very valuable information for the art historian seeking to understand the precise part played by the painter and sculptor in the execution of altarpieces. In general, the control of the guilds extended to the strict division of tasks between painter and sculptor; when the latter wished to supply a polychrome statue, he had to pass the carving, once finished, to a painter or a specialist in polychromy who might well be a member of his own workshop. The commission for the altarpiece of St. Nikolaus in Feldkirch was awarded to the painter Wolf Huber, who drew the *Visierung* and probably undertook the painting, but he had to let a sculptor do the carving. In return, the contract stipulated that he should paint panels "in his own hand." A contract like that required the painter to ensure that he gave the finished work the relative unity that depended on the chromatic effect of the whole and the overall design of the composition.

Often—as in Cologne, Ulm, Augsburg, and Lübeck—sculptors and painters were members of the same guild. Conflict could arise when that was not the case. In Strasbourg in 1427, for instance, cartwrights claimed that woodcarvers employed by the painters should join their own guild, because cartwrights and woodcarvers worked the same materials with the same tools. The cartwrights accused the painters of engaging woodcarvers as journeymen, while the painters argued that their work necessarily brought woodcarvers into their orbit. The city council wisely concurred in this form of recognition of the specifity of artistic work.

Granting a sculptor or painter the authorization to employ a specialist in polychromy gave workshops greater opportunities to accept commissions and honor them under the sole control of the master of the workshop and with relatively little delay. It is easy to imagine the difficulties a program demanding a variety of skills could cause when a sculptor was obliged to entrust work to a painter resident in another town. One case on record is that of Jacques de Baerze, who lived in Termonde and remitted carvings for the Charterhouse at Champmol to the painter Melchior Broederlam in Ypres.

The ideal situation was when a master practiced several skills jointly. This was the case with Veit Stoss, as well as a relatively large number of others: Hans Stethaimer was a stonecutter, painter, and architect; Max Doerger was a painter and sculptor; Jacotin Paperocha was described as *sculptor ymaginum* or *talhator ymaginum*, *pictor*, and *menuserius*; André Beauneveu was equally active as a painter and sculptor; the "HL Master" was a sculptor and engraver, like Stoss; and Ulrich Griffenberg of Constance was a sculptor, painter, and glazier; Perrin Denys, "mason," had a commission from the Duke of

Burgundy for wood carvings for the Hôtel d'Artois; conversely, Jean de Liège, "carpenter," was asked to execute carvings and other work in stone for the Duke of Orléans.

We should also bear in mind that painting could be combined with another, nonartistic occupation: there was a painter in Louvain who was also a baker, and one in Valenciennes who kept a cheese shop. The practice of two trades was more common than we think.

Disputes could arise about demarcations between cabinetmakers or joiners and woodcarvers. Cabinetmakers played an important role in the overall program of an altarpiece: their skill was exercised in particular in the ornamental carving concentrated in canopies and crownings. But just as it was not always easy to settle questions of demarcation between stonecutters and stone carvers, it was no easier, understandably, in cases involving the two kinds of woodworkers. In principle, the cabinetmaker worked only with planks of wood, never with blocks. A municipal ordinance of Strasbourg concerning joiners and cabinetmakers specifies that their work is confined to parts that will be nailed. The intention was to distinguish the normal work of the cabinetmaker from that of the sculptor in wood, but the former could rival the sculptor in the dexterity of his chisel. In 1515, Anton Tucher paid the cabinetmaker Stengel for making a napkin holder decorated with four human heads. The client's contractual demands could be as exigent in such cases as for representational carving: witness the very detailed order for stalls for the conventual church of Georgenberg at Schwaz, given to the carpenter (*Tischler*) Konrad of Bayrischzell in 1482.

Several instances are known where the contract for an important piece of work was agreed with the cabinetmaker: the high altar of Notre-Dame in Strasbourg is one, where the work itself is signed by the sculptor Nicolas de Haguenau; at Constance, by contrast, the joiner Simon Haider entrusted the relief carvings on the portal to a sculptor but signed them himself. Even though the stalls in the Frari church in Venice are signed by the cabinetmaker Marco di Giampietro Cozzi of Vicenza, most of the reliefs are the work of, again, a Strasbourg workshop from around 1468. In Ulm, where sculptors and cabinetmakers belonged to the same guild, Jörg Syrlin the Elder, who is mentioned twice in his official capacity, as *Kistler* (joiner) in 1462 and as *Schreiner* (carpenter) in 1469, was most certainly the sculptor of the carvings on the episcopal throne, to which he put his name.

Beyond the great disparity between individual cases, it is possible to say that when it comes down to single works neither the stylistic distinctions nor the clear division of tasks between woodcarver and cabinetmaker, or between

painter and sculptor, should be taken too literally. The particular regulations governing the status of artists in different cities and the personal capabilities of individual artists constitute enough essential factors to make any picture of this period especially complex.

What is true of Gothic architecture is even more true of Gothic sculpture: polychromy was preeminent. Painters as well-known as Jean Malouel, Melchior Broederlam, Robert Campin, and Rogier van der Weyden were engaged to paint sculpture when they had had nothing to do with the original conception. Veit Stoss did not scorn to undertake the polychromy of the Münnerstadt altarpiece, carved ten years earlier by his fellow sculptor Tilman Riemenschneider.

Generally speaking, painting was much more highly regarded than carving. The differences in the tariffs for sculpture and painting can be explained partly by the prices of certain pigments, such as lapis lazuli and gold, but another factor was the difference in how the work was perceived: in the case of the Xanten altarpiece, the sculptor Wilhelm von Roermond was paid 125 florins and the painter and polychromist 525 florins! Riemenschneider was paid 145 florins in 1490 for the Münnerstadt altarpiece; for coloring it, Veit Stoss received 220 florins.

If painting was better paid, it was not because of the cost of pigments and gold leaf but because it was more "noble" to practice a craft that, like goldsmithing, involved handling precious materials. Rather than being regarded as an aesthetic fact and more in conformity with the "humble" style, carved altarpieces without polychromy were considered unfinished.

In Brussels, despite the significance of the work produced in the city's sculpture workshops, it was the painters who had the greater influence on the art market in the mid-fifteenth century. If they were more or less equal with the sculptors for works executed to order, they were ahead of them in works destined for the open market. For instance, sculptors were required to put their work on sale unpainted and only after a month might unsold work be painted by a member of the Brussels guild. Otherwise, the choice of polychromy was left to the buyer. All this obviously allowed commissions of experts authorized by the guilds to exercise strict control over each phase of the work and over the quality of the materials used.

The painter's preeminence is also connected with the fact that it was he who conferred formal unity on the finished work, in the case of an altarpiece composed of polychrome carving and painted panels. The color could easily mask faults in the carving and enhance the quality of the whole assemblage. In Innsbruck in 1552, a sculptor declared that he had no need to perfect the

details of the work he was engaged on because that task would fall to the polychromist in the end.

Two examples will illustrate the painter's position. The first comes from a contract referring to the collaboration of two painters on the volets of an altarpiece; it is stipulated that the work, once finished, should show no sign of the collaboration. The second shows the extent of the options a contractor reserved to himself whenever the client did not express any particular wishes. The painter Michael Wolgemut signed the contract for the Schwarzach altarpiece in 1507. He entrusted the carving, an important element in this piece of work, to a close colleague of Veit Stoss, and the scenes that were to be painted to an artist who did not work in his own manner. Wolgemut may have kept the gilding and polychromy for himself. There is no escaping the fact that he honored the commission by subcontracting the work, not even employing one of his own pupils for the painting.

One extraordinary case gives an even better demonstration of how badly the spirit of enterprise could desert the man of the late Middle Ages. When the church at Tegernsee was being rebuilt in 1478, no fewer than sixteen altar panels—some of which perhaps entailed two or three volets—were commissioned from one and the same painter, the aptly named Gabriel Mäleskircher. The complete batch cost the considerable sum of 1,280 florins, showing that the pious flock in Tegernsee had more money than imagination, even if it is very likely that so ambitious a project would have involved recruiting the assistance of colleagues or even subcontractors.

## THE DISPLAY AND SALE OF ART

Trade in uncommissioned works of art seems to have made a very early appearance. It is probably safe to say that it always accompanied artistic production to some degree. But the development of great trade fairs and rivalry between towns and cities inevitably changed medieval man's attitude toward art, so that it too became merchandise to be bought and sold like all sorts of other goods. The acquisition of paintings and sculptures is likely to have been inspired less by any reasons of purely aesthetic delectation—certainly, there are no records of such motivation—than by a wish to possess goods that had both a religious or historical function and a commercial value. The composer Guillaume Dufay, a canon of Cambrai, owned at least three pictures, including a Crucifixion and a Mauresque, as well as a portrait of the king of France.

The existence of traders in art is attested relatively early. The duke of Burgundy bought "from Crestiau le Roux, citizen of Bruges, a little image of Our

Lady, made of amber" and "from Jehan Dicon, of Bruges . . . two images made of white amber." German traders are mentioned at Saint-Vaast in 1432 and at Amiens in 1456; one merchant from Lübeck found an opportunity to trade everywhere, making a profit from a journey to the shrine of St. James at Compostela; an art merchant was admitted to Antwerp's Guild of St. Luke in 1518.

Artists frequently traded in their own or other artists' works. And their widows did, too: in 1479 the widow of Jan van der Perssen, a polychromist in Brussels, sold an altarpiece. Artists also dealt in works they had contrived to collect. In 1362, for instance, Hugh of Saint Albans, the English painter who conceived the mural decoration of St. Stephen's Chapel Westminster, sold a Lombard painting that belonged to him.

The most abundant sources of information about the art market in the late Middle Ages come from the Low Countries. In general, towns and cities (not without a degree of xenophobia, as in Bruges) exercised protectionism in favor of artists who had rights of citizenship; limits or outright bans on imports went hand in hand with a very strict control of the market itself. Within their home towns, however, painters had the chance to engage in trade, authorized and controlled by the guild, during the big annual fairs. The right to sell was considered a privilege but the right to show work with a view to sale was an even greater one; it allowed the painter to speculate in works he had not produced himself, but above all he was able to produce works without a commission, the sole criterion for their purchase being their direct appeal. All the evidence suggests that this opportunity contributed to artists' becoming more acutely aware than ever before of their role as creators, even if at the time the content of their works scarcely reflected any such awareness. Several sales of altarpieces to churches took place in Ghent and Antwerp in the 1430s and 1440s, but we do not know the reasons why the painter had them in his stock.

It is easy to comprehend that the Medicis sent agents from Bruges to the fair in Antwerp to buy paintings and tapestries on their behalf. It is more surprising to see churches in Brabant and Flanders commissioning agents to purchase altarpieces at that same fair in 1422. Already before 1411, one artist went to the fairs in Bruges and Antwerp to sell his works, among them a carved Pietà.

According to Pero Tafur's chronicle, specialized sales took place in Antwerp in 1438: paintings were sold in the Franciscan convent throughout the duration of the fair, while goldsmiths' work was on sale in that of the Dominicans. In 1445, the Dominicans' market became a *pand*, a term that is presumed to designate a section of wall (*pan* in French) before which sales were conducted. During Antwerp Fair, the Dominicans' *pand* sheltered the stalls

of the guilds of St. Éloi (gold- and silversmiths) and St. Nicholas (jewelers and tapestry weavers), and of the guilds of St. Luke (painters) from Brussels and Antwerp. There is something inappropriate about these displays of artistic luxuries inside a building owned by a mendicant order, but such a use represented a considerable source of income for the clergy; the revenue from the *pand* of Onze Lieve Vrouw in Antwerp in 1509 raised ten percent of the cost of constructing this most ambitious of church buildings. But unlike the others, the *pand* of Onze Lieve Vrouw was a separate structure, erected in 1460 for the sole purpose of sheltering an art market. The Antwerp and Brussels guilds of St. Luke installed themselves there after leaving the Dominicans' *pand*.

An important market in altarpieces grew up within this economic framework. Large numbers of altarpieces are known to have been exported from the Low Countries to Germany, Burgundy, Spain, Portugal, and Scandinavia. Their construction is reasonably well-known: each scene could be mounted inside the case, and it was up to the joiner to remedy any problems encountered on erection. They were mass produced, and it was scarcely within the scope of a single workshop to realize one entirely: ornamental sections, for example, would be ordered from other workshops that perhaps specialized in such work. Often, figures made for one altarpiece were integrated into a scene in another: practices like this eventually did such damage to the work's stylistic unity that the Brussels and Antwerp guilds forbade the mixing of old and new pieces. Attestations of concern for the relative homogeneity of the assemblage are frequent: the collaboration of two painters on one volet was required to be undetectable.

The repetition of the same narrative cycles of the Birth and Passion of Christ aided standardization. Probably altarpieces so lacking in distinguishing features could be purchased easily by any parish. It is even possible that carved groups went on sale, leaving it to purchasers to assemble their altarpieces from such carvings as they possessed. The conditions of the Antwerp art market during the fifteenth century and their evolution provided the framework for a new relationship between artist and client and gradually enabled the status of each to be redefined. In becoming something public, even if for only a brief period in an open economic forum, art was more exposed than before to public judgment, and more easily the subject of comments. As a result, the artist was taken into the process of the socialization of art at a crucial moment, and he then had to seek to please the hypothetical customer who, for his part, was in the position to judge, to compare one work with another, and, at the end of the day, to choose.

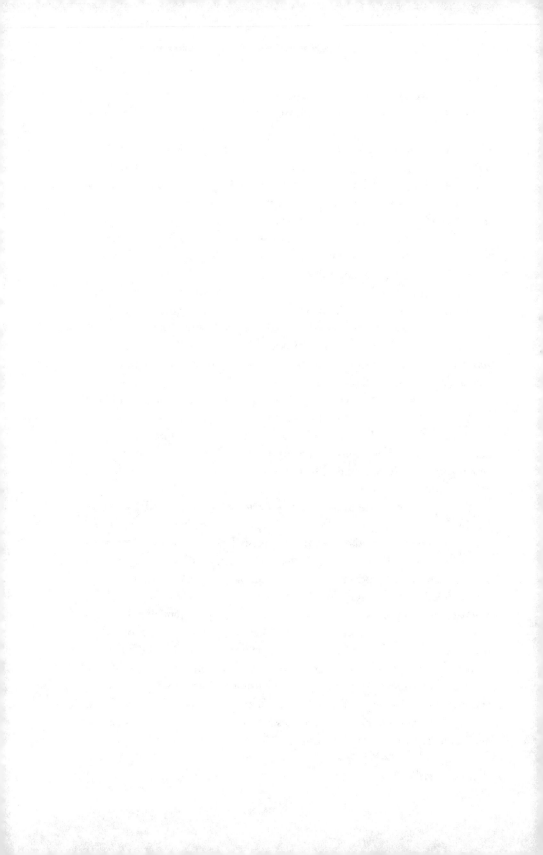

# The Cathedral as a
# System of Seeing

Vasari's censure of the "Gothic" seems to me to pinpoint precisely some of its essential characteristics. In a celebrated passage in the Introduction to his *Lives of the Artists*, he calls it:

> monstrous and barbarous, and lacking everything that can be called order. Nay it should rather be called confusion and disorder. In [these] buildings, which are so numerous that they sickened the world, door-ways are ornamented with columns which are slender and twisted like a screw, and cannot have the strength to sustain a weight, however light it may be. Also on all the façades, and wherever else there is enrichment, they built a malediction of little niches one above the other, with no end of pinnacles and points and leaves, so that, not to speak of the whole erection seeming insecure, it appears impossible that the parts should not topple over at any moment. Indeed they have more the appearance of being made of paper than of stone or marble. . . . [W]ith one thing being put above another, they reach such a height that the top of a door touches the roof.[1]

Gothic is presented here as a cumulative art, with structural elements lacking any relation of scale to each other (human scale, that is) and intent on de-materializing stone as a matter of structural principle ("the parts . . . have more the appearance of being made of paper"). The above passage follows imme-diately after a comment on various types of ancient terms: "a figure down to the waist, the rest, towards the base, a cone or a tree trunk; in the same way

they made virgins, chubby infants, satyrs, and other sorts of monsters or grotesque objects, just as it suited them."[2] Vasari borrowed this description from Vitruvius, inveighing against a certain kind of Pompeian mural decoration: "Instead of columns there rise up stalks; instead of gables, striped panels with curled leaves and volutes.... Again, slender stalks with heads of men and of animals attached to half the body."[3]

For both the Roman and the Florentine, these artistic forms were depraved in their defiance of the classical norm. But Vasari's readers and followers significantly reduced its range by taking architecture alone as the basis of their own rejection of the Gothic as a whole. It was Gothic's capacity for creating hybrid, nonclassical forms that Vasari condemned.

Paradoxically, Vasari's critique is more effective if it is not restricted to architecture: he objected to Gothic art's ability to "betray" function by form— that is, ultimately to overstep the limits of "reasonable" agreement between what one wishes to say and the manner of saying it.

Since Vasari, all interpretations of the Gothic have sought to prioritize architecture over the other arts. There is some justification for this point of view, but it does not do justice to three other factors that complement and reinforce each other, without which no "Gothic" art would ever have seen the light of day: the way the sacrament of the Eucharist developed; the mysticism of the Passion inaugurated by St. Bernard of Clairvaux and extended in the practices initiated by St. Francis; and the new standing of the visual arts in a society where the written word surrendered its dominant position to them. The result was necessarily a rethinking of architectural language. The mysticism of the Passion, thanks to the renewal of modes of figurative expression, acquired an ever more elaborate mode of representation, and thanks to architecture it acquired a space entirely governed by the "eucharistic perspective."

"Gothic" art is first and foremost an abundance of visual images that make architecture their support. But the architecture itself is treated as an image; it solicits attention continually, one form pointing to another in accordance with a play of relationships, never allowing the human eye to rest. Never were forms so numerous or so complex, giving visible shapes to the teachings of Scripture, with pride of place taken by the Incarnation and its final, tragic act, the Passion—which allowed evil, cruelty, hatred, and suffering to enter the artistic representation. Everything that Neoplatonism had dismissed from the definition of beauty thus found a place in the story of salvation. Christ is God, "but made himself of no reputation, and took upon him the form of a servant, and was made in the likeness of men: And being found in fashion as a man,

he humbled himself, and became obedient unto death, even the death of the cross," as we read in the Epistle to the Philippians.[4]

The Passion is the culmination of that abasement. The word used of the Incarnation in Christian literature in Latin is *humilis*, meaning humble or lowly. It has other associations: *humilitas* is the humility of the simple people to whom the teachings of Scripture are addressed, and St. Augustine speaks of the apostles as *humiliter nati*—men of humble birth, illiterates. Finally, *stilis humilis* (humble style), or *sermo humilis*, is the "inferior genus" in classical literary theory.

St. Augustine wrought a revolution in the classical art of oratory by rejecting the hierarchical classification of the three *modi*, or *genera*, of discourse, handed down from Cicero and deemed to correspond to, respectively, sublime, intermediate, and lowly subjects. This distinction has no relevance, St. Augustine argued, to spiritual subjects concerning the salvation of mankind. In the Christian view, nothing is low or despicable; everything has its place in the overall plan of salvation. Similarly, the comical, the obscene, the ugly occupy a position equal to that of the beautiful. The ugly is not the diametrical opposite of the beautiful, which means that it is possible for the devil to adopt the lineaments of divine beauty. If the truth of the Scriptures remains inaccessible to many, it is not because their style is too lofty but because the truth is lodged in the most profound depths of the text, where greatness and littleness mingle. It is humility that will show us the only path of access to this truth.

This argument laid the foundations of a medieval aesthetics in which the central figure was that of Christ on the Cross. This aesthetics may share the image of the human body with the platonic philosophy of beauty, but it submits the body to torture: to confront *superbia*—platonic pride—it elevates a beaten, humiliated body. As St. Augustine says: "Christ is humble, you may be proud" (*Christus humilis, vos superbi*). In this context, the alleged growing realism of art in the fourteenth and fifteenth centuries is rather a more general manifestation of the tendency to emphasize the abject nature of Christ's humility in order to bring out its spiritual beauty.

The image of the crucifix also has a cosmic dimension, at least in the light of a beautiful passage in the writings of one of the Church Fathers, St. Irenaeus. Christ nailed on the Cross, according to him, shows us:

[The] Word of Almighty God, who fills us with his unseen presence at every moment: that is why he embraces the whole world in its length and breadth.... The Son of God is crucified in all things according

as he imprints himself on each in the form of the cross. It was just and equitable that through his own physical appearance he clearly expressed his common belonging, through the Cross, to the realm of the visible. For his action would demonstrate in a visible form and in the touch of visible things themselves that it is he who illumines the heights (that is, the heavens), who reaches down to the depths, the foundations of the earth, who spreads out surfaces from dawn to darkness, who directs the whole world from the north to the south, who announces the assemblage of all that is scattered in order to make the Father known.[5]

When, in the middle of the fourteenth century, the papal legate Jean de Marignola desired to plant a cross in southern India, "on the world's cone, facing towards Paradise" (*in cono mundi contra paradisium*), destined to endure until the end of time, unknowingly he was reviving St. Irenaeus's cosmic image.

But it is not necessary to follow the missionaries to Cape Comorin. The cross as a symbol and the Eucharist as a rite define a perspective space within which is deployed man's vision of the world from the twelfth century to the end of the Middle Ages, that is, the choir of the church, approached by the nave. St. Irenaeus's text almost constitutes a definition of it. Let us first look at this eucharistic scenography.

The elevation of the consecrated Host renders the real presence of Christ visible at a given point in space. It is like a bull's-eye or a vanishing point on which all lines of sight converge. The whole spatial arrangement takes its meaning outwards from this point, based on the rhythmic succession of the bays and the alignment of the piers, closer together optically than in the past. The addition of engaged columns and the doubling of elements on the upper walls are so many factors helping to reinforce the perspective effect.

Once again, it is in Flemish painting that we find a kind of symbolic summary marking the conclusion of the Gothic age: Rogier van der Weyden's altarpiece of the Seven Sacraments (fig. 85). Its construction, three fixed volets, is determined by the threefold division of the body of the church in a central nave and two side aisles: each of the panels gives on to one of these aisles, the central one obviously being the highest. The composition is arranged slightly off the central axis so that the group in the foreground can be read easily, representing Christ on the Cross with Mary and John at its foot, while it does not conceal the middle ground scene of a high altar where a priest stands raising the Host. Unlike the Berlin panel by Jan van Eyck, showing the Virgin in a church nave from the viewpoint of someone standing on the

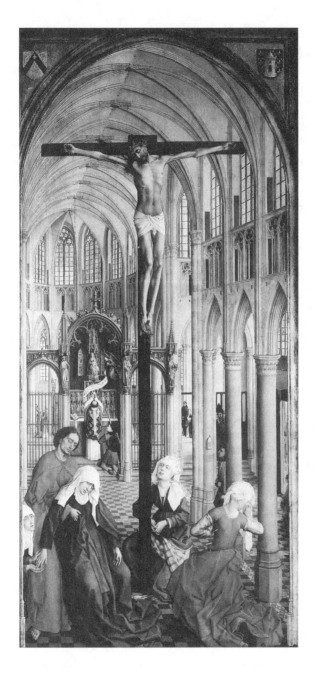

FIGURE 85. Rogier van der Weyden, altarpiece of the
Seven Sacraments, central panel. Musée des Beaux-Arts,
Antwerp. (Photo: Giraudon)

church floor (see fig. 9 on p. 64), in Rogier's painting the viewer is placed so as to look at the group in the foreground from above. At the same time, the cross stands in the center of the panel, immensely tall, with the figure of Christ positioned to dominate the nave and the hypothetical viewer. In this one marvelous composition, Rogier assembles all the elements we have been considering. He paints the Crucifixion as if it was a historical scene in a real church, and these two orders of reality act against each other to such an extent that the "unreal" results. Ultimately, the Host elevated in the middle ground is the most important "sign" in the painting, not for its own sake but for what it refers to. The picture presents itself as a symbolic representation of the Real Presence of which Aquinas writes.

We have seen that the medieval conception of space remained reliant on two-dimensional vision because it was determined by the vertical axis. The ordering of every description, every idea, and above all every symbolic system was in terms of a hierarchy. The vision of the cosmos and the daily conduct of human behavior alike were subject to the polarity of high and low, the above and the below. The celestial hierarchies of Pseudo-Dionysius and the mystical ark of Hugh of Saint-Victor are two constructs using images with a value representative of the Middle Ages as a whole. In *De Arca Noe mystica*, Hugh describes an ark in the form of a pyramid surrounded by a *mappa mundi* and a Christ in Majesty. This intellectual construction, perfectly two-dimensional, allows its author to set the entire history of the world within it. History does not imply progression, even less a progress.

The unceasing emphasis on verticality in the architecture of the twelfth and thirteenth centuries, taken to the point where the material is close to disintegrating, is not the product of an exclusive delight in technical prowess. It is the concrete and measurable expression of a world ordered from bottom upwards, allowing for the display of carvings or painted images in stained-glass windows.

Time does not exist in this vision because thinking about time necessitates concepts of "before" and "after." By inventing artificial perspective, the Florentines would introduce simultaneity into pictorial representation; the breadth and depth of time preoccupied them far more than any central space. Admitting, as they did, that several events could take place at the same time in a given space was to admit that there are planes beyond the foreground, that a picture is an arrested image, and thereby imply that there is a "before" and an "after."

While these plastic effects in the Gothic church offer a living structure to the eye, animated by infinite variations of the light, themselves amplified or merely

modified depending on the profile of the moldings, the liturgical space in the chancel is monopolized by the clergy. Mass is celebrated behind the screen, sheltered in the enclosed choir. In his altarpiece of the Seven Sacraments, Rogier van der Weyden depicts a grill preventing access to the chancel, so that the congregation must stay in the ambulatory (see fig. 85 above). Even that space is only accessible when the church doors are open, and there are strict rules governing the exhibition of relics and the opening and closing of altarpieces. The growing subtlety of architectural forms, complemented by the layer of color that covers them, is opposed by a whole system of means— cloths and hangings—by which to conceal color, cover altars, wrap reliquaries. The world of forms grows ever richer, demanding attention with increased insistency, while the clergy preserves strict control over ritual and the objects of worship.

Before the advent of liturgical drama, certain moments in the Easter liturgy began to be developed in dramatic forms, with a special function falling to works of sculpture: the body of the crucified Christ could even be transformed in full view. The congregation became eyewitnesses of the most important moments of the Easter festival. Paraliturgical ceremonies inform us about the new place and significance images acquired during the twelfth and thirteenth centuries. This period saw the institution of two distinct orders of reality: that of ritual and that of narrative, corresponding to two opposing conceptions of time. In ritual, time is eternal recurrence, since what happens in ritual is what was for all time and will be forevermore. Narrative time, by contrast, is a perpetual present; each moment in such ceremonies, and even more each scene depicted on a tympanum, is a memorial, a reminder, and puts itself forward as the image of a reality, the totality of which is presented by the forms it takes.

Medieval conceptions of time and ritual did not allow narrative anything other than a subordinate position. But the great novelty of Gothic art was that it granted its existence; narration now had a place, either alongside liturgical rites or in their train.

The question of the Real Presence, to which I have referred in connection with the mystery of the Eucharist, has a direct link with the carved effigy. Unlike a painting, a carved body introduces a form of real presence. This is an essential distinction, I believe, between Gothic and Byzantine art, in which painting is preeminent. An icon is only a door, a passage opening on to the divine. A carved figure, inasmuch as it is a spatial equivalent of a human body, is a substitute for the man or woman it represents.

In his *Liber miraculorum sancte Fidis*, Bernard of Angers expressed disapproval of the making of holy images except for the crucifix, "because it arouses

our affective piety in the commemoration of Our Lord's Passion." Saints may also be represented on walls, but Bernard agreed with those who regarded the representing of a saint in precious metal and using the object as a container for relics as pagan superstition. The crucifix was the only three-dimensional representation that should be authorized, and saints' images should be confined to books or mural paintings. The only reason for allowing carved effigies was that people had become accustomed to them by long tradition and therefore would not tolerate their removal. Thus Bernard clearly equated images of saints with pagan idols.

When Bernard visited Conques on the day when the general public was admitted to the part of the church where the statue reliquary of St. Foy was kept, the crowd pouring in to prostrate itself before the image was so dense that he could not move from the spot where he stood. He was forced to admit, however, that far from being an idol, a "mute and insensate thing," the statue "commemorates a martyr [and] reverence to her honors God on high."[6]

Dating from the eleventh century, this account is extremely valuable, because it concerns the three-dimensional representation of a saint at a time when such figures were relatively rare. My purpose is to underline the pagan associations Bernard attributes to a Christian "idol" that excites all the more enthusiasm in the crowd for being three-dimensional. The degree of verisimilitude achieved by this form of representation is the direct cause of its effectiveness.

Throughout the Middle Ages, the simulacrum is always mentioned in connection with the place where it is kept. The object is one with the place, and this prevents any possibility of removal or even of true three-dimensionality; frontality remains the indispensable principle of plastic representation. Even statues carved in the round, placed in the embrasures of doorways, are inconceivable without the shadow that outlines them because they have their backs to the wall. Every projecting form has its receding counterpart, which reinforces its plasticity. This law applies as much to moldings as to monumental sculpture.

Every part of the church is treated as a plane, a surface from which plastic forms detach themselves, more or less tactile according to whether or not they are carved or painted. The portal statue is a plane, just as the upper wall of the nave or the choir is a plane. Every figure carved in the round is itself less a form in space than a juxtaposition of planes. Models are transmitted in this way, their three-dimensionality being reduced to the plane and becoming drawing, pure outline.

The reason for the success of the stained-glass window during the twelfth and thirteenth centuries is that it corresponded less to allegories of light than to a conception of form, with allowance for its being two-dimensional. The variation of light could cause the figure-background relationship to be reduced, even inverted.

The gaze is able, therefore, to move about inside the church, or rather over its surfaces of stone and glass, and consciously take in everything; there is nothing "behind" the visible forms. Nothing clarifies this complex relationship between the visible and the invisible more tellingly for us than Roger Bacon's statement that the Eucharistic sacrament has a "certificatory" worth in the world of faith similar to that of optics in the physical world. The analogy is far from fortuitous; it shows how important the visible was in the thirteenth century as a witness to the veracity of things. That is one register of truth. The other is that of the enlightenment where the inner light shines that allows us to approach the only truth worth knowing: the truth of God.

Suppose the visible world, impenetrable by the eye, revealed more of itself accordingly as the eye explored more of it. This would be to recognize the infinite nature of the spiritual quest. Only in a two-dimensional world can the eye avoid the deceits of *trompe l'oeil*. There, figures and scenes are ordered in one plane, figure and background are fixed in one frame.

It is in Flemish painting that we find the logical conclusion of such a conception of form. In the Mérode altarpiece, the Master of Flémalle paints the Virgin in an architectural structure of folds, and outlines her with a shadow that runs continuously—and this is what matters—all around the silhouette (see fig. 6 on p. 58). In other words, this shadow treats a three-dimensional figure as if it was entirely flat, on the same plane as the picture or its frame. Things on the table, similarly, are projected as if the table, and not the picture, constituted the plane of projection.

What was new about the perspective system of Florentine painters was that the plane, for them, was no longer a plane of projection but of section (of the visual pyramid) whereby we see the depth of a space. Whereas in thirteenth-century optics the cone of rays leaving the eye was met by that of the *species* issuing from the visible object, in Florentine perspective the object was only visible because of the theoretical existence of the vanishing point, the "double" of the human eye. The vanishing point is the other eye, symmetrical to one's own, at the furthest distance, which is always inaccessible. The existence of these two poles makes it possible to monitor the existence of the objects placed between them. The device was inconceivable as long as the visible

had only an anagogic function. A form the eye had not circumscribed in its totality could not have been the anagogic equivalent of an invisible reality, since the invisible reality itself could not be limitless. The perspective with central vanishing point used by a Brunelleschi treats the visible world as a fragment, using the mediation of illusionistic representation. The fragment, to be sure, is arranged wholly around what the painter wants to render visible—a fragment of a happy coincidence, as it were—but it is nonetheless a fragment. The two-dimensional visible content of Gothic art was not a fragment but an *analogon*. It therefore needed to hold both its beginning and its end within itself: it had to constitute a totality.

From the twelfth century to the fifteenth, the Incarnation was the basis of the possibility of representing the world. By His assumption of a visible form, God gave His blessing to the worth of ocular witness and, consequently, to the standing of the representational arts. But it was only after narrative developed in ways due to the mystery of the Passion that medieval art embarked on the path of mimesis.

Even so, during those centuries art had at its disposal a means of visual construction that made it possible to arrange the elements of the story of salvation in hierarchic order. One form taken by this order was the *mappa mundi*, but there were relatively few of them. Everyone could see it, however, in the form of a church building. Unlike a *mappa mundi*, a cathedral was a system with two surfaces: the exterior, the obvious support for this hierarchic order, and the interior, governed by axiality. All the architectural articulation, its organization according to elements that could be separated and rearranged as the builders wished, provided the support and the ideal framework for a theater of memory. But a church interior was also a perspective system, as some Flemish paintings remind us. In fact, it was the only system akin to Florentine perspective. It manifests consciousness of distance and proximity, of absence and presence, because forms take on dimensions relative to their height, breadth, and degree of distance, exactly as when they are seen on a checkered floor. But unlike the space depicted in Italian painting after 1425, the space inside a church cannot continue to infinity; the high altar, the cross, the altarpiece constitute the true center—both topographic and symbolic—and the closure of the spatial system.

In the countries of northern Europe, from the twelfth century to the end of the fifteenth, the only space where a perspective view was possible was the interior of a church, but this was a real space, unlike the illusionistic space of Quattrocento painting. No architectural system would ever try again to recover such emphatic axiality, after that time, for the simple reason that the

religious order to which it corresponded ceased to exist at the start of the sixteenth century. The perspective space of the cathedral could have disappeared from about 1430 onward, but Florentine geometrical perspective took a very long time to take root north of the Alps. For almost a century, representation in two dimensions and the conception of "Gothic" architectural space continued to exist side by side.

This type of axiality originated, in fact, in classical architecture as transmitted through the architecture of the early Christian era: Chartres, Reims, and Amiens sublimated it to some extent. Paradoxically it was at Cluny and Bourges, where the attempt was made to reproduce the grandeur of the Roman basilica, that the perspective effect was diminished. The cause is not hard to find; Cluny and Bourges sought greater breadth, with five aisles instead of three, which makes them less "classical" than our other examples. At Bourges, a kind of construction by imbrication was invented, leading to a method involving the addition of elements which preserved more or less the same section, regardless of the differences in their functions and dimensions. Never before had architecture given such priority to the visual aspect of even the smallest details.

For such subtle visual values to be sought after, their creators had to be certain that they were discernable: their effects were intended to be seen, judged, compared, appreciated, imitated. It has been believed for too long that the viewers for whom they were designed were the same people as the congregations who filled the churches.

In order to bring a little order into this question of the "public," I want to examine a text relating to Amiens Cathedral that has been overlooked by art historians. Yet it is a highly interesting document; it is the longest sermon in the vernacular to have survived from the thirteenth century,[7] in which the preacher—probably a Dominican friar—seeks to persuade his flock to buy indulgences.

Addressed to a sparse congregation at a morning service, the sermon was certainly not delivered in the cathedral itself, but in the nave of another church in the diocese, only for the cathedral's benefit. With consummate rhetorical skill, the preacher pitches it directly at the public he seeks to convince. Just as Mary Magdalene's alms were pleasing to God, if not to the world ("and know, she had her reward in paradise"), the preacher asks the people to give in the same spirit, for "truly Our Lady St. Mary of Amiens will give to all benefactors of the church seven score days of true pardon to lighten the punishment you will suffer in purgatory" and "you will be closer to paradise by seven score days than you were this morning." In particular, those guilty

of abusive distraint will be granted absolution if they donate all or some of the distrained goods, not to their rightful owners, but to "the Mother of God, St. Mary of Amiens, who is your mother church."

The sermon is made up of short segments, each complete in itself. It is a reasonable assumption that the speaker could omit one passage or another, according to his listeners and the time available, without losing sight, however, of the object of selling indulgences in aid of Amiens Cathedral.

What strikes the art historian before anything else is that this sermon, which is quite exceptional in its length and testifies to the skill of a preacher in addressing a crowd of peasants, does not make the slightest allusion to the work in progress at Amiens or to the beauty of the works of art adorning the church. In order to collect money for a building close to completion, a French cathedral church of the very first rank, the preacher puts himself on the side of his flock, not of his objective. It is as if a merchant—and the comparison is not frivolous for this sermon—did not speak of his merchandise but only of the reasons that should convince the buyer and the benefits he could expect from his purchase.

Probably the smallness of the numbers who heard this sermon, not long after 1276, was one more symptom of the economic crisis that struck the major architectural enterprises in northern France. The collapse of Beauvais a few years later was another; the limits, financial as well as technical, appeared insuperable for the time being. But the case of this church in the diocese of Amiens, sheltering a preacher and a few worshippers, seems to contradict the thesis I have developed in this book of art being increasingly wrought to appeal to the eye. The point is that art was intended for a different public—not for the congregations, who were not concerned about it, but for groups of individuals with a shared aesthetic sensibility. It would be wrong to suppose that only those who commissioned this art cared about it. Prelates, artists, and some intellectuals were probably also of their number. Such groups constituted the true critical authority, liable to stir debate and controversy but also capable of spreading information. An elite, if you will, like the noble public able to appreciate the lyric art of the troubadours, who commanded the system of references necessary to understand any new artistic enterprise; at Saint-Denis, at Sens and Notre Dame of Paris, at Bourges and Wells, we can sense the existence of such circles of connoisseurs. It was in this context from the 1170s onwards that the role of the architect was affirmed and his standing began to carry weight with his client.

There is no documentation testifying to the existence of these groups. Members will have included people like Abbot Suger; Henry of Blois, bishop

of Winchester and collector of antiquities; and Matthew Paris—what we know of them allows us to suppose as much. Other groups perhaps were formed of twelfth-century architects and goldsmiths (such as Godefroy de Huy). In any case, the development is implicitly attested by the very way architecture and the representational arts evolved. The obvious borrowing of certain forms, the manifest adherence to a certain tradition, the references above all to classical art, or at least to the past, can be taken as guarantees of fidelity to tradition. All of this contributes to the language of art.

As defined by St. Bonaventure, the architect and the artist produced nothing that did not refer to tradition; *compilator*, *commentator*, or *auctor*, each had always to position himself in relation to authority. And the authority had to be visible. Villard d'Honnecourt was a simple *compilator*; Gautier de Varinfroy, to judge by Évreux at least, was a true *commentator*, putting his creative powers at the service of what he preserved. But indisputably no Gothic artist was a "creator" in the modern sense of the word. The greatest of them—the Master of Saint-Denis around 1230, the Master of St. Eustace at Chartres, the sculptor who carved the apostles in the Sainte-Chapelle—may be regarded as the interpreters of a tradition they dealt with by making the most of their own genius.

Just as the clergy sought constantly to contain any risk of an upsurge of heresy or idolatry by extending ever further the register of representation so as to please the congregation, including even sacred relics in subtle plays of unveiling, so artists too, greatly encouraged to assist in this process, came to approach commissions by taking the artistic form itself as one level of meaning, separate from its content. This level of meaning rested on sensory qualities that were accessible to the *illiterati*, although the allusions, references, and cross-references made by the artists were perceptible only by the circle of connoisseurs, which only partly overlapped the circle of *literati*.

The sheer quantity of representational works of art always made the clergy uneasy to varying degrees; that must be the reason why Suger so often busied himself with demonstrating that all his sumptuary expenditure contributed to the propagation of the gospel of salvation. An artist could not have borne the responsibility for so lavish an undertaking without exposing himself to the thunderbolts of someone like Bernard of Clairvaux. Art that presumed to be an end in itself was to be condemned.

Furthermore, a new form of perception began to dawn in the discreet but influential public for which the works of art were intended; as their visual qualities grew, works of art solicited closer attention as well as more discerning eyes—and fostered these things as they demanded them. They themselves

focused the viewer's eyes on the level of formal meaning defined above. Before exploring the total extent of the visible world, the eye restricted itself to studying the representation of the world more attentively. Within those limits it learned greater acuity. A way of seeing born of art and applied to art encouraged the proliferation of differentiation in the works of art themselves. Without it, the elaboration of a system such as the illusionist representation of the three-dimensional world would have been, quite simply, unthinkable.

# NOTES

CHAPTER ONE

1. Frankl, *The Gothic*, 826–27.

2. Laugier, *Observations sur l'architecture*, 294.

3. Gauthey, *Mémoire sur l'application des principes de la mécanique à la construction des voûtes et des dômes*, 67. Sainte-Geneviève became the Panthéon at the French Revolution.

4. Soufflot, *Mémoire sur l'architecture gothique* (Bibliothèque de l'Académie Lyon, MS 194, fol. 144ff). Cited after Petzet, *Soufflots Sainte-Geneviève und der französische Kirchenbau des 18. Jahrhunderts* (Berlin: Walter de Gruyter & Co., 1961), 140.

5. Viollet-le-Duc, *Rational Building*, 175.

6. Ibid., 193–94.

7. Ibid., 194–95.

8. Source unidentified.

9. See Watkin, *Morality and Architecture*, 24, 29.

10. Wright, *In the Cause of Architecture*, 175–76.

11. Taut, *Architekturlehre*, 94–95.

12. Ibid., 96–97.

13. Abraham, *Viollet-le-Duc et le rationalisme médiévale*, 102.

14. Ibid., 115.

15. Ibid., 113.

16. Ibid., 102.

17. Masson, "Le rationalisme dans l'architecture du Moyen Âge," 30–31.

18. Ibid., 41.

19. Focillon, "Le problème de l'ogive," 6.

20. See Kubler, "A Late Gothic Computation of Rib Vault Thrusts."

21. Heyman, "Beauvais Cathedral," 30.

22. Gropius, *Bauhaus 1919–1928*, 18.

23. Source unknown.

24. Source unknown.

25. We may recall in this context the passage in *Abstraction and Empathy* (*Abstrak-tion und Einfühlung*, 1907), where Wilhelm Worringer characterizes the novelty of Gothic buildings as follows: "In the Gothic cathedral . . . matter lives solely on its own mechanical laws; but these laws, despite their fundamentally abstract character, have become living, i.e. they have acquired expression. Man has transferred his capacity for empathy onto mechanical values. Now they are no longer a dead abstraction to him, but a living movement of forces. And only in this heightened movement of forces, which in their intensity of expression surpass all organic motion, was Northern man able to gratify his need for expression, which had been intensified to the point of pathos by inner disharmony" (112–13).

26. Source unknown.

27. Gall's review in *Kunstchronik*, 4 (1950–1951), 14–21, 330–32; Simson's review, 78–84; Überwasser's review, 84–92, 329–30.

28. This phrase and others in this and the following paragraph are taken from Panofsky, *Gothic Architecture and Scholasticism*, 21–26 (quoted material appears on 27 ["mental habit"], 24 ["meeting ground"], 25 ["a social prestige"], and 26 ["Scholastic"]).

29. It was Gottfried Semper (*Der Stil in den technischen und tektonischen Künsten oder praktische Aesthetik*, 1878) who first suggested the analogy between Gothic ar-chitecture (which he did not much like) and scholasticism. Worringer (*Formprobleme der Gotik*, 1911) said that a Gothic building was mystical outside and scholastic inside. On Riegl's *Kunstwollen*, see chapter 2, p.35.

30. Panofsky, *Abbot Suger on the Abbey Church of St-Denis* (for the references in this and the following paragraphs see especially pp. 21–24).

31. His activities are described as follows: "To recover, as canon law demands, all goods alienated or usurped and to augment the patrimony of land by acquisition, to improve management structures and modernize equipment, to keep the workforce at all levels within bounds and to put an end to parasitism, to repay debts and to produce a profit" (Suger, *La Geste de Louis VI et autres oeuvres*, 11–12).

32. It is worth noting that Sedlmayr's contribution to the 1938 Festschrift for Wilhelm Pinder, which he prefaces with a tribute to Hitler, addresses "hypotheses and questions about the definition of French art of the past" and develops the theme of paradise "as the central monad of French art" (*Festschrift Wilhelm Pinder zum sechzigsten Geburtstage*, Leipzig: Seeman, 1938, 322).

33. Jantzen, "Über den gotischen Kirchenraum," 7–8.

34. Ibid., 11.

35. Ibid., 15.

36. Ibid., 20.

37. Jantzen, *Ottonische Kunst*, 61–63.

38. See Jantzen, *High Gothic*, 70ff.

1. Wickhoff dealt particularly severely with Schmarsow's 1905 work *Grundbegriffe der Kunstwissenschaft* (*Fundamental Principles of Art History*) and declared in 1913, after reading *Barock und Rokoko*, that he would never again look at a single line of his. Given that the point of departure for Schmarsow's book was a critique of Riegl, however, Wickhoff was obliged to read *Grundbegriffe* notwithstanding. He accused its author of complete ignorance of the subject he was writing about and dismissed the content as "aesthetic babble." The worst thing in Wickhoff's eyes was that Schmarsow held the chair of art history at the University of Leipzig, ranked the second in Germany: "It is to the detriment of art history as a whole that the chair at a university like Leipzig . . . should be occupied by a man who has no notion of historical research, and understands nothing of the fundamental problems of history." (See "Abhandlungen, Vorträge und Anzeige" in *Die Schriften Franz Wickhoffs*, 365–70.)

2. Wickhoff, *Roman Art*, 3. (This text is a translation of the essay "Römische Kunst," which was originally published in the edition of the *Vienna Genesis* (Vienna, 1895) by Wilhelm von Härtel and Franz Wickhoff.)

3. Ibid., 8.

4. Ibid., 11–16.

5. Ibid., 119–20.

6. Ibid., 120.

7. Weisse had defined style as "a mode of physiognomic appearance pertaining directly to the individual mind" (*Stil und Manier*, 1867, quoted in R. W. Wallach, *Über Anwendung und Bedeutung des Wortes Stil*). Ernst von Garger argued that the Middle Ages, unlike classical antiquity, had given rise to an art which is the constant expression of the struggle for the mastery of form ("Über Wertungsschwierigkeiten bei mittelalterlicher Kunst"). Ernst Gombrich objected to a fundamental aspect of Garger's argument, namely that "In such judgments the style as a whole expressive system is set over against a hypostasized collective personality—either of a people or a period—of which it is held to be the expression" ("Achievement in Mediaeval Art," 75).

8. Semper, *Kleine Schriften*, 261.

9. Wölfflin, *Renaissance and Baroque*, 79.

10. Wölfflin, "Prolegomena zu einer Psychologie der Architektur," 45–46.

11. Wölfflin, *Principles of Art History*, 11.

12. Dvorak, *Idealism and Naturalism in Gothic Art*, 6–7.

13. Ibid., 122–23.

14. Dvorak, *The History of Art as the History of Ideas*, 28–29. (It is worth noting that this volume and *Idealism and Naturalism in Gothic Art* contain translations of all the essays published in his 1924 work *Kunstgeschichte als Geistesgeschichte. Studien zur abendländischen Kunstentwicklung*.)

15. Ibid., 60.

16. Dvorak, *Idealism and Naturalism in Gothic Art*, 109; see also 125–29.

17. Dilthey, *Der Aufbau der geschichtlichen Welt in den Geisteswissenschaften*, 172–73.

18. Frey, *Gotik und Renaissance*, xxviii.

19. Ibid., 11–12.

20. Ibid., 52.

21. Ibid., 53.

22. Ibid., 58–59.

23. Ibid., 88.

24. Ibid., 89.

25. Schmarsow, *Grundbegriffe der Kunstwissenschaft*, 32–33.

26. Ibid., 41.

27. Ibid., 52.

28. Schmarsow, *Kompositionsgesetze der Franzlegende in der Oberkirche zu Assisi*; see 120–21 and throughout.

29. The sources of the comments by Schmarsow quoted in this and the following paragraph are not identified.

30. Frankl, *Zu Fragen des Stils*, 17.

31. Ibid., 72–73.

32. Focillon, *L'Art des sculpteurs romans*, ix.

33. Ibid., ix.

34. Ibid., 3.

35. Ibid., 3.

36. Source not identified.

37. Source not identified.

38. Source not identified.

39. Focillon, *The Life of Forms in Art*, 44. (The translation of this work is self-confessedly free, and it was not always possible to precisely relate Focillon's ideas as quoted in the French edition of this book to Hogan and Kubler's translations.)

40. Ibid., 52–53.

41. Bergson, *Creative Evolution*, 92.

42. Ibid., 263.

43. Ibid., 243.

44. Ibid., 252.

45. Ibid., 249.

46. Ibid., 232–49.

47. Ibid., 217.

48. Focillon, *The Life of Forms*, 46–47.

49. Ibid., chapter 5.

50. Grimschitz had published a negative review of Focillon's book about nineteenth-century painting in *Belvedere* in 1932. As for *The Art of the West*, its original date of publication, 1938, was hardly favorable to reviews in German periodicals. However, Dagobert Frey regarded it as "the best and most extensive interpretation . . . with a sovereign command of a broad range of material concerning the current state of art history, unrivaled in the German academic community" (*Kunstwissenschaftliche Grundfragen*, 26).

51. In 1931 Walter Benjamin wrote a critical article for the *Frankfurter Zeitung*, after Carl Linfert sent him the first volume of *Kunstwissenschaftliche Forschungen*, edited by Otto Pächt, published that same year in Berlin. Two of the newspaper's editors, F. T. Gubler and B. Reifenberg, refused the article. Gubler, who was Swiss, thought that Benjamin's attitudes toward art history as generally practiced, and to Wölfflin in particular, were too extreme. In fact, Benjamin was particularly laudatory about Linfert's contribution on architectural drawing, and about Pächt's on Michael Pacher's historical significance. In support of the rigorous approach to art history practiced by the younger Viennese, Benjamin cited Riegl's article of 1898, "Art History as Universal History," and after praising these scholars for living on the frontiers of their discipline, he concluded with the lines: "The men whose work is combined in this yearbook represent the most rigorous of this new type of researcher. They are the hope of their field of study." After receiving a long letter from Linfert telling him about the *Frankfurter Zeitung*'s refusal to publish his article and the points in it that Gubler, in particular, had disputed, Benjamin revised it, and this second version appeared on July 30, 1933, under the pseudonym Detlef Holz.

Several passages from the first version were cut, the references to differences between Wölfflin and Riegl toned down, and the ending, quoted above, was replaced by the following: "That is what ensures the contributors to this new yearbook their place in the movement that, from Burdach's Germanistic studies to the Warburg Library's work on the history of religions, is today breathing new life into the frontier regions of historical science." (Both versions of the review are published under the title "Strenge Kunstwissenschaft," 363–74; see also pp. 652–60, for Carl Linfert's long letter and Benjamin's reply. An English translation of the first version of the review can be found in Benjamin, *Selected Writings*, 666–70.)

52. Schapiro, "On Geometrical Schematism in Romanesque Art," 283.

53. Schapiro, "The Romanesque Sculpture of Moissac," 131–132.

54. Schapiro, "On Some Problems in the Semiotics of Visual Arts: Field and Vehicle in Image-Signs."

55. Schapiro, "The New Viennese School."

56. In a review of the Salon of 1926, Focillon wrote: "Art is not the vague instinct of a dream about the subject, or of a hazardous representation of it, it is system, it is order. One of the best-known forms of historical genius at the start of the twentieth century,

and one of the most abundantly commented-on, is cubism. . . . Who cares about the particular nature of the technical means employed to grasp the interaction of the three spatial dimensions and the rhythm of the inner life, if the outcome has the charm or eloquence of the painted form? . . . There is the cubism of Gleizes and the cubism of Picasso: the latter was nothing but the temporary nourishment of a style . . . there is the tone of an age, its language, or, rather, its grammar" ("Les Salons de 1926").

57. The first volume of Cassirer's book, on language, appeared in 1923, the second, on mythic thought, in 1924. The third, on the phenomenology of knowledge, was not published until 1929, that is, after Panofsky's essay. The third volume, however, contains most of the material of interest to the art historian, on the form of knowledge constituted by the perspective geometry of Quattrocento Italy.

58. Panofsky, *Perspective as Symbolic Form*, 65.

59. Ibid., 62.

60. Ibid., 70. A comment by Schmarsow on Rintelen's theories that the Assisi frescoes represented a stage in the progression towards the Renaissance ides of space could be applied equally well to Panofsky's attitude: "[his] views on art . . . are born of familiarity with the renaissance and accord with the strictures of renaissance specialists such as Fiedler, Hildebrand and Marées, and also their belief that the 'clarity and logic of the visible' is the ultimate goal of all art, without distinction of periods and styles, without distinction even of the different arts" (Schmarsow, *Kompositionsgesetze der Franzlegende in der Oberkirche zu Assisi*, 136).

61. Panofsky, *Perspective as Symbolic Form*, 54.

62. Ibid., 139.

63. Pächt, "Gestaltungsprinzipien der westlichen Malerei," 18.

64. Ibid., 21.

65. Ibid., 26.

66. Ibid., 34.

67. Ibid., 34.

68. Panofsky, *Perspective as Symbolic Form*, 70.

69. Panofsky, *Die deutsche Plastik des elften bis dreizehnten Jahrhunderts*, 29.

70. Panofsky, *Perspective as Symbolic Form*, 151–152.

71. Aloïs Riegl used the concept of "composition in the mass" (*Massenkomposition*) to designate "planimetric symmetry with multiple axes," such as is found in snow crystals or even, in Riegl's words, "the composition of several individual elements within a greater unity." Gottfried Semper used the terms "mass effect" (*Massenwirkung*) and "mass resistance" (*Massenwiderstand*); the concept as used by Riegl is disputed by Schmarsow in *Grundbegriffe der Kunstwissenschaft*.

72. Panofsky, *Perspective as Symbolic Form*, 52.

73. Panofsky, *Die deutsche Plastik des elften bis dreizehnten Jahrhunderts*, 9.

74. Panofsky, *Perspective as Symbolic Form*, 61.

75. Ibid., 150n71.

76. Ibid., 54.

77. Ibid., 153.

CHAPTER THREE

1. Chevalier, *Les bonnes villes de France du XIVe au XVIe siècle*, 256.

2. In his *Rationale*, Guillaume Durand says that the casket (*capsa*) "in which the consecrated host is kept, signifieth the frame [body] of the blessed Virgin . . . [w]hich sometimes is of wood: sometimes of white ivory: sometimes of silver: sometimes of gold: sometimes of crystal: and according to its different substances of which it is made, designateth the various dignities of the body of Christ" (*The Symbolism of Churches and Church Ornaments*, 56 [part 1, chapter 3, §25]).

3. Francis of Assisi, *His Life and Writings as Recorded by His Contemporaries*, 168–69. (This work uses Ronald Knox's version of quotations from the Gospels.)

4. Source unknown.

5. In an article written in 1955, Pierre Francastel attempted to deny the influence of St. Francis in two areas of Italian art: iconography and sentiment ("L'art italien et le rôle personnel de saint François," 365ff). It is useful to distinguish these two areas. If it is true that Sienese altarpieces provided models for the very conception of an icon of the saint uniting his effigy and his *historia*, which was then adopted for St. Francis, it is no less true that the models in question depicted "historical" saints, such as John the Baptist, Mary Magdalene, Peter, and Zenobia. When adopted for a contemporary saint, the schema assumes a completely new value. Secondly, Francastel was right to say that the new kind of religious feeling instigated by the example of St. Francis does not in itself account for the art of either Cimabue or Giotto. Both were affected by the upheavals in Roman art at the end of the Duecento; their access to the art of classical antiquity allowed them to be influenced by that style. What counts even more in this context, however, is that in Giotto's case, this appropriation of a language was put at the service of a new iconography. The utilization of the heritage of classical sculpture, in the instances of the altarpieces of the 1230s and of Giotto's frescoes, was destined to give the nascent Franciscan tradition the foundation of a formal legitimacy, a true *exemplum*. See Krüger, *Der frühe Bildkult des Franziskus in Italien*.

6. See also Auerbach, *Mimesis*, chapter 9.

7. St. Bonaventure, *The Life of Our Lord Jesus Christ*, 32–33.

8. Ibid., 191–92.

9. *"Proprie vero est arca in qua reconditur sanctorum reliquie"* ("Strictly speaking, it is a casket which contains relics of saints") (Du Fresne Du Cange, *Glossarum mediae et infirmae latinitatis*, 2, 144). Guillaume Durand gives two terms for reliquaries: *capsae* and *phylatteria*. The latter is "a vessel of silver or gold, or crystal, or ivory, or some substance of the same kind, in which the ashes or relics of the saints are kept" (*The Symbolism of Churches and Church Ornaments*, 57 [part 1, chapter 3, §26]).

10. From *orenda*, denoting an invisible magic power believed by some native North Americans to pervade all natural objects as spiritual energy (translator's note: with acknowledgements to the *Oxford English Dictionary*, 2nd ed.).

11. "Mercy and truth are met together; righteousness and peace have kissed each other. / Truth shall spring out of the earth; and righteousness shall look down from heaven."

12. Brown, *The Cult of the Saints*, 78.

13. "De iride seu de iride et speculo," in Grosseteste, *Die philosophischen Werke*, 72.

14. Passages from Plotinus's *Enneads* are cited after André Grabar, *Les origines de l'esthétique médiévale*. The translations and paraphrases given here are from Grabar's French versions.

15. Plotinus, *Enneads* 2.8–1.

16. Ibid., 2.4–5.

17. Ibid., 1.6–9.

18. Pseudo-Dionysus, "The Celestial Hierarchy," 146.

19. See Hedwig, *Sphaera lucis*, 162–63, 171–72.

20. Ibid., 168.

21. Aquinas, *The "Summa Theologica" of Thomas Aquinas*, vol. 3, 265 (first part, question 91, article 3).

22. See Bacon, "Optical Science," 451–52.

23. See Baeumker, *Witelo*, 79, 132, 142, 151–52, 477, 615, 624.

24. Source not identified.

25. Bacon, "Optical Science," 473–85.

26. Ibid., 497–99.

27. Bacon, "Tractatus fratris Rogeri Bacon de Multiplicatione specierum," 492–93.

28. Eckhart, *German Sermons and Treatises*, 1, 288. The translator, M. O'C. Walshe, points out that *himel* (like the modern German *Himmel*) means sky as well as heaven.

29. Ibid., 2, 104.

30. Nicholas of Cusa, *The Vision of God*, 3.

CHAPTER FOUR

1. Panofsky, *Abbot Suger on the Abbey Church of St-Denis*, 43.

2. Ibid., 99.

3. Pseudo-Dionysius, "The Celestial Hierarchy," 145.

4. Panofsky, *Abbot Suger on the Abbey Church of St-Denis*, 47.

5. Ibid., 47.

6. Ibid., 47–49.

7. Ibid., 49–51.

8. Ibid., 51–53.

9. Ibid., 101.

10. Ibid., 105.

11. After 1 Corinthians 3:10–11.

12. Quoted in Duby, in *Saint Bernard: L'art cistercien*, 94.

13. Kunst, "Freiheit und Zitat in der Architektur des 13. Jahrhunderts—Die Kathedrale von Reims."

14. See Paris, *Chronicles of Matthew Paris*, especially 14–15.

15. Gervase of Canterbury, *Of the Burning and Repair of the Church of Canterbury*, 8.

16. Quotations from Viollet-le-Duc from here to the end of the chapter come from the articles "Peinture" and "Vitrail," in the *Dictionnaire raisonné de l'architecture*, vols. 7 and 9, respectively.

17. In another place in his treatise, Presbyter prescribes taking "particles of clear sapphire" (*parcellae saphiri clari*) to make hyacinths (in the sense of a blue stone). The blue Suger praised so highly was not a pale shade but dark, and the windows in the choir of Saint-Denis would never have served to illustrate the "orgy of neo-platonic [*sic*] metaphysics of light" of which Panofsky speaks.

18. See, for example, Hugh of Saint-Victor, *L'Art de lire*, 194.

CHAPTER FIVE

1. There were three reasons for having the crucifix on the altar, according to Honorius of Autun: "Firstly because our King's standard is placed in the house of God as in the capital city to be adored by the soldiers; secondly, in order that Christ's Passion be always present before the eyes of the Church; thirdly, in order that Christian people imitate Christ, crucifying their flesh for its vices and concupiscence" ("*Gemma animae*"). See also Keller, "Zur Entstehung der sakralen Vollskulptur in der ottonischen Zeit," 72.

2. Abelard, *Abelard & Heloise*, 204.

3. From the Middle English of *The Vernon Manuscript*, chapter 11. Cf. Aelred of Rievaulx, *De institutione inclusarum*, 35.

4. The term *crucifixerunt* is from the Vulgate, the Latin Bible.

5. Acts 5:30 and 10:39–40.

6. Suso, *Little Book of Eternal Wisdom*, 118.

7. St. Bonaventure distinguishes four different kinds of light: the exterior light that illumines a work of man's hands, for example; the inferior light of knowledge obtained through the senses; the interior light of philosophical knowledge; and the superior light of grace (*Opera omnia*, vol. 2, 317–26).

8. These three steps correspond, to some extent, to St. Augustine's three categories of visions. They are also found in St. Thomas Aquinas (*oratio, meditatio, contemplatio*); see Chatillon, "Prière."

9. "Should any image or any *likeness* remain in you, you would never be one with God," says Meister Eckhart (*German Sermons and Treatises*, 1, 66–67).

10. "[W]hatever is conveyed inwards by the senses of images and forms does not give light to the soul, but merely prepares and purifies the soul so that in her highest part she may receive unveiled the angel's light and, with it, God's light" (Ibid., 1, 279).

11. Suso, *Life of the Servant*, 49.

12. Ibid., 104.

13. Ibid., 106–7.

14. In both cases, the image's suggestive power can assist the mental effort, so long as it does not come between the devotee and the end he pursues. All experiences of this kind, those of Rhenish mystics and those of the Eastern world alike, show that there are two ways for the spirit to achieve enlightenment: either by creating a void by expelling all images from the spirit or by occupying it continually by the same image—it may be something visual or a word, a mantra—which will end by producing the "void."

15. This is the case with an early-sixteenth century crucifix in the Schweizerisches Landesmuseum in Zurich, and one in the museum in Döbeln in Saxony (see Taubert, "Mittelalterliche Kruzifixe mit schwenkbaren Armen").

16. Even in the religious dramas acted in Germany in the fifteenth and sixteenth centuries, many roles were still played by clerics; in the Bolzano Passion Play of 1495, six of the apostles were played by priests (see Kully, "Le drame religieux en Allemagne: une fête populaire").

17. Manuscript reprinted in Fowler, J. T., ed. *Surtees Society*. Vol. CVII, *Rites of Durham* (Durham, 1902).

18. Again, this undermines Solange Corbin's thesis that the *Depositio* was not developed dramatically. It is true that she acknowledged not having explored German-language sources.

19. Mâle, *Religious Art in France, The Thirteenth Century*, 3ff.

20. Suso, *The Life of the Servant*, 64.

21. The *imitatio* practiced by Suso is an extreme instance of identification, that is, resorption of all distance, both temporal and spatial. In such a case, memory has no further raison d'être, because the mystical experience places the subject in a perpetual present. But if this *imitatio* is to reach its tragic conclusion, the successive stations must be followed, along the course prescribed by the layout of the cloister and conventual buildings.

22. Source unidentified.

23. Panofsky, *Abbot Suger on the Abbey Church of St-Denis*, 75.

24. Source unidentified.

25. Legrand, *Archiloge Sophie*, 145.

26. Gnudi, Cesare, "Le jubé de Bourges et l'apogée du 'classicisme' dans la sculpture de l'Île de France au milieu du XIIIe siècle."

27. Gnudi, in "Le jubé de Bourges," saw fit to single out the two figures of St. James the Less and his neighbor from the rest of the Cluny group of apostles, finding the adumbration of a kind of "Alexandrianism" in them. There are perhaps stylistic differences, but parallels are to be found in this "Parisian style." For evidence, one should compare the Angel of the Nails from the central portal of Notre Dame of Paris (fig. 65) with the apostle holding the consecrated wafer in his left hand, still at La Sainte-Chapelle (fig. 66).

28. See John of Garland, *The* Parisiana poetria *of John of Garland*, 86–87.

29. Source unidentified.

30. Pseudo-Aristotle, "Physiognomonica."

31. That this smile could be attributed to angels is not surprising to anyone familiar with the descriptions of angels, in literature for example, as figures possessing an ideal beauty (see Neubert, "Die volkstümlichen Anschauungen über Physiognomik in Frankreich bis zum Ausgang des Mittelalters," 578f.). But at Reims the smile is not confined to angels. The question of intentionality and the ideal recipient was raised by Flach in *Die Psychologie der Ausdrucksbewegung*, 98ff.

32. See Weise, *Die geistige Welt der Gotik*, 447ff. Weise cites examples such as "vos debonaire vis / ke je vix si riant et cler" and "Le visage ot roont et les iex vairs, rians, / Bouche brief et petite, les dens clers et rians. . . . "

33. Fastening a cloak by means of a cord or leather strap attached to tasseled ornaments fixed to the two edges is found already on carvings at Laon, Angers, Sens, and so forth, and was general practice by the 1220s.

34. Alberti, *On Painting and On Sculpture*, 87.

35. Warburg, *Gesammelte Schriften*, 1, 19. See also Gombrich, *Aby Warburg*, 61.

CHAPTER SIX

1. In 1300, quantities of plaster and wax were ordered "for making the models of heads for the said chamber." Seven years later tin crowns were put on the heads, and in 1316 glass was bought "to make enamels of the said heads." Mahaut had a replica of the gallery made for her own chamber (see Richard, *Une petite nièce de saint Louis*, 331–43).

2. There is a similar contrast of the value of a written text and a pictorial representation in the celebrated portrait of Erasmus engraved by Dürer. The Latin inscription says the portrait is from life (*ad vivum*), but the Greek inscription claims that Erasmus's writings leave a more faithful portrait of him (see Panofsky, *The Life and Art of Albrecht Dürer*, 239–40).

3. See Thomas Aquinas, *The "Summa Theologica" of St. Thomas Aquinas*, vol. 20, 66–67 (third Part, supplement, question 71, article 11).

4. Ibid., 121 (question 75, article 1).

5. Ibid., 66 (question 71, article 11).

6. Durand, *The Symbolism of Churches and Church Ornaments*, 82.

7. From the moment when the slab and the *gisant* were cut from different materials, polychromy was reduced to an ancillary role, serving to emphasize certain details or display heraldic bearings.

8. See Thomas Aquinas, *The "Summa Theologica" of St. Thomas Aquinas*, vol. 20, 186ff. (third part, supplement, question 81, articles 1–3).

9. Source unknown.

10. The earliest *gisants* with closed eyes are not encountered in France before the first half of the fourteenth century; the head, which is assumed to be that of Robert de Jumièges, may be earlier than that of Bishop Guillaume de Chanac (d. 1343) in the Louvre.

11. G. S. Wright ("A Royal Tomb Program in the Reign of St. Louis") gives priority to the part played by the abbey of Saint-Denis, and considers St. Louis's role to have been a minor one. I think this hypothesis is more probable than the more widespread belief that St. Louis was the instigator of the program of royal tombs (see, for a recent example, Le Goff, *Saint Louis*).

12. Already in the fourth century, Ammianus Marcellinus described Constantius II in terms appropriate for a statue (see also Castelnuovo, *Portrait et société dans la peinture italienne*, 9).

13. Rousseau, *Émile or On Education*, 144.

14. See also in chapter 3, p. 105, and chapter 5, notes 9 and 10.

15. Weise, *Die geistige Welt der Gotik*, 69, 75–76.

16. The term *pleurant* (weeper) is better attested in contemporary sources than the alternative *deuillant* (mourner).

17. *Steinguss* can be translated literally as "cast stone," but the question of how this artificial material was actually made is still the subject of discussion, probably because techniques varied. In the majority of cases, there was a mortar of plaster mixed with sand, which could be molded in the form of blocks to be carved, or molded entirely according to the shape of a wax model (see Koller, "Bildhauer- und Maler-Technologische Beobachtungen zur Werkstattpraxis um 1400 anhand aktueller Restaurierungen").

18. This conception of a figure formed from two interchangeable halves says a lot about the unilateral angle from which the plastic object would be viewed, predominant in the art of this period.

19. This raises the question of an image's cultural function and value, as well as its ideological function. Types, even if individualized, were thought to transfer the ideological values informing court models. On the cultural model, see Duby, "La vulgarization des modèles culturels dans la société féodale."

20. For a description, publication history and some excerpts, see Dürer, *The Writings*, 227–61.

21. Leonardo da Vinci, *The Literary Works*, vol. 1, 303 (precepts 484 and 486).

22. Alberti, *On Painting and On Sculpture*, 101.

23. Vasari, *Vasari on Technique*, 144.

24. It is apposite to recall Goethe's distinction between the three levels of artistic representation: simple imitation of nature, manner, and style—the highest of the degrees to which the greatest artists aspired (*Einfache Nachahmung der Natur, Manier, Stil*).

25. This is what explains the choice of the bust as a universal form. We should recall that the Renaissance in southern Europe turned, like the Middle Ages, to the physiognomic types bequeathed by antiquity. Aby Warburg was the first to confirm this in "Dürer und die italienische Antike."

26. Most images in the iconography of medieval lodges or workshops show sculptors working alone. There are a few, however, which depict more than one person busy on the same work: a manuscript from the early fourteenth century shows two workmen cutting the stone panels for a tomb (London, British Library, Ms.Add.10292, fol.55v); the window depicting the legend of St. Chéron at Chartres (1220–1225) shows stonecutters and sculptors at work, with the former cutting the stone and the latter apparently examining the work in progress; the *Vita S. Augustini* (ca. 1460) from Constance shows three sculptors at work on the *gisant* of a bishop. In a manuscript in Munich (Bayerisches Nationalmuseum, Ms.2502), a stonecutter is seen executing the *gisant* of a king with the aid of a model in the presence of the client and his attendants.

27. Other types of collaboration can be envisaged; the tympanum of the Coronation of the Virgin on the south transept of Strasbourg Cathedral shows that two sculptors worked on the same block of stone, the more proficient having executed the central group, and a much less experienced one (no doubt of a different generation) the censer-bearing angels. But it is by no means certain that their contributions were successive: they could have been simultaneous, as at Orvieto (White, "The Reliefs on the Façade of the Duomo at Orvieto").

CONCLUSION

1. Vasari, *Vasari on Technique*, 83.

2. Ibid., 82–83.

3. Vitruvius, *Vitruvius on Architecture*, vol. 2, 105 (book 7, chapter 5).

4. Philippians 2:7–8. Cited in Auerbach, *Literary Language and Its Public in Late Latin Antiquity and in the Middle Ages*, 41. The essentials of the discussion of *sermo humilis* are taken from this important essay.

5. Translator's note: this passage is translated from the French as quoted by Roland Recht from an unidentified source. The original source is in St. Irenaeus's *Epideixis* §34 (*Demonstration of the Apostolic Preaching*).

6. *The Book of Sainte Foy*, 78.

7. The sermon is undated, but a reference to the number of abbeys subject to the diocese gives their number as twenty-six, so it cannot be earlier than 1276 (see Zink, *La prédication en langue romane avant 1300*, 206ff.). Although the essential construction

was completed by that date, work still continued on decorating the cathedral, including, notably, the installation of stained-glass windows. Stephen Murray, who appears not to know Zink's work, seeks to establish a concordance between the sermon and the cathedral's iconographic program, proceeding from the hypothesis that the sermon was preached in the cathedral itself (Murray, *Notre-Dame Cathedral of Amiens*, 116–17).

# BIBLIOGRAPHY

*Translator's note.*  In the original French edition of *Believing and Seeing*, each chapter was accompanied by generous reading lists with some annotation, but without a complete apparatus of notes supplying bibliographical data for the bulk of the citations and references in the text.

It did not prove feasible to construct that kind of apparatus in full, in retrospect, for this translation. This first of two bibliographical lists details the published sources cited in the footnotes of this edition, including published English translations of sources originally in other languages. Where no such English source is specified, the translations in the text were done by myself, from the original sources listed below or from the French and Latin, as cited by Roland Recht. Some of the sources cited substantively in the text are also included in this list.

The second list is based on the *Orientations bibliographiques* in the French edition, which details titles mentioned in the text but not included in the Works Cited, as well as other relevant material.

I am indebted to Christine Y. Hahn and Stacy Hand, graduate students in art history at the University of Chicago, for their help in the hunt for sources.

*Mary Whittall, July 2005*

Abelard, Peter, and Heloïse. *Abelard & Heloise: The Letters and Other Writings.*
    Translated by William Levitan. Indianapolis, IN: Hackett Publishing Co., 2007.
Abraham, Pol. *Viollet-le-Duc et le rationalisme médiévale.* Paris: Ancienne Maison
    Auguste Vincent; Vincent Fréal et cie, successeurs. 1934.
Aelred of Rievaulx. *De institutione inclusarum: Two English Versions.* Edited by
    John Ayto and Alexandra Barratt. Early English Text Society, no. 287. London:
    Oxford University Press, 1984.

Alberti, Leon Battista. *On Painting and On Sculpture: The Latin texts of* De Pictura *and* De Statua. Edited and translated by Cecil Grayson. London: Phaidon, 1972.

Aristotle. See Pseudo-Aristotle.

Auerbach, Erich. *Literary Language and its Public in Late Latin antiquity and in the Middle Ages.* Translated by Ralph Manheim. London: Routledge & Kegan Paul, 1965. Originally published as *Literatursprache und Publikum in der lateinischen Spätantike und im Mittelalter* (Berne: Francke Verlag, 1958).

———. *Mimesis: The Representation of Reality in Western Literature.* Translated by Willard Ropes Trask. Princeton, NJ: Princeton University Press, 1953.

Bacon, Roger. "Optical Science" ["De Scientia Perspectiva"]. In vol. 2 of *The Opus Majus of Roger Bacon; A Translation by Robert Belle Burke*, 419–582. 2 vols. [continuous pagination]. Philadelphia: University of Pennsylvania Press, 1928.

———. *The "Opus Majus" of Roger Bacon.* Edited by John Henry Bridges, 3 vols. Oxford: Clarendon Press, 1897.

———. "Pars Quinta, De Scientia Perspectiva." In vol. 2 of *The "Opus Majus" of Roger Bacon*, 1–166. Edited by John Henry Bridges. 3 vols. Oxford, Clarendon Press, 1897.

———. "Tractatus fratris Rogeri Bacon de Multiplicatione specierum." In *The Opus Majus of Roger Bacon; A Translation by Robert Belle Burke.* 2 vols. [continuous pagination]. Philadelphia: University of Pennsylvania Press, 1928.

Baeumker, Clemens. *Witelo. Ein Philosoph und Naturforscher des XIII. Jhs:* Beiträge zur Geschichte der Philosophie des Mittelalters, III, 2. Münster: Druck und Verlag der Aschendorffschen Buchhandlung, 1908.

Baltrusaïtis, J. *La Stylistique ornamentale dans la sculpture romane.* Paris: Librairie Ernest Jeroux, 1931.

Benjamin, W. "Strenge Kunstwissenschaft." In W. Benjamin, *Gesammelte Schriften*, 3, 363–74. Edited by H. Tiedemann-Bartels. Frankfurt am Main: Suhrkamp, 1972.

———. *Selected Writings*, 2, 666–70. Cambridge, MA: Belknap Press, 1999.

Benoit de Sainte-Maure. *Le Roman de Troie.* Société des anciens textes français, 6 vols. Paris, 1904.

Bergson, Henri. *Creative Evolution.* Translated by Arthur Mitchell. Westport, CT: Greenwood Press, 1975, c. 1939. Originally published as *L'Évolution créatrice* (Paris, 1907).

Bernard of Angers. See *Book of Sainte Foy* and *The Song of Sainte Foy.*

Bonaventure. *The Life of Our Lord Jesus Christ from the Latin [Meditationes vitae Christi].* Dublin: J. Christie, 1821.

————. *Opera omnia. Edita studio et cura PP. Collegii a S. Bonaventura.* 4 vols. Quaracchi: Ex typographia Collegii S. Bonaventurae, 1882–1902.

*The Book of Sainte Foy.* Translated by Pamela Sheingorn. Philadelphia: University of Pennsylvania Press, 1995.

Brown, Peter. *The Cult of the Saints: Its Rise and Function in Latin Christianity.* Chicago: University of Chicago Press, 1981.

Castelnuovo, E. *Portrait et société dans la peinture italienne.* Translated by S. Darses. Paris, [1973] 1993.

Chatillon, J. "Prière", in *Dictionnaire de spiritualité ascétique et mystique: Doctrine et histoire,* 12, ii. Paris: 1986, coll. 2271ff.

Chevalier, Bernard. *Les bonnes villes de France du XIVe au XVIe siècle.* Paris: Aubier Montaigne, 1982.

————. *Le Chevalier au barisel: conte pieux du XIIIe siècle.* Edited by Félix Lecoy. Classiques français du Moyen Age, no. 82. Paris: Honoré Champion, 1955.

Clasen, Karl Heinz. *Der Meister der schönen Madonnen: Herkunft, Entfaltung, Umkreis.* Berlin, New York, 1974.

Corbin, Solange. *La Déposition liturgique du Christ au vendredi sain: Sa place dans l'histoire des rites et du théâtre religieux.* Paris, Lisbon, 1960.

Dilthey, Wilhelm. *Der Aufbau der geschichtlichen Welt in den Geisteswissenschaften. Gesammelte Schriften,* 7. Leipzig, Berlin: B. G. Teubner, 1927.

Dionysus. See Pseudo-Dionysus.

Duby, Georges. *Saint Bernard: L'art cistercien,* Paris: Flammarion, 1976.

————. "La vulgarisation des modèles culturels dans la société féodale" (1967). In *Hommes et structures du Moyen Age: Recueil d'articles.* Le savoir historique, no. 1. Paris, The Hague: Mouton, 1973.

Du Fresne Du Cange, C. *Glossarum mediae et infirmae latinitatis.* Edited by P. Le Favre. Paris, 1883–87.

Durand, Guillaume. *The Symbolism of Churches and Church Ornaments; A Translation of the First Book of the* Rationale Divinorum Officiorum, written by William Durandus, with an introductory essay and notes by J. M. Neale and B. Webb. 2nd ed. London: Scribner, 1893.

Dürer, Albrecht. *The Writings.* Edited and translated by William Martin Conway. New York: Philosophical Library, 1958.

Dvorak, Max. *The History of Art as the History of Ideas.* Translated by John Hardy. London: Routledge Kegan Paul, 1984.

————. *Idealism and Naturalism in Gothic Art.* Translated by R. J. Klawiter. Notre Dame, IN: University of Notre Dame Press, 1967.

Eckhart, Meister. *German Sermons and Treatises.* Edited and translated by M. O'C. Walshe. 2 vols. London, Dulverton: Watkins, 1979–81.

Flach, A. *Die Psychologie der Ausdrucksbewegung.* Vienna, 1928.

Focillon, Henri. *L'Art des sculpteurs romans: Recherches sur l'histoire des formes.* Paris: Librairie Ernest Leroux, 1931.

———. *The Art of the West in the Middle Ages.* Edited and introduction by Jean Bony. Ithaca, NY: Cornell University Press, 1980. Originally published as *L'Art d'Occident: le Moyen Âge roman et gothique* (Paris, 1938).

———. *The Life of Forms in Art.* Translated by Charles B. Hogan and George Kubler. New York: Zone Books, 1989. Originally published as *La Vie des formes* (Paris: PUF, 1934).

———. "Le problème de l'ogive." *Recherche* 1 (1939): 5–28.

———. "Les Salons de 1926." *Gazette des beaux-arts*, 68 (1962): 257–80.

Francastel, Pierre. "L'art italien et le rôle personnel de saint François." In *La Réalité figurative: éléments structurels de sociologie de l'art.* Paris, 1965.

Francis of Assisi. *His Life and Writings as Recorded by His Contemporaries: A New Version of* The Mirror of Perfection *Together with a Complete Collection of All the Known Writings of the Saint.* Translated by Leo Shirley-Price. London: Mowbray, 1959.

Frankl, Paul. *The Gothic: Literary Sources and Interpretations through Eight Centuries.* Princeton, NJ: Princeton University Press, 1960.

———. *Zu Fragen des Stils.* Leipzig, 1988.

Frey, Dagobert. *Gotik und Renaissance als Grundlagen der modernen Weltanschauung.* Augsburg: Filser, 1929.

———. *Kunstwissenschaftliche Grundfragen.* Vien: R. M. Rohrer, 1946.

Garger, E. von. "Über Wertungsschwierigkeiten bei mittelalterlicher Kunst." *Kritische Berichte*, 5 (1932–33): 97ff.

Gauthey, Emiland-Marie. *Mémoire sur l'application des principes de la méchanique à la construction des voûtes et des dômes, dans lequel on examine . . . la coupole de l'Église Ste-Geneviève de Paris.* Dijon: Frantin, 1771.

Gervase of Canterbury. *Of the Burning and Repair of the Church of Canterbury in the Year 1174, from the Latin of Gervase, a Monk of the Priory of Christ Church, Canterbury.* Edited by Charles Cotton. *Canterbury Papers.* 2nd ed., no. 3. Cambridge: Friends of Canterbury Cathedral and Cambridge University Press, 1932.

Gnudi, Cesare. "Le jubé de Bourges et l'apogée du 'classicisme' dans la sculpture de l'Île de France au milieu du XIIIe siècle." *Revue de l'art* 3 (1969): 18–36.

Gombrich, Ernst. *Aby Warburg: An Intellectual Biography.* London: Warburg Institute, 1970.

———. "Achievement in Mediaeval Art." In *Meditations on a Hobby Horse and Other Essays on the Theory of Art*, 70–77. London: Phaidon Press, 1963. Originally published as "Wertprobleme und mittelalterliche Kunst." *Kritische Berichte* 6 (1937): 109ff.

Grabar, André. *Les origines de l'esthétique médiévale.* La littérature artistique. Paris: Macula, 1992.

Gropius, Walther. *Bauhaus 1919–1928.* Edited by Herbert Bayer, Walter Gropius, and Ise Gropius. New York: The Museum of Modern Art, 1938; repr. ed., New York: Arno Press, 1972.

Grosseteste, Robert. *Die philosophischen Werke . . . zum erstenmal vollständig in kritischer Ausgabe.* Edited by L. Baur. Münster, 1912.

Hedwig, Klaus. *Sphaera lucis: Studien zur Intelligibilität des Seienden im Kontexte der mittelalterlichen Lichtspekulation.* Beiträge zur Geschichte der Philosophie und Theologie des Mittelalters NF, no. 18. Münster, 1980.

Heyman, Jacques. "Beauvais Cathedral." *Transactions of the Newcomen Society* 40 (1967–68): 15–35.

Honorius of Autun. *"Gemma animae," Patrologia Latina.* Vol. 172, c. 587a.

Hugh of Saint-Victor. *L'Art de lire: Didascalicon.* Paris, 1991. Translated by M. Lemoine as *Didascalicon: A Medieval Guide to the Arts.* Edited by Jerome Taylor. New York: Columbia University Press, 1961.

Jantzen, Hans. *High Gothic.* Translated by James C. Palmes. London: Constable, 1962. Originally published as *Kunst der Gotik. Klassische Kathedralen Frankreichs: Chartres, Reims, Amiens* (Hamburg: Rowohlt, 1957).

———. *Ottonische Kunst.* Munich: Münchner Verlag 1947.

———. "Über den gotischen Kirchenraum." In *Über den gotischen Kirchenraum und andere Aufsätze,* 7–21. Berlin: Gebrüder Mann, 1951.

John of Garland. *The* Parisiana poetria *of John of Garland.* Edited with introduction, translation, and notes by Traugott Lawler. Yale Studies in English, no. 182. New Haven, CT: Yale University Press, 1974.

Keller, H. "Zur Entstehung der sakralen Vollskulptur in der ottonischen Zeit." In *Festschrift für Hans Jantzen.* Berlin: Gebrüder Mann, 1951.

Koller, M. "Bildhauer- und Maler-Technologische Beobachtungen zur Werkstattpraxis um 1400 anhand aktueller Restaurierungen." *Kunsthistorisches Jahrbuch* 24 (1990): 135–61.

Krüger, K. *Der frühe Bildkult des Franziskus in Italien. Gestalt und Funktionswandel des Tafelbildes im 13. und 14. Jahrhundert.* Berlin: Gebrüder Mann, 1992.

Kubler, George. "A Late Gothic Computation of Rib Vault Thrusts." *Gazette des beaux-arts* 26 (1944): 134–48.

———. *The Shape of Time: Remarks on the History of Things.* New Haven, CT: Yale University Press, 1962.

Kully, R.M. "Le drame religieux en Allemagne: une fête populaire." In *La culture populaire au Moyen âge: études présentées au quatrième colloque de l'Instut d'Études Médiévales de l'Université de Montréal, 2–3 avril 1977,* 203–30. Edited by Pierre Boglioni. Montreal: L'Aurore, 1979.

Kunst, Hans Joachim. "Freiheit und Zitat in der Architektur des 13. Jahrhunderts—Die Kathedrale von Reims." In Karl Clausberg et al., eds., *Bauwerk und Bildwerk im Hochmittelalter. Anschauliche Beiträge zur Kultur- und Sozialgeschichte.*

Kunstwissenschaftliche Untersuchungen des Ulmer Vereins, Verband für Kunst- und Kulturwissenschaft, no. 11. Giessen: Anabas, 1981.

Laugier, Marc-Antoine. *Observations sur l'architecture*. The Hague: DeSaint, 1765.

Le Goff, J. *Saint Louis*. Paris: Gallimard, 1996.

Legrand, Jacques. *Archiloge Sophie: Livre de bonnes meurs*. Edited by Evencio Beltran. Bibliothèque du XVe siècle, no. 49. Paris: Honoré Champion, 1986.

Leonardo da Vinci. *The Literary Works*. Compiled and edited by J. P. Richter. 2 vols. 3rd ed. New York: Phaidon, 1970.

Lorris, Guillaume de, and Jean deMeun. *Le Roman de la Rose*. Publié par Félix Lecoy. Classiques français du Moyen Age, nos. 92, 95, 98. Paris: Champion, 1965–70.

Mâle, Émile. *Religious Art in France, the Thirteenth Century: A Study of Medieval Iconography and Its Sources* Translated from the 9th ed. by M. Mathews. Princeton, NJ: Princeton University Press, 1958. Originally published as *Art religieux du XIIIe siècle en France* (Paris: Librairie Armand Colin, 1925).

Masson, H. "Le rationalisme dans l'architecture du Moyen Âge." *Bulletin monumental*, 94 (1935): 29–50.

Murray, Stephen. *Notre-Dame Cathedral of Amiens: The Power of Change in Gothic*. Cambridge: Cambridge University Press, 1996.

Neubert, F. "Die volkstümlichen Anschauungen über Physiognomik in Frankreich bis zum Ausgang des Mittelalters." *Romanische Forschungen* 29 (1911): 557–679.

Nicholas of Cusa. *The Vision of God [De Visione Dei]*. Translated by Emma Gurney Salter. London, Toronto: J.M. Dent; New York: E.P. Dutton, [1928].

Pächt, Otto. "Gestaltungsprinzipien der westlichen Malerei des 15. Jahrhunderts." In *Methodisches zur kunsthistorischen Praxis: Ausgewählte Schriften*, 17–58. Munich: Prestel-Verlag, 1977.

Panofsky, Erwin, ed. and trans. *Abbot Suger on the Abbey Church of St-Denis and Its Art Treasures*. 2nd ed. Princeton, NJ: Princeton University Press, 1979.

Panofsky, Erwin. *Die deutsche Plastik des elften bis dreizehnten Jahrhunderts*. 2 vols. Munich: K. Wolff, 1924.

———. *Gothic Architecture and Scholasticism*. New York: Meridian Books, 1957.

———. *The Life and Art of Albrecht Dürer*, Princeton, NJ: Princeton University Press, 1943.

———. *Perspective as Symbolic Form*. New York: Zone Books, 1991.

[Paris, Matthew.] *Chronicles of Matthew Paris: Monastic Life in the Thirteenth Century*. Edited, translated, and with an introduction by Richard Vaughan. Gloucester: Alan Sutton; New York: St. Martin's Press, 1984.

[Patrologia Latina]. *Patrologiae cursus completus. Series Latina*. Edited by J.-P. Migne and A.-G. Hamman. Paris: Garnier Frères, 1958–.

Petzet, Michael. *Soufflots Sainte-Geneviève und der französische Kirchenbau des 18: Jahrhunderts*. Berlin: Walter de Gruyter & Co., 1961.

Pseudo-Aristotle. "Physiognomonica." In *Opuscula*, Vol. 6 of *The Works of Aristotle translated into English under the editorship of J. A. Smith and W. D. Ross*, 804–14. Oxford: Clarendon Press, 1913.

Pseudo-Dionysius. "The Celestial Hierarchy." In *The Complete Works*. Translated by Colm Luibheid, foreword, notes, and translation collaboration by Paul Rorem. Mahwah, NJ: Paulist Press, 1987.

Richard, J. M. *Une petite nièce de saint Louis: Mahaut, comtesse d'Artois et de Bourgogne 1302–1329. Étude sur la vie privée, les arts et l'industrie en Artois et à Paris au commencement du XIVe siècle*. Paris, 1887.

Riegl, Aloïs. *Problems of Style: Foundations for a History of Ornament*. Translated by Evelyn Kain. Princeton, NJ: Princeton University Press, 1992. Originally published as *Stilfragen: Grundlegungen zu einer Geschichte der Ornamentik* (Berlin: George Siemans, 1893).

*Le Roman de la Rose* [by] Lorris, Guillaume de, and Jean de Meun. Publié par Félix Lecoy. Classiques français du Moyen Age, nos. 92, 95, 98. Paris: Champion, 1965–70.

Rousseau, Jean-Jacques. *Émile or On Education*. Introduction, translation, and notes by Allan Bloom. New York: Basic Books, 1979.

Sauerländer, Willibald. *Gothic Sculpture in France 1140–1270*. Translated by Janet Sandheimer. New York: H. N. Abrams, 1972. Originally published as *Gotische Skulptur in Frankreich, 1140–1270* (Munich: Hirmer, 1970).

———. "Die Naumburger Stifterfiguren. Rückblicke und Fragen." In *Die Zeit der Staufer. Geschichte—Kunst—Kultur* [exhibition catalog] (Stuttgart, Altes Schoss und Kunstgebaude, 26.März–5.Juni 1977). Edited by R. Haussherr. 5 vols. Stuttgart: Württembergisches Landesmuseum, 1977–79.

Schapiro, Meyer. "The New Viennese School." *The Art Bulletin* 18 (1936): 258–66.

———. "On Geometrical Schematism in Romanesque Art (1932)." In *Romanesque Art*, 265–84. New York: George Braziller; London: Chatto & Windus, 1977. Originally published as "Über den Schematismus in der romanischen Kunst: Jurgis Baltrusaitis, *La stylistique ornamentale dans la sculpture romane*, Paris, Ledoux, 1931" [book review], *Kritische Berichte* 5 (1932–33): 1–21.

———. "On some problems in the Semiotics of Visual Arts: Field and Vehicle in Image-Signs" *Semiotica* 1 (1969): 223–42.

———. "The Romanesque Sculpture of Moissac." In *Romanesque Art*, 131–264. New York: George Braziller; London: Chatto & Windus, 1977. Originally published in *Bulletin of the Providence R.I. College Art Association* 13, nos. 3, 4, etc., (1913–).

Schlosser, Julius von. "Randglossen zu einer Stelle Montaignes." In *Präludien, Vorträge und Aufsätze*. Berlin: J. Bard, 1927.

———. "Zur Genesis der mittelalterlichen Kunstanschauung." In *Präludien, Vorträge und Aufsätze*. Berlin: J. Bard, 1927.

————. "Zur Kenntnis der künstlerischen Überlieferung im späten Mittelalter" [1902]. *Wiener Jahrbuch*, 23 (1903).

Schmarsow, August von. *Grundbegriffe der Kunstwissenschaft am Übergang vom Altertum zum Mittelalter, kritisch erörtert und in systematischem Zusammenhange dargestellt.* Leipzig, Berlin: B. G. Teubner, 1905.

————. *Kompositionsgesetze der Franzlegende in der Oberkirche zu Assisi.* Leipzig: Karl W. Hiersemann, 1918.

Semper, Gottfried. *Kleine Schriften.* Edited by Manfred and Hans Semper. Berlin, Stuttgart: Verlag von W. Spemann, 1884.

————. *Der Stil in den technischen und tektonischen Künsten oder praktische Aesthetik.* 2 vols. 2nd ed. Munich: F. Bruckmann, 1878.

Settis, Salvatore. "Von auctoritas zu vetustas: die antike Kunst in mittelalterlicher Sicht." *Zeitschrift für Kunstgeschichte* 51/2 (1988): 157–79.

————. "Des ruines au musée: La destinée de la sculpture classique." *Annales* 48/6 (1993): 1347–80.

*The Song of Sainte Foy.* Translated by Robert L. A. Clark. In *The Book of Sainte Foy.* Translated by Pamela Sheingorn. Philadelphia: University of Pennsylvania Press, 1995.

Suger. *La Geste de Louis VI et autres oeuvres.* Edited by M. Bur. Paris, 1994.

Suso, Heinrich. *Little Book of Eternal Wisdom and Little Book of Truth.* Translated by James M. Clark. London: Faber & Faber, 1953.

————. *The Life of the Servant.* Translated by James M. Clark. London: James Clarke, 1952.

Taubert, Johannes. "Mittelalterliche Kruzifixe mit schwenkbaren Armen." In *Farbige Skulpturen: Bedeutung, Fassung, Restaurierung*, 38–50. Munich: Callwey, 1978.

Taut, Bruno. *Architekturlehre. Grundlagen, Theorie und Kritik . . . aus der Sicht eines sozialistischen Architekten* [1937]. Edited by T. Heinisch and G. Peschken. Hamburg, Berlin: Verlag für das Studium der Arbeiterbewegung GmbH, 1977.

Thomas Aquinas. *The "Summa Theologica" of St. Thomas Aquinas.* Literally translated by Fathers of the English Dominican Province. 22 vols. London: Burns Oates & Washbourne, 1911–22.

Vasari, Giorgio. *Vasari on Technique, being the introduction to the three arts of design . . . prefixed to the lives . . . by Giorgio Vasari.* Edited by G. Baldwin Brown, translated by Louisa S. Maclehose. London: J. M. Dent, 1907.

*The Vernon Manuscript: A Facsimile of Bodleian Library, Oxford, MS Eng. Poet. a1.* Cambridge: D. S. Brewer, 1987.

Viollet-le-Duc, Eugène-Emmanuel. *Dictionnaire raisonné de l'architecture française du XIe au XVIe siècle*, 10 vols. Paris: B. Bance, 1854–68.

————. *Rational Building.* Translated by George Martin Huss from the article "Construction" in the *Dictionnaire raisonné de l'architecture française du XIe au XVIe siècle.* New York, London: Macmillan, 1895.

Vitruvius. *Vitruvius on Architecture*. Edited and translated by Frank Granger. Loeb Classical Library. 2 vols. Cambridge MA: Harvard University Press; London: William Heinemann, 1931; 1962.

Wallach, R. W. *Über Anwendung und Bedeutung des Wortes Stil*. Munich: E. Reinhardt, 1919.

Warburg, Aby: "Dürer und die italienische Antike" [1906]. In *Ausgewählte Schriften und Würdigungen*, 125-35. Edited by Dieter Wuttke. Saecvla Spiritalia, no. 1. Baden-Baden: Verlag Valentin Koerner, 1979.

———. *Gesammelte Schriften*. Edited by Gertrud Bing and Fritz Rougemont. Leipzig, Berlin: Kunstwissenschaftliche Bibliothek Warburg, 1932ff.

Watkin, David. *Morality and Architecture: The Development of a Theme in Architectural History and Theory from the Gothic Revival to the Modern Movement*. Oxford: Clarendon Press, 1977; Chicago: University of Chicago Press, 1984.

Weise, G. *Die geistige Welt der Gotik und ihre Bedeutung für Italien*. Edited by P. Kluckhorn and E. Rothacker. Deutsche Vierteljahrsschrift für Literaturwissenschaft und Geistesgeschichte, Buchreihe, no. 25. Halle-Saale: N. Niemeyer, 1939.

White, J. "The Reliefs on the Façade of the Duomo at Orvieto." *Journal of the Warburg and Courtauld Institutes* 22 (1959): 254–302.

Wickhoff, Franz. *Roman Art: Some of Its Principles and Their Application to Early Christian Painting*. Translated and edited by S. A. Strong. London: Heinemann, 1900.

———. *Die Schriften Franz Wickhoff*. Edited by M. Dvorak. Berlin, 1912–13.

Wölfflin, Heinrich. "Prolegomena zu einer Psychologie der Architektur" [1886]. In *Kleine Schriften (1886–1933)*, 13–47. Edited by Joseph Gantner. Basle: Benno Schwabe & Co. Verlag, 1946.

———. *Principles of Art History: The Problem of the Development of Style in Later Art*. Translated from the 7th German ed. by M. D. Hottinger. London: Bell & Sons, 1932. Originally published as *Kunstgeschichtliche Grundbegriffe: Das Problem der Stilentwicklung in der neueren Kunst*. 1st ed. 1915.

———. *Renaissance and Baroque*. Translated by Kathrin Simon. London: Collins, 1964. Originally published as *Renaissance und Barock* (Basle: Benno Schwabe & Co, 1961).

Worobiow, N. "Zur Neubegründung des Formalismus. Henri Focillons *Vie des formes*." *Kritische Berichte* 5 (1932–33): 40ff.

Worringer, Wilhelm. *Abstraction and Empathy: A Contribution to the Psychology of Style*. Translated by Michael Bullock. London: Routledge, Kegan Paul, 1953. Originally published as: *Abstraktion und Einfühlung: Ein Beitrag zur Stilpsychologi*. (Munich: Pieper, 1908).

Worringer, Wilhelm. *Formprobleme der Gotik*. Munich: Pieper, 1911.

Wright, Frank Lloyd. *In the Cause of Architecture: Essays by Frank Lloyd Wright for*

*the* Architectural Record *1908–1952*. Edited by Frederick Gutheim. New York: Architectural Record Books, 1975.

Wright, G. S. "A Royal Tomb Program in the Reign of St. Louis." *The Art Bulletin* 56 (1974): 224–43.

Young, Karl. *The Drama of the Medieval Church*. 2 vols. Oxford: Clarendon, 1933.

Zink, Michel. *La prédication en langue romane avant 1300*. Paris: H. Champion, 1976.

CHAPTER ONE

Bandmann, Günther. *Early Medieval Architecture as Bearer of Meaning*. Translated by Kendall Wallis. New York: Columbia University Press, 2005.

Braham, Allan. *The Architecture of the French Enlightenment*. London: Thames & Hudson, 1980.

Crossley, P. "Medieval Architecture and Meaning: The Limits of Iconography." *The Burlington Magazine* 130, no. 1019 (1988): 116–21.

De Bruyne, E. *Études d'esthétique médiévale*. 3 vols. Bruges: De Tempel, 1946.

Eisner, Lotte H. *The Haunted Screen: Expressionism in the German Cinema and the Influence of Max Reinhardt*. Translated by Roger Greaves. London: Thames & Hudson, 1969.

Foucart, B. "La 'cathédrale synthétique' de Louis Boileau." *Revue de l'art* 3 (1969): 49–66.

Francovich, Geza de. "L'origine e la diffuzione del Crocifisso gotico doloroso." *Kunstgeschichtliches Jahrbuch der Biblioteca Hertziana* 2 (1938): 143–261.

Gosebruch, M. [Review of Sedlmayr, *Die Entstehung der Kathedrale*] *Göttingische Gelehrte Anzeigen*, 208th year (1954): 237–77.

Grabar, André. *Martyrium, recherches sur le culte des reliques et de l'art chrétien antiques*. 3 vols. Paris: Collège de France, 1943–1946.

Grodecki, L. [Review of Sedlmayr, *Die Entstehung der Kathedrale*] *Critique* 8, 65 (1952): 847–57.

*Der Hang zum Gesamtkunstwerk. Europäische Utopien seit 1800*. Edited by Suzanne Häni [exhibition catalog]. Aarau, Frankfurt am Main: Sauerländer, 1983.

Herrmann, W. *Laugier and Eighteenth-Century French Theory*. London, 1962.

Jantzen, Hans. *Die Gotik des Abendlandes. Idee und Wandel*. Cologne: DuMont Schauberg, 1962.

Jantzen, Hans. *Das niederländische Architekturbild*. Leipzig: Klinkhardt und Biermann, 1910.

Jantzen, Hans. *Deutsche Bildhauer des dreizehnten Jahrhunderts*. Leipzig: Insel-Verlag, 1925.

Kidson, P. "Panofsky, Suger and St. Denis." *Journal of the Warburg and Courtauld Institutes* 50 (1987): 1–17.

Kimpel, Dieter, and Robert Suckale. *Die gotische Architektur in Frankreich, 1130–1270*. Munich: Hirmer, 1985.

Kracauer, Siegfried. *From Caligari to Hitler: A Psychological History of the German Film*. London: D. Dobson, 1947.

Krautheimer, Richard. "Introduction to an 'Iconography of Mediaeval Architecture,'" *Journal of the Warburg and Courtauld Institutes*, 5 (1942): 1–33.

Kurtz, R. *Expressionisme et cinéma*. Translated by P. Goden. Grenoble, 1986.

Pehnt, W. *Expressionist Architecture*. New York: Praeger, 1973.

Poelzig, H. *Gesammelte Schriften und Werke*. Edited by J. Posener. Berlin: Mann, 1970.

Recht, Roland. *Le Dessin d'architecture: Origine et fonctions*. Paris: A. Biro, 1995.

Reudenbach, B. "Panofsky et Suger de Saint-Denis." *Revue germanique internationale* 2 (1994): 137–50.

Salzman, L. F. *Building in England down to 1540: A Documentary History*. London: Oxford University Press, 1952.

Scheerbart, Paul. *Glasarchitektur*. Berlin: Verlag Der Sturm, 1914.

Schmarsow, A. "Raumgestaltung als Wesen der architektonischen Schöpfung." *Zeitschrift für Ästhetik und allgemeine Kunstwissenschaft* 9 (1914): 66ff.

Sedlmayr, Hans. *Die Entstehung der Kathedrale*. Zurich: Atlantis, 1950.

Sedlmayr, Hans. *Art in Crisis*. Translated by Brian Battershaw. London: Hallis & Carter, 1958. Originally published as *Verlust der Mitte: Die bildende Kunst des 19. und 20. Jahrhunderts als Symbol der Zeit*. (Salzburg: O Müller, 1948).

Simson, Otto von. *The Gothic Cathedral: The Origins of Gothic Architecture and the Medieval Concept of Order*. New York: Pantheon Books, 1956.

Smith, E[arl] Baldwin. *The Dome*. Princeton, NJ: Princeton University Press, 1950.

Warnke, Martin, ed. *Politische Architektur in Europa vom Mittelalter bis Heute: Repräsentation und Gemeinschaft*. DuMont Taschenbücher, no. 143. Cologne: DuMont, 1984.

CHAPTER TWO

Badt, K. *Raumphantasien und Raumillusionen. Wesen der Plastik*. Cologne: DuMont Schauburg, 1963.

Benesch, O. "Max Dvorak: Ein Versuch zur Geschichte der historischen Geisteswissenschaften." *Repertorium für Kunstwissenschaft* 44 (1924): 159–97.

Coellen, L. *Der Stil in der bildenden Kunst. Allgemeine Stiltheorie und geschichtliche Studien dazu*. Traisa, Darmstadt: 1921.

————. *Die Methode der Kunstgeschichte*. Traisa, Darmstadt: 1924.

Dilly, H., ed. *Altmeister moderner Kunstgeschichte*. Berlin: D. Reimer, 1990.

Focillon, Henri. "Sur la notion de style." In *Actes du XIIIe Congrès international d'histoire de l'art*, 300ff. Stockholm, 1933.

Frankl, Paul. "Der Beginn der Gotik und das allgemeine Problem des Stilbeginns." In *Festschrift Heinrich Wölfflin*, 107–25. Munich: H. Schmidt, 1924.

————. *Das System der Kunstwissenschaft*, Brünn and Leipzig: R. M. Rohrer, 1938.

Frey, Dagobert. *Kunstwissenschaftliche Grundfragen. Prolegomena zu einer Kunstphilosophie*. Vienna: R. M. Rohrer, 1946.

Ginzburg, Carlo. *Myths, Emblems, Clues*. Translated by John and Anne C. Tedeschi. London: Hutchinson Radius, 1990.

Gombrich, E. H. *Aby Warburg: An Intellectual Biography*. London: The Warburg Institute, 1970.

Kreis, F. *Die kunstgeschichtliche Gegenstand. Ein Beitrag zur Deutung des Stilbegriffs*. Stuttgart, 1928.

Panofsky, Erwin. *Early Netherlandish Painters: C. E. Norton Lectures 1947–48*. 2 vols. Cambridge, MA: Harvard University Press, 1953.

Passarge, W. *Philosophie der Kunstgeschichte*. Berlin, 1930.

Recht, Roland. "Du style en général et du Moyen Âge en particulier. Quelques remarques d'ordre théorique." *Wiener Jahrbuch für Kunstgeschichte* 46–47/2 (1993–94): 577–93.

Riegl, Aloïs. *The Late Roman Art Industry*. Translated by R. Winkes. Rome: G. Bretschneider, 1985. Originally published as *Die spätrömische Kunst-Industrie nach den Funden in Oesterreich-Ungarn* (Vienna: K. K. Hof- und-Staatsdruckerei, 1901).

Rykwert, J. "Semper und der Begriff des Stils." In *Gottfried Semper und die Mitte des 19. Jahrhunderts* [symposium proceedings, Zurich, December 1974]. Edited by A. M. Vogt et al. Basle, Stuttgart: Birkhäuser, 1976.

Schlosser, Julius von. *Die Wiener Schule der Kunstgeschichte: Rückblick auf ein Säkulum deutscher Gelehrtenarbeit in Österreich*. Innsbruck: Wagner, 1934.

Schmarsow, August. *Die Kunstgeschichte an unseren Hochschulen*. Berlin, 1891.

Sedlmayr, Hans. "Die Quintessenz der Lehren Riegls." Introduction to *Gesammelte Aufsätze*. Vienna: Dr. B. Filser, 1929.

Thuillier, J., R. Recht, J. Hart, and M. Warnke. *Relire Wölfflin: cycle de conférences organisé au musée du Louvre par le Service culturel du 29 Novembre au 20 Décembre 1993 sous la direction de Matthias Waschek*. Paris: Ecole nationale supérieure des beaux-arts, 1995.

CHAPTER THREE

*800 Jahre Franz von Assisi: Franziskanische Kunst und Kultur des Mittelalters* [exhibition catalog]. Vienna: Arnt des Niederoesterreichische Landesmuseums, 1982.

Alcouffe, D. "La glyptique antique, byzantine et occidentale." In *Le Trésor de Saint-Marc de Venise: Galeries nationales du Grand Palais* [exhibition catalog], 73–76. Editions de la reunion des Musée Nationaux: H. Laurens, 1984.

Auerbach, E. "Figura." Translated by M. A. Bernier. Paris: 1993. Originally published in *Archivum Romanicum*, 22/4 (1938): 436–89.

Bakhtin, Mikahil. *Rabelais and His World*. Translated by Hélène Iswolsky. Bloomington: Indiana University Press, 1984.

Batiffol, P. *L'Eucharistie: La présence réelle et la transsubstantiation*. 5th ed. Paris, 1913.

Belting, H. *Bild und Kult: Eine Geschichte des Bildes vor dem Zeitalter der Kunst*. Munich: Beck, 1990.

———. *Das Bild und sein Publikum im Mittelalter: Form und Funktion früher Bildtafeln der Passion*. Berlin: Mann, 1981.

———. *Die Oberkirche von San Francesco in Assisi: Ihre Dekoration als Aufgabe und die Genese einer neuen Wandmalerei*. Berlin: Mann, 1977.

Braun, Joseph. *Die Reliquiare des christlichen Kultes*. Freiburg im Breisgau, 1940.

Browe, P. *Die Verehrung der Eucharistie im Mittelalter*. Munich: M. Hueber, 1933; Rome, 1967.

Brown, Peter. *Society and the Holy in late Antiquity*. London: Faber, 1982.

Carton, R. *L'Expérience physique chez Roger Bacon. Contribution à l'étude de la méthode et de la science expérimentale au XIIIe siècle*. Paris: J. Vrin, 1924.

———. *L'Expérience mystique de l'illumination intérieure chez Roger Bacon*. Paris: J. Vrin, 1924.

Cassirer, Ernst. *The Individual and the Cosmos in Renaissance Philosophy*. Translated by Mario Damandi. Oxford: B. Blackwell, 1963.

Chydenius, J. "The Theory of Medieval Symbolism." *Commentationes humanarum litterarum* no. 27, 2: Helsinki, 1960.

Devlin, D. S. *Corpus Christi: A Study in Medieval Eucharistic Theory, Devotion and Practice*. PhD diss., University of Chicago, 1975.

Dumoutet, E. *Le Désir de voir l'hostie et les origines de la dévotion au saint sacrement*. Paris: Beauchesne, 1926.

Flasch, K. "*Ars imitatur naturam:* Platonischer Naturbegriff und mittelalterliche Philosophie der Kunst." In *Parusia: Studien zur Philosophie Platons und zur Problemgeschichte des Platonismus. Festgabe für Johannes Hirschberger*. Edited by K. Flasch. Frankfurt am Main: Minerva, 1965.

Fritz, J. M. *Goldschmiedekunst der Gotik in Mitteleuropa*. Munich: Beck, 1982.

Gadamer, H. G. *Truth and Method*. Edited by Garrett Barden and John Cumming [translated by William Glen Doepel]. London: Sheed & Ward, 1975.

Gauthier, Marie-Madeleine. *Émaux du Moyen Âge occidental*. Fribourg: Office du Livre, 1972.

———. *Les Routes de la foi: Reliques et reliquaires de Jérusalem à Compostelle*. Paris: Bibliothèque des Arts, 1983.

Guibert de Nogent. *Quo ordine sermo fieri debeat; De bucella ludae data et deveritate Dominici corporis; De sanctis et eorum pigneribus.* Edited by R. B. C. Huygens. Corpus Christianorum. Continuatio mediaevalis, no. 127. Turnholt: Brepols, 1993.

Hahnloser, H. R., and Susanne Brugger-Koch, *Corpus der mittelalterlichen Hartsteinschliffe des 12. bis 15. Jahrhunderts.* Berlin: Deutscher Verlag für Kunstwissenschaft, 1985.

Hempel, Eberhard. *Nikolaus von Cues in seinen Beziehungen zur bildenden Kunst.* Berichte über die Verhandlungen der Sachsischen Akademie der Wissenschaften zu Leipzig. Philologisch-historische Klasse, no. 100, iii. Berlin: 1953.

Henze, U. "Edelsteinallegorese im Lichte mittelalterlicher Bild- und Reliquienverehrung. Forschungsbericht." *Zeitschrift für Kunstgeschichte 3* (1991): 428–51.

Koyré, Alexandre. *Études d'histoire de la pensée philosophique.* Paris: A. Colin, 1961, 1971.

Meyer, Erich. "Reliquie und Reliquiar im Mittelalter." In *Eine Gabe der Freunde für Carl Georg Heise,* 55–66. Edited by Erich Meyer. Berlin: Mann, 1950.

*Ornamenta ecclesiae. Kunst und Künstler der Romanik: Katalog zur Ausstellung des Schnütgen-Museums in der Josef-Haubrich-Kunsthalle.* Edited by Anton Legner [exhibition catalog]. 3 vols. Cologne: Schnütgen-Museum, 1985.

Pontal, O. *Les Statuts de Paris et le synodal de l'Ouest.* Vol. 1 of *Les statuts synodaux français du XIIIe siècle: Précédés de l'historique du synode diocéssain dupuis ses origines.* Paris: Bibliothèque Nationale, 1971.

Ragusa, I., and R. B. Green, eds. *Meditations of the Life of Christ: An Illustrated Manuscript of the Fourteenth Century, Paris BN Ms ital. 115.* Princeton monographs in art and archaeology, no. 35. Princeton, NJ: Princeton University Press, 1961.

Steingräber, E. "Beiträge zur gotischen Goldschmiedekunst Frankreichs." *Pantheon* (1962): 156–66.

*Les Trésors des Églises de France: Musée des arts décoratifs, Paris, 1965* [exhibition catalog]. 2nd ed. Paris: Caisse national des monuments historiques, 1965.

CHAPTER FOUR

*Les Bâtisseurs des cathédrales gothiques,* sous la direction de Roland Recht [exhibition catalog]. Strasbourg, 1989.

Bischoff, B. "Eine Beschreibung der Basilika von St-Denis aus dem Jahre 799." *Kunstchronik 34* (1981): 97–103.

Bony, J. "Architecture gothique: Accident ou nécessité?" *Revue de l'art 58–59* (1983): 9–20.

Boutier, M. "La reconstruction de l'abbatiale de Saint-Denis au XIIIe siècle." *Bulletin monumental 145* (1987): 357–86.

Branner, R. "Gothic Architecture 1160–1180 and Its Romanesque Sources." In *Studies in Western Art: Acts of the Twentieth International Congress of Art History*, 92–104. Edited by Ida E. Rubin. New York, 1961. Vol. 1 of *Romanesque and Gothic Art*. Princeton, NJ: Princeton University Press, 1963.

―――. *St. Louis and the Court Style in Gothic Architecture*. London: Zwemmer, 1965.

―――. *The Cathedral of Bourges and Its Place in Gothic Architecture*. Edited by Shirley Prager. New York: Architectural History Foundation, 1989. Originally published as *La Cathédrale de Bourges* (Paris, Bourges: 1962).

Bruzelius, Caroline. *The Thirteenth-Century Church at St-Denis*. New Haven, CT: Yale University Press, 1985.

Chenu, M.-D. "Auctor, Actor, Autor." *Archivium latinitatis medii aevi. Bulletin Du Cange* 3, iii: 81–86.

Claussen, P. C. "Kathedralgotik und Anonymität 1130–1250." *Wiener Jahrbuch für Kunstgeschichte* 46–47, i (1993–94): 140–60.

Compagnon, A. *La Seconde Main, ou Le travail de la citation*. Paris: Seuil, 1979.

Crosby, Sumner McKnight. *The Royal Abbey of Saint-Denis from Its Beginning to the Death of Suger, 475–1151*. Edited and completed by Pamela Z. Blum. New Haven, CT and London: Yale University Press, 1987.

D'Alverny, M. T. "Les Mystères de l'église, d'après Pierre de Roissy." In *Mélanges offerts à René Croizet . . . à l'occasion de son 70e anniversaire*, 1085–1104. Edited by P. Gallais and Y.-J. Riou. Poitiers: 1966.

Deremble, Jean-Paul, and Colette Manhès. *Les Vitraux légendaires de Chartres: Des récits en images*. Paris: Desclée de Brouwer, 1988.

Deuchler, F. "Le sens de la lecture. À propos du boustrophédon." In *Études d'art médiéval offertes à Louis Grodecki*, 251–58. Edited by Sumner McKnight Crosby et al. Paris: Ophrys, 1981.

Esch, A. "Spolien. Zur Wiederverwendung antiker Baustücke und Skulpturen im mittelalterlichen Italien." *Archiv für Kulturgeschichte* 51 (1969): 1–64.

Gage, J. *Colour and Culture: Practice and Meaning from Antiquity to Abstraction*. London: Thames & Hudson, 1993.

Grodecki, Louis. *Gothic Architecture*. In collaboration with Anne Prache and Roland Recht, translated by I. Mark Paris. New York: Harry N. Abrams, 1977.

―――. "Le maître de saint Eustache de le cathédrale de Chartres." In *Gedenkschrift Ernst Gall*, 171–94. Edited by Margarete Kühn and Louis Grodecki. Munich: Deutscher Kunstverlag, 1965.

―――. "Le vitrail et l'architecture au XIIe et XIIIe siècle." *Gazette des beaux-arts* 36 (1949):5–24.

Gross, Werner. *Gotik und Spätgotik*. Frankfurt am Main: Umschau-Verlag, 1969.

Hahnloser, H. R. *Villard de Honnecourt. Kritische Gesamtausgabe des Bauhüttenbuches ms. fr. 19093 der Pariser Nationalbibliothek*. 2nd rev. ed. Graz: Akademische Druck- und Verlagsanstalt, 1972.

Heitz, C. *Recherches sur les rapports entre architecture et liturgie à l'époque carolingienne*. Paris: S.E.V.P.E.N, 1963.

Henriet, J. "La cathédrale Saint-Étienne de Sens: le parti du premier Maître et les campagnes du XIIe siècle." *Bulletin monumental* 140 (1982): 81–174.

Illich, Ivan. *In the Vineyard of the Text: A Commentary to Hugh's* Didascalicon. Chicago: University of Chicago Press, 1993.

Jencks, Charles A. *The Language of Post-Modern Architecture*. London: Academy Editions, 1977.

Kemp, Wolfgang. *The Narratives of Gothic Stained Glass*. Translated by Caroline Dobson Saltzwedel. Cambridge: Cambridge University Press, 1997.

Kimpel, D. "Le développement de la taille en série dans l'architecture médiévale et son rôle dans l'histoire économique." *Bulletin monumental* 135 (1977): 195–222.

Kunst, H.-J. "Freiheit und Zitat in der Architektur des 13. Jahrhunderts. Die Kathedrale von Reims." In *Bauwerk und Bildwerk im Hochmittelalter. Anschauliche Beiträge zur Kultur- und Sozialgechichte*. Edited by Karl Clausberg et al. Giessen: Anabas-Verlag, 1981.

Lautier, C. "Les peintres-verriers des bas-côtés de la nef de Chartres au début du XIIIe siècle." *Bulletin monumental* 148 (1990): 7–45.

Leniaud, Jean-Michel. *Jean-Baptiste Lassus (1807–1857), ou Le temps retrouvé des cathédrales*. Bibliothèque de la Société française d'archéologie, no. 12. Paris: Arts et métiers graphiques, 1980.

Michler, J. "Über die Farbfassung hochgotischer Sakralräume." *Wallraf-Richartz Jahrbuch* 39 (1977): 29–64.

———. "La cathédrale Notre-Dame de Chartres: reconstitution de la polychromie originale de l'intérieur." *Bulletin monumental* 147 (1989): 117–31.

———. "Die Dominikanerkirche zu Konstanz und die Farbe in der Bettelordensarchitektur um 1300." *Zeitschrift für Kunstgeschichte* 55 (1990): 253–76.

Minnis, A. J. *Medieval Theory of Authorship: Scholastic Literary Attitudes in the Later Middle Ages*. London: Scolar Press, 1984.

Mortet, V. "La maîtrise d'oeuvre dans les grandes constructions du XIIIe siècle et la profession d'appareilleur." *Bulletin monumental* 70 (1906): 23–70.

Mortet, V., and P. Deschamps. *Recueil de textes relatifs à l'histoire de l'architecture et à la condition des architectes en France, au Moyen Âge, XIe-XIIIe siècles*. [1911–26]. Format, no. 15. Paris: C.T.H.S, 1995.

Muratova, X. "Vir quidem fallax et falsidicus sed artifex praelectus: Remarques sur l'image sociale et littéraire de l'artiste au Moyen Âge." In *Artistes, artisans et production au Moyen Âge* [conference proceedings, Haute-Bretagne, May 1983], 53–72. Edited by X. Barral i Altet. Vol. 1, *Les Hommes*. Paris: Picard, 1986.

Prache, Anne. *Saint-Rémi de Reims, l'oeuvre de Pierre de Celle et sa place dans l'architecture gothique*. Bibliothèque de la Société française d'archéologie, no. 8. Paris: Arts et métiers graphiques, 1978.

Presbyter, Theophilus. *Theophilus Presbyter: Schedula diversarum artium. I. Band. / rev. text übersetzung und appendix von Albert Ilg.* Vienna: W. Braumuller, 1874.

Reudenbach, B. "Säule und Apostel. Überlegungen zum Verhältnis von Architektur und exetischer Literatur." *Frühmittelalterliche Studien* 14 (1980): 310–51.

Schlink, W. *Zwischen Cluny und Clairvaux: Die Kathedrale von Langres und die burgundische Architektur des 12. Jahrhunderts.* Beiträge zur Kunstgeschichte, 4. Berlin: Walter de Gruyter, 1970.

Sauer, J. *Symbolik des Kirchengebäudes und seiner Ausstattung in der Auffassung des Mittelalters.* Freiburg im Breisgau: 1902.

Warnke, Martin. *Bau und Überbau: Soziologie der mittelalterlichen Architektur nach den Schriftquellen.* Frankfurt am Main: Syndikat, 1979.

Webb, Geoffrey Fairbank. *Architecture in Britain: The Middle Ages.* Pelican History of Art. Harmondsworth: Penguin Books, 1956.

CHAPTER FIVE

Antoine, J.-P. "*Ad perpetuum memoriam*: Les nouvelles fonctions de l'image peinte en Italie: 1250–1400." *Mélanges de l'École française de Rome, Moyen Âge-Temps modernes* 100–2 (1988): 541–615.

Barasch, Moshe. *Gestures of despair in medieval and early Renaissance art.* New York: New York University Press, 1976.

Baxandall, Michael. *The Limewood Sculptors of Renaissance Germany.* New Haven, CT: Yale University Press, 1980.

———. *Painting and Experience in Fifteenth-Century Italy: A Primer in the Social History of Pictorial Style.* Oxford: Clarendon Press, 1972.

Berger, Blandine-Dominique. *Le drame liturgique de Pâques du Xe au XIIIe siècle: Liturgie et théâtre.* Théologie historique, no. 37. Paris: Beauchesne, 1976.

Berliner, R. "Arma Christi." *Münchner Jahrbuch für bildende Kunst* 3.F. 6 (1955): 35–152.

Braun, J. *Der christliche Altar in seiner geschichtlichen Entwicklung.* Munich: Alte-meister Guenther Koch, 1924.

Buttner, Frank Otto. *"Imitatio pietatis": Motive der christlichen Ikonographie als Modelle zur Verähnlichung.* Berlin: Gebrüder Mann, 1983.

Carruthers, Mary J. *The Book of Memory: A Study of Memory in Medieval Culture.* Cambridge: Cambridge University Press, 1990.

Corbin, Solange. *La Déposition liturgique du Christ au vendredi saint: Sa place dans l'histoire des rites et du théâtre religieux.* Paris, Lisbon: Amadora, 1960.

Dettloff, Szczęsny. *Wit Stwocz.* 2 vols. Polska Akademia Nauk. Komitet Nauk o Sztuce. Wrocław: Zakład Narodowy im. Ossolińskich, 1961.

Duggan, L. G. "Was Art Really the 'Book of the Illiterati'?" *Word and Image* V, 3 (1989): 227–51.

Ehresmann, D. L. "Some Observations on the Role of Liturgy in the Early Winged Altarpiece." *The Art Bulletin* 64 (1982): 359–69.

Engemann, J. "Das Hauptportal der Hohenkirche in Soest, sein komplexes Bildprogramm und die Frage nach der Beziehung zum Betrachter." In *Artistes, artisans et production au Moyen Âge* [conference proceedings, Haute-Bretagne, May 2–6, 1983], 387–435. Edited by X. Barral i Altet. Vol. 3, *Fabrication et consommation du travail*. Paris: Picard, 1990.

Esmeijer, Anna C. *Divina quaternitas: A Preliminary Study in the Method and Application of Visual Exegesis*. Assen: Gorcum, 1978.

Francovich, G. de. "L'origine e la diffusione del Crocifisso gotico doloroso." *Kunstgeschichtliches Jahrbuch der Bibliotheca Hertziana* 2 (1938): 143–261.

Gougaud, L. *Dévotions et pratiques ascétiques du Moyen Âge*. Paris: Abbaye de Maredsous, 1925. Translated by G. C. Bateman as *Devotions and Ascetic Practices in the Middle Ages* (London: Burns, Oates, and Washbourne, 1927).

———. "Muta praedicatio." *Revue bénédictine* 42, 1 (1930): 168–71.

Gy, Pierre-Marie. *La Liturgie dans l'histoire*. Paris: Cerf, 1990.

Hajdu, Helga. *Das mnemotechnische Schrifttum des Mittelalters*. Vienna, Budapest: Deutsches Institut der Königl. Ung. Peter Pazmany Universität Budapest, 1936.

Hamburger, J. F. "The Use of Images in the Pastoral Care of Nuns: The Case of Heinrich Suso and the Dominicans." *The Art Bulletin* 71 (1989): 20–46.

———. "Art, Enclosure and the *Cura Monialium*: Prolegomena in the Guise of a Postscript." *Gesta* 31/1 (1992): 108–34.

Hausherr, Reiner. "Das Imewardkreuz und der Volto-Santo Typ." *Jahrbuch für Kunstwissenschaft* 16 (1962): 129ff.

———. *Der Tote Christus am Kreuz. Zur Ikonographie des Gerokreuzes*. PhD diss., Rheinische Friedrich-Wilhelms-Universität, Bonn, 1963.

———. "Über die Christus-Johannes-Gruppe. Zum Problem 'Andachtsbilder' und deutsche Mystik." In *Beiträge zur Kunst des Mittelalters: Festschrift für Hans Wentzel zum 60. Geburtstag*, 79–103. Edited by Rüdiger Becksmann et al. Berlin: Gebr. Mann, 1975.

Heiler, F. *Prayer. A Study in the History and Psychology of Religion*. Edited and translated by Samuel McComb. New York: Oxford University Press, 1932.

Hood, W. "Saint Dominic's Manner of Praying: Gestures in Fra Angelico's Frescoes at S. Marco." *The Art Bulletin* 68 (1986): 195–206.

Keller, H. "Der Flügelaltar als Reliquienschrein." In *Studien zur Geschichte der europäischen Plastik. Festschrift Theodor Müller, zum 19. April 1965*, 125–44. Edited by Kurt Martin et al. Munich: Hirmer Verlag, 1965.

Konigson, E. *L'Espace théâtral médiéval*. Paris: 1975.

Kruger, K. *Der frühe Bildkult des Franziskus in Italien. Gestalt- und Funtionswandel des Tafelbildes im 13. und 14. Jahrhundert*. Berlin: Gebrüder Mann, 1992.

Kurmann, P. "Die Pariser Komponenten in der Architektur und Skulptur der West-fassade von Notre-Dame zu Reims." *Münchner Jahrbuch für bildende Kunst* N.F. 35 (1984): 41–82.

Lane, Barbara G. *The Altar and the Altarpiece: Sacramental Themes in Early Nether-landish Painting*. New York: Harper & Row, 1984.

Lipphardt, W. ed. *Lateinische Osterfeiern und Osterspiele*. 4 vols. Ausgaben deutscher Literatur des XV. bis XVIII. Jahrhunderts. Reihe Drama, no. 5. Berlin: 1975–90.

Lugli, Adalgisa. *Guido Mazzini e la rinascimento della terracota nel quattrocento*. Turin: U. Allemandi, 1990.

Marrow, James H. *Passion Iconography in Northern European Art of the Late Middle Ages and Early Renaissance: A study of the Transformations of Sacred Metaphor into Descriptive Narrative*. Kortrijk: Ghemmert, 1979.

Meier, T. *Die Gestalt Mariens im geistlichen Schauspiel des deutschen Mittelalters*. Berlin: 1959.

Pächt, Otto. *The Rise of Pictorial Narrative in Twelfth-Century England*. Oxford: Clarendon Press, 1962.

Parker, Elizabeth C. *The Descent from the Cross: Its Relation to the Extraliturgical Depositio Drama*. New York: Garland, 1975.

Philippot, P. "Les grisailles et les 'degrés de réalité' de l'image dans la peinture fla-mande des XVe et XVIe siècles." *Bulletin des Musées royaux des beaux-arts de Belgique* 15 (1966): 225–42.

Pickering, F. P. *Literature and Art in the Middle Ages*. London: Macmillan, 1970.

Pressouyre, L. "St. Bernard to St. Francis: Monastic Ideals and Iconographic Pro-gram in the Cloisters." *Gesta* 12 (1973): 71–92.

Recht, Roland. *Nicolas de Leyde et la sculpture à Strasbourg (1460–1525)*. Strasbourg: Presses universitaires de Strasbourg, 1987.

Ringbom, Sixten. *Icon to Narrative: The Rise of the Dramatic Close-up in Fifteenth-Century Devotional Painting*. Acta Academiae aboensis. Ser. A. Humaniora, no. 31/2. Åbo: 1965.

———. "Devotional Images and Imaginative Devotions: Notes on the Place of Art in Late Medieval Piety." *Gazette des beaux-arts* 73 (1969): 159–70.

Roeder, A. *Die Gebärde im Drama des Mittelalters. Osterfeiern-Osterspiele*. Munich: Beck, 1974.

Rosenberg, A. *Die christliche Bildmeditation*. Munich: O. W. Barth, 1955.

Rossi, P. *Logic and the Art of Memory: The Quest for a Universal Language*. Trans-lated by Stephen Clucas. London: Athlone, 2000.

Sauerländer, W. "Kleider machen Leute. Vergessenes aus Viollet-le-Ducs *Diction-naire du mobilier français*." *Arte Medievale* 1 (1983): 221–40.

Schaelicke, B. *Die Ikonographie der monumentalen Kreuzabnahmegruppen des Mit-telalters in Spanien*. Berlin: 1975.

Schmitt, J.-Cl. *La Raison des gestes dans l'Occident médiéval*. Paris: Gallimard, 1990.

Skubiszewski, P. "Der Stil des Veit Stoss." *Zeitschrift für Kunstgeschichte* 41 (1978): 93–135.

Smith, M. T. "The Use of Grisaille as a Lenten Observance." *Marsyas. Studies in the History of Art* 8 (1959): 43–54.

Söhring, O. *Werke bildender Kunst in altfranzösischen Epen.* PhD diss., Friedrich-Wilhelms-Universität, Erlangen: 1900.

Stratford, N. "Le mausolée de saint Lazare à Autun." In *Le Tombeau de saint Lazare et la sculpture romane à Autun après Gislebertus: Ville d'Autun–Musée Rolin 8 juin–15 septembre 1985* [exhibition catalog], 11–38. Autun: Musée Rolin, 1985.

Stuhr, Michael. *Der Krakauer Marienaltar von Veit Stoss.* Leipzig: Seemann, 1992.

Suckale, Robert. "*Arma Christi*: Überlegungen zur Zeichenhaftigkeit mittelalterlicher Andachtsbilder." *Städel Jahrbuch* N.F.6 (1977): 177–208.

Taralon, J. "La Majesté d'or de Sainte Foy du trésor de Conques." *Revue de l'art* 40–41 (1978): 9ff.

Toschi, P. *L'antico dramma sacro italiano.* 2 vols. Florence: Libreria editrice fiorentina, 1926.

Vetter, E. M. "Das Christus-Johannes Bild der Mystik." In *Mystik am Oberrhein und in benachbarten Gebieten,* 37–49. Freiburg im Breisgau, 1978.

Weymann, U. *Die deutsche Mystik und ihre Wirkung auf die bildende Kunst.* Berlin, 1938.

White, John. *Duccio: Tuscan Art and the Medieval Workshop.* London: Thames & Hudson, 1979.

Wilmart, André. *Auteurs spirituels et textes dévots du Moyen Âge latin: Études d'histoire littéraire.* Paris: Bloud et Gay, 1932.

Wirth, Jean. *L'Image médiévale. Naissance et développements (VIe-XVe siècle).* Paris: Méridiens Klincksieck, 1989.

Yates, Frances A. *The Art of Memory.* London: Routledge and Kegan Paul, 1966.

Zinn, G. A. "Mandala Symbolism and Use in the Mysticism of Hugh of St. Victor." *History of Religions* 12/1 (1972): 317–41.

CHAPTER SIX

Bauch, K. *Das mittelalterliche Grabbild. Figürliche Grabmäler des 11. bis 15. Jahrhunderts in Europa.* Berlin: De Gruyter, 1976.

Beck, H., and H. Bredekamp. "Kompilation der Form in der Skulptur um 1400. Beobachtungen an Werken des Meisters von Grosslobming." *Städel-Jahrbuch* N.F.6 (1977): 129ff.

Beck, Herbert, et al. *Kunst um 1400 am Mittelrhein. Ein Teil der Wirklichkeit.* Ausstellung im Liebieghaus Museum alter Plastik, Frankfurt am Main 10. Dezember 1975 bis zum 14. März 1976. Frankfurt am Main: Liebieghaus, 1975.

Bialostocki, Jan, ed. *Spätmittelalter und beginnende Neuzeit.* Propyläen Kunstgeschichte, no. 7. Berlin: Propyläen-Verlag, 1972.

Bloch, P. "Bildnis im Mittelalter—Herrscherbild—Grabbild—Stifterbild." In *Bilder vom Menschen in der Kunst des Abendlandes. Jubiläumsausstellung der Preussischen Museen, Berlin 1830–1980* [exhibition catalog], 105–120. Edited by Brigitte Hufler. Berlin: Die Museen, 1980.

Brüggen, Elke. *Kleidung und Mode in der höfischen Epik des 12. und 13. Jahrhunderts.* Beihefte zum *Euphorion,* no. 23. Heidelberg: Winter, 1989.

Campbell, L. "The Art Market in the Southern Netherlands in the Fifteenth Century." *The Burlington Magazine* 118 no. 877 (1976): 188–98.

Claussen, P. C. "Antike und gotsche Skulptur in Frankreich um 1200." *Wallraf-Richartz-Jahrbuch* 35 (1973): 83–108.

Dehaisnes, C. *Histoire de l'art dans la Flandre, l'Artois et le Hainaut avant le XVe siècle. Documents et extraits divers.* 2 vols. Lille, 1886.

Didier, R. and R. Recht. "Paris, Prague, Cologne et la sculpture de la seconde moitié du XIVe siècle: À propos de l'exposition des Parler à Cologne." *Bulletin monumental* 138 (1980): 173–219.

Erlande-Brandenburg, Alain. *Le roi est mort: Études sur les funérailles, les sépultures et les tombeaux des rois de France jusqu'à la fin du XIIIe siècle.* Bibliothèque de la Société française d'archéologie, no. 7. Paris: Arts et métiers graphiques, 1975.

Ewing, D. "Marketing Art in Antwerp, 1460–1560: Our Lady's Pand." *The Art Bulletin* 72 (1990): 558–84.

*Les Fastes du gothique: Le siècle de Charles V. Exposition organisée par la Réunion des Musées Nationaux et la Bibliothèque Nationale, 9 octobre 1981—1er février 1982.* Paris: Éditions de la Réunion des Musées Nationaux, 1981–82.

Floerke, H. *Studien zur niederländischen Kunst- und Kulturgeschichte. Die Formen des Kunsthandels, das Atelier und die Sammler in den Niederlanden vom 15.–18. Jahrhundert.* Munich, Leipzig: G. Müller, 1905.

Giesey, Ralph E. *The Royal Funeral Ceremony in Renaissance France.* Travaux d'humanisme et Renaissance, no. 37. Geneva: E. Droz, 1960.

Gilson, Étienne Henry. *La Philosophie au Moyen Âge.* 2 vols. Paris: Payot, 1922.

Grassi, Ernesto. *Die Theorie des Schönen in der Antike.* Neuausgabe. DuMont Taschenbücher, no. 90. Cologne: DuMont, [1962] 1980.

Guenée, Bernard. *Histoire et culture historique dans l'Occident médiéval.* Paris: Aubier Montagne, 1980.

Hahnloser, H. R. "Das Gedankenbild im Mittelalter und seine Anfänge in der Spätantike." *Atti del convegno internazionale sul tema Tardo Antico e Alto Medievo,* 225ff. Academia Nazionale dei Lincei, Anno 365. Rome: 1968.

Heinrich, Johanna. *Die Entwicklung der Madonnenstatue in der Skulptur Nordfrankreichs von 1250 bis 1350.* Inaugural diss., Frankfurt am Main. Borna, Leipzig: 1933.

Hohenzollern, Johann Georg, Prinz von. *Die Königsgalerie der französischen Kathedrale. Herkunft, Nachfolge.* Munich: Fink, 1965.

Huth, H. *Künstler und Werkstatt der Spätgotik.* 2nd ed. Darmstadt: Wissenschaftliche Buchgesellschaft, [1925] 1967.

Jacobs, L. F. "The Marketing and Standardization of South Netherlandish Carved Altarpieces: Limits of the Role of the Patron." *The Art Bulletin* 71 (1989): 208-29.

Jenni, U. *Das Skizzenbuch der internationalen Gotik in der Uffizen. Der Übergang vom Musterbuch zum Skizzenbuch.* 2 vols. Vienna: Holzhausen, 1976.

Kaemp, H. *Pierre Dubois und die geistigen Grundlagen des französischen Nationalbewusstseins um 1300.* Leipzig and Berlin: B. G. Teubyer, 1935.

Kantorowicz, E. H. *The King's Two Bodies. A Study in Mediaeval Political Theology.* Princeton, NJ: Princeton University Press, 1957.

Keller, Harald. "Die Entstehung des Bildnisses am Ende des Hochmittelalters." *Römisches Jahrbuch für Kunstgeschichte* 3 (1939): 226-356.

———. *Das Nachleben des antiken Bildnisses von der Karolingerzeit bis zur Gegenwart.* Freiburg, Basle, Vienna: Herder, 1970.

Köhn, A. *Das weibliche Schönheitsideal in der ritterlichen Dichtung.* Form und geist; arbeiten zur germanischen philology. Greifswald, 1930.

König, E. "Gesellschaft, Material, Kunst: Neue Bücher zur deutschen Skulptur um 1500." *Zeitschrift für Kunstgeschichte* 4 (1984): 535-58.

Kurmann, Peter. *La Façade de la cathédrale de Reims: Architecture et sculpture des portails.* Paris: CNRS, 1987.

Labuda, A. S. "Individuum und Kollektiv in den Forschungen zur spätgotischen Kunst." *Actes du congrès international de l'histoire de l'art* [1983], 3: 45-50. Vienna, 1984-86.

Ladner, G. "Die Anfänge des Kryptoporträts." In *Von Angesicht zu Angesicht, Porträtstudien. Michaël Stettler zum 70. Geburtstag,* 78-97. Edited by Florens Deuchler. Berne: Stämpfli, 1983.

Legner, A. "Bilder und Materialen in der spätgotischen Kunstproduction." *Städel-Jahrbuch* N.F.6 (1977): 158-76.

Le Goff, J. *The Birth of Purgatory.* Translated by Arthur Goldhammer. Chicago: University of Chicago Press, 1984.

Montias, J. M. "Socio-Economic Aspects of Netherlandish Art from the Fifteenth to the Seventeenth Century: A Survey." *The Art Bulletin* 72 (1990): 358-73.

———. *Le marché de l'art aux Pays-Bas (XVe-XVIIe siècles).* Paris: Flammarion, 1996.

Panofsky, Erwin. *Idea: A Concept in Art History.* Translated by Joseph J. S. Peake. 2nd rev. ed. New York: Harper & Row, [1924] 1975.

———. *Tomb Sculpture: Its Changing Aspects from Ancient Egypt to Bernini.* Edited by H. W. Jansen. London: Thames & Hudson, 1964.

*Die Parler und der schöne Stil 1350-1400: Europäische Kunst unter den Luxemburgern. Ein Handbuch zur Ausstellung des Schnütgen Museums in der Kunsthalle Köln.* Edited by Anton Legner. 5 vols. Cologne: Museen der Stadt, 1978-80.

Pouchelle, Marie-Christine. *The Body and Surgery in the Middle Ages*. Translated by Rosemary Morris. Cambridge: Polity, 1990.

Quicherat, J. *Histoire du costume en France, depuis les temps les plus reculés jusqu'à la fin du XVIIIe siècle*. Paris, 1876.

*Rhein und Maas. Kunst und Kultur 800–1400: Eine Ausstellung des Schnütgen Museums der Stadt Köln und der belgischen Ministeriens für französische und niederländische Kunst*. 2 vols. Cologne, 1972–73.

Robin, Françoise. *La Cour d'Anjou-Provence: La vie artistique sous le règne de René*. Paris: Picard, 1985.

Scheffler, W. "Die Porträts der deutschen Kaiser und Könige im späten Mittelalter (1259–1519)." *Repertorium für Kunstwissenschaft* 38 (1910): 318–38.

Schlosser, Julius von. "Portraiture." *Mitteilungen des Österreichischen Instituts für Geschichtsforschung* 11. *Ergänzungsband Oswald Redlich zugeeignet* (1929): 881ff.

Schmidt, Gerhard. *Gotische Bildwerke und ihre Meister*. 2 vols. Vienna, Cologne, Weimar: Böhlau, 1992.

Schulz, A. *Das höfische Leben zur Zeit der Minnesänger*. Leipzig: S. Hirzel, 1879.

Siebert, F. *Der Mensch um Dreizehnhundert im Spiegel deutscher Quellen. Studien über Geisteshaltung und Geistesentwicklung*. Berlin, 1931.

Sommer, C. *Die Anklage der Idolatrie gegen Pabst Bonifaz VIII und seine Porträtstatuen*. Freiburg im Breisgau, 1919.

Strayer, R. *The Reign of Philip the Fair*. Princeton, NJ: Princeton University Press, 1980.

Suckale, Robert. "Die Bamberger Domskulpturen." *Münchner Jahrbuch für bildende Kunst* 3.F. 38 (1987). 27–82.

Taubert, Johannes. *Farbige Skulpturen: Bedeutung, Fassung, Restaurierung*. Munich: Callwey, 1978.

Vöge, Wilhelm. *Die Anfänge des Monumentalen Stiles im Mittelalter*. Strasbourg: J. H. E. Heitz, 1894.

———. *Bildhauer des Mittelalters. Gesammelte Studien*. Berlin: Gebrüder Mann, 1958.

Wenck, K. *Philipp der Schöne von Frankreich, seine Persönlichkeit und das Urteil der Zeitgenossen*. Marburg: Koch, 1905.

CONCLUSION

Brincken, A. D. von den. "*Mappa mundi* und *Chronographia:* Studien zur *imago mundi* des abendländischen Mittelalters." *Deutsches Archiv für Erforschung des Mittelalters namens der Monumenta Germaniae Historica:* 24/1 (1968):118–86.

Camille, M. "Seeing and Reading: Some Visual Implications of Medieval Literacy and Illiteracy." *Art History* 8/1 (1985): 26–49.

Davies, Martin. *Rogier Van der Weyden: An Essay, with a Critical Catalogue of Paintings Assigned to Him and to Robert Campin.* London: Phaidon, 1972.

Gombrich, Ernst H. *Norm and Form: Studies in the Art of the Renaissance.* London: Phaidon, 1966.

———. *The Sense of Order: A Study in the Psychology of Decorative Art.* Oxford: Phaidon, 1979.

Jauss, H. R. "Die klassische und die christliche Rechtfertigung des Hässlichen in mittelalterlicher Literatur." In *Die nicht mehr schönen Künste. Grenzphänomene des Ästhetischen*, 143–68. Edited by H. R. Jauss. Poetik und Hermeneutik, no. 3. Munich: W. Fink, 1968.

Quadlbauer, F. *Die antike Theorie der genera dicendi im lateinischen Mittelalter.* Österreichische Akademie der Wissenschafter. Phil.-hist. Klasse. Sitzungsberichte. 241/2. Vienna: Wien, H. Böhlaus Nfg., Kommissionsverlag der Österreichischen Akademie der Wissenschaften, 1962.

Zumthor, P. *La Mesure du monde.* Paris: Seuil, 1993.

*Cross references to subjects of artwork can be found in the index of persons.*
*Page references in italics refer to illustrations.*